Design *and* Practice *for* Printed Textiles

andrea mcnamara
patrick snelling

Melbourne

OXFORD UNIVERSITY PRESS

OXFORD UNIVERSITY PRESS

Oxford New York
Athens Auckland Bangkok Bombay
Calcutta Cape Town Dar es Salaam Delhi
Florence Hong Kong Istanbul Karachi
Kuala Lumpur Madras Madrid Melbourne
Mexico City Nairobi Paris Singapore
Taipei Tokyo Toronto

and associated companies in
Berlin Ibadan

OXFORD is a trade mark of Oxford University Press

National Library of Australia
Cataloguing-in-Publication data:

McNamara, Andrea.
 Design and practice for printed textiles.

 Bibliography.
 Includes index.
 ISBN 0 19 553371 2.

 1. Textile design. 2. Textile printing.
 I. Snelling, Patrick.
 II. Title.

677.022

Illustrations by Vaughan Duck
Printed in Singapore by Global Com
Published by Oxford University Press
253 Normanby Road, South Melbourne, Australia

Contents

Acknowledgments

Author Acknowledgments

The authors gratefully acknowledge the assistance and support of the Department of Fashion and Textile Design, the Department of Visual Communication (Photography), and the National Key Centre for Design at the Royal Melbourne Institute of Technology, Melbourne.

We also thank students of the BA (Textile Design) course at RMIT, past and present, and our professional colleagues in the textile design industry, who have contributed work to this book. Invaluable technical information was provided by Graeme Francis and Bonnie Derwent at Kraft Kolour: their patience (over many years) is greatly appreciated. We received great technical support and encouragement from Kathryn Williamson and Ruth Belfrage, technical officers at RMIT, during the time of writing this book. Thanks also to Verity Prideaux, for all her help on the repeat exercises and diagrams.

A special thank you to our good friend and RMIT colleague, Dr John Storey, for his expertise and great generosity with the photography in this book.

ANDREA MCNAMARA
PATRICK SNELLING

Source Acknowledgments

The authors and publishers would like to thank the following copyright holders for permission to reproduce material:
The Design Library, page 117
Mambo: Mambo bull fabric designed by Robert Moore, page 45
Pantone, Inc., page 33
View textile magazine, page 31 (Issue 23), page 20 (Issue 25)

Disclaimer

Acknowledgment is also given to Susan Banks, Helen Wilson and Private Collections, Jemma Dacre of Textiles for Nomads, and Davenport for their contributions to the real-life design briefs in Chapter 1.

Glossary

Glossary words are indicated in the text by a **bold** typeface.

acrylic a pigmented polymer paint used by artists more than textile designers. Can be used to create thick impasto styles for working back into with a hard tool.

airbrush the application of ink or gouache through an airbrush using compressed air. Creates fine, controlled gradation of colour.

all-over design a design style that has connecting, irregularly occurring motifs within one repeat unit. Fairly close and compact in style, e.g. Laura Ashley sprigs of flowers.

analogous colours colours that are next to or near each other on any part of the colour wheel.

backing cloth the top layer on a print table, onto which fabric is stapled ready for printing. The backing cloth is easily removed for washing.

batik a traditional form of resist printing using wax.

bleed a term used in screen printing when the print crawls beyond the design area when drying and does not form a crisp edge.

blends fabrics with combinations of yarn types, e.g. cotton and linen.

block printing one of the first forms of repeat printing. Wood, copper and lino blocks are carved with the design in one repeat unit. Also used in this text to create a mark making process.

blotch a solid background area surrounding the motifs in the printed or painted design.

border a design that runs alongside and independently from the main body or field design. Bed linen, tablecloths, wallpaper, scarves and carpets incorporate borders within the design.

bracket a piece of metal that is screwed into the wooden frame of the screen for correct alignment with the stop.

brief information relayed by the client to the designer in written or verbal form.

CAM computer-aided manufacturing.

CATD computer-aided textile design.

cellulosic fibres natural fibres made from plants.

challis a light weight woollen fabric.

check, plaid or tartan a pattern of interlacing squares, lines and colour, usually woven but also printed. Yarn dyes are used to replicate these styles for printing.

chroma intensity or strength of a colour or hue.

client individual/s or company for whom you are doing the work.

collage an illustration technique where cut or torn paper is applied to a surface to create a pattern or image.

colour chips small areas of painted colours taken from the finished painted design. Informs the client or printer how many colours there are in the design.

colour palette the palette describes what sort of colours are used in the design.

colour predictors designers who make colour predictions. They forecast colours for forthcoming seasons or styles. The industry uses specialist prediction colour periodicals.

colourist person in the design studio or a freelancer who specialises in developing correct colours for a given market and season.

colour separation see **process colour**

colourways a term used to describe an alternative colouring of a design.

complementary colours colours opposite each other on the colour wheel.

concept boards visual reference for a client or designer to explain a development theme or concept. Can be constructed from magazine cut-outs, photocopies etc.

constructed textiles knitted or woven textiles.

coordinates a term used to describe two or more different designs that relate by colour or pattern.

copyright a term used to describe the legal rights of the designer when negotiating the selling of the design work.

croquis a word to describe a design that implies a repeat but is not painted up to final production specification. The word *croquis* comes from the French, meaning 'to sketch'.

découpage process of decorating a surface with paper cut-outs.

degreasing process to prepare the mesh for the photographic emulsion.

design styles in textile design, styles for categorising designs have emerged, e.g. floral, geometric, novelty, toile.

detail paper similar to tracing paper, used for tracing the design to put into repeat.

devoré style technique of printing that uses an acid print paste on cellulosic and synthetic blended cloth. The cotton is burned out leaving a transparent area where the design was printed.

directional, non-directional describes the direction in which a style of pattern repeats, i.e. vertically, horizontally or both. Furnishing fabrics are often directional (can only be used one way), while fashion fabrics are more economical to use if they are non-directional.

discharge a printing style where a special print paste removes the colour from the printed area on the base cloth.

fashion fabrics fabrics that have specific qualities of weight and and texture suitable for garments. Design motifs are usually smaller and in all-over repeat styles.

finished design painted design work that is in accurate repeat, to scale, in full colour and can be used by the printer for production.

flat bed screens flat bed printing uses flat screens.

freelance a term used to describe designers who are self-employed and work for a number of different clients.

Frisk film a semi-adhesive plastic film used to create stencils or masks around motifs on paper.

frottage a technique where an image is transferred onto paper by rubbing over with dry media.

furnishing fabric fabric that has specific qualities of weight and and texture suitable for furnishing. Designs are usually larger in scale and have borders with specific repeat sizes.

gouache or designers' colour: a good quality paint used by professional designers. It is widely used in textile design for finished artwork because it gives good flat colour.

halftones the process of converting tonal areas into dots, e.g. newspaper photographs.

hue refers to the pure colour, e.g. red

in-house designer a designer who is employed and works in a company studio.

Indalca or **Guar gum** a thickener used for printing discharge and *devoré* styles. Also used for printing woollen fabrics.

intensity describes the strength of a colour, i.e. whether it is dull or bright.

intercut a technique for cutting out and replacing problem areas in a design.

'knocking off' copying another design that already exists in production. Copyright laws forbid this unethical practice.

layout an arrangement of motifs in full repeat. The size of the layout relates to the dimensions of the screen.

Manutex RS or **F** An alginate. When mixed with water it is used as the printing paste for dyes.

market areas of commercial activity that are targeted by textile designers for selling work.

mark making methods of applying different media onto a surface with tools.

masks used to protect an area while colour is applied around it.

masking fluid liquid latex applied with a brush. Used as a resist.

media all types of wet and dry art materials.

monochromatic colour scheme where colour stays the same but values change from light to dark.

monoprint any printing process that results in one print.

ogee a traditional 'onion'-shaped design style.

opaque base a term used to describe media that does not allow light to pass through them. Brown opaque is used for painting film positives; gouache is used by designers because of its opacity as solid colour; opaque printing ink is used for printing lighter colours on top of darker ones.

pattern a term used to describe a repeating set of motifs.

percale denotes the density of a closely woven cotton fabric.

photocopy acetate a plastic acetate film used in a normal photocopier to copy from originals onto film for use as an overlay on artwork or for exposing onto a photographic screen.

pinholes small holes that occur on the coated area of the mesh after exposing the screen.

polychromatic printing refers to a one -off printing technique that uses reactive dyes.

process colour the photographic separation of colour into cyan, yellow, magenta and black. These four colours, when mixed in certain ratios, can make any colour

within the colour spectrum. The technique is more common with paper printing.

process white A high solids paint used for wash-off technique and used to touch up photographs.

***protein* based fibres** fibres made from animal hair or silk worms.

proving the design checking the design to make sure it repeats.

regenerated cellulose fibre fibres made from wood pulp.

registering your screens the design must be squared to the rail prior to coating.

registration rail a metal rail running along the length of the print table. Used in conjunction with stops and brackets to print fabric in repeat.

registration stops metal devices that are placed and screwed onto the rail at exact intervals for repeat printing.

repeat images or motifs that recur to create pattern. Putting a design into repeat is the process of accurately drawing up the design ready for production.

repeat mirror/glass a tool for visualising a design in repeat.

repeat size the dimensions given by the client or printer to the designer for finished artwork for production.

repeat systems traditional design systems used by textile designers for putting designs into repeating formats.

repeat unit an area of the design that indicates the boundary of repeating motifs.

reprographic camera a camera used to convert line and halftone design work onto film for textile screen printing.

resist a substance used to block the application of wet media.

resource book refer to **visual diary**.

rotary screens printing with rotary screens is a continuous production printing system, using cylindrical rather than flat screens. The rotary screens do not move, the cloth is passed underneath them on a moving belt.

ruling pen a tool used by designers to create yarn dyes and fine lines using gouache paint.

saturation refers to the intensity of a colour; whether it is dull or bright.

scanning a scanner is a laser device that can scan artwork with light, then convert the light into digital information, which is stored in the computer.

selvedges woven strips running along both sides of the fabric; they reinforce the fabric edges.

shades colours with black added.

silk screen positives film produced by hand or camera ready art for exposure onto a screen.

spot repeats a traditional form of repeat based on a sateen weave structure.

stencils paper or film that is cut or torn and colour is applied within the area.

story board a finished version developed from a concept board. This is the product shown to clients to sell design work or to show how a design works in an illustration format.

stylist a designer who coordinates and arranges themes and directions for other design team members. Can also be freelance.

sublistatic printing or transfer printing disperse dye is printed or painted onto paper. The design work is transferred by heat. Used on synthetic fibres.

surface pattern design a term used to describe other forms of two-dimensional design, e.g. gift wrap, tiles.

swatchbook a range of printed fabrics, all cut to the same size and presented in a book format. Shows printed designs that coordinate or are in colourways or are on different fabrics.

swatches pieces of fabric used for matching colours in a design, or a piece of printed or other fabric used on interior or fashion story boards.

swiss repeat another version of a full drop design.

technical drawing pen a professional drawing tool for creating accurate line work in a variety of widths.

tints colours with white added.

toile a traditional 18th century fabric incorporating a pastoral or pictorial narrative.

tones colours with grey added.

tram tracks unintentional lines or gaps formed by the negative spaces in the repeating design.

transfer printing see **sublistatic printing**

translucence refers to the quality of transmitting light. For example, ink is translucent and gouache is not.

twill a constructed cloth creating diagonal lines.

value how light or dark a colour is.

visual diary a resource book kept by designers and students in which ideas, sketches, fabrics, colours and magazine cut-outs are kept for reference.

wash off an illustration technique that uses permanent ink over a resist of process white paint.

yarn dyes simulated weave patterns using ruling pen and spray effects to create warp and weft characteristics on paper.

Introduction

Design and Practice for Printed Textiles was written because of a perceived absence of a text that covers the entire process of design for printed textiles taken right through to a conclusion of fabric. The approach is from a design perspective, within the textile industry; beginning with the development of ideas, and what to do with them, through the use of mark-making techniques and pattern formation. The book then looks at the processes through which those ideas can be translated, through the medium of print, onto textiles.

This book has particular relevance for students and teachers of the VCE. The structure of the book, the methods of research, and the exercises directly relate to or can be adapted for use in study designs within the subjects of Art, Studio Arts, Materials and Technology, and Technology, Design and Development. Anyone who wishes to know more about design processes, and how ideas can be applied to fabrics, will find this book useful — designers, craftspeople, artists, and those who are interested in finding out 'how to'.

The discipline of 'textiles' has many outcomes, only one of these is printed fabric. Knitted and woven textiles are as important in everyday life as printed textiles. Many of the design processes described are applicable to constructed textiles — the resourcing of images and ideas, the selection and evaluation process, the conversion of ideas into pattern. The difference lies in the production of the fabric, and the limitations of process that affect designers.

It is not suggested that successful designers for printed textiles must be able to produce printed fabric. It is, however, important for textile designers working in industry to have an understanding of the processes involved in the production of printed fabric. The print processes described are, in principle, those used by industry, although where, for example, the process of handprinting is described, industry is mechanised. The technical information is presented so that processes can be done on a limited budget, without sophisticated equipment. The aim is to encourage experimentation by designers, through the translation of ideas onto fabric.

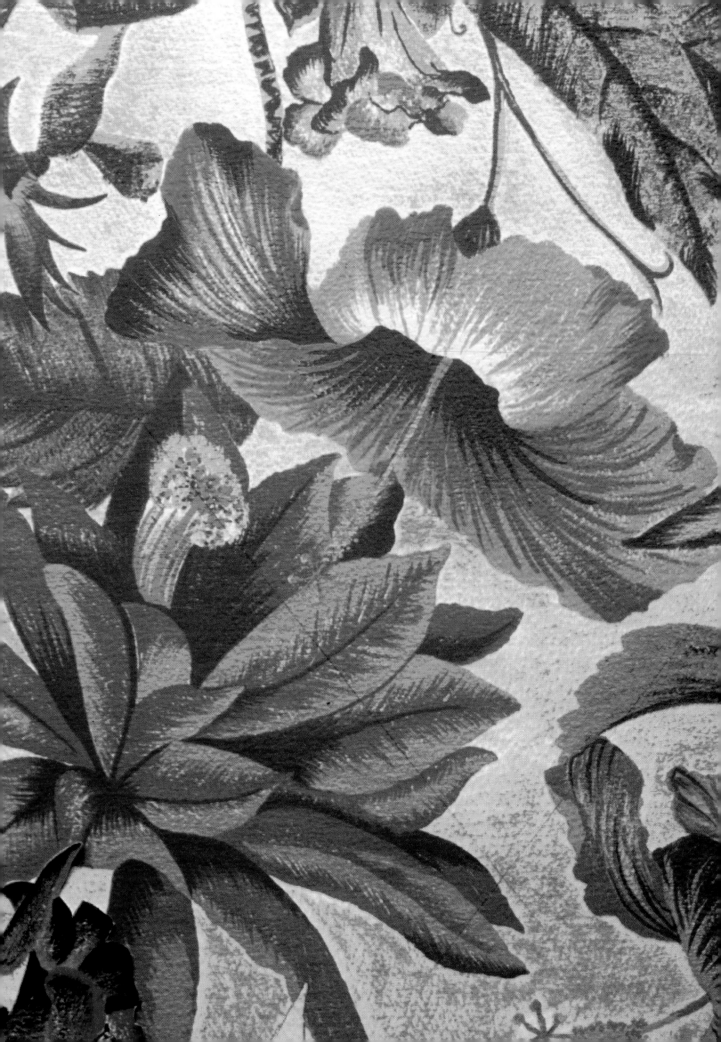

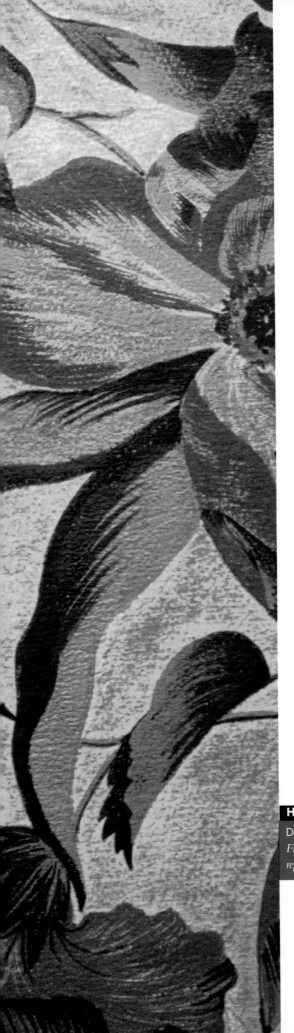

Making
a start

1

Helen Wilson

Designer
*Floral design painted up in
repeat, using gouache.*

3

Design is the **organisation** of **parts** into a **coherent whole.**
Design is **creating** order out of **chaos.**

(Marjorie E Bevlin, *Design through Discovery*)

design: 1 The **general form** or **composition** of any building or **work of art.**
2 In **applied art,** the **shape** given to any **object** of use and also the way in which it **functions.**

applied art: Art which is **essentially functional,** but which is also **designed** to be **aesthetically pleasing** (e.g. furniture, metalwork, clocks, textiles, typography).

(Thames & Hudson *Dictionary of Art Terms*)

The implication in the above definitions is that design is associated with function. Designers have to be aware of the end-use (or function) of their work.

It doesn't really matter what area we talk about when looking at the link between form and function, which is called design. When designing, for example, a new chair, which they hope to sell, furniture designers have to consider several things:

- where the chair might go — in the home, the office, a corporate foyer

- who might sit in the chair and for how long

- whether the chair is stable when someone sits in it

- the surface of the chair — wood, metal, fabric — and how appropriate it is for the environment of the chair

- current trends in furniture design.

Of course, designers may choose to ignore all of these considerations and design a work of art that happens to be a chair — high on aesthetic value and low on functionality. This is only a problem if the designer hopes to sell that chair as *a chair*, and not as a piece of art.

Consumers have certain expectations about a chair such as that it won't fall over or break when you sit on it, and won't give you a bad back if you sit in it for two hours watching TV. If the chair is to have only a decorative function, then other

The professional designer responds to the **marketplace,**
to the **requirements** of industry, to the **needs** of the **manufacturer**
and **sales personnel,** and to the **demands** of the **consumer.**

(Richard Fisher & Dorothy Wolfthal, *Textile Print Design*, preface)

criteria apply: How does it look? Does it suit its proposed location?

The design of the chair will be assessed according to the context in which it is placed. If it is in a furniture retail outlet, it is expected to be functional; if it is in a gallery, it will be judged more on its aesthetic merit. Ideally, the design would be a union of *form* and *function*. Textile designers' considerations are less easily defined. The variety of outcomes for textile design and the multitude of products that use print as a covering (whether functional or decorative) require that textile designers are very versatile, or carefully define the area in which they will specialise. Textile designers could be designing T-shirt prints for a surfwear company, bed linen for department stores, souvenir teatowels for the tourist market or exclusive prints for top-of-the-range homeware. Any surface that is decorated in a patterned format is appropriate for textile design: tiles, wrapping paper, laminex, Con-Tact, wallpaper, carpet, to name a few. Textile design is distinguished from other design disciplines by the repetitive nature of the designs. Commercially produced fabric is often in 3000 metre minimum runs of continuous pattern. The design is produced so that it will work 'in repeat', which means that it will join up and appear continuous. This is a skill peculiar to textile designers. Graphic designers or artists might have ideas for fabric designs but it is unlikely they would have the skills to put that idea into repeat, that is, into a format that makes the idea suitable for fabric.

Textile designers have to be aware of the chain of processes through which the design will go before it appears on fabric although often they will be quite removed from that process.

These croquis designs were developed for a design brief for floral bedding.

Alex Lawrance
2nd year student, RMIT
Gouache, sandpapered paper

Alex Lawrance
2nd year student, RMIT
Gouache, pencil, sandpapered paper

Jason Kenah
2nd year student, RMIT
Gouache

Jason Kenah
2nd year student, RMIT
Gouache, ink, pencil

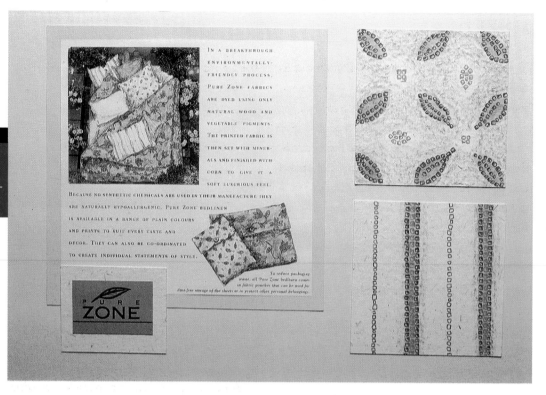

Kate Dorahy
3rd year student, RMIT
Story board to present croquis designs for bedding in a particular market.

Pro-duction of fabric with Australian print designs often takes place offshore and **freelance** designers have little to do with production. However, the more knowledge designers have of the production processes, the more saleable their work is likely to be and the less subject to interpretation by the production house that converts their design into printed fabric.

Textile designers can sell **croquis** (pronounced croakie) designs (*croquis* is a French word meaning a sketch, and has come to apply to a design that is not in repeat). Croquis are ideas for designs, to which more work will have to be done before production takes place. Designers may be required to paint up the croquis into a finished design so it can be produced. Sometimes this job will be handed over to the in-house designers of the company that bought the croquis or to the design team attached to the factory that will print the fabric. Some textile designers are better at having

ideas for fabric and others are better at interpreting those ideas into patterns suitable for production. Another role traditionally given to textile designers has been that of **'knocking off'** designs, from swatches of fabric or magazines — a particular European trend might be perceived to be the one to follow for the next season, and the shortest road to success is to copy the designs. Strict **copyright** laws now mean that designers, while influenced by overseas trends, must ensure the originality of their design.

Awareness of the **market**, manufacturing needs and consumer demands has to take place at some point. It might be when the design manager or art director hands down the design brief to the design team or when the freelance designer is producing designs to take around to companies to sell or when the company's **stylist** is assembling the range of designs for a collection that is to be taken through to production.

However you look at it, *'The textile designer is a link in an industrial production line.'* (Susan Meller & Joost Elffers, *Textile Designs*)

'Designer-maker' is a term coined in the 1990s to apply to those (relatively few) people who design and produce work within their chosen discipline. They are still involved in an industrial production line, but it is one over which they have complete control.

Design is appraised in terms of its suitability for a defined purpose.

A **brief** is the term used to define what is required of designers. It gives the boundaries within which the suitability of the design will be assessed. It is the document that contains instructions to designers. Often, design briefs are verbal and may be given over the phone — when this happens, designers should make their own notes immediately, so they have something to refer to.

Design is about communication.

The **client**, or the people for whom designers work, must communicate what they want. Then designers visually communicate their response to the brief, in whatever form is specified: rough sketches, croquis designs, colour samples. If the brief is for a product that message will eventually be communicated to consumers who buy it.

Complete artistic or creative freedom is something that always appears to be enviable.

For experienced designers, such freedom may well be the case as they have probably built up a 'style' or preferred way of working, have favourite themes to work with, or have been given the job because the client likes their work.

When designers start out, complete freedom can be daunting; a good place to start is to define limits by writing a design brief. If designers are working freelance, or developing a folio of work to be shown to a variety of clients for possible sale, then they might write their own brief. They still need to think about potential outcomes for their designs, colour trends and so on.

At the start of a career, designers are asked to do fairly specific work, which might be as basic as painting up someone else's design, in different colours. Sooner or later, designers have to deal with an audience, whose reception of their work might determine its success or whether a design is bought and taken through to production.

The briefs given to textile designers are many and varied. The following real-life examples give an idea of the scope for design projects, and also the variety of limitations imposed on designers.

Lewis F Day in *Pattern Design* wrote that *'The very strictness of such bounds is a challenge to invention'*.

Susan Banks

Susan Banks, a self-employed textile artist, was commissioned to design and produce a wearable fashion scarf and tie for the Royal Australian Chemical Institute. The brief was to develop designs representative of the chemical world. In order to do this, Susan asked the clients to provide visual information that they felt represented their members. From this, a number of options were shown to the clients, and a design direction established. This resulted in the development of the finished fabric design, which incorporates the Institute logo, an Ehrlenmeyer flask, combined with a hexagon, symbolic of the basic structure of organic chemistry. The main limitation was that the design was to be handprinted. The process of design development through to finished product took about four months.

Private Collections

The brief was given to Helen Wilson, a freelance textile designer. Private Collections is a bedding company with products designed for the middle market. Helen was asked to develop a floral design based on exotic flowers to be used in quilt covers, sheets and pillow cases. The brief provided by the client stated that the number of colours was not to exceed ten, and the quilt cover was to be a large scale all-over floral for the top, and a scattered floral with a **border** for the reverse. Helen has worked in the bedding industry for some time, so she was aware of the formats used for design layout; the repeat was to be standard rotary size of 64.2 cm. Colours were to have a strong, rich feel, in keeping with colour forecasts for bedding.

Helen chose to use books as the reference for the floral motifs, including *The Complete Book of*

Susan Banks

Designer
Handprinted fabric, reactive dyes. The design was developed for the Royal Australian Chemical Institute.

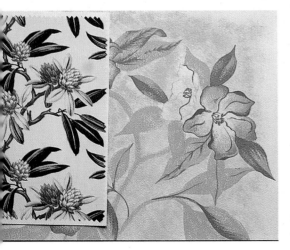

Houseplants by Russell C Mott, and an assortment of botanical drawings. The main inspiration for layout was from *Fabulous Fabrics of the 50s* by Bosker, Mancini and Gramstad. Helen allowed three weeks to develop and finish the design.

Textiles for Nomads

Textiles for Nomads is a Fremantle-based company that designs and prints its own textiles. It has established a reputation as a producer of original quality products, including scatter cushions and table linen, which are sold throughout Australia. Designed by Jemma Dacre, the range is aimed at a design-conscious market; to sit on a retail shelf alongside an imported product, with the hope that the customer will appreciate the quality, character and design of the Australian range. The prints are all one- or two-colour, which is Jemma's preference, in keeping with the company's ethos of identifying with the tradition of the artisan. This also helps limit manufacturing costs. The colourways in each print are designed to mix and match. The biggest restriction for Jemma is being limited to printing with pigment, which in turn limits the end-use of products and the fabrics used.

Helen Wilson

Designer

Left, top: *design idea for an exotic floral for Private Collections, a bedding company. The reference for the painted floral is on the left;* **middle:** *section of exotic floral design for Private Collections painted up in repeat, using gouache;* **bottom:** *sketch of flowers to consider for use in exotic florals, shows reference for the flower/leaf structure.*

Jemma Dacre

Designer, Textiles for Nomads
Coordinating designs for napkins and tablecloth: screen printed with pigment on 100 per cent cotton.

Jemma sets her own design brief, although the designs need to fit in with the style of her company. Her design references vary for each collection, and include handpainted tiles in a palace courtyard in Udaipur, India, a 17th century Indo-Portugese embroidery, and handpainted ceramics of regional Italy. These references are interpreted into print. Jemma confesses to an 'emotional/intuitive response' to colour, but acknowledges that colour is vital for successful retail sales and needs to conform to current trends.

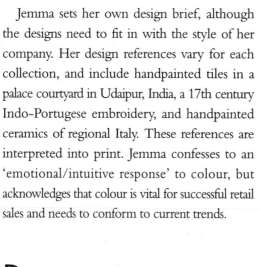

Davenport

Davenport is a company that 'markets wit and style in the medium of underwear'. The product range includes boxer shorts, ties, socks, briefs, sleepwear and swimwear, and is directed primarily at 16 to 30 year old males, in the mid to upper market. Most of the products use printed fabric, either **all-over designs**, or placement,

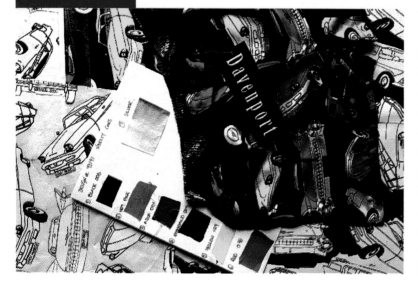

and some use embroideries. The design briefs are usually given verbally to the in-house design team which needs to work quickly to meet production deadlines. Generally, no more than two days would be spent on an all-over repeat design, and designs for ties and socks would take about a day each. The designers must work within certain production restrictions: eight colours is the maximum number that can be used in print. Davenport licenses the use of characters such as Mickey Mouse, and the colours and treatment of the actual characters is restricted. All character designs must be approved by the licensee prior to production. The repeat size used is 30.5 cm x 30.5 cm, and prints are generally directional. Any designs that do not use licensed characters are sourced from a variety of places, including magazines and video clips, and the colours are loosely based on fashion trends.

Where do you, the designer, start?

Decide what you want to produce. From the examples of briefs, several limitations, or considerations, emerge. These are linked to the perceived market for the end product, or the way in which the fabric will be produced. The design is not an end in itself. It is part of a chain that will lead, as in the examples, to a product on a shelf in a retail outlet for purchase by consumers, so the chain continues and the designers continue their employment. The success of the designs is judged by how well they meet the brief. A good design for Textiles for Nomads would be considered inappropriate for Davenport.

You start a design by defining the elements of the design brief (see the pro forma, right):

- product — fashion, furnishing, homewares
- market — this can be done by age, income, lifestyle
- production method — this will determine whether you have to come up with ideas (croquis designs) or finished designs (in repeat),

how many colours can be used, what sort of marks can be reproduced on the fabric
- **colour palette** — this might be determined by the theme, other fabrics in the range, current trends, or next season's predictions
- deadline — as in the examples, the time allotted varies according to the task, the nature of the work and the designer's other commitments.

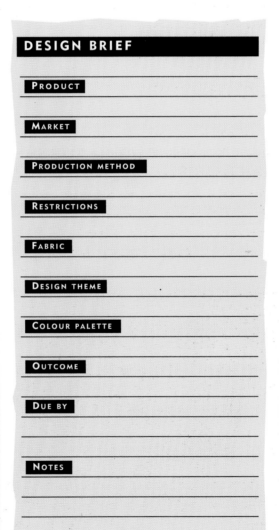

DESIGN BRIEF

PRODUCT

MARKET

PRODUCTION METHOD

RESTRICTIONS

FABRIC

DESIGN THEME

COLOUR PALETTE

OUTCOME

DUE BY

NOTES

Georgia Chapman
Silk scarf designed for David Lawrence, Sportsgirl.
Design was produced on paper and printed using reactive dyes.

Design
resources
2

Anna Berreen

1st year student, RMIT
*Croquis paper design,
'Animal Care'; gouache, cut
and collaged paper.*

Once you have established what you are designing, and who it is for, the next step is to work out a strategy. Sometimes, you will have a very clear idea of what you are going to do with a design brief. This is OK, and sometimes the first idea you have will be the one you end up using. But this is not necessarily the case. When you are working with a client, your opinion and their opinion about what is best may be quite different. And what about the times your mind goes blank when you read the brief? In industry, your employer is not going to want to pay you to sit staring into space while you wait for inspiration to hit you. What if you are not in the right mood, even if you have worked out your own brief, and your project has to be handed in tomorrow?

Remember!
- The first idea is not always the best.
- The most obvious solution is not always the best.
- Your first solution might not be what the client wants.

You need a strategy that will help you explore many solutions to the problem: a way of working you can fall back on when the going gets tough. After all, when you show your one great idea to the client, and they hate it, what do you do? You don't want the client to think you only had one idea — you want to be able to pull a few more tricks out of the bag. You show them the other possibilities you explored, and perhaps some of these might be more like what they were after.

Your design will be assessed in terms of its suitability for the defined purpose.

Every designer will have a different strategy they employ when they are working to a theme. Many experienced designers will have a very clear idea of the outcome to a design problem and will hardly do any preliminary work, which will save everyone time and money. Perhaps they have worked with the client before, or they specialise in the field and are familiar with the market. What they are doing is drawing on their experience.

Student designers, or designers embarking on a career, don't have experience to fall back on. They need to develop resources to help communicate their ideas to the client, and discover the not-so-obvious solutions.

Keeping a resource book

Most people who work in the field of art and design keep some sort of **visual diary**, whether it is an ordered notebook of ideas and sketches, or a box containing scribbles, cut-outs from magazines, bits of paper or fabrics. Whatever form it

takes, it is a personal resource — a bank of ideas. It is a good idea to start keeping a **resource book**, if you don't already. It's what you fall back on when your mind goes blank. The format of the resource book is not as important as the content; ideally, it should be no smaller than A4, and portable. Put in it ideas you have that are just that — ideas. These will need working on at a later date. Include things in magazines that appeal to you and note why you found them interesting. As a designer, it is vital that your resource book contains a variety of information, from original sketches to pages from magazines. If you are working in textile design, you should include fabric **swatches** or yarn samples. You can use photography to help you keep records of things you have seen. Your collecting can be very general, and lots of things will never be used.

Without being too selective in the beginning, but keeping your theme in mind, start collecting information that relates to your theme.

This is **the work** that will **back up**, or **support**, the **designs** you **submit** to the **client** in the end. Or, when you **feel** that you have gone as **far** as you can with **your own theme**, look back over the early **collecting** you did to see if there are any **leads** you didn't **explore**.

Tangible resources relating to the design project are vital for triggering off ideas and solutions. As an example, say your project theme is based on flora. An appropriate starting point might be your garden, the local nursery, flower catalogues and photos in flower magazines, your own photographs, drawings, sketches, postcards, fabrics, greeting cards, wrapping paper or paintings by artists. The flora might be contained in another format: patterned china, rugs, stained glass windows or computer-generated images.

The next step is to refine the collection process, by confining the collection to a restricted colour palette, which will probably be given in the design brief.

Maria Avtzoglou
1st year student, RMIT
Top left and below:
Resource material and design ideas in a visual diary for a project based on tools: gouache and paper collage.

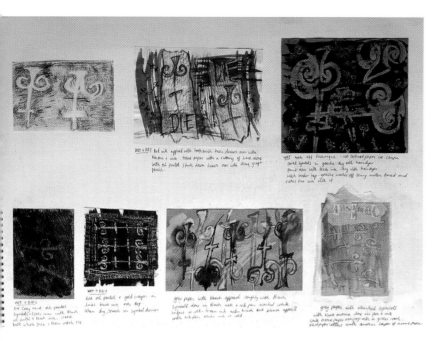

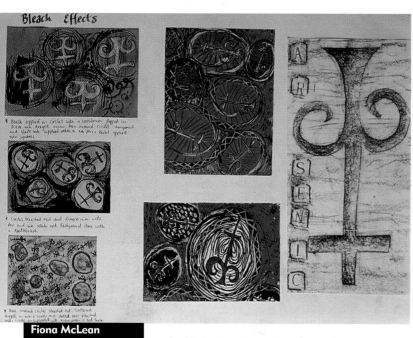

Is a resource book a personal or public document?

Like a written diary, the contents of a visual diary may not be the sort of thing you wish to share with others. However, the method of collecting that you use might also be appropriate for a more objective assembling of visual material for a design brief, whether it is given to you, or you devise it yourself.

In the **resource book** you can **informally articulate** and **accumulate** physical examples of **ideas** you are **collecting** for **current** or **future projects.**

What does the client mean?

The client might give you a brief that tells you the style reference is, for example, art deco. You might have some idea of what this means, but unless art deco designs are your specialty, you will certainly need to go to a library for more information, even if it is to remind yourself of the breadth of styles under the umbrella of art deco. Refer to the design briefs described in Chapter 1. Each designer used a different method of resourcing material. Sometimes, the client will be able to provide the visual information you require; this was the case with the corporate scarf designed for the Royal Australian Chemical Institute by Susan Banks. In contrast to this, Helen Wilson had to do her own library research into exotic florals for the Private Collections bedding design. The design influences for Jemma Dacre came from personal research and material collected while travelling, and Davenport designers use characters

A useful design resource will be a collection of ideas, photographs, illustrations, sketches, photocopies, magazine pages, or notes that describes ways of solving design problems. The experience of design and what it is to be a designer stems from a creative and intuitive sense of colour, style, innovation and ideas. Designers collect, notate and describe ideas through visual media.

that are licensed by the company, or material derived from popular culture. Regardless of where the material came from, the early stages provide a solid basis on which to start visually communicating with your client.

Designers require a visual as well as verbal communication system.

How can you explain or promote your ideas without a visual reference? You can't, and so to help the client/teacher/viewer, you must show what you mean. After all, your design isn't going to be described in words on a doona cover — it will be printed in images, textures, colours, and it will be the visual appeal that makes the client buy the design, and the customer buy the doona. If you say, 'I want to use a red stone-patterned texture here on this illustration', the verbal communication is clear, but the visual is not. What is red to one person, might be terracotta to another. There are hundreds of reds. What sort of stone texture? There are thousands. To make sure you are understood, illustrate what you are going to do. Then you are speaking the language of design — a visual language. If you can't draw what you mean, find an example of the colour and texture. It could be a piece of red fabric that is the exact colour you had in mind. Find a photo of Italian marble, and that's your example of texture. The marble need not be red; the fabric is referred to for the colour.

Resource gathering is a learning and enquiring process and is often the most interesting part of the design process. Don't limit where you go for ideas: it might be libraries, bookshops, magazines, but it might also be catalogues and specialist shops. Be resourceful: searching for ideas need not cost an arm and a leg.

Putting together a resource book of ideas from other sources raises the question of copying and, ultimately, copyright. What belongs to whom is a difficult question. It is inevitable that other people's images will be part of what you collect. There is nothing wrong with that — it's what you do with it in the end that counts. Think about the difference between being 'influenced by' or 'inspired by' and 'knocking off'. You can't pass off something as your own that you have traced or copied from someone else's work. But you might get an idea of your own from looking at the way other artists/designers have solved problems. Copying is largely a matter of commonsense — *you* know when you have pinched someone else's idea outright.

The hard part: what to do with your resources

After you've collected all these resource materials, what do you do with them?

The initial collection phase will result in a large and varied assortment of paper and ideas. Now it is time to be critical about what has been collected. A mad jumble of incoherent ideas does not solve the design brief, it merely confuses you. You could start by sorting your material into categories according to colour, texture, pattern, or images.

These categories will help you to work out your ideas. The collecting of information for a brief need not stop at that initial exploratory stage; as you sort through what you have, you might see a need for something you haven't got — so try to find it.

This is the process to go through to make the most of these resources:

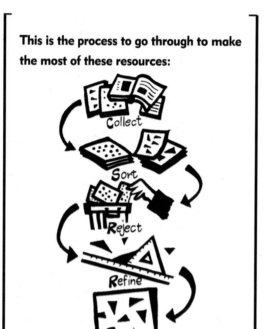

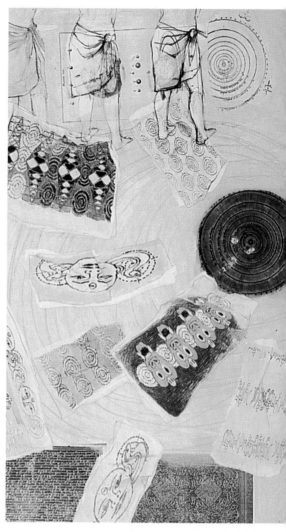

Start putting your own interpretation on what you are collecting. A small section of a photograph might trigger off an idea for a patterned fabric. Sketch it in your book. Think about colour in reference to the images you are collecting. You might need to think about current fashion trends for colours. Is yellow fashionable this year? Look at current paint charts. Paint manufacturers have to be aware of trends in interior colours — use their colour chips to reference colour ideas with your images. Keep an eye on magazines — not only to see what is currently popular, but to see what everyone else is doing. Why do something that everyone else has already done?

The client brief is an opportunity for you to develop a theme in an original and innovative way. You have all the resource materials you need. Once you have organised your information, you will have to present it.

Telling the story: concept boards and story boards

Concept boards are usually the initial communication between designer and client, after receiving the brief. It's your chance to see if the client likes the approach you are taking. The concept board may not contain a lot of original material — it is more about ideas than finished designs. The format this takes will vary, from A4 to A2

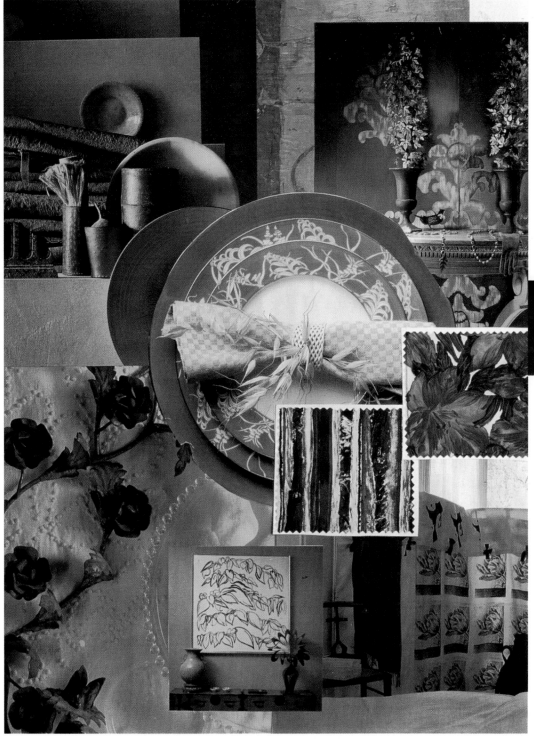

Helen Wilson

Concept board using magazine cut-outs to show coordination between colours and a theme/mood direction.

THINKING AHEAD **241** WINTER 1995/96

THINKING AHEAD **243** WINTER 1995/96

THE HOUSEKEEPER
She was handsome, pale, her face rather long and absolutely still, her eyes bright but revealing nothing.

THE ECCENTRIC
Crimson Burnt Orange Prussian Blue Copper Saffron Aubergine

View textile magazine

Far right: *series of concept ideas using objects, colours and textures for fabric forecasting;* **right:** *arrangement of floral concept ideas for fabric forecasting.*

paste board, to pages of rough sketches and collages from your visual diary. The concept board should show that you are thinking.

Design directors in a company might have concept boards put together to tell the design team about the direction or 'feel' for next season. The boards might give a theme to follow, and might include yarn samples, fabric swatches, or magazine pages. *International Textiles* and *View* are two of many magazines that specialise in predicting trends in textile design. Many companies rely on this information for the direction of their new ranges.

Once you know that you are on the right track, the client might want to see a **story board** which, as it sounds, tells the story of the designs you will produce. In some cases the difference between a concept board and a story board is negligible. As a general rule, the story board tends to be more developed in direction than the concept board. As you will have begun to think about the actual designs, on the story board you should include your sketches, interpretation

of the brief, ideas for designs, and the colours you think are appropriate on the story board. Again, the format you choose should be appropriate for what you wish to communicate. Large boards are unwieldy and require large scale images and designs, as well as a lot of work to fill them. An illustration showing how the design works in context should be included. This might be a fashion illustration giving an idea of the print on a men's shirt, or an interior scene showing the textile design used as fabric on a chair. These illustrations do not have to be accurate, but are working drawings to show how you think your design will fit into the specified use of the fabric. The illustrations should give some indication of the scale, and distribution of colour and motifs. It might be a good idea to show on the story board a small detail of a design idea you are working on for the brief. Colour references must be accurate on a story board, especially if the client has indicated a preferred palette. You might include a **swatchbook** of fabrics the client has given you,

or you might have been asked to source fabrics yourself.

Once the client has approved the direction indicated on the story board, the next step is to produce croquis designs, which are designs indicating repeat that do not necessarily take into account production restrictions like the number of colours or the method of reproducing the marks.

One of the first things you will consider will be colour. A colour palette is likely to be specified in the brief — you will be given an idea of the feel (for example, *Mediterranean*), if not the actual colours.

Think about texture. Not all print is flat colour. You might duplicate the feel of an ancient woven cloth by sponging or splattering colour in several layers. (See Chapter 4 for techniques.)

Think about **pattern**. If you are designing for fabric, dealing with pattern is inevitable. In textile design, often it is the pattern that attracts the eye, rather than the images or motifs, which actually form the patterns. Look for images or motifs in what you are collecting that might form patterns when placed next to each other and repeated. Change the scale of the images. Use a photo-

copier, or redraw the image, putting your own 'stamp' on it.

When you have sorted out for yourself what you want to do, or have established a direction with the client, then you are ready to start producing croquis designs. You need to look at the various techniques/styles/media you can use to communicate your ideas.

Does this process really happen?

Obviously, designers working in industry do not have unlimited time in which to come up with a new range of designs. They have to work to a deadline; the longer it takes to produce designs, the more costly it is. Experience is a substitute for many production steps; the longer designers have worked for a client, the quicker they are likely to achieve the desired end result, eliminating some of the early exploratory work. Communication in an **in-house** design team is ongoing and there may not be a need for the formal presentation of boards. This is a different situation from that between a freelance designer and client, where they may not have worked together; part of the process of presenting ideas is so the designer can

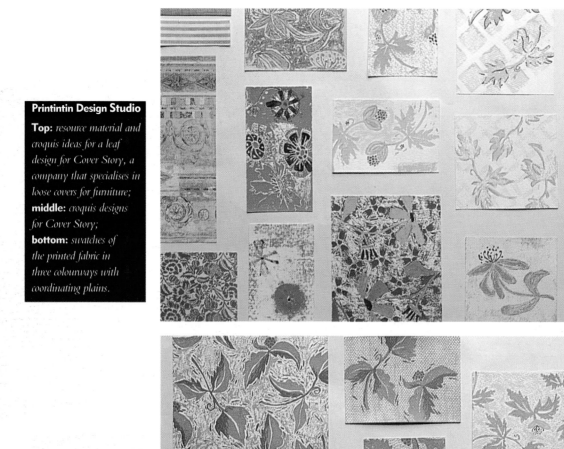

Printintin Design Studio

Top: *resource material and croquis ideas for a leaf design for Cover Story, a company that specialises in loose covers for furniture;* **middle:** *croquis designs for Cover Story;* **bottom:** *swatches of the printed fabric in three colourways with coordinating plains.*

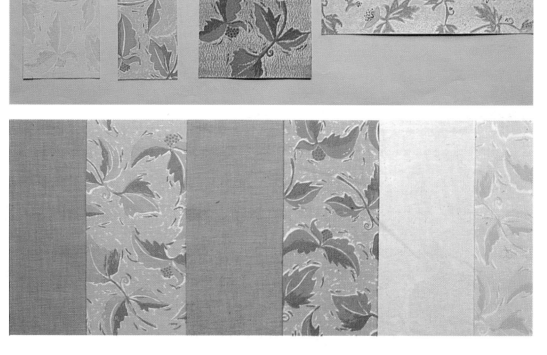

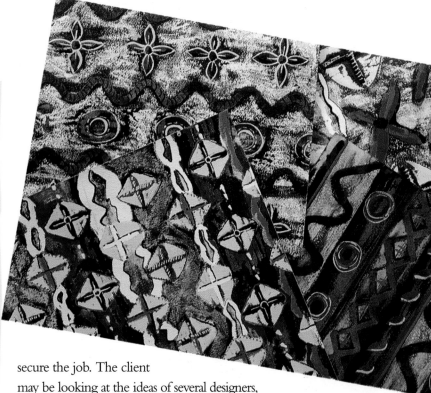

DESIGN BRIEF – EXAMPLE

PRODUCT *Swimwear*

MARKET *Fashion, female, 25–35 years, mid to upper market price range*

PRODUCTION METHOD *Screen printed and handpainted*

RESTRICTIONS *Number of colours restricted to three screens (because of availability of screens and the cost of preparing screens) but extra colours could be painted. Printed with pigment and acid dyes. The theme will dictate to some extent the style and scale of the chosen print.*

FABRIC *Cotton lycra*

DESIGN THEME *Ethnic: fashion prediction for swimwear, from forecast magazine; possibilities of African, Indian, South American, Aboriginal. Ethnic theme because of strong visual imagery and colours.*

COLOUR PALETTE *Following international predictions, emphasis on strong natural colours with bright key colours.*

OUTCOME *Concept board, series of croquis designs, printed fabric for swimwear.*

DUE BY

NOTES

Tanya Juchima

3rd year student, RMIT

Croquis paper design, 'Tribal': gouache and ink, wash-off and resist techniques.

secure the job. The client may be looking at the ideas of several designers, and will choose one to work with. Some clients will not want to look at story boards. They will want to see a range of croquis designs and choose some to buy for inclusion in their range.

This is the design process in its most detailed form, illustrating the intellectual processes that take place, whether or not they have a physical outcome, which is formally presented to the client. Even if you do not have to present a board, visualise what it would look like to help yourself sort out the direction you will take.

Putting the design process into practice

Chapter 1 looked generally at the sort of information that might be contained in a design brief. The following brief is an example of a design project you might set yourself; it is designed so that you can change the details and work to specifications set by yourself or the client.

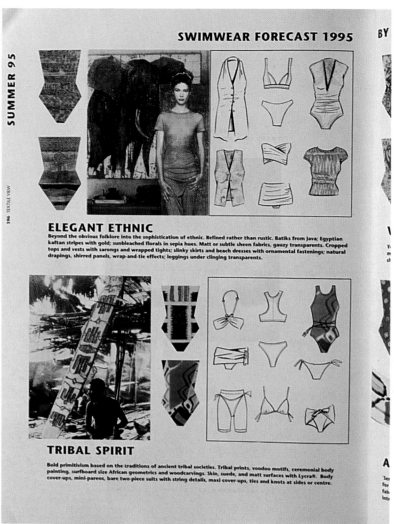

SUMMER 95

1996 TEXTILE VIEW

ELEGANT ETHNIC

Beyond the obvious folklore into the sophistication of ethnic. Refined rather than rustic. Batiks from Java; Egyptian kaftan stripes with gold; sunbleached florals in sepia hues. Matt or subtle sheen fabrics, gauzy transparents. Cropped tops and vests with sarongs and wrapped tights; slinky skirts and beach dresses with ornamental fastenings; natural drapings, shirred panels, wrap-and-tie effects; leggings under clinging transparents.

TRIBAL SPIRIT

Bold primitivism based on the traditions of ancient tribal societies. Tribal prints, voodoo motifs, ceremonial body painting, surfboard size African geometrics and woodcarvings. Skin, suede, and matt surfaces with Lycra®. Body cover-ups, mini-pareos, bare two-piece suits with string details, maxi cover-ups, ties and knots at sides or centre.

View textile magazine

'Elegant Ethnic' and 'Tribal Spirit' themes illustrating concept and story boards ideas for lycra swimwear promotion.

One of the first things to do is research the market for which you are designing. You need to know where your product will fit: try to imagine the shops where it might sell. Visit those shops, talk to sales assistants about the clientele, look at the other products (your competition) that sell there. Then clarify what is meant by ethnic. For this purpose, it refers to cultural groups that have an identifiable range of images and motifs. An ethnic feel has been suggested in the brief, but no specific reference has been given, so visit the library to start broad research into ethnic resources. Look for images, motifs, colours that you find appealing and appropriate for the ethnic theme. Look for strong images that will form patterns when put into a textile design, for example, African body painting.

Now you can:

- Select the ethnic culture you think will best fit the brief requirements, for example, Mexican.

- Establish a colour palette that is representative of the chosen culture, and appropriate for your chair.

- Select a range of appropriate motifs to work into textile designs. You will be putting your own stamp on them and selecting ideas to play around with. Look at methods of decoration used in your chosen culture.

Put this information — photocopies, photos, magazine cut-outs, sketches — in your resource book. Start playing around with multiples of images, seeing what they look like as patterns. It might be a good idea to organise the material into a concept board; even though, in this case, you are your own client, it often helps clarify whether you are on the right track. What you are looking for is the core of a design theme. Do you have a strong base to work from? Is there enough on the board to inspire you to start producing designs? If there isn't, gather more material. If you don't like what you see, start again. Double check your brief, to make sure you haven't forgotten to consider something.

The next step is to begin work on your own designs.

Chapter 3 helps use the colour references you have collected.

Chapter 4 gives lots of options for using different media and techniques.

Chapter 6 helps with creating patterns.

Summary of design process

- Receive brief
- Clarify brief
- Collect resource material
- Organise resource material
- Present concept board
- Start work on croquis designs
- Present story board
- Continue croquis designs
- Present croquis designs
- Present finished designs

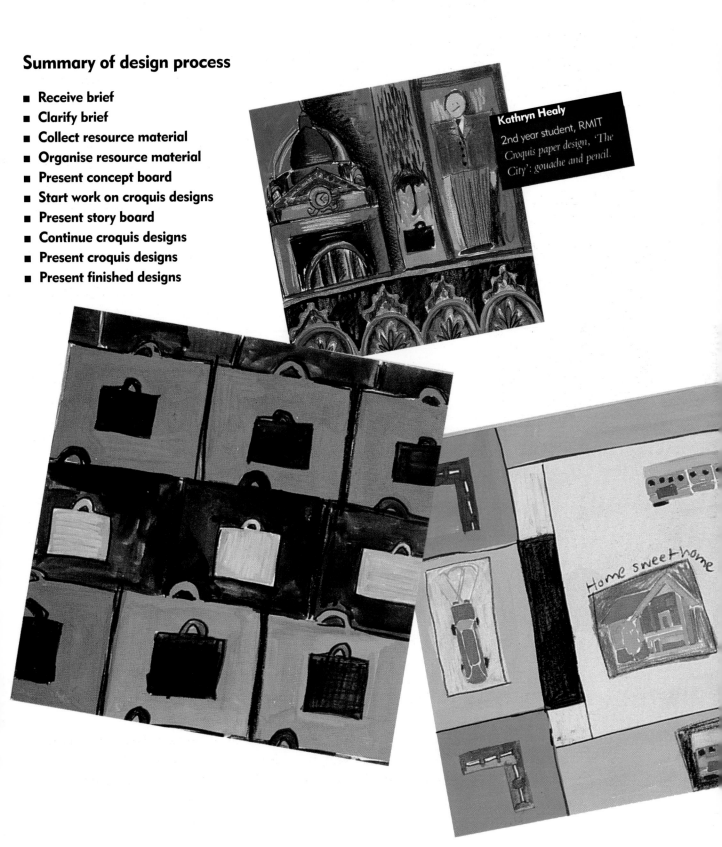

Kathryn Healy
2nd year student, RMIT
Croquis paper design, 'The
City': gouache and pencil.

Home sweet home

Colour

Many books have been written on the subject of colour, giving great detail about the science of colour, its composition and properties, how colour wheels work and so on. These are valuable texts: this chapter is not intended to duplicate or contradict any technical information in these books.

Our contemporary understanding of colour is based on fundamental scientific discoveries by Sir Isaac Newton in the 17th century when he discovered that bands of different colours were produced by sunlight hitting a prism. As a result of this he produced the colour wheel, a system that organises colours into groups. The 20th century in particular has seen many proponents of colour theory, whose aim was to develop theories for the application of colour to an art and design end. Some of these were Alfred Munsell, Johannes Itten, and Otswald. The outcomes of their theories have created painting movements such as Impressionism, Fauvism and Pop Art, to name a few.

Chapter 3 is a practical guide to becoming competent with the use of colour, as a designer. The focus is on developing an awareness of the importance of an understanding of colour relationships, knowing where to get information and inspiration about colour in design and how to apply that resource material to design projects.

Colour in design

For designers, colour is yet another tool to be used to achieve an end. Some designers specialise in colour-related work and are employed as stylists, fashion consultants, colour consultants, or **colour predictors**. These occupations might involve colour coordinating ranges of textile designs, fabrics or garments, instead of, for example, designing the prints. Colour predictors are responsible for forecasting future trends, and the information they supply is used worldwide by designers in many industries, such as home decorator services, paint or tile manufacturers, and manufacturers of fashion accessories. Based on available data about sales, buying trends, and what has been fashionable, colours are determined for seasons that might be two years away. Interior designers need these colour predictions when putting together proposals for the interiors of buildings: the buildings may be only at planning stage but the deals for them are often clinched two years before building commences. Car manufacturers need to be aware of colour trends for the interior and exterior of new models: colours of cars have to keep pace with other areas of design.

Someone, somewhere, decides what colour things will be. It is important for designers to think about who determines these colours, why they were chosen, and what sort of factors were taken into consideration when the decisions were made.

How does a large fashion company like Sportsgirl know what colours are going to be fashionable two years from now? And who says

that, say, chartreuse will be the colour of the year? Who decided that the colours for the 1990s will have an environmental feel, implying the use of natural dyes and unbleached natural fibres? Designers and manufacturers need access to colour forecasts well before the consumer has to think about it.

Colour plays a role in nearly every aspect of our everyday lives. We take for granted that we can have a colour choice in most things we buy — in products as ordinary as toothbrushes and soaps, as well as in our clothes and homewares.

Textile designers and colour

The colour of a piece of fabric is often the first thing a customer perceives. Remember that more often than not the customer is uneducated in terms of visual literacy, or the ability to look at, and subsequently recall, details of a design. The colour is the first and most obvious thing that is seen. Second is the pattern, and last of all the motifs or imagery used in the design. Designers or visual artists will, of course, see things differently to the average customer. Their view is coloured by their experience and their tastes are likely to be more defined,

Tanya Juchima
3rd year student, RMIT
Swatches of printed fabric show the same design in different colourways.

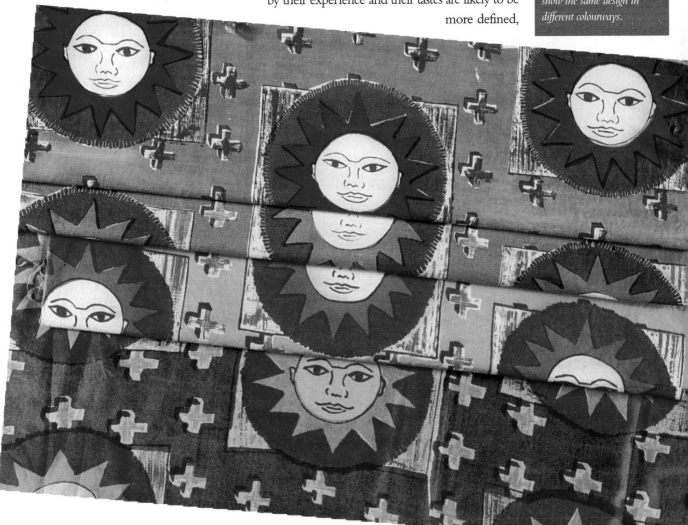

or particular. Designers in any field need an awareness of the market for which they are catering and, to some extent, the ability to imagine how the customer will see things. It may not be the detail that is initially observed, but merely the overall feel of the design, and much of the customer's first impression will be of colour.

Textile designs are produced to be used, and this distinguishes them from other design areas. When graphic designers have completed the advertisement they are working on, it is finished. It will be assessed in terms of how it fits the brief, and will be accepted or rejected on this basis. An advertisement needs to be effective but it isn't taken into people's homes and lived with for the next five to ten years, as furnishing fabrics are, nor is it worn for several seasons, as clothing might be. Textile designers working in industry have to be acutely aware of the economic viability of colours they produce — the colour will so often be what determines whether or not a product sells. Fabrics are usually available in more than one set of colours (called **colourways**) so textile designers need the ability to substitute one set of colours for another. Sometimes, this will be the job of a stylist, or the particular job of one employee in a design team — the **colourist** — but skill in the use of colour will often be what sells a design to a client in the first place, before it even gets into production.

The products that use fabrics designed by textile designers are more often useful commodities, rather than luxury items. The textile industry caters predominantly for the mass market so is to a large extent consumer or market driven. Textile designers *must* take colour into account and cannot rely on their own preferred colour palette.

Consider the colour effects peculiar to the textile field that can be achieved on cloth: coloured yarns can be woven or knitted together to produce coloured fabrics that have print applied to them; the fabric to be printed might have a shiny surface or a textured surface that will affect the colour. Specialist inks can be used to create opalescent, fluorescent or metallic effects. There are heat-sensitive inks, where the print is only visible when near heat (or the body), and ink where the print only shows up under water. Such inks are fads in the marketplace, but can still be useful for designers to know about. The fact that dyes can be over-printed to produce other colours should be kept in mind as well. (For more detail on this, see Chapter 12.) Colour on fabric can be achieved in many different ways. Textile designers must have a good understanding and appreciation of colour and its application in design, and of the industrial processes available to manufacturers.

Consumer v. designer: colour in the marketplace

Colour can be fashionable and changeable according to the seasons. Colour preferences are also highly subjective and personal. 'I don't like that colour' or 'It doesn't suit me' will often be heard from customers as a valid reason for not purchasing something — such reasons are not valid for designers defending the use of a particular colour palette. Often, the colour palette will be given by the client in the brief. It may not be the palette the designer would prefer to be working with, but the client may believe:

DAILY BREAD

PANTONE 12-4306

PANTONE 12-4302

PANTONE 11-06

PANTONE 12-0812

PANTONE 11-4303

PANTONE 11-4601

PANTONE 11-0701

PAIN QUOTIDIEN

• A sifting of whites, ranging from clear, bright whites to slightly tinted, bleached, greyish and dirty off-whites in soft cottons and linens, fluffy meltons and jerseys, with floury or brushed surfaces, or even creased and crackled effects. Garments are tied around the body in superpositions for a boxy, close-fitting silhouette.

• Un choix de blancs, allant des blancs clairs et vifs à des blancs cassés légèrement teintés, délayés, grisés et salis pour des cotons et des lins doux, des moltons et des jerseys moelleux, avec des surfaces enfarinées ou brossées, ou même des effets froissés et craquelés. Les vêtements sont noués autour du corps et superposés pour une silhouette anguleuse et près du corps.

> **View textile magazine**
>
> *This page illustrates a theme and is used to convey an idea about how designers source inspiration for colour palettes. The PANTONE colour references are added for specific colour matching.*

- through market research or experience, that those colours sell best

- from international textile magazines, such as *View* or *International Textiles*, that they will be the fashion colours for that season.

If designers want a job, they have to work with the client's colour preferences.

It can be argued that in the end colour is subjective and based on personal preferences. This is certainly true for customers who can exercise any whim they like when making their decision to purchase a fabric, or a product that relies on textile design for its appeal, such as bedding.

Textile designers and the client or company commissioning the design cannot let their personal preferences for certain colours dominate a range. Textile designers often have to work within unfamiliar colour palettes or with colours they intensely dislike. They have to learn to separate 'I don't like those colours' from 'I don't think those colours work together very well'. The latter is an objective assessment of the viability of a colour combination and it is essential that professional textile designers are able to look at what they have produced in this way. Because they need to be impartial, it is handy for designers to have a basic understanding of a few colour principles.

The language of colour: terms and definitions

Having a language to describe colours, and an understanding of some of the characteristics of particular colours, or combinations of colours, can make life much easier, although it might initially seem a tedious and uninspiring way to go about designing. One of the first things introduced in art classes at school is the colour wheel, and the idea of primary and secondary colours. For student designers, constructing a colour wheel based on their own needs is a good way to understand the interaction and physical properties of colour. They can quickly become familiar with colour mixing, observing the characteristics of colour and pigment. For many years the colour wheel has been used with three primary colours: red, yellow and blue. These have been the basic colours to work from. Mixing these three primaries together makes a new group of colours called secondary colours: green is made from yellow and blue; orange, from yellow and red; violet, from red and blue. A third group of colours called intermediaries can be made: yellow-orange, orange-red, red-violet, blue-violet, blue-green and yellow-green. When these colours are placed together on the outer rim of the colour wheel, the colours flow in succession creating a colour spectrum. These are the basic working colours. The colour wheel is then used as a system for mixing colours.

What is often neglected is an explanation of how the colour wheel can work for designers as a quick reference for developing a colour palette for a design or colourways. This is described in more detail on pages 37–9.

The ascribing of qualities to particular colours is essential in the language of colour. Every day

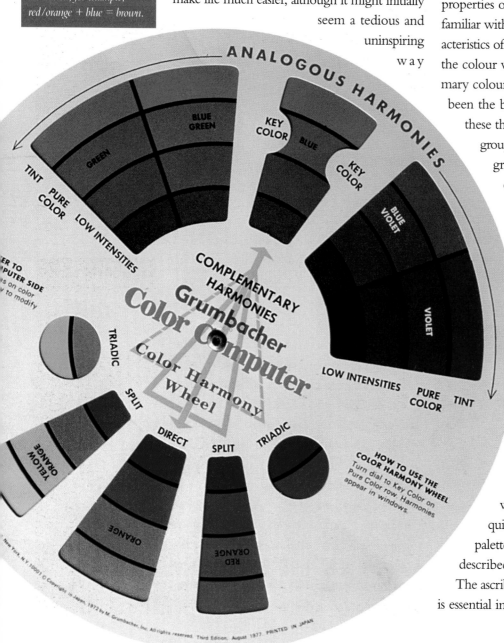

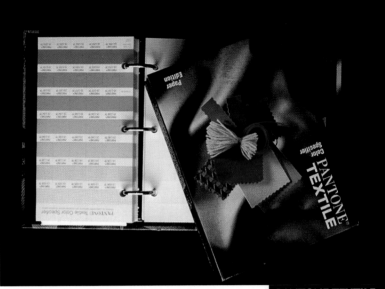

colour references reinforce words and meaning. Red is commonly used for warning or attention seeking: the red letterbox, the red fire engine, the red Don't Walk sign. Everyone knows what the colours red, amber and green mean. Colour has the capacity to signify different meanings: on taps, red means hot, blue means cold. Colour establishes moods and atmosphere. A restaurant might choose a colour scheme that will make a soothing, relaxing environment, while a night-club could choose colours that invite an energetic and vibrant response. Wiring and circuitry are colour coded for safety reasons and to ensure correct installation. Colour designates and identifies.

These associated meanings of colours often make it confusing for designers when they are trying to establish what colours a client has in mind. What does crimson mean? Of course, it is always wise to try to get actual colour samples from clients, to identify what they want, but sometimes this is not possible. Systems have been established for colour identification in the print industry, the most common is the PANTONE MATCHING SYSTEM®.★ It is described as 'a worldwide printing, publishing and packaging colour language for the selection, presentation, specification, matching and control of colour'. Colours are referred to by numbers. These numbers are defined in the PANTONE Color Formula Guide 1000, for example, PANTONE 528C or PANTONE 205U. For those in the paper printing industry, the PANTONE MATCHING SYSTEM is ideal, as the composition of colours is also listed with the number, enabling accurate matching, for example: PANTONE 205U is 7 parts PANTONE

Rubine Red, 1 part PANTONE Yellow, 8 parts PANTONE Transparent White.

For the textile industry, Pantone offers a special system, the PANTONE TEXTILE Color System, which is based on 1701 colours dyed on fabric. PANTONE TEXTILE Color Publications are available in either fabric or lacquer (paper) formats, and each colour is also available in individual fabric swatch cards, offering a number of alternatives. The colours of the textile range are completely different from the printing range

* PANTONE MATCHING SYSTEM is a registered trademark of Pantone, Inc.

PANTONE TEXTILE
Color Specifier

PANTONE colour chips are removed from this book and stapled to finished artwork or colour photocopies for accurate matching.

PANTONE MATCHING SYSTEM

A system for the world-wide printing, publishing and packaging of colour.

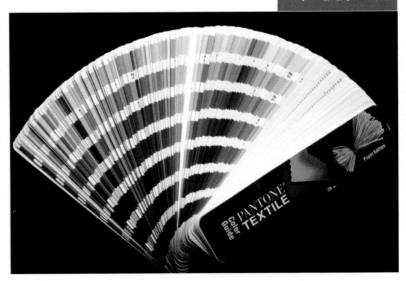

and represent the most popular colours in the apparel and home furnishings industries. Dye formulations are available worldwide, making the PANTONE TEXTILE Colors easy to reproduce. While many companies use the PANTONE TEXTILE Color Publications, most freelance textile designers could not afford it. They would find, however, that the PANTONE MATCHING SYSTEM is an invaluable communication tool with clients who are trying to explain the colours they have in mind.

The technical qualities of colour are very useful to understand, not only for communicating about colour, but for applying to design work. To describe colour, designers need to understand what hue, value and saturation (or intensity or chroma) mean.

Hue refers to the pure form of the colour or the quality of colour that identifies it by the family to which it belongs. *The Australian Concise Oxford Dictionary* defines hue, among other things not relevant here, as the 'attribute by virtue of which a colour is red, green etc.'

Every hue can be further defined by its **value**. Its value is how light or dark a colour is. Each hue has a range of values, which begins from a midpoint (or middle grey) on a straight line and runs in two directions. One leads to white and the other to black. Black, white and grey are values that do not contain hue.

The **saturation**, **intensity** or **chroma** of a colour describes its strength, whether it is dull or bright. A pure hue is an intense colour to which no black, white or grey has been added. Colours with high saturation are nearer to pure hues and colours with low saturation are closer to greys. Saturation is important for defining colour in

computer-aided textile design (CATD) systems. These colour samples are defined according to hue, colour and saturation.

Tints of colours are made by adding white, if working with gouache, or water, if using dyes.

Tones can be created by adding grey.

Shades of colours are made by adding black.

Tints, tones and shades alter the intensity of colours and are good ways of altering colours to make them work together. Adding a little grey to pure colours will often help them coordinate better within a design or range.

It is important to realise that the appearance of colours can change in relationship to other colours. The same colour could look dull next to a pure hue, or intensely bright next to a grey.

The technical jargon is all very well, but what practical use is it to designers? Colour theory is studied so that its properties are understood. This enables designers to quickly detect whether the colours are 'wrong' in a design and to know what to do to improve them. An understanding of colour allows flexibility, as colour is used in a controlled way, rather than relying on an intuitive approach. Such an approach might be fine if you are working with preferred colours, but could have disastrous results if you have to work with an unfamiliar colour palette.

Colourways in textile design

Colourways are colour combinations used in a design. A design will be produced and then presented in alternative colours to those in the orig-

inal. Nearly always, the colourways do not substantially change the nature of the design, they merely make the design appeal to a wider range of people with their own colour preferences for clothing and homeware. If the design has a dark background with four bright colours, the colourways should also have a dark background and bright colours. The blue background could change to dark green in one colourway, and a dark reddish brown in another. So, the colourways — usually at least two or three — must be substantially different in general colour appeal from each other, and yet similar enough in the way the colours are used so that it is recognisably the same design. Usually, the balance of colours, or the way in which the colours relate to each other, remains consistent throughout colourways. Not every colour needs to be altered either. Often the more neutral shades will remain consistent throughout all colourways.

In a design studio, the specific job of a colourist or stylist could be to determine the colourways for a design. If the design has to fit in with several other fabrics in the company range, this will dictate the colours to a certain extent. Producing colourways of a design is one of the first jobs designers have in a studio. There is no need to paint up the whole design in the new colours: the colourways accompany the main design in presentation. A small representative section of the design clearly indicates the feel of the new colours. Each colour must be replaced accurately. Only one set of screens will be made for all colourways, so, for example, everywhere orange appears, it must be replaced by blue. **Colour chips** should be presented to the printers and these should be in the same order for the main

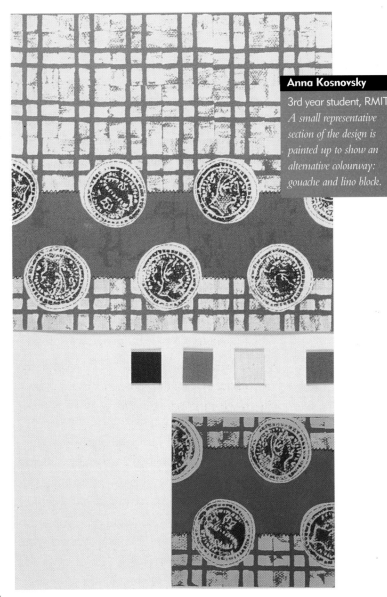

Anna Kosnovsky
3rd year student, RMIT
A small representative section of the design is painted up to show an alternative colourway: gouache and lino block.

design and colourways, usually in order of dominance of the colours. This makes it easier for the printers to read.

In small studios, or when working freelance, designers might have to do everything, producing a design complete with colourways. It is worth noting too that changing the colours of a design

can completely alter the look of it. Commercially, it is more usual for the design to have consistency over all colourways: the change of colour is to widen the options for the buyers, rather than to make the design look completely different. Often, though, completely changing the colours is a way of revamping old designs, making them conform to current fashion colours, for example.

Another system of producing colourways is by doing strike offs of the print, which is labour cost-effective but can slow down production particularly if the fabric is printed offshore. Colour chips are given to the printers as samples, the screens are made, and the colourways are trialled on fabric for the client or designer to approve or adjust. This way of doing things is best suited to small manufacturers, who design and produce their own fabrics, or where there is a design team and a production facility in the one location.

Experienced colourists or stylists will usually work intuitively to produce colourways of a design. They may be very familiar with a company's colour feel, so they produce the different colour combinations quickly, being fairly certain of the results. Experience means they have control over their use of colour.

The following terms are useful to know when producing colourways.

Complementary colours are those opposite each other on the colour wheel. When placed next to each other, they vibrate visually. When mixed, they make dark brown/grey. A small amount of the complement of a colour can neutralise it, or alter its intensity if it is too 'loud'.

Analogous colours are those close to each other on the colour wheel. Analogous colours can be used in determining colourways: if one colourway uses blue-green analogous harmonies, another colourway should use orange-red analogous harmonies.

Monochromatic describes a colour scheme where the colour stays the same, but the values change from light to dark. In colourways, the values must remain consistent if the scheme is monochromatic: if one colourway uses several greens, made from one green with black or white added to it, then the next colourway must follow the same pattern, using a different colour and its tints and tones.

Producing colourways

Use Exercises 1–5 in this chapter as a starting point for acquiring skill in the use of colour — you don't have to go through the process every time you tackle a brief. These exercises are a substitute for the experience that designers use to tell them what to do.

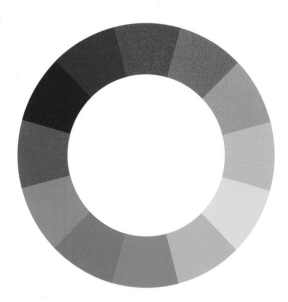

Exercise 1
Comparing colourways

Start familiarising yourself with colourways by collecting fabrics that come in at least three different colour combinations.

1 Define the colours in each piece of fabric, matching them in gouache or ink to make colour chips.

2 Keeping the colourways separate, place them in a line in order of predominance. The most dominant colour in a colourway is called the 'key colour'.

3 Look at the relationship of the key colours to each other, over the three colourways. Go through each colour, comparing it to what it has been replaced with in the next colourway. Compare the hue, value and intensity of the key colours and analyse why they have been chosen. Are they similar?

You will usually find that they are comparable, because that is one way of keeping the feel of the design consistent throughout the colourways. You will probably also find that some colours will be altered in value or intensity to make them work in the context of the design. The colours on chips might look quite different to how they appear within the design.

Colourways can be produced by 'formula', at least in the early stages of your development as a textile designer, and it's a good idea to go through this process in order to familiarise yourself with the ways in which a colour wheel and an understanding of colour language can assist you. Colour wheels, which can give you quite a lot of information to quickly refer to, are available from art supplies shops. The colour wheel on page 32 gives the standard primaries and secondaries, as well as tints and shades, and includes a colour guide that shows what happens when colours are mixed, for example, red/orange + blue = brown.

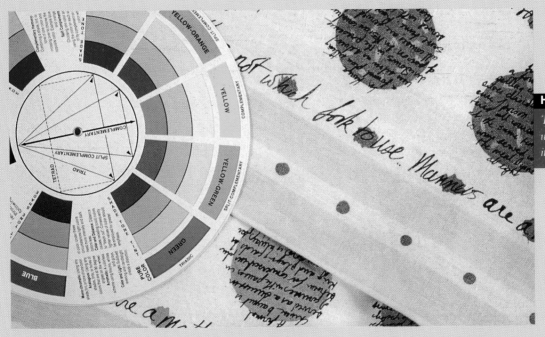

Helen Butler
The colour wheel is a useful way of working out possibilities for colourways; napery.

Exercise 2
Making colours for colourways

Working with one of your own designs that has three or four colours, and using a colour wheel, go through the following process:

1 Paint colour chips using the same gouache or ink that the design is painted in.

2 Put the colour chips in order of predominance, as you did in Exercise 1.

3 Decide on the general colour feel of the first colourway. If your main design is red, you might choose to do a blue colourway.

4 Locate the key colour of your design on the colour wheel, as closely as you can.

5 Replace this key colour with a colour of similar value and intensity, but different hue. Paint a chip of this colour and place it under the first key colour.

6 Locate this replacement colour on the wheel and count how many divisions you have moved, and in what direction, for example, three spaces to the right. Try to make sure this new colour has similar value and intensity to the first one.

7 Go back to Step 2. Choose the next colour in your original design and locate it on the colour wheel, as accurately as you can.

8 Turn the colour wheel in the same direction and the same number of spaces as in Step 6. Paint up a chip of this colour and place it next to the second key colour, underneath the corresponding colour. Again, ensure this new colour has similar value and intensity.

Repeat, this process with all colours in the design. It is not foolproof by any means, but you do have a reasonable chance of maintaining the balance between colours, by keeping their relationship on the colour wheel consistent. Start a third colourway by selecting another key colour, locating it on the wheel, and starting again.

9 Choose a small representative section of your design and paint it up in the new colours, to check whether they correspond in feel to the original when placed together.

10 Make any alterations to the value and intensity of the colours, so they work within the context of the design. It is quite likely that you will have to alter the strength of a colour (use a tint, tone or shade of the colour) as colours do appear different within the context of other colours and their position (or distribution) in the design. A colour that is used very minimally, for example, might have to be made more intense to make it look right. A colour that occupies a large area may have to be toned down so it doesn't dominate everything else.

Try matching colours in fabric by painting them in gouache. Here, several attempts had to be made to get close to the colours in a fifties fabric.

The value of Exercises 1 and 2 is two-fold. By analysing the characteristics of colours and their relationships to one another within a design, you acquire experience of working with colour objectively. Both exercises involve a lot of colour mixing, which helps develop the ability to mix and match colours. It is a good idea to keep a notebook of all the colours you mix, showing a sample and what they are made up of like this:

$\frac{1}{2}$ **Pelican, Burnt sienna +**

$\frac{1}{2}$ **Windsor & Newton,**

Viridian Green

This can form your own colour reference for later use or if you want to repeat a colour in another design. The series of books *Designers' Guide to Colour* is also a useful reference for colour combinations, showing colours in combination with one, two or three others. Adjustments still have to be made when colour combinations are taken from references that show 50 per cent of one colour and 50 per cent of another because a design might need 20/80 per cent. When you are searching for new colour combinations, or looking to extend your personal colour palette outside your old favourites, reference books, or your own record of colour chips, can be a source of inspiration.

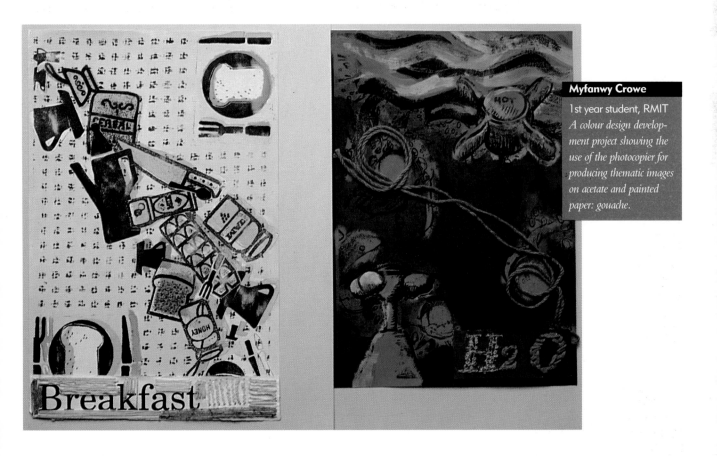

Myfanwy Crowe
1st year student, RMIT
A colour design development project showing the use of the photocopier for producing thematic images on acetate and painted paper: gouache.

Where does colour inspiration come from?

Designers should have the ability to collect reference materials from a variety of sources. It is not good enough to say 'I couldn't find anything'. One of the main prerequisites of designers is the ability to source information on any given theme or subject. This applies as much to colour references as to research on imagery, patterns or concepts.

Colour inspiration is everywhere. Start looking out for colour combinations such as unusual colours put together. These can be anywhere: in a garden, a shop window, another textile design, a photograph. As discussed in Chapter 2, books, magazines, postcards, paintings are easily accessible areas to start. Theme selection will often give designers an indicator of colour palette. If your design is for a fashion range that has a 1960s feel, then you need to look at not only the patterns of that time, and the motifs used, but also the colour palette. Of course, the juxtaposition of image and colour can often be used to effect while being out of synch with each other thematically (consider 1960s motifs with pastel colours), but designers have to be sure this will be appropriate for the client's needs.

Remember, there are specific jobs in the textile and design industries where colour forecasters are employed, usually on a freelance basis, to sell their expertise in colour prediction and styling trends. The colour stylist will assemble a series of colour concept boards coordinated with fabric or yarn swatches and usually tie them in with a theme. International styling magazines are published for the purpose of prediction and forecasting for the textile industries. These are worth looking at if you can get access to them in a library. (*View* and *International Textiles* are the most relevant to textile design but are quite specialist and unlikely to be in, for example, your local library. Try the library of a tertiary institution that has a textile, craft or design course.) It might be a good starting point for the development of any brief to produce concept boards for a colour palette, particularly when the theme and colours are likely to be linked.

Exercises 3, 4 and 5 will improve your ability to find colour reference material.

Narelle Lloyd
1st year student, RMIT
A colour design development project showing the coordinated use of theme, painted photocopy acetate and yarn wraps: gouache.

Exercise 3
Using fabrics and yarns as a resource

Look at fabric as the starting point for a brief instead of collecting magazine cut-outs and paper-based resource materials. Fabric choice is vast and includes yarns, trimmings, accessories, and natural, synthetic, knitted, woven and printed fabric swatches. Opportunity shops and fêtes have older fabrics with a variety of patterns and colours that are not available today.

In your resource book make up a colour story of different fabrics arranged together in colour relationships, grouping them as light, dark, strong, weak and so on. Replicate the colours accurately with pencil, paint or ink.

A fabric clutch bag found in an op shop is the starting point for this colour story. The colours are matched in gouache, and coordinated with yarn colours. This could be the inspi ration for a design of your own.

Exercise 4
Converting resource material using paints or wet media

For this exercise you can use gouache, watercolour or inks.

1 Choose from your resource material a drawing or magazine cut-out that fits in with the brief you are working on.

2 Select six or eight colours from the cut-out or drawing, and choose paints or inks that resemble these colours.

3 Mix the colours, matching them to the reference. Divide each colour into four equal parts.

4 With one part, paint a series of squares, arranging them in sequence from light to dark.

5 With the second part of colour, produce another series of squares but this time use a small amount of white to create a tint.

6 Repeat with the third part but use grey to create tones.

7 With the last part add black to create shades.

You have now built up a comprehensive colour reference from the resource material. This will enable you to use your chosen colour palette with all the options of value and intensity within the hues.

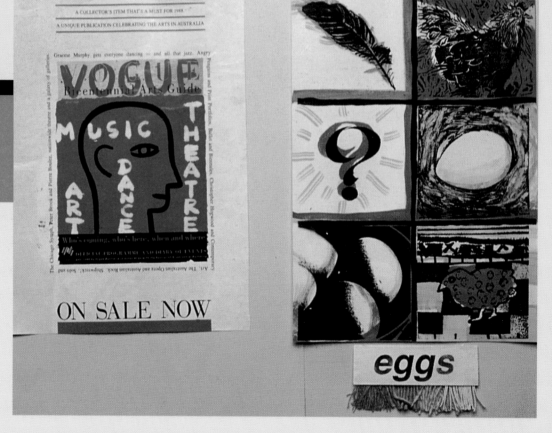

Myfanwy Crowe

1st year student, RMIT
The starting point for a colour design development project. An illustration or drawing is sourced for colour ideas.

Exercise 5
Distribution of colour in resource material

1 From your resource material, select a photograph, which appeals to you because of its colours, for any brief that you are working on.

2 Section off an area of the image that best shows a range of colour that might be useful for your colour palette.

3 With tracing paper, trace the shapes and as much of the colour boundaries as possible. If it is a small area, increase it on the photocopier. The colour areas are probably round and fluid in form and some will be hard to define, but you can square off the shapes.

The idea is to create a mathematical analysis of the colours used and the amount of

space they occupy in relation to each other and the area as a whole.

4 Put the tracing on top of graph paper and count how many segments make up that colour: for example, the colour pink occupies twelve segments, while lime green only takes up about five segments. This can be approximated — it doesn't have to be accurate. The important thing is the proportional relationship between the colours.

5 Paint up colour chips matching the colours and indicate the relationship between the colours by their size.

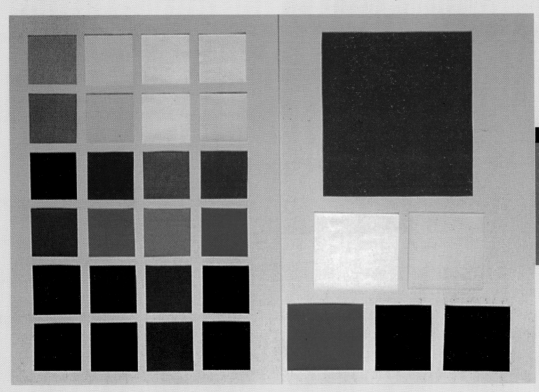

Myfanwy Crowe

1st year student, RMIT
The colours are analysed and painted up accurately in size ratios. The colours are then divided into tints, tones and shades to make an extensive colour palette.

Narelle Lloyd

1st year student, RMIT
*Colour project shows the
way an illustration is used
for colour value and
weighting. This informa-
tion can help with the
designing of stripe patterns
for textiles.*

you altered the balance of these colours, then the result would not be in keeping with your original resource. The information can be used to colour your own designs, as long as you are aware of the size and shape of motifs and their placement in relation to each other, and how it will affect the look of your design. It doesn't matter, of course, if you stray from the resource material and come up with some fabulous and unexpected results. Remember, though, the purpose of this exercise is to show you how to analyse your colour references, to enable you to reproduce the feel of something you have observed.

If you have access to a computer with 2D paint programs, the speed of assembling colour variations in this way is fast and the number of variations you can come up with is infinite.

Do all colour choices work?

We are all familiar with the adages that say certain colours do not work together ('Blue and green should never be seen except with a colour in-between'). But, as in every other facet of contemporary life, ideas and rules change. The colour rules for the 1950s, for example, do not apply today. It is the task of designers to make colour palettes work, and their success or failure will be viewed in the context of the design brief, if working for a client, or the end-use of the design and, eventually, the fabric. Some colours may be difficult to work with for all sorts of reasons, but the range of colours available today, in pigments, dyes, paints, inks, fabrics, is vast and designers of all sorts are challenging the rules.

How can this information from Exercise 5 be used? In its most simple form, this information can be used to create stripes or checks, where, in order to duplicate the colour feel of the photograph, you would ensure, for example, that the pink was used twice as much as the green. If

We look to **magazines** for **inspiration** and for **ideas** on **how** to bend the **rules.**

It is good to develop an understanding of colour and its inherent characteristics of value and intensity, before heading towards wacky colour combinations that have unpredictable results. As with most disciplines — learn the ropes before you break the rules.

If you look in fashion and styling magazines the convention of colours for seasons is still prevalent: there are references to 'next summer's colours' or 'the colours for spring fashion'. Trends in interior design or the furnishing fabric industry last much longer: they have to, because of the huge investment required to change the interior of a house.

Often, in fashion and interior design magazines, you will see things that look fantastic, but which you would probably consider to be unusable, or unwearable. For example, a small chair might be covered in a very large print, which would seemingly be breaking all the rules of appropriate scale in design. A model might be wearing a dress with large concentric stripes, in clashing colours, which looks fine because she is 6 feet tall and very thin. These things break the rules because most people don't want to see what they already have.

Electronic colour: how is it different?

The textile industry has been the precursor to change and invention in electronic colour. The computer has introduced designers to an overwhelming choice of colours, as well as the capacity to instantly respond to client needs. With most textile software programs, there is the potential to use 16 million colours: in reality, particularly in print, there will be restrictions imposed by the economics of production, which dictate a maximum of eighteen or twenty colours and often much fewer than that. The 16 million colours are useful for trying out possibilities; there is so much more scope for trialling combinations electronically.

A knowledge of colour theory and its vernacular is essential for dealing with colour in CATD. On the screen, it is possible to adjust the hue, value and saturation of each colour, so to

effectively use the system designers should understand what result this will have. In most systems there are difficulties of resolving the discrepancy between the colours on the screen and the printout, and these problems will vary within each system. They are easier to resolve if designers working on the system can determine those aspects of the colours affected in the printout, so adjustments can be made on the screen to get the colours right on the printout.

Electronic colour is a system of additive mixing, where wavelengths of light produce all colours. Colour television and stage lighting are other examples of additive colour mixing. In contrast to this, the use of pigments to mix colours is subtractive colour mixing.

Process colour

Most textile printing in industry is based on the system of separating all colours, then printing them one after the other on fabric by flat or rotary screens. The colours (up to eighteen for some furnishing fabrics) are premixed to match designers' artwork. This is known as subtractive colour mixing using pigment.

In the paper printing industry, colour is printed using the **process colour** system. This is the same principle as that used in colour photography: all colours are broken down into combinations of the process colours, which are cyan, magenta, yellow and black. The artwork must be photographed or electronically colour separated on a computer, using **halftones**, and the end result is four colour separations, which give an unlimited number of colours. The separations do not look like the ones we are accustomed to seeing in screen printing, and the pigments used are premixed to a special cyan, magenta and yellow. Combinations of these pigments must be able to make every colour. Greeting cards, wrapping paper and posters are usually printed using this method.

Process colours have *some* application to textiles, but because cloth is not stable or flat, like paper, the results of this expensive process can be too variable. The registration of the colours must be 100 per cent accurate for those four colours to make up all the colours in the artwork. The most common application for process colours in textiles is to printed T-shirts. As it is a small area that is to be printed as a placement print, there is more opportunity for stabilising the fabric with adhesives. Screens have to be prepared very carefully, and the correct pressure used with the squeegee, so the print looks the same as the original artwork. In textile printing the balance between the four colours can be easily distorted so the end result looks wrong — too blue or too yellow or too dark.

Working to a brief with colour

The following two briefs are examples of what you can do with your own visual material. The first brief gives you much more freedom as you can choose your own colour palette, while the second brief contains restrictions such as those a client would give you. In both these situations, you need to be able to justify your decisions with back-up work. (Note that the term 'vegetal' encompasses all things that grow.)

Brief No. 1
Your choice of colours for napery (floral or vegetal)

You are to produce a range of designs for table napery based on floral or vegetal ideas. You will design and print the napkins yourself. Think about appropriate colours for the theme. What is a better colour palette for napery to use in the home: dark grey mechanical colours or colourful natural hues? You are making a design decision, so what is more appropriate and likely to result in a better finished product? Think about the practicalities of the product — table napery is used with food and therefore has to look good with food.

Collect your reference material. Start first with paper-based drawings and designs. A good idea is to work full scale so you can see how the paper design will work on a table with cutlery and plates. Your colour choices are limitless. Do you use a coloured paper to work on or start with a white background? What colour media will you use in conjunction with illustration techniques? Try washes, cut paper, gouache or resists. If you have limited facilities, your options for producing the napery may be restricted to paper stencils and hand-painting, so this will influence your illustration style. Remember that you have a specific area to decorate — the size of the table napkins. You have to decide what size they will be. You can buy plain coloured napkins to work on, thus reducing time spent on dyeing, printing or painting background colours.

Initially, while trialling your ideas, you will probably put as many colours on paper as possible, to achieve rich effects. This may look stunning but think of the practicalities of translating all those colours to the fabric. Good design is often about achieving wonderful effects with a minimum of colour, and working within the production limitations.

Once you have a reasonably good idea of the design, which could have three or four colours in it, you need to finalise what those colours will be. Select those ones in Exercises 3, 4 and 5 that might be appropriate for converting your colour references into usable visuals. Perhaps you have piled fruit, vegetables and flowers on the table, all in warm autumnal colours. Copy the colours and use Exercise 5 (using your own drawing instead of a photograph) to analyse why the colours of the natural forms look so appealing. Does a particular shade of red dominate? Is there a yellow highlight? You might decide to discard all imagery and use checks or stripes inspired by floral or vegetal colours. You don't always need to work through the exercises as formally as you did the first time, but it is useful to refer back to the colour principles involved.

Regardless of whether this is a client based or personal brief, there is still a theme with a practical outcome that has to be adhered to. Look at the excellence of what you have produced — how well resolved is the design? How do the colours look with plates and food? Look at the end result as if someone else had done it — would you use it?

Brief No. 2
The client's choice of colours for napery (floral or vegetal)

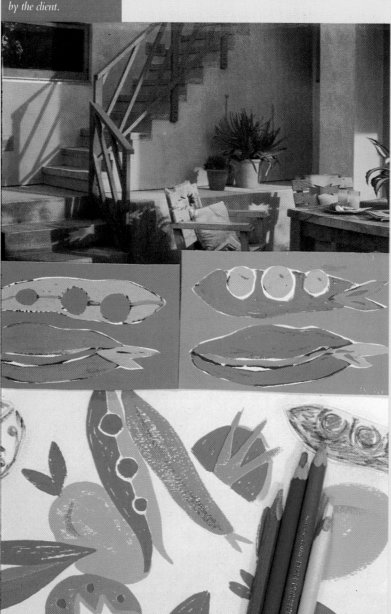

Ideas for napery based on the photograph provuded by the client.

Brief No. 2 has been presented by a client.

The use of colour in these circumstances is objective and has known boundaries. You may not like the colours personally but the client is paying for the work. Colour has a very practical and logical format in this example. The task here is obvious: this is what the client wants and they will pay you to do it. The end result of the client-based brief is the satisfaction of a job well done and professional evaluation.

DESIGN BRIEF

PRODUCT *Table napkins*

MARKET *Outdoor cafe*

PRODUCTION METHOD *Placement printed on carousel, printed in pigment.*

RESTRICTIONS *Maximum of four colours*

FABRIC *100 per cent cotton, unbleached.*

DESIGN THEME *Summer, outdoor feel, using floral or vegetal motifs.*

COLOUR PALETTE *Summery, not too bright, fresh, to look good with food and the tables, consistent with the colours of the interior (paint chips supplied) and staff aprons.*

REQUIREMENTS *Design presented to scale, with one colourway, and a border idea possibly to be used for a tablecloth.*

Here, you would have to take into account whether the tables are wood or metal. What sort of plates do they have? If you can't visit the cafe, ask for photographs so you can see what the feel of the place is. You don't have to go searching for colour references, as they have been given to you. Look instead at how the given colours have been used in the decoration of the cafe. Is one particular colour more dominant? Establish whether the client wants to retain the unbleached colour, or whether the napkins can be dyed. You are seeking the same end product as in Brief No. 1, but the restrictions are so different.

The colourway would probably not be put into production, but would serve to offer the client a choice. You might stick to the colour palette they give you, matching the colours to the chips supplied, but change their dominance within the design, for example. You have to show the client that you are interested (if you want the job) and that you have done your research.

Summary

As a designer, you should be collecting colour references from everywhere, all the time: things that show colours you like, interesting colour combinations, swatches of fabric. The trick is in knowing how to make these things applicable to your own work.

- Analyse the resource material you have collected — why do those colour relationships work? How can the principles be applied to your design?
- Colours have particular attributes that can be altered: you can change the value or intensity of a colour to make it fit your brief, whether it be personal or client based.
- It is probably a good investment in your future as a designer to have good colour materials and references: wet and dry media, colour reference books and a PANTONE Color Formula Guide (or substitute).
- Keep your own notebook of colour chips you have used, for reproduction and for inspiration.
- Keep your own record of current colour trends in the fashion and interior design industries. Take note of the popular colours for this winter, for example. After a while you should be able to observe what the colour trends have been, and the ways in which those industries conform to forecasts.
- Take any opportunity to become competent with electronic colour: practice reconciling your printout with what appears on the screen. Electronic colour is the way of the future for the textile industry, because of the capacity to increase output with colourways, and the links with manufacturing processes.

Mark making

materials
and
techniques

Mi Kyoung Kim

3rd year student, RMIT
Collage can be used in
conjunction with other
media such as monoprinting.
Corrugated paper was inked
up and transferred to paper
for a collage on the design.

Once you have your resource material, you have to decide, to some extent, what you want to do with it. Your aim may be to simply explore the material further, before you actually decide that you want to produce, for example, a range of textile designs or a series of three framed pieces. Or, you may have a very clear idea of the end result, the outcome (for example, a length of printed fabric). Either way, you have quite a way to go before you get to the end result.

This process could be simplified as:

Ink
Resource
Explore
Outcome

This chapter deals with the exploration process. It provides a list of materials and techniques commonly used by designers. Understanding the potential and mastering the use of these will give you a range of design possibilities at your fingertips. Whether you are working in industry as a designer or your prime motive is self-expression, you cannot have too many tools at your disposal. The list is introductory, rather than comprehensive, as you will work out combinations of materials and techniques for yourself as you need to achieve various effects.

There is no definitive design process. The techniques given here could be seen as a set of warm-up exercises, which help you explore and exploit your ideas. This chapter will help you find your feet as a designer, encourage you to be versatile in your approach to design and flexible in your interpretation of a design idea.

Mark making
materials

The list of materials for applying colour and marks is grouped as **media**, tools, and surfaces.

Dry media

pencils

coloured, lead, watercolour

In general, pencils are useful for line work, rendering of textures and tonal effects, and blending of colours. The effects you can achieve will be affected by the choice of paper, for example, flat or textured. When purchasing coloured pencils,

a set of ten or twelve good quality pencils is a much better investment than a huge range of cheaper pencils. Cheaper coloured pencils tend to be harder and therefore more difficult to blend, and break more easily. With the better quality brands, extra colours can be bought as required. Coloured blocks, which are good for broader marks and blending effects, are also available.

Lead pencils range from hard to soft. Hard pencils (H,HB or 2B) are used where fine lines or accuracy are important, such as when tracing or for layout work. Softer pencils (6B, EB or EE) are blacker and tend to be more suitable for textured effects, tonal work, and for rubbings. Chinagraph pencils are very soft and greasy. They tend to be thicker and pick up very good detail when rubbing. They can be worked onto many surfaces such as acetates and films. Be careful with the softer pencils as the leads tend to break very easily inside the wooden case. (They are also only available in a limited colour range.)

Watercolour pencils are ideal for blending effects and have the advantage of being able to be used dry or wet. They can be applied dry and water brushed over to create a watercolour effect, or the lead can be dipped in water and used wet. If using water with these pencils, choose a good quality paper, which will not crinkle when wet.

charcoal

stick, pencil, compressed

Charcoal is most commonly used for large scale life drawing, as it is direct, inexpensive and expressive, and suitable for line work through to rendering tone. Charcoal is available in different densities: compressed charcoal is denser than

stick. In pencil form, it can be useful to designers in combination with wet media. Charcoal comes off very easily with rubbing — with an eraser this can be a drawing technique to create highlights, but the charcoal should be fixed, when the drawing is completed.

crayon

conté (stick and pencil), wax

pastels and chalks

oil pastels, natural chalks

Crayons, pastels and chalks are available in a wide range of colours and sizes/formats. These dry media have different inherent qualities that you will need to play around with, remembering that the choice of paper (flat or textured, white, black or coloured) can considerably alter the effects. They all have good opacity, which enables them to be worked over other media such as paint, ink. They are very effective when used for blending: a 'tortillon' is a special tool for that purpose (it is a compressed paper stick) but blending with small pieces of paper can be as effective.

Conté crayon is available in hard, medium and soft, it has a limited colour range, and like charcoal is known for its expressive qualities in line and tonal work. Pastels and chalks are available in a wide colour range. They are expensive so buy colours as you need them.

Oil pastels can be washed over with turps for a blending effect. Handle turps with care, using it in a well-ventilated area and avoid making direct contact with skin. Wax crayons are inexpensive, and can be used for rubbings and resist techniques, in combination with ink washes. White crayons (sharpened to a point with a blade) give a good clear resist.

markers

fibre tipped, felt or nylon tipped

A range of colours, sizes and tip shapes is available. Markers are suitable for line work, filling in large areas of colour, and are noted for their direct, clean and simple application and their clarity of colour. They are useful in the design process from the concept stage through to finished artwork. Specialist markers are available for use on films and photographs but tend to be costly. Markers are not appropriate where flat colour is required in finished design work or where it is necessary to accurately match colours by mixing. Some brands do have markers that form part of a colour system, where markers, papers, films and printing inks are available in coordinated colours, enabling colours to be easily matched throughout the design process. These products are, of course, expensive but in a design studio they save a lot of time.

Wet media

ink

permanent, water based

Inks are easy to use, available in a wide range of colours and can be applied with a variety of tools such as brushes, airbrushes, and pen. Colours can be mixed quickly when using water-based inks. Transparent inks can be used to layer colours over each other for depth or for wash effects. Generally, inks are a cheaper alternative than watercolour paints (depending, of course, on the effects you wish to achieve). Permanent inks are better for working onto films and acetates and are available in opaque — choose inks that suit your requirements. The choice of paper is important: if you are using large areas of ink (or any wet media for that matter) choose a paper that will not crinkle. Inks can produce great results when used with resists, and in combination with dry media.

paint

gouache or designers' colour, poster paint, watercolour paints, acrylic paints, oil paints

In the textile industry, **gouache**, or designers' colour, is the most acceptable and most professional medium in which to present finished design work. Gouache is produced from high quality pigments and therefore has good light fastness, a great colour range, colours that mix very successfully, good opacity and very even application on a range of papers. Because of all these great qualities, gouache tends to be expensive — if you are using it, buy a few colours that will mix to produce a secondary range, and buy other colours as you require them. Gouache is usually bought in a tube.

Poster paint, or tempera, is available in tubes and jars and being less expensive, is a good alternative to gouache. The colour range is reasonable, as is the opacity.

Natalie Ryan

1st year student, RMIT
Illustration for a gift wrap project called 'St Patrick's Day' shows use of mixed media: gouache and gold ink, overworked with coloured pencil.

Both gouache and poster paint should be mixed to a creamy consistency with water before applying with a brush — use ice cube trays or coated baking trays as palettes to keep the colours separate. Check your colours on a scrap of paper before you paint up the design, letting them dry before you decide that the colour is what you want. Colours that have been mixed using gouache or poster paints can be kept indefinitely in airtight containers. (Clear film cannisters are good for this — they are compact and sealable.) If you are leaving your design work for a short time, cover your palette with cling film so the paint doesn't dry up.

Watercolours are good for wash effects because of their translucence on paper or board, and they can be used in conjunction with dry media. Choose a paper that is suitable for wet media. Watercolours are also suitable for use with an **airbrush**.

Acrylic paints are fast drying, and inexpensive brands are available. They can be used diluted (preferably with acrylic medium) to create wash effects, or thick for impasto effects (paint applied, often with a knife or hybrid tool, to create a textured surface). A thicker paper, card or board should be used for acrylics.

Oil paints are fluid, slow drying and expensive. They are not commonly used by designers, as they should be used on a prepared surface — the techniques shown here are suitable for working on paper.

bleach

Liquid household bleach can be applied to a variety of papers to remove colour. It will result in negative marks and is often used by textile designers to create soft lines or textures. The bleach can be used undiluted and should be applied with a nylon brush; if you use good quality natural brushes, the bleach will destroy them. Bleach can also be applied with hybrid tools for a variety of textural effects. Some paper will **discharge** the colour more readily than others — tissue paper and cartridge weight papers work well. Be careful when using bleach; wear gloves, work in a ventilated area, and take care not to spill or splatter it. Bleach can also be applied to areas painted in gouache or poster paint to 'fade' them.

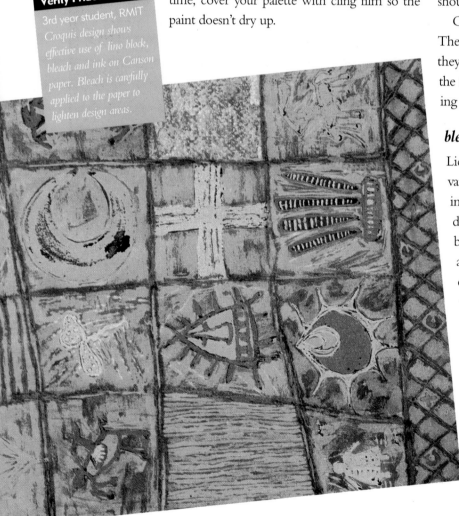

Verity Prideaux
3rd year student, RMIT
Croquis design shows effective use of lino block, bleach and ink on Canson paper. Bleach is carefully applied to the paper to lighten design areas.

Tools

brushes

natural (sable, hog hair,
ox hair, squirrel), mixed fibre
(mixtures of natural fibres),
synthetic

Natural fibre brushes are more expensive but, if they are well looked after, have better lasting qualities, hold their shape much better and can be trimmed to suit designers' needs. Synthetic brushes are cheaper, but lose their shape and hair much more quickly, and the fibres are coarser.

The basic shapes of brushes are: pointed, rounded, flat and fanned. Brushes should be chosen for their size and shape, according to the media you are applying and the effects you wish to achieve, and the marks you want to make. If you have large, broad areas to cover, you need a brush that will hold a lot of paint or ink (a full-bodied brush) with a broad end, so you don't take all day to paint up your design and, if flatness of colour is important, the brush marks are less likely to show. If you have detail in your design, choose a brush with a tip that suits the fineness.

To start with, choose sable brushes in two or three sizes, for example 1 or 2 (for fine line work), 5 or 6 (for multipurpose marks) and 8 or 10 (for broader application). Buy more specialist brushes as the need arises. A household paintbrush about 2 cm wide is a useful tool to have when applying broad washes. Keep separate brushes for applying media like masking fluid, wax or bleach. It is often a good idea to use cheaper, synthetic brushes for these purposes, as they can be thrown out and replaced, or used as part of hybrid tools. Look after your brushes by washing them thoroughly, and don't leave them standing in jars of water as this will flatten the tips.

airbrush

An airbrush is a device that uses compressed air to atomise liquid to produce an even spray or splatter. This can be done mechanically, using a compressor unit, or manually, using refillable air cylinders.

Airbrushes are most commonly used in the design industry and professional studios, as they are expensive pieces of equipment and require a well-ventilated area when in use. They can be used with inks, watercolours, gouache and poster paints; for good results care must be taken to get the right consistency of gouache and poster paints. The diffuser head can be varied, depending on the liquid used and the effect desired, for example, fine spray, coarse splatter.

This equipment requires considerable hands-on experience and patience to master. The benefit of using a mechanically controlled airbrush is that the

spray is even, enabling the creation of tonal effects, particularly when used in combination with specialist films and masks, which can be used to achieve hard edges and layering of colours. An airbrush must be cleaned thoroughly after use.

atomiser, mouth diffuser

An atomiser or mouth diffuser is an inexpensive tool used to give spray and splatter effects with ink or paint. It is an L-shaped tool: the longer end is placed in a container of the liquid to be sprayed, the gap at the 'elbow' is blown through and the colour comes out the other end. Practice an patience are necessary to get good results, as drips

and unwanted splatters tend to occur in the beginning. It is a substitute for an airbrush, but as the variables are greater, the results are less predictable. **Masks**, films and **stencils** enhance the effects you can achieve using this very simple tool. It can be quickly washed and the next colour sprayed. An atomiser tends to be more suitable for smaller areas and for effects where variation will not matter. It is also better with inks than with thicker paints, which must be diluted considerably in order to spray them.

A toothbrush and sieve are another alternative that can be used for spray/splatter effects, and tend to be appropriate for thicker media like paint. The toothbrush is dipped in the paint and rubbed across the sieve. Like the airbrush and atomiser, trial and error is unavoidable in learning to use the technique. Care must also be taken to work in a well-ventilated area and to avoid direct contact with skin.

technical drawing pen

These are available in a range of sizes, from 0.1, which is very fine, to 2.0, which produces quite a thick line. They have a cartridge for ink, which means the flow is controlled. Specialist inks (opaque inks for use on films and acetates, for example) are available for use in **technical drawing pens** — take care with what you put in them as the nibs are delicate. These pens must be kept clean, as they clog easily, particularly if they are left unused for some time. When you buy one, check the manufacturer's recommendations for cleaning.

Useful sizes for textile design work are 0.4 for fine lines that can be easily reproduced in print and 0.8 for thicker line work.

ruling pen

Often found as part of a technical drawing set, the **ruling pen** is used to produce precise lines of a constant width (such as stripes) with a variety of wet media such as ink, gouache, poster paint. The flow of the liquid is controlled by adjusting the screw on the nib: this alters the width of the line produced. It can be used with a compass to produce circles. Because they can be used with paint, they are useful where colours have to be accurately matched; technical drawing pens also produce lines of a constant width but can only use inks. As ruling pens do not have a cartridge, they have to be loaded as you work, like a brush.

Ruling pens are difficult to master, requiring experience in getting the right consistency of the wet media, and a steady hand so the flow is even. They are commonly used in textile design studios to produce striped or checked designs, and **yarn dyes** (weave simulations).

Useful accessories

ruler

A metal ruler is essential if you need a straight edge for cutting paper and card; 60–100 cm is a useful length. A thicker metal straight edge is useful for cutting mounts for presentation of work, where heavy board in large sizes is being used. The weight of the straight edge will be needed to keep the board stable. In textile design work, a 30 cm clear plastic ruler is often useful, for example, when measuring the distance between design motifs that repeat.

eraser

Erasers come in a variety of forms (soft, kneadable and hard) for the removal of various media. Erasers are not only useful for removing errors. They can be mark-making tools when combined with pencil, charcoal or pastel, for working back into drawings to create highlights, tone and negative marks. Erasers can be cut and shaped for special purposes. A hard eraser is necessary for the removal of liquid masks.

cutting tools

A retractable knife (such as a Stanley) is necessary for heavy duty cutting, or for cutting card, or mount board. For finer, more detailed work, a scalpel is used. These come in a variety of forms, from inexpensive plastic holders with blades, which are snapped off as they become blunt, to the more sophisticated knives with different blades such as round edges, pointed tips. These blades are usually screwed in and are better where accuracy is important, as they are more stable and less likely to break. Knives with swivel blades for cutting circles and curves are also available.

cutting boards and mats

Choose carefully the surface you cut on. The heavier the material you are cutting, the firmer and heavier your cutting board should be. Plywood or masonite makes a good cutting sur-face for heavy duty work. For lighter cards and papers used in design work, cutting mats, which have a non-slip surface that will not be damaged by cutting, are available. These are great, particularly if accuracy is important, as the cutting is not affected by surface nicks and cuts on the board, and they have a grid that keeps your work square.

scissors

A pair of scissors for general purpose is useful. Have a separate pair of scissors for cutting fabrics, as they will easily become blunt if used for paper and card.

set square

A metal or plastic set square is useful for textile design work, when working out repeat systems and laying out work that must be square and accurate.

compass

A compass is vital for textile design work, where a motif based on a circle or arc may have to be repeated. Choose a compass that can be tightened by a screw to hold the size and that has attachments for use with pencils and technical drawing pens.

protractor

A plastic or metal protractor is used to divide circles into even segments, and to work out angles. In textile design this is very useful when creating patterns.

adhesives

rubber cement, PVA, spray adhesives, clear adhesive tape, double-sided tape, masking tape

Rubber cement is a general purpose adhesive, which is strong and dries clear, without wrinkles. It allows for the repositioning of artwork (before it is dry), and any excess can be gently rubbed off paper and film without leaving a mark (providing you have clean fingers). It is applied with a brush (kept for that purpose) or pieces of card or sticks that can be thrown away.

PVA is a water-based general purpose adhesive. It tends to be less permanent than rubber cement, but is available in several handy formats, like squeeze bottles and sticks. It can be diluted and used as a 'glaze', can have paint added and used to create textured surfaces, and is used for papier mâché.

Spray adhesives in aerosol cans provide an adhesive that is tacky, rather than strong. For reasons of health and safety, and environmental damage, they should be avoided.

Clear or 'magic' tape is useful for taping surfaces together for photocopying or where light has to pass through, such as in the preparation of **silk screen positives**, or where a process camera is being used.

Double-sided tape is great for temporary positioning of artwork, mounting work and holding stencils in place.

Masking tape can be used where a stronger hold is required — it can be folded in half and used like double-sided tape. It is also useful in mounting work. When working on films and acetates, it can be used to create a mask for straight lines.

Surfaces

paper

A great variety of papers is available for the designer to use: in cut and torn paper work, or collage, or to work on with wet and dry media. It is best to select paper according to use: will it be used for wet or dry media, for ideas only, or for finished artwork? Would a flat or textured surface be more appropriate? Would coloured paper give a better surface to work on?

Newsprint and butcher's paper in rolls or sheets are inexpensive and commonly used to map out quick design ideas or for large scale life drawings using pencil or charcoal. They are not papers to use where the long life of the drawing or design work is required.

Cartridge paper in different weights, formats and sizes is a good general purpose paper for wet and dry media. In sketchbooks it is portable for

on-location drawing and can provide a handy format for a 'visual diary'.

Specialist papers should be chosen according to need, as they can be quite expensive. Watercolour paper is not necessary to use with watercolour paints, particularly if you are using watercolours as a design tool and in combination with other media. Pens and markers give better results on a smooth surface, whereas textured papers can enhance the marks produced with pencils, chalks, pastels. Think about what you want to achieve before you invest in a vast range of expensive papers.

Cardboard in a variety of weights can be a good surface on which to work, as well as being useful for mounting work. Some boards have a coating on them, which can be used as a design device. Wrapping papers can provide alternative surfaces to work on. Tissue paper is great for layering colours and can be worked on with bleach to remove the colour.

Experiment with different media on scraps of all sorts of papers and card.

transparent surfaces

papers, films and acetates

Layout paper, in sheet and pads, is used in concept work. It is white and has reasonable transparency particularly over a lightbox (or held up to the light coming through a window). In textile design, it is often necessary to trace shapes from other designs when working out repeat systems so it can be very handy to work in a layout pad.

Detail paper in sheets, rolls and pads is designed for tracing and copying. It is smooth and flat and ideal where accuracy is important, as is often the case in textile design work.

Tracing paper is available in a variety of weights, sizes and formats, and can be used in overlays for tracing and layout work. Tracing paper tends to be less stable than detail paper but used carefully can be a good substitute.

Litho paper in sheet form is white with reasonable transparency. It is shiny and non-absorbent on one side, and matt and absorbent on the other. It is used in transfer printing (see Chapter 11).

Polyester drafting films are used for the preparation of silk screen positives (see Chapter 10).

Acetate sheets in a range of thicknesses and sizes are great for overlays in design work, for example in combination with typography to trial various effects. They can be painted on, used with permanent inks and markers, scratched into, and can be used in a photocopier.

graph paper

Available in sheets, pads and rolls, graph paper is essential when working out textile designs that are in repeat (see Chapter 6). It is used under detail paper to give a grid structure when working on repeat systems; or simple patterns can be worked out in graph pads so you can quickly see how patterns work. On a roll, graph paper is called 'continuous sectional'.

typography

Various brands of pressure-sensitive lettering are available in a range of styles and sizes, for example, Letraset. The letters are transferred by rubbing onto the design surface, or onto films or acetates

for overlays. Choice of typography can be vital in presenting finished design work, such as for titles, or where type is required as part of a design. Handwriting is not always appropriate. Type can be photocopied, reassembled, and copied onto acetate. Look for catalogues of typography you can photocopy and cut up, as lettering can be very expensive to buy.

hybrid tools

Hybrid tools are tools made to fit a purpose. This might be done because you can't find a tool to do the job or because you can't afford the tool professional designers might use, but still want to simulate the effect. A good example of a hybrid tool is the use of a toothbrush and sieve as a substitute for an airbrush. You might adapt existing tools to alter their function, such as attaching a sponge to an old paintbrush. Hybrid tools encourage improvisation, often with unexpected great results. Wet media can be applied with rags, textured fabrics, sticks, string wrapped around rollers to give great variety to a limited amount of materials. Making your own tools is all about deciding what you want to achieve and keeping an open mind about how you'll get there. Have a collection of things that might make good hybrid tools: cotton reels, old kitchen utensils, wire.

Natalie Ryan

1st year student, RMIT
'St Patrick's Day' gift
wrap idea shows combined
use of gouache and gold
ink overworked with
coloured pencil. Gift
wrap can be termed
surface pattern design and
is therefore of interest to
textile designers.

Mark making
techniques

The following are techniques that can be used to develop drawings or any resource material into a variety of formats and styles. They have been chosen for their particular application to textiles, whether they be design or art based.

You are at the exploration stage of the design process, having collected resource material to be used as inspiration and perhaps having worked out, or been given, a design brief or project. Now it is time to get the most out of your resource material by interpreting it in a variety of ways with a range of media. This can lead to solutions you hadn't contemplated. Ideally, you will have a range to select from when it comes time to evaluate and refine your results.

The idea here is to become adept at using materials and tools in a variety of ways so you have all sorts of tricks up your sleeve when called upon to produce design work. Colour plays a vital role in all these techniques: refer to Chapter 3 for information about the use of colour in design work.

In this section, a simple illustration shows the most obvious use of each technique. These techniques need not be used in isolation, but rather in combinations with other media. Your resource material will not necessarily be appropriate for every technique but give it a try even if it is in the form of a quick sketch. Sometimes it is difficult to visualise the results.

Line work

Look at your resource material in terms of *line* only.

What is line?

Line is directional, straight or curved, it has smooth or rough edges, it is solid or textured, it has rounded, pointed or blunt ends, and it can be fine or broad. It can define a shape or enclose an area. Line can be created using a variety of media and applied with a range of tools. Line is affected by the surface to which it is applied.

How is line used by the designer?

The first mark designers make is probably a line, perhaps to roughly sketch an illustration idea. Line may be seen as a simple concept, but to designers an awareness of the expressive potential of line is the development of an important skill. Designers can use line to rationalise a complex drawing into elements of form and structure; it might be necessary to simplify material in order for it to be reproduced in production or for expressive purposes.

The visual impact of a line can be enhanced or reduced by the choice of media and surface. A solid painted line is an obvious statement, whereas a whimsical pencil line has a more subtle appeal. What best suits your resource material? What effect are you trying to achieve? Choose the material and surface to suit your need.

You might find that one colour is the most expressive (say, black on white) or that cross-hatching (a series of lines placed together to give tonal effects) in lead pencil is the most efficient and effective means of communicating your idea. Don't forget, though, that combinations of line and colour are also effective for creating visual imagery. Look at coloured lines on coloured surfaces, lines of lots of different colours, and combinations of media, such as painted with drawn

lines stitched onto paper or made with string onto paper.

One of the most difficult tasks designers can set themselves is to capture the essence of a drawing, illustration or photograph (the resource material) in one simple continuous line, without the distractions of decoration. You are trying to deliver maximum information or feeling with minimum means.

When you think about your resource material in terms of line you are thinking about the essential elements, or structure, of your subject. The expressive or informative qualities of your illustration will rely on the combined effect of line, media, colour and surface.

brush and gouache

4B pencil

Solid form

Instead of looking at your resource material in terms of line only, look at it in terms of its *form*. What is form?

Form is a flat surface, an uninterrupted area, defined by edges. The edges can be rough or smooth. Surfaces can be flat or change direction, and solid forms can have perspective. The space between the shapes (the negative space) can be as important as the forms themselves.

How can designers use form?

Looking at your resource material in terms of solid form is one of the basic ideas of design and illustration. Like exploring your idea in line only, it is another way of simplifying material that could become complex. If you limit yourself to one way of looking at your material, the result is often clear, precise and uncluttered. To represent form, you are looking for planes and shapes that suggest recognisable forms, without the detail.

brush and gouache

brush and process white

Think, perhaps of silhouette or volume, when trying to decide the information you need in order to express or inform.

If you are working in solid forms, the use of colour is of utmost importance. The solid form or surface is an uninterrupted area and, as such, can be a great vehicle for expression using colour: refer to colour schemes you have collected as part of your resource material and Chapter 3, which deals with designers' use of colour. Think about what colours you will place next to each other, what colour you might use as a highlight only and what colour background you might work on. Colour used creatively on a flat surface can trick the eye.

Some media are more appropriate to use when depicting solid form, just as some are more suitable for producing flat colour. Cut or torn paper is in many ways ideal as the cutting ensures you keep your shapes simple; you could try using papers with a variety of surfaces, such as shiny, matt or textured. Markers are a quick way of blocking in solid colour. Painting flat colour requires patience and skill but has the advantage of enabling you to mix and match your own colours.

Illustrations that use solid colour are easily translated into printed textile designs or fabrics. Most print techniques, particularly in industry, give a finish that is flat colour.

When you are working with solid form, you are thinking about the volume and shape of your subject, in terms of uninterrupted surfaces. The expressive quality of your illustration, or the amount of information conveyed, is dependent on the combined effect of media, colour and surface.

Cut or torn paper

Paper can be used to achieve effects that are difficult to produce using other media. For example, a torn paper edge is very difficult to paint or draw. Paper can be very quick to work with: why paint up a huge flat area of colour, when you can cut it out of a piece of coloured paper? Paper can also have a very strong expressive impact and can be used to exaggerate or simplify elements of your illustration.

The range of papers at designers' disposal is enormous; specific papers have qualities that are useful for design illustration purposes. Rough handmade papers are more suitable for torn effects, while smooth cold pressed papers lend themselves to cut work. The tool that cuts the paper can play a role in defining the visual effect of the illustration: pinking shears will give a serrated edge, a scalpel will give a sharp definite edge. A torn edge is likely to be less accurate than a cut one and can therefore produce quite unpredictable results. Tearing paper can be a free sweeping gesture, which rips out a shape, or it can mean carefully picking and teasing an outline to a form. Perhaps a combination of cut and torn edges is required to create a dramatic variation on your original theme. The use of opaque or transparent paper adds another dimension to the process. Tissue paper can be folded or crushed to achieve tonal effects; brown wrapping paper is hard, shiny and great for tearing. You could try cutting or tearing the shapes and placing them on a background of the same colour, such as white on white, matt black on shiny black. As with all the illustration techniques, your use of colour will play a vital role in the visual impression you create. The paper itself need not be plain. Newspaper can be a very expressive medium with which to work, as the size and style of type can be used to advantage in your design illustration. You can paint or decorate or texture the surface of any paper before you use it. It is a good idea to have a collection of scraps of paper, even old design work, which you considered to be unsuccessful, to use for this sort of work.

The choice of paper, plain or decorated, torn or cut, combined with the way in which you use colour, can enable you to look at your resource material in a fresh way. Working with paper is an indirect form of mark making that allows designers more freedom than when using the more traditional pens, paints and pencils.

torn white paper glued onto black paper

cut white card glued onto black paper

Verity Prideaux

3rd year student, RMIT
Top: *Paper croquis design shows uses of monoprinting. Coloured ink is used to show how effective a design can look without traditional black ink. Monoprinting requires drawing skill and planning;* **right:** *croquis design shows effective use of lino block, bleach and ink on Canson paper. Bleach is an effective medium for creating tonal effects on paper; its application can be controlled to vary colouration.*

Anna Berreen

2nd year student, RMIT
Design created by collaging fabric to paper and then painting over with acrylic. Croquis designs can be made by using fabrics, papers and unusual surface materials in conjunction with drawing and painting techniques to create visual and tactile effects.

Patrick Snelling

Designer and lecturer
Series of four paper ideas shows the use of photocopy techniques on handpainted papers. Clockwise from top left: wash-off technique with over-painting; overlay using iron-on stiffening; collaging and bleaching paper onto paper; bleaching of the paper after photocopying then painting with ink.

Textural effects

Think about texture in relation to your resource material. What is texture? How can designers use it in illustration techniques?

Texture is the nature of the surface of something and can be visual or tactile or both. Designers create the illusion of a surface via reproduction of the visual effect of that surface, for example, in a fashion illustration, where the fabric of a suit is woven, the illustrator should show it as such by reproducing the texture of that weave. As well as having an informative function in design illustration, the use of texture provides an important decorative element.

There are an infinite number of ways of achieving textural effects with various media and materials and combinations thereof. Think about what you want to achieve. Is your intention to inform or to decorate? Look at the surface on which you are working, the media you are using and the tools used to apply those media. To create textural effects, surface, media and tools are inextricably linked. For example, crayon or pastel on textured paper gives one type of surface effect, while sponging ink onto brown wrapping paper gives another. Wood grain effects can be achieved by blending colours on watercolour paper; corroded metallic surfaces can be simulated by splattering, blowing or airbrushing paints onto cold pressed papers.

Achieving the desired surface effect is dependent upon observation and analysis. Look at the surfaces around you and think about how you might reproduce them. What hybrid tools could you make that would allow you to interpret an observed texture? Can a surface you have seen be used to take a rubbing from? More details about rubbings or '**frottage**', as the technique is formally known, are given on page 77.

rubbing from lino block with wax, washed over with ink

rubbing from wallpaper, using wax, washed over with ink

Textural effects are used in combination with other illustration techniques. Think about textural effects you could achieve with line. Try texturing some areas of your illustration that use solid form: combinations of techniques can sometimes provide the best solution. As with all the techniques outlined, colour is vital in achieving any visual effect. If your purpose is to inform, say, you want to suggest a gnarled wooden surface, choose appropriate colours to enhance that aspect of your illustration. If decoration is your prime motive, choose colours from a scheme you have observed or collected in your resource material.

Working in the textiles field, whether it be in design, or art or craft-based practice, involves working with texture. Texture is either tactile in that it can be felt or has a raised surface, or simulated through a visual effect created by designers. Textural effects are used by designers to inform, or to enhance aspects of an illustration.

Lino or block printing

Sometimes it is useful to look at your images as part of a pattern that can be stamped onto paper. One very simple and quick way to do this is to cut a lino block of a motif, and using either **block printing** ink or gouache, try out a number of different pattern formations. Gouache can be painted onto the lino – play around with the consistency of the paint to make the stamped image look the way you want it to. While block printing ink is great when working with lino for paper printing, it is fiddly if the pieces of lino are very small; you will also have a much better range of colours to work with in gouache. Other things can be used to get block printed effects on paper—try bits of corrugated cardboard or found

the shape was cut into lino, painted with gouache and printed on paper

objects. Once you have the stamped image, it is very easy to try lots of different colours and patterns.

Resists

A **resist** is a substance applied to a surface to block the application of wet media. For example, in **batik**, wax, which resists the dye, is applied to the fabric.

For designers, resists increase the possibilities for the use of wet media.

Using resists often results in negative marks, as in the example of batik. The simple application of this for designers can be the use of a white candle to draw onto paper; the paper is then washed over with wet media, such as ink or paint. The candle marks will resist the wet media, forming a design, which is in negative. A white candle is not the only wax resist — any colour wax crayon can be used. Illustrations produced in this way have a particular quality of line and texture, which is difficult to produce in any other way. If you are

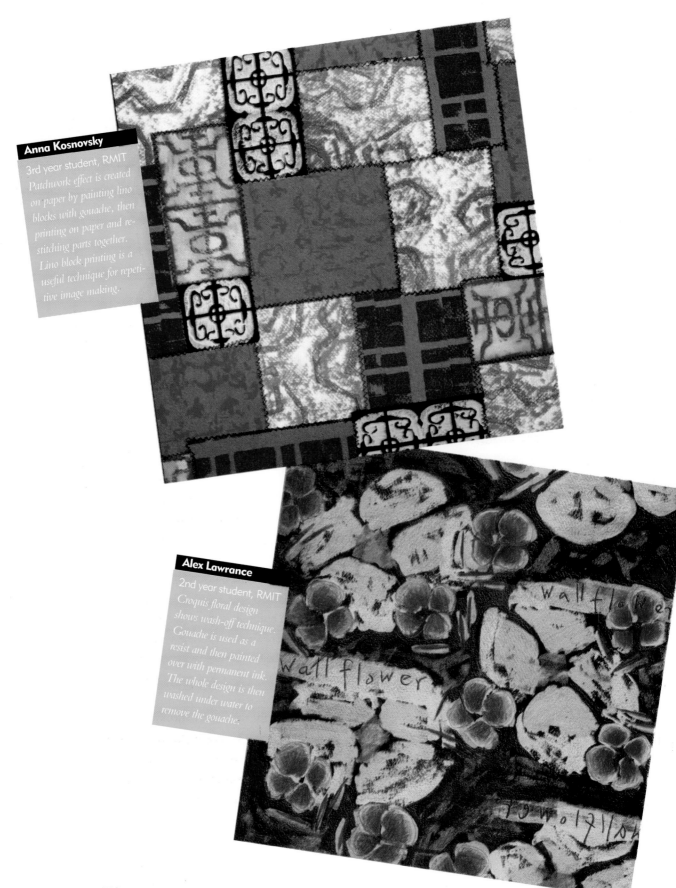

Anna Kosnovsky

3rd year student, RMIT
Patchwork effect is created on paper by painting lino blocks with gouache, then printing on paper and re-stitching parts together. Lino block printing is a useful technique for repetitive image making.

Alex Lawrance

2nd year student, RMIT
Croquis floral design shows wash-off technique. Gouache is used as a resist and then painted over with permanent ink. The whole design is then washed under water to remove the gouache.

looking at your resource material in terms of line, it might be useful to think of producing your lines in this way. Wax crayon is also a good medium for taking rubbings from textured surfaces, which can then be used to resist wet media. Hot liquid wax could be applied (batik style) to the paper, and paint or ink washed over. It may not be necessary to remove the wax, by ironing, depending on the effect you want to achieve. Remember that the wax resist can be applied as line or texture and the wash can be solid colour, textured, washed or applied with a hybrid tool.

Masking fluid or liquid rubber is a resist used by designers either to make marks or for technical reasons in the production of finished design work. Masking fluid is usually applied with a brush and therefore can be used to block out quite detailed lines, textures or patterns. Usually, the illustration is mapped out in pencil and the masking fluid applied to the areas that are to remain unpainted. Some masking fluids are tinted; others dry clear, but have a shiny surface so you can see what you are doing. The chosen wet media are applied over the masking fluid, which must be completely dry, and once the paint or ink is dry, the masking fluid is rubbed off with a soft vinyl eraser. Practice is important in using this resist; you might have to play around with the consistency of the wet media you use, as well as getting used to the sort of effects you can achieve. You will need to follow the instructions on the bottle, which, among other things, will tell you to wash your brushes immediately after use. If you want to mask a large, flat area, it may be more appropriate to use a cut mask or stencil. Professional textile designers use masking fluid when painting up finished design work, particularly for small repeated motifs on a background.

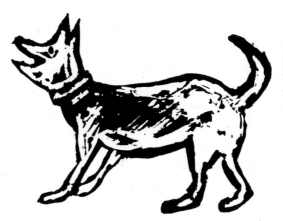

masking fluid used as a resist with black gouache to create rough textured lines

The small motifs will be pencilled in and covered with masking fluid so the background colour can be applied with a broad brush. When the masking fluid is rubbed off, the detail of the small motifs can be painted in. Without the use of masking fluid, the painting in of the background colour would be very tedious, as designers would have to work carefully around each motif.

Remember that wax crayon and masking fluid need not be applied to white paper only. Think about colour, as well as the technique.

Liquid resists are suitable for use with wet media only, as the resist is removed using an eraser, which would remove everything if you were working with dry media. Stencils and masks might be appropriate for some resist work using dry media.

When using resists, it is often necessary to plan and prepare your illustration, as you are sometimes working back to front: you might have to think first about where you don't want colour. An understanding of your materials and the techniques for which they are appropriate is fundamental to their creative use.

Wash-off technique

This technique requires patience and persistence. It is very useful where textural brushed effects are required; the results are often surprising, but can be controlled with practice. For best results you need:

- good quality textured paper
- **process white** (a high solids paint used to touch up photographic work)
- waterproof ink.

(White gouache can be substituted for process white, and water resistant ink for waterproof ink, but the results will not be as good.)

Lightly draw your design idea on paper. Using inks, put areas of colour where you want them. Dry thoroughly. Now use the process white to paint over the ink colours and any white areas that you want to retain. Dry thoroughly. Paint over the whole page with coloured ink—a darker colour will give the strongest results. Dry thoroughly. Wash off in a shallow tray or sink. The paper has to be immersed in water, which is why it has to be good quality. The process white, which is not waterproof, will '**wash off**' (hence the technique's name), leaving the inks.

wash-off technique creates soft textural lines

Masks and stencils

Masks and stencils can be used to create positive or negative shapes, they can be specialist or improvised products, they are usually some sort of paper or film and can be used with wet or dry media. A mask is usually placed over an area to protect it while colour is applied *around* it: a stencil is usually something that is cut or torn and colour applied *within* the area.

Designers can use masks and stencils as an alternative to defining images or shapes by the more conventional means of drawing and painting and filling in colour. It increases the mark-making potential of wet and dry media. Like the use of a liquid resist, a mask or stencil may be required from a technical point of view or for aesthetic reasons. Sometimes, it will not be obvious that you have used a mask — it may have been just a means to an end and made your job a lot easier. For example, when you have a large flat area to paint up, it might be quicker to cut the shape out of card or paper and then use a broad brush to apply the paint. The stencil will ensure that the edge is defined and your time and effort can be spent getting the colour flat and even, rather than keeping the edges straight. Other times, the use of a mask or stencil will be a deliberate illustrative device. You might need to repeat a shape over and over again. (This will be covered in greater detail in Chapter 6.) You may want the effect of paint applied to paper using a roller through a torn paper stencil, which controls and defines a shape.

As with resist techniques, using masks or stencils often requires preparation. You need to think about the appropriate material with which to make them. How many times will you have to

use the stencil? If you want to use it over and over again, cut or tear it out of strong card or acetate (note that acetate will not tear). If it is to be used only a few times, cartridge paper will do the trick. Litho paper, with the non-absorbent side facing up, will last a reasonable distance; if the paper becomes too wet and the image bleeds, let the stencil dry between uses. Give some thought to the thickness of your stencil — you are more likely to get a messy edge if you use thick cardboard, as the paint collects at the edges and blots when you remove the stencil. Think about whether you can hold the stencil in place or whether it might be better to stick it down temporarily with tape (making sure the tape doesn't leave a mark on your artwork). Some adhesive labels are designed to be removable and can be very useful for holding stencils in place. Specialist masking films (for example **Frisk film**), which are adhesive and removable and facilitate the cutting of detailed shapes, are available (at a price). If your design surface is film or acetate, Con-Tact can be a reasonable substitute for masking films. A sharp blade and safe surface on which to work are essential.

The intricacy of images that masks and stencils can produce is limited, but clever designers learn to use techniques, whatever the limitations. Wet or dry media can be used: paint, ink, pencil, pastel, chalks. Think about the ways you can apply wet media within a stencilled or masked area: by stippling, sponging, rolling, splattering the colour. Found objects can also be used to mask areas in design work. Some of the more obvious ones are leaf shapes or wire netting.

Using a stencil or mask to translate resource material into illustration requires careful observa-

lino block printed over a cut paper stencil in the shape of the dog

the negative of the stencil is stuck to paper, and a toothbrush and ink are used to spray within that shape

tion and planning, as it is often necessary to reduce or simplify the imagery. This can be useful to designers aiming for a clean, crisp, uncluttered approach, and can be another way of rationalising complex imagery.

Monoprint

Monoprint refers to any printing process that results in one print. Compare this to silk screen printing, which is used to produce multiples of the same image. Monoprint is an indirect means of mark making that produces a unique result. It is usually a one-colour process, but can be combined with other techniques using wet or dry media to add colour. It can produce positive or negative imagery.

Designers might use monoprint techniques where variation on line or texture is required or as a way of looking at resource material in a fresh, simple way.

Monoprint techniques are very easy and quick. The skill is in the application of the process. Ink

is applied to a non-absorbent surface, which is usually glass or perspex, with a hard roller. Take care not to have the layer of ink too thick, as the print will bleed, blot or smudge when it is taken off. Draw into the layer of ink with any tool that will remove it from the glass: pencils, the end of a paintbrush, sticks. Turn the sheet of glass or perspex over onto a piece of paper, which is on a firm, flat surface, rubbing the back evenly to ensure the print is evenly transferred. Carefully peel off the paper. The result will be a negative mirror image of your original marks.

Alternatively, monoprint can create a positive print. Roll the ink onto the glass as before. Place a sheet of paper over the ink and draw onto the back of it with a tool such as a soft lead pencil. Don't use anything too sharp as it will rip the paper. The paper will pick up the ink where you draw. Carefully peel off the paper. The result will be a positive mirror image of what you drew and incidental textured marks will occur where the paper was resting against the ink. Monoprint gives a particular quality of line — think about using the technique when you are looking at your resource material in terms of line only, when you are investigating the potential of tex-

tural effects and when you want to reduce complexity.

Use a water-based block printing ink — you need the thickness of block printing ink to be able to roll it evenly onto glass. The use of oil-based products should be avoided for health and safety reasons. You may, however, find that you achieve the result you want by rolling acrylic paint onto glass and drawing into it — there are no hard and fast rules about what you can and cannot do.

Found objects or masks and stencils can be used in monoprint — you could adhere cut shapes onto the glass before rolling on the ink. The shapes are removed before transferring the print to paper. Used in combination with drawn and scratched marks, these can greatly increase the range of possibilities of monoprint. You could ink up items such as leaves or fabrics and transfer them to paper. The paper could be textured or decorated or drawn on before you print it. You could roll several colours onto the glass at once.

The results of monoprint are varied by the tools used to make the marks, the paper to which the print is applied, and the other mark-making devices with which it is combined. It is an indirect technique that provides designers with a

fresh approach to drawing. The results are somewhat unpredictable and, therefore, it can be an exciting way to work as it produces surprising solutions to design problems. For designers, the skill is also in recognising the potential of some 'accidental' marks in the evaluation process.

Frottage

Frottage is the formal name given to the technique of taking a rubbing from a surface. Any surface will do, as long as it has a texture or relief designers can utilise. When working with textural effects or collage/mixed-media work, a good understanding of the possibilities of frottage is essential for designers.

There are no rules with frottage, however make sure the surface you are rubbing onto is not too thick (it will not pick up detail) or too flimsy (it will tear with the pressure of rubbing). The media you use to take the rubbing should be soft, like a 6B or EE pencil, a wax crayon, or soft conté. A hard medium will be more likely to highlight its own marks, rather than capture the quality of the rubbed surface. Experience and experimentation are needed to gauge the required balance of medium and surface to give the result you want; the pressure you need to use will depend on all the variables. You may have to use the side, rather than the point, of a pencil or a wax crayon may need to be sharpened to pick up more detail.

Wax crayon and pastels can be used to take rubbings. These form a resist for wet media, which are washed over the paper. Sometimes it might be appropriate to manufacture your own surface, which will then be used for frottage. A piece of thick card can be scored to resemble brick work or cut a pattern into a piece of lino, and take a rubbing from it.

rubbing from cut lino block, using a chinagraph pencil

rubbing from textured wallpaper, using EE pencil

dog shape is cut from photocopied gingham, and a line drawing on acetate is overlaid

Keep an open mind about how you might achieve the textural effect or illusion you want to create: designers should be inventive, flexible and innovative.

Photocopies and overlays

A photocopier is of great use to designers, as a quick way of reproducing images or varying their size. It is of particular use to textile designers, who are working with patterns and repeat designs. Clever designers can put a photocopy machine to much wider use.

Because photocopiers reproduce imagery, the result is only as good as what you decide to reproduce or how you decide to use it. In concept work, you might use existing magazine layouts, which you cut, copy and piece back together in a new context, to illustrate your idea. You might want to simplify a coloured line drawing by reducing it to one colour; you could change the scale or blow up one section of a drawing to substantially alter its visual impact. A drawing can be photocopied, worked on, and copied again. Liquid paper and white paint are good for this. An image can be moved during the copying process; this can soften it or, if the movement is extreme, give a blurred image. Objects or fabrics can be photocopied to become part of an illus-

tration, which is then worked over with wet or dry media. The paper used in a photocopier might be able to be varied, depending on the type of photocopier and who is in charge of it. Tracing paper or acetate sheets are useful if overlays are needed, particularly where typography is required. Collage and mixed-media work utilise the photocopier's full range of design possibilities.

When using a photocopy machine, be aware that paper is a limited resource. Make sure you need all the copies you are making and that the ones you don't use go into your own collection of resource material for further projects or into a box destined for the recycling depot.

Overlays are exactly what they sound like: a transparent sheet that is laid over the top of something else. This can be done for aesthetic or technical reasons. Because the overlay is clear, it can be laid over a variety of backgrounds; this is particularly useful if you are using type or can't decide on the right colours for a design. The line work could be copied onto acetate and held over background colours, which have been quickly painted up, so a choice can be made. The size and style of type can be varied, without having to go to the expense of buying different typefaces in expensive Letraset. And with the accessibility of computers and good quality typewriters, you can produce

the type you want, print it out, photocopy it onto acetate, and lay it over your design, producing variations until you get what you, or the client, want. It is also possible to work in gouache straight onto the back of acetate or film — the colour can be wiped off if you don't like the result.

Overlays are produced in the design industry by using a **reprographic camera**, which will copy your design work onto film. It works in black and white only, but can also produce halftones — it converts tonal areas into groups of dots, which, depending on their spacing, give the illusion of tone. Look closely at newspaper photographs to see how they have been converted to halftones. This process is very useful when making silk screen positives (see Chapter 10). Of course, this method of production is expensive and requires sophisticated equipment, so the more economical alternative is to use photocopied acetate sheets. These are not as good quality and can't convert artwork into halftones, but are affordable, accessible and can save you a lot of time.

Collage and mixed media

Working with **collage** (and découpage, montage and décollage) and mixed media offers a flexibility of approach that allows for the inventive use of materials, media and techniques. Cutting, sticking, stitching or scratching are as relevant to designers as painting, drawing, cross-hatching or airbrushing.

It is useful to look at each technique, highlighting its application for designers.

Collage means, literally, 'to stick': what to stick on, what to stick with and what to stick to.

Good collage requires careful planning in the selection of materials and media, composition and the use of colour. However inventive the use of materials, the success of the collage still has to be evaluated in terms of the brief. The materials that are suitable are endless: papers, fabrics, magazine cut-outs, string, found objects (or *objet trouvé*, or object trivia), and all of these can be combined with any wet or dry media. Look at the work of the Cubists in the 1920s for the origins of collage.

Découpage is the process of decorating a surface with paper cut-outs. This issues the challenge to designers of investigating the possibilities of paper: coloured, textured, matt, shiny, magazine cut-outs, paper you decorated.

Décollage is 'unsticking'. It is used to distress or destroy an illustration. A series of papers might be layered over each other and then peeled and torn away to reveal the layer/s underneath.

Montage, or more commonly photomontage, is the process of putting elements from other pictures or photographs into a new context, to make new pictures, photographs or illustrations out of them. This technique tends to have a pictorial element.

Mixed media are similar to collage, but allow for even greater flexibility of media and materials, as the means of assemblage is left wide open. You are not confined to sticking. This means you could stitch, bind or place your found objects in the context you wish them to be seen. The work does not have to be two dimensional. To explore your idea, you might find it necessary to build a three dimensional 'scene'. If you have the facilities, you might photograph this, reducing it to a two dimensional (and more portable)

format or you may draw from what you have set up. Remember, though, attention still must be paid to colour and composition; it is often tempting to get carried away with innovation. Pop artists in the 1960s exploited the possibilities of mixed media as an expressive medium. When working with any of these techniques you will require a wide range of materials. Look for services such as Melbourne's Reverse Garbage where industrial waste and scrap materials are taken to a depot for subscribers to go through. This is a very cheap way of getting access to a range of materials. With these techniques, the old saying is certainly true: one person's junk is another person's treasure. Keep your unsuccessful design work: it could be recycled into mixed media or collage work.

These techniques encourage innovation and improvisation, enhancing the array of design options at the designers' disposal.

collage: gingham, newsprint, ink and stitch

Evaluating your illustrations

As you will have found from working through the illustration techniques, there are many ways of solving design problems. Although the techniques themselves might be used by many designers, the resource material that provided the inspiration for the design work and the way in which you manipulate the materials and techniques in the interpretation of your ideas will be the key to the originality of the result. The exploration process is, however, far from over, even though you may have thoroughly worked through all the illustration techniques and come up with new and innovative solutions of your own. You have explored the possibilities of your resource material. Now, you must evaluate your results.

If you are working to a brief given to you by a client, they may want to see your work at this stage, to ascertain whether or not you are on the right track with any of your illustrations. The client's evaluation of the results is as valid as your own. If you are working to your own brief, it is still necessary to evaluate what you have produced, because the design process relies on stages where rational decisions are made, before proceeding to the next step, regardless of who is calling the shots. In evaluating your work, choices are valuable. Of course, with experience, you can eliminate some techniques or approaches as inappropriate, but while you are learning it is a good idea to try as many solutions as possible.

Why might one solution be better than another? Ask yourself if you are happy with any of your results. Read the design brief again and look critically at your work to see if it meets the

criteria established. If your project involves an end product, there will usually be restrictions on the production methods. These restrictions will relate to things like:

- colour (number of colours, colour range specified)
- production methods (machine printed, hand-printed, pigment printed, printed with dyes, printed in Australia, printed in Japan)
- potential market for the product (department store, designer boutique)
- fabric to be used (lightweight, heavyweight, synthetic, natural).

Being aware of these factors early can determine how you approach the illustration part of the design process. You may limit your design illustration exercises to certain colours, for example, select a palette of five colours and use only those colours. Or you may limit yourself to the use of no more than three colours in any illustration.

Look at the potential of your illustrations. Does one aspect of a particular piece lend itself to a design for fabric in repeat? It may not be your favourite illustration, but it may be the most appropriate for what you have in mind. If your project involves an end product, assess the potential of your design work in terms of that product. If you want to produce fabric for soft furnishings, is the scale suitable or should you alter it? When you are making something wearable, what will the print look like when it is cut up to make the garment?

After the exploration and evaluation of your work comes the refining process. By being aware of certain limitations that may be imposed on you, some of which have been indicated, you can begin the refining process early.

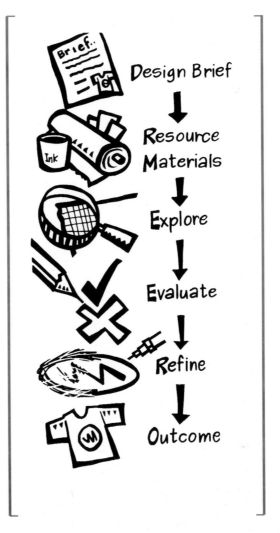

Design Brief
↓
Resource Materials
↓
Explore
↓
Evaluate
↓
Refine
↓
Outcome

By refining your illustrations, you may be tidying up your work, redoing it (having mastered the technique), altering the colours, changing the scale, or taking it a step further and using computers to convert it to a pattern, ready to print or knit. Aspects of the design may have to be refined in order to reproduce it to take it through to production, for example, altering certain marks to make the silk screen positive when printing fabric. The refining process will be dealt with in Chapters 5 to 8.

Computer-aided textile design

Tanya Juchima

3rd year student, RMIT
Paint programs allow you to put scanned images into simple repeat formats.

Sandy Stokes

3rd year student, RMIT
*Border design for project '
East meets West'.
Computer was used to
generate a line image
that was photocopied onto
paper and bleached back.
Computer-generated
images can look very
obvious, but if images are
used in conjunction with
other illus-tration tech-
niques and media, the
results can be unique.*

*I*ncreasingly, the use of technology to aid designers is viewed as a saving of time and resources, leading to an increase in productivity. In the textile industry, computer technology has introduced new methods of directly translating concept and finished designs into manufacturing processes.

The textile industry has played an important historical role in the development of computer-aided textile design (**CATD**) and computer-aided manufacturing (**CAM**) from as long ago as the early 19th century. The Jacquard loom was the first machine to use a punchcard system to lift the heddles on the weaving machine, enabling complex patterns to be woven into a cloth structure. Textile manufacturing processes are ripe for conversion to CAM, because they rely on repetition, whether the cloth is woven, knitted or printed. Most textile design, whether for **constructed textiles** (knit or weave) or for print, also has an element of repetition, and therefore has the capacity to use CATD to a large extent.

Why use computers?

To designers, the most obvious advantage of using CATD systems is one of labour saving. Textile designers often need to execute a new design to a client's precise specifications, with a complex repeat system in more than one colour-way, quickly. This traditionally time-consuming process just has to be done and might involve designers working very long hours, or all night, to meet the deadline. Contemporary computer-

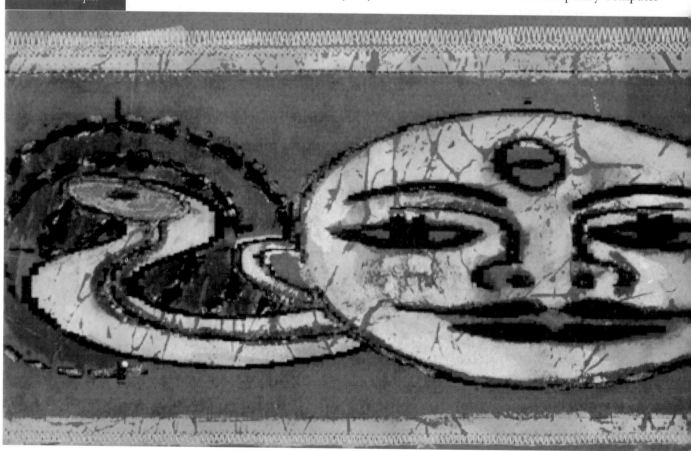

aided textile design systems have enabled these traditional tasks to be accomplished faster, with more accuracy and with a flexibility that enables designers to provide the client with numerous versions of the design, in different repeat formats and colourways. Where previously the whole design process took several weeks, now it might be reduced to several days. Something that needs to be changed in a hurry can be done in an hour, instead of a day.

Sometimes, it will be advantageous to have designers work on a CATD system, which is linked to a manufacturing process. This is the case at Tennyson Graphics, in Dingley, Victoria. A design can be scanned, adjusted, finalised on screen, and sent straight to another process where it will be colour separated and laser etched onto **rotary screens**. Previously, several different people would be involved in this production line, which would have taken several days just to get from finished design to the screen.

The concept of designers at a studio desk with paintbrushes, inks and paper is still valid, but add to that picture an electronic monitor and controls.

The more sophisticated CATD systems allow designers to experiment with a variety of materials and media, but on a screen instead of paper. Electronic colour and data can be fed into a computer by laser scanner and video camera. This one (very expensive) piece of equipment can practically reproduce all the media and material effects traditional designers can. And it can remember effects and techniques by storing them in the memory of the computer. An example of this is designers using a variety of media and illustration techniques to draw an original image that is scanned using a laser scanner. The information is fed into the computer using one of the many paint programs, or graphics packages available. The image can be saved, altered on screen or made to fit particular dimensions. Colours can be changed or enhanced and other visual effects can be applied to the drawing. Sections of the drawing can be cut out and worked on separately from the original drawing. The section that is cut out can be put into a variety of repeat formats. The resulting design, with the appropriate software, can be colour separated for printing purposes or digitised onto a disk and sent to a knitting or weaving machine for direct production of cloth.

The computer has allowed designers to have a flexible working environment. In some cases textile designers buy a personal computer and laser

scanner and work from home or in small studios. Designers can be linked with each other via a software program and compatible equipment, but need not work in the same location. While CATD systems often link into manufacturing processes, the computer has also allowed independence from the manufacturer.

At international textile trade fairs in Europe and the USA, some textile designs are shown to clients on computer monitors. Alternative colourways can be accessed immediately for client approval and the textile design can even be shown *in situ*, as a fashion illustration or in an interior setting. The client can have the option of purchasing the design in disk format or high quality print reproduction. The speed and flexibility of the computer are having tremendous effect on the printed, woven and knitted textile industries worldwide.

Why are traditional methods still being used?

Few companies involved in design and manufacture of printed, woven or knitted textiles would dispute the value of computer-aided design and manufacture. However, many would baulk at the price they would have to pay for the purchase and installation of equipment. Not only is there the cost of the hardware, but most of the software packages for specific textile design use are specialised and therefore expensive. High quality printouts are essential and good printers are expensive; equipment for scanning original images is another cost. On top of that, there is the added expenditure of training staff who are used to working in more traditional ways. Clients also have to be educated to read printouts as finished designs. Much of the textile industry relies on freelance designers supplementing the work of the in-house designers at busy times, and freelance designers may not have access to CATD facilities, or might use a different system. The long-term gains of installing CATD equipment are great, but so are the immediate establishment costs.

This is why conventional techniques are still being used, but the trend is for a hybrid form of design where traditional drawing skills are used in conjunction with computers and other related technology.

The main change in the textile industry's production process is that one machine and one designer can design and manufacture textiles — they are no longer necessarily separate processes.

Using computers as media and tool: hybrid design

Designers will probably never discard conventional media and illustration techniques as their primary methods of mark making. Nor should they, despite the prevalence of computer-aided design within many sectors of industry. Nothing beats the creative immediacy of brush, colour and paper. So, given the advantages (speed, accuracy, links with manufacturing) and disadvantages (cost of establishment) of CATD systems in industry, the current trend seems to be for a hybrid form of design, where traditional drawing skills are used in conjunction with computers and technology.

Is the computer media or tool? Some commentators have said it is both and others have argued that it is neither. It is probably somewhere in between. Engineers view the

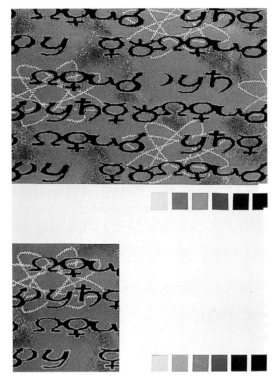

Sandy Stokes

3rd year student, RMIT
Far left: *Hand-drawn images can be altered on screen or made to fit particular dimensions or other visual effects can be applied to the drawing. Sections of the drawing can be cut out and worked on separately from the original drawing. Machine stitching has also been applied to the paper surface.*

computer as a production tool that can facilitate the manufacture of textile fabrics. As pure technology, it might be seen as outside the province of studio designers, but increasingly the computer is described as a multi-media device enabling designers to input a far wider and more creative series of alternatives for the design of two dimensional pattern and constructed cloth. It can facilitate the simultaneous development of design ideas and product.

Textile designers will use computers to do the obvious: to offer relief from much of the tedious work they have had to do by hand (such as altering the scale, or the repeat structure, recolouring, producing colourways). It is much more effective time-wise to alter artwork that has been scanned in and then to print it out with the changes, than it is to recolour or redraw by hand. **Scanning** the image, saving it, and then playing around with it is a sensible way to explore the potential of the idea. Although the changes are made on screen, most designers would not ini-

Jacqui Lewis

3rd year student, RMIT
Left and top right: *illustrations for design development project show combined use of drawing, paper collage and bleaching of printouts. Computer-aided design is used for creating variations of original drawings and changing them to fit into other formats or styles.*

tially draw directly on screen — they would work on their image, which had been scanned in.

The computer as media and design tool requires a different form of drawing application from that to which designers have traditionally been accustomed. The concept of drawing on screen is not tactile or intuitive like the feel of

Jacqui Lewis

3rd year student, RMIT
*Combined use of drawing,
paper collage and bleaching of
printouts.*

brush or pencil on paper. The drawing is executed with a mouse or pen and designers select appropriate brushes or tools with specific colours to achieve visual effects on screen. However, once designers have seen the potential of the computer, acquisition of computer skills doesn't seem so hard.

Computer-aided textile design subjects have been introduced in textile design courses in all industrialised countries. For textile design students graduating today, the need to have hands-on experience of CATD is a necessary skill for prospective employment. The textile industry is increasingly technology driven. It has to be to survive market demands and competition. However, traditional mark-making skills are still required to facilitate the conversion of an original design into printed cloth. The old computer saying still rings true: *garbage in, garbage out.*

As mentioned, computers and designers have to work together in the contemporary industrial climate. The input of design and visual data is best accomplished by textile designers who have an art and design background, and also a good understanding and experience of current computer software and technology. Today's textile designers are required to have skills that encompass these ideals. The traditional art, design and illustration techniques must be acquired through conventional as well as electronic means for designers to fully understand the language and concept of textile design application.

Getting started

You may not have access to computer equipment in a school, home or studio, but it is a good idea to make an effort to become familiar with using it. Short courses are available through TAFE colleges and colleges of advanced education, as well as councils for adult education. At most schools and colleges, basic entry systems are available. These systems are designed to run a variety of software programs for different applications. You may have word processing, statistical, maths or possibly 2D and 3D design programs. The most common systems will be Macintosh and PCs.

Specific textile design software programs are not designed for personal home computers. These programs require specific machines and a large memory for scanning and resolution purposes, and are, therefore, very expensive to install. However, a good 2D Paint Draw program will enable you to get started as a textile designer and will at least make you familiar with using a computer as a design tool. For PC users there is the Corel Draw software, which is a versatile and affordable package. The Macintosh-based programs are more expensive because the graphic

design industry uses specific 2D/3D software; however MacDraw and MacPaint are affordable packages, while Painter and Illustrator offer more budget options. Software packages are being constantly updated. What you use will largely depend on what you can afford or gain access to. Better equipment does not necessarily make you a better designer. Basic systems are good for acquiring keyboard and mouse/pen skills. Coordination between hand, eye and mouse/pen is essential for designers using electronic media.

One major limitation with computer-aided design is the hard copy or printout. There is, of course, a size restriction with most printers and problems with the quality of the printout. The image may look fantastic on screen but the hard copy can be very disappointing. The colours might look completely different and the image less defined than on the screen. It is possible to take your disk to a professional copy centre and have the image (file) printed out with laser or bubble jet printers. The results will be much better than any with the standard dot matrix printer used in offices and schools. It is also possible to take a transparency or photograph of an image on the monitor screen so you have a record of what you have done.

Another common problem with basic systems is the lack of memory, which can severely affect the operation of the software, laser scanning capabilities and any complex designing procedures. Software packages will indicate the basic minimum memory requirements to run the program on your computer. Regardless of these limitations, the basic systems will help you understand how the computer works and how you interact with it.

Using the computer: techniques and methods

The computer is useful at every stage of the design process. Just how useful it is will depend to some extent on your level of skill and the sophistication of the equipment to which you have access. The computer should be thought of as another design tool. Each system and software package that you use will have different methods of operation you will need to become familiar with. Outlined are general ways of using the computer as part of your design repertoire. You need to find out the instructions specific to the system you are using, enabling you to use the computer in ways useful to textile design.

The computer as a resource tool

Look again at the design brief in Chapter 2 (page 23). If you have followed this brief then you will have resource materials to start with and perhaps a story board of visual ideas based on an ethnic culture. At the resource stage, data can be put into the computer via the laser scanner or video camera. If you do not have access to this expensive equipment then the mouse or pen can be used to draw directly onto the screen. Like a resource book, the computer can store images and information for you. The information is stored on a disk, instead of within the pages of a book. If you are using the computer, you have the advantage of being able to very quickly duplicate, rework, add to or change the format of visual data.

Drawing directly onto the screen

Select a strong motif from the resource material. Draw this motif onto the computer screen with

the mouse, using the 2D paintbox software tools and colour palette. Start by drawing a black line on a white background. Draw it carefully, including as much detail as possible. Put colour into the motif. You can work within any colour restrictions from the beginning, or be aware that you may have to reduce the number of colours later. The software can be used to reduce the number of colours. Once you are happy with the way the motif looks, grab it as a 'brush', and save it. In doing this, you are making the image itself something that you can draw with. It will enable you to repeatedly stamp down the motif across the screen or elongate, rotate or shrink it. Use a grid for accurate placement of the motifs.

Scanning

If you have access to laser or video scanning, you can scan in the resource material, but be selective.

Before you scan, work out what it is that you wish to use. It might be better to trace the motif in black line and scan this into the computer, rather than isolating it later on the screen, but if the motif you want to use is textured, or if it is a texture you wish to scan, then there is no point drawing it first. Again, once you are satisfied the motif looks the way you want, save it as a brush, so you can repeat it and change it.

Scanning is very useful for design briefs. You can scan in a line drawing of the chair for which you are designing fabric and when you have some finished designs, you can superimpose them on that drawing, to help decide which design works best on your chair. This way, you don't have to actually paint up the finished designs. It is also possible to electronically cut and paste the chair into an environment. This is possible by scanning in an interior room setting. If you don't

Jacqui Lewis

3rd year student, RMIT
Computer printouts can be used in croquis design. Illustration shows various computer-generated images as collage on a background design.

have scanning equipment the same thing can be done, with more difficulty, by drawing the chair onto the screen with the mouse. This demands better drawing skills, as you have to be able to accurately represent the three dimensional object in line on the screen.

Repeating the motif: making patterns

It is very easy to play around with making patterns out of motifs on a computer, without knowing very much at all about formal repeat systems for textile designs (see Chapter 6). The motif can be reversed, rotated or stretched to fit different configurations. Most 2D paint programs will enable you to put the motif into simple repeat formats, such as full drop and half drop, while software specifically for textile design will make other formats quick and easy as well: scale, step, ogee, diamond repeat or spot repeats. Without a textile design package, you will have to use a grid for accurate placement of the motifs. The size of the motif can be altered quickly, as well as the direction and placement. The only limiting factor at this stage is the screen monitor size.

Electronic colour

Colours and textures can be added to the design by using the paintbox software tools and colour palette controls. 2D paintbox software can achieve various effects depending on the quality of the software and the system you are using. Select a range of colours that relates to the ethnic theme and try out combinations on your motifs/patterns. It is also possible to use the 2D paintbox software to create surface textures and tonal effects. One of the hardest things to get used to when using a

computer is the difference between the screen colours and those on the printout: these can vary considerably according to the quality and sophistication of the equipment used. You need to become familiar with the discrepancies produced by your particular equipment.

Using the printout

Once you have created a number of repeat formats using your motif and have tried various colour combinations and surface effects, a hard copy or printout is required. You need it to communicate your ideas, or to incorporate them into a story board or to determine what works best with the rest of your ideas.

If an A4 printout restricts your presentation or you need to work bigger or see a larger area of the repeat design you have worked out on the screen, photocopy the printout and paste copies together to form a larger design area. Enlarge the images with a photocopier. Using photocopies is more economical than using multiples of computer printouts.

Tanya Juchima

3rd year student, RMIT
Paint programs allow you to put scanned images into simple repeat formats: four variations of how a motif is used in terms of scale, colour and textured effects.

When you have a number of motif ideas and have designed various patterns with appropriate colourways, it is possible to work further on these after the printout stage. Using coloured pencil, paint and even monoprint on the printout is a good way of developing illustration styles and methods of surface decoration. This reworked design is a hybrid of CATD and personal illustration style. This new design can be rescanned and then shown on a 3D illustration. For example, a chair with appropriate pattern can be printed out and reworked in pencil for presentation. It can be collaged into an interior setting; patterns can be superimposed on garments on figures. The possibilities for using printouts for finished design are restricted only by your imagination.

As with most technical processes, it will take quite a while to become proficient in drawing on screen, scanning, creating patterns, selecting and applying colours and textures, superimposing patterns onto 3D images and getting satisfactory printouts. However, adding computer skills to your repertoire of design tools and resources is a necessity for a versatile designer.

Exercises using the computer as a design tool

Exercises 6 and 7 are simple and do not require very sophisticated equipment to do at least some of the suggested tasks. The exercises indicate processes specific to textile design and which can be made a lot easier with the use of a computer.

The point is to think and design for a given task, while developing your computer skills. If you can think of easier, faster ways of accomplishing a task, then try it, because a mistake can easily be corrected with the 'undo' button on a computer.

Sandy Stokes
3rd year student, RMIT
Adding computer skills to your repertoire of design tools and resources is a necessity for a versatile designer.

Exercise 6
Using a computer to design a tile

The brief

You are to design a tile that, when used in multiple, will join on all four sides to create a pattern.

- The design must extend to the edge of the tile for the pattern to be formed.
- The dimension of the tile is not critical but all sides must be equal in length.
- The tile is to be white with a black or coloured design on the surface — one colour only.
- The design on the tile can be drawn directly onto the screen with a mouse, or a drawing can be scanned in and used (if you have access to a scanner).

Method

Before you do anything, it is worth attempting some market research into tile design. Have a look at your nearest hardware store or visit a specialist tile store for the latest in 'designer' tiles. Keep the brief in mind: the design must connect, or repeat, on all four sides.

Before trying to fit a design into the area of the tile, it is best to play around with some ideas, and it is probably easier to do this quickly on paper, particularly if you have scanning facilities. Once you are onto the computer, having drawn on screen or scanned an image, you can create brushes or 'grab areas' from the original drawing, or you can use the tools from the software program to create special effects. At this stage, look carefully at scale to ensure that reduction or enlargement of the design does not interfere with its clarity on screen. It is important to make the design square and to be aware that some programs have features to correct screen pixel size. Try to design one unit or tile and get it looking right. Create several more designs and save them individually. You can then load and work on each design whenever you like.

Once you have a design you are pleased with, you need to check that it links on all four sides and what sort of pattern is created when the tiles are put together. Use the rotation and brush effect tools from the program to show on screen how the

Patrick Snelling

Designer and lecturer
Using a computer to design a repeating tile motif. The brief asks you to design a tile that repeats accurately on all four sides and when joined creates a multiple pattern. The computer can speed up the process of aligning, repetition, scaling and layout.

Patrick Snelling

Designer and lecturer
*Pigment print on cotton,
creating variations of the
pattern from the same motif
using CATD.*

design will work in repeating unit formats. If the software program has a grid feature, use it to align your design work. The computer is particularly useful at this stage, because it can very quickly do things electronically. If this was being done manually, the design would be traced accurately four times and the connecting edges checked, or the single tile would be photocopied, cut and checked. Without printing anything, you can see on screen if it works and how it will look.

Once you have it right, if you find the size of the monitor too small to show an adequate representation of your repeating tile design, then print out one tile unit on your printer. If it is too small, enlarge it on the photocopier and then make sev-

eral copies of this and join them together. It is cheaper to photocopy than to print out hard copies. Be critical of your design decisions. Place the design on a floor or wall and view it from a distance. Ask yourself: is the design recognisable? Does it create a good pattern? Ask friends to view the work and offer constructive criticism. Can the design be improved? Does it repeat fluidly or do the joins look awkward and obvious?

When you have selected a successful tile design, photocopy and paste together enough units to show how the design repeats. For presenting your tile design, you might think of how this sort of tile might be used: in a bathroom, kitchen, decorative tiled path, external wall.

Exercise 7
Designing children's wear

Patrick Snelling

Designer and lecturer
Creating a theme/motif and developing it through a series of design configurations: changing the scale of the image — small repeating motifs and large placement print; creating colourways by swapping the four colours in each design; working with various repeat formats: step repeat, half drop, stripe etc. The work shown here has been developed using only one line drawing and four colours.

The brief

For this project you are going to produce a half drop repeating design using a maximum of four printing colours. (For an explanation of half drop designs, see pages 133–4.) You have a client who requires new children's wear designs for the age range 3 to 6 years. The children's wear design must incorporate animal motifs in the all-over pattern and there is to be a coordinating placement print for a T-shirt. The client is a large interstate company with overseas connections equivalent in style and quality to Esprit children's wear.

Before you start on the designs, consider the following:

- Who are you designing for?

- Are there production limitations?

- Will you need to conduct market research to become familiar with the relationship between the age of the children and the style and colouring of prints for their clothing?

- How will you devise an appropriate design strategy, since the theme has been given to you?

- Is the scale of the initial designs appropriate?

The design process should be no different in approach, whether you are working on paper or screen. The same things need to be considered and decided on. The computer is used to help you achieve the desired end result, in the most efficient and effective way.

Method

Before starting work on the computer, collect resource materials relevant to the theme and organise a colour palette to use throughout the design stages. Scan in or draw on screen the motifs and symbols you have created on paper. Be careful to limit your design to four colours only. Use

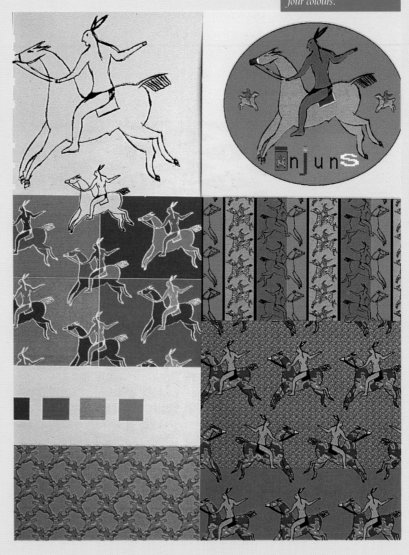

the software program tools to select a colour palette. Use the brush or grab tool controls to create repeating patterns. Turn on your screen grid to accurately plot the position of the half drop design. If the design on screen is too small, produce larger units of the half drop and print them out. You can join several printouts together to form a larger repeating hard copy. Always be selective about what you print out.

For the placement print idea, select the motif from the repeating design you wish to print out. You can include graphics or typography in this placement design to emphasise the company producing the range or the identity of the animal/s you have used. You might enlarge or enhance the motif to make it appropriate for a placement print.

If your colour printer is not accurately matched to your computer, you may have to trial a few colour chips, in order to adjust the screen colour before you print out. If you do not have access to a colour printer, you can take your disk to a copy centre or photograph the monitor screen yourself.

If you want to take the project a stage further you can scan in a black line drawing of a fashion model and then superimpose the design you have created onto the fashion figure. Be careful of scale when you try this exercise.

The speed at which ideas can be trialled visually is the biggest plus in using a computer as a design tool, and this facility should override frustration caused by lack of expertise or equipment or satisfactory hard copy.

Patrick Snelling
Designer and lecturer
Pigment print on cotton, creating variations of the pattern from the same motif using CATD.

Summary of computer design sequence

- Select motifs/textures from resource material.
- Draw motifs with mouse on screen, or scan via laser or video.
- Make the motif or texture into a 'brush' to create repeat patterns.
- Use colour and texture to enhance the image/ patterns.
- Experiment with scale of motifs.

- Draw or scan in the shape of the end product of the fabric, for example a chair.
- Superimpose the fabric designs onto the 3D form.
- Print out your finished design ideas for use in presentation.
 or
- Work on these ideas further with wet or dry media and mark making techniques.
- Present as finished design ideas or resource material.

Pattern

Natalie Ryan
2nd year student, RMIT

*I*t is in the making of patterns that textile design as a discipline departs from other areas of design. All designers have to work to briefs: dealing with concepts, resourcing images and information, thinking about colour and so on. The thing that sets textile designers apart is the use of repetitive pattern: fabric is continuous and because of that fabric designers have to think about not only what is in front of them, on a 30 cm square piece of paper, but what that pattern is going to look like when it is repeated over many metres. **Surface pattern design** is a growth employment area for textile designers. Other areas of design use patterning and **repeat** for decoration: tile design and wrapping paper are good examples outside the textile field. The difference is that wrapping paper and tiles have defined edges: the four sides of the tile are defined by the grout, which keeps it on the wall. The patterns on fabric, however, are continuous, and the 'join' where the pattern starts and finishes is usually not obvious — in fact, textile design is very much about disguising that join.

In this chapter how patterns can be developed from resource material and taken through to the finished design stage is shown. The process of putting designs into repeat requires patience and accuracy; almost at odds with the creative approach promoted in previous chapters. Although textile designers often work in croquis form (sketches that indicate repeat), they must understand the notion of repeat patterns and be familiar with the production process of printed textiles. In printed textiles there are often restrictions imposed by production processes that affect the design, such as the repeat size used by the factory printing the fabric. Designers who work freelance selling designs will work in croquis form, because the production restrictions are not known. The repeat can be altered later, or the number of colours reduced, when the buyer knows what the design will be used for. Often in a design studio, it will be the specific job of one person to put the croquis of other designers into repeat; this must be done before a design is taken through to production. However, there are many situations, in smaller studios or with freelance designers, where one person is required to do the lot.

Production and the mechanisation of fabric printing, weaving and knitting processes, demand that repetition exists in the textile industry. Textile designs are also known as 'repeat patterns'.

The use of pattern introduces a lot more possibilities for outcomes from resource material and developmental design work. The motifs or images can remain the same, but by changing their order, or format, and maybe the scale, the look of the design can completely change. From one idea you could get an infinite number of designs, if you are competent with creating patterns.

Pattern: where did it come from?

Some of the best resource books on formal pattern design stem from the 19th century when the investigation of pattern was required at a technical level to produce decorative imagery for machines to reproduce. With the industrial revolution machines were required to work non-stop, which meant that one-off images were neither appropriate nor economically viable.

Where did the patterns come from? Some of the earliest known forms of pattern

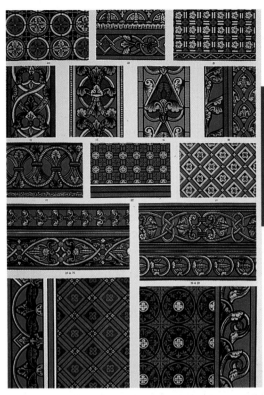

Islamic mosques of Arabia and Hindu temples of India provide numerous examples of patterning systems using wall and floor tiles. Intricate patterns are made up of thousands of tiles, each decorated to form sub-patterns.

have been discovered in caves in Europe, Australia and Asia. These early forms of decoration were achieved with ground pigments mixed with water, applied to the wall surface with improvised sticks or traced around human hands. Initially the drawings described events of cave dwelling society, detailing hunting scenes and myths. This drawing led to decoration and pattern where specific patterns and colours helped distinguish different tribes and cultures. Patterns were developed from the things the people saw around them and experienced every day: flora, animals, people and events. This is not unlike what happens with design today. Pattern became decorative to cover plain surfaces. The surface could be the wall, floor or body.

With the industrial revolution, designers looked to countries with a strong tradition of pattern. Islamic mosques of Turkey, Persia and Arabia and the Hindu temples of India provided numerous examples of patterning systems using

wall and floor tiles, where intricate patterns were made up of thousands of tiles, each decorated to form sub-patterns. These are known as tessellations, which is derived from the Greek *tesseres* (having four corners). The tile was one of the first repeating pattern systems devised by architects for the decoration of mosques. The Victorians studied these systems carefully, and wrote and illustrated numerous books based on their travels overseas. Throughout textile history the symbols and motifs identified by those early historians have been influential: the pine cone or paisley from India, the chintz and lattice from Asia, the tile and border designs from Persia.

The problem facing designers in the early days of the textile industry was much the same as today: how do you put a single image or motif into a complex repeating pattern that has to be broken at some point into sections (to print it) and must match up perfectly so the joins don't show? **Repeat systems** were developed to

formalise the mathematical process of measuring where motifs recur in relation to each other, over the fabric. These systems are the structure over which the motif or images are placed in an order that ensures they recur at regular intervals. The systems are not enough on their own — designers have to use the structures skilfully so the design flows, or appears random, as the case may be. The appropriate system has to be selected for particular motifs or to achieve certain effects. Sometimes a system will be chosen because it makes the design multi-directional; for example, the fabric will be economical to cut for clothing if pattern pieces can be placed upside down. The repeat systems used today are the same as those used more than 100 years ago; the only thing that has altered is the method of execution. Things like graph paper, tracing paper, photocopiers, not to mention computers, have sped up the process. One of the best and most comprehensive references is still *Pattern Design* by Lewis F Day (BT Batsford Ltd), first published in 1903; while the language is somewhat dated, the diagrams indicating the construction of textile designs make it an invaluable reference.

Looking for pattern

An awareness of pattern and the systems of repeat are prerequisites to understanding the role of the

Matthew Flinn

Designer and lecturer
A simple motif can make good use of positive and negative space.

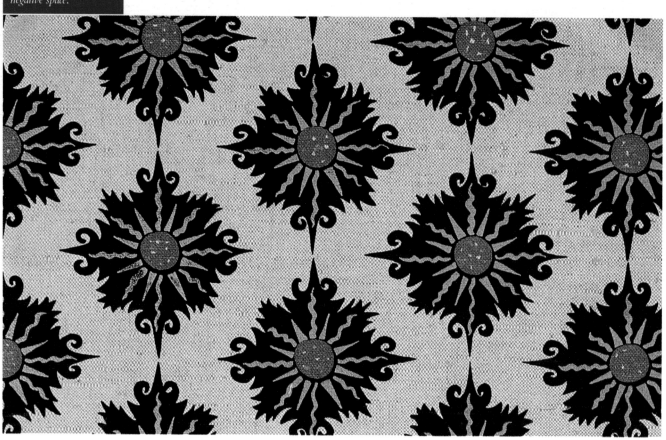

textile designer. Some people have a natural instinct for generating pattern and decoration, while others may require lots of experience and tuition to achieve the same effects. Learning to use patterns or repeat systems is quite easy if you grasp the basics, accurately measure your design work, and understand *why* it has to be done. As with all aspects of design (ideas, information, illustration and colour) it's a good idea to collect resources for pattern formation as well. Once you are at this stage of design development, you need to be thinking of everything.

A great reference for pattern formation is history. Islamic tiles or Persian rugs are inspiration for formats that can be adapted to lots of different motifs. Look at woven tribal fabrics to see how colour alone creates pattern within a structure.

Throughout the history of textile production, natural and synthetic themes have been used to create pattern on cloth. It is worthwhile to look through historical textile books, because even if the imagery is out of date, design format and layout have changed very little. Look in particular for *Textile Designs* by Susan Mellor and Joost Elffers (Thames & Hudson, 1991), which covers 200 years of patterns for fabrics and is a comprehensive reference for **design styles** and influences. Most repeat formats are versions of three or four standard repeat systems; the most common are full drop, half drop and diamond repeats, with

A designer should be always looking for something new to work with, and a good designer can create a pattern from any form of resource material.

mirror or turn variations. The history of production has dictated that these work best. Historical references can give you a lot of information about structures to use and formats for **layouts**.

Pattern in natural and synthetic forms is all around us. Nature provides a huge array of resource materials for pattern forming: from geology to flora, to reptile skins and landscape, there is evidence of recurring images. Think about how nature's order can be reproduced. There has always been a preference for using natural forms in textile design and contemporary designers are no exception. Homeware ranges of companies such as

Country Road will always include a large proportion of designs inspired by the patterns of nature, as will the bedding ranges of Sheridan.

Synthetic pattern is created from elements that do not exist in a natural state. Synthetic forms or artificial structures offer pattern potential as well: consider industrial skylines, conveyor belts. In the built environment, designers have a huge array of visual influences to access. As an example, think of the journey to school or work. The roads and railways travelled on, the planning of cities, street furniture, road advertisements, shopfronts and the use of colour are all elements taken for granted, but these are planned and

Marie Smyth

2nd year student, RMIT *Designing croquis from selected resource material. The brief was to create croquis designs for the theme 'The Victoria Market', Melbourne.*

actually create synthetic pattern. Designers should be always looking for something new to work with and good designers can create a pattern from any form of resource material. Think about these examples: road signage/road lane markings; road maps of cities; methods of transport — the train, tram, car, plane, ship. All of these can be used in a variety of ways to create a designed pattern.

In your resource material, your sketches and design ideas, look for images and motifs that have potential for pattern. Imagine more than one of them, turn them around, move them up and down. This involves forgetting about the image to a certain extent and concentrating on the patterns formed; this is as much about the spaces in-between the shapes, as about the shapes themselves.

Designing croquis from resource material

The art of pattern design consists of not spreading yourself over a wide field, but of expressing yourself within given bounds.

In this book pattern is only referred to in a technical sense, to show how surface decoration is arranged in formats of repetition that can be reproduced to print fabric. In a natural state the use of pattern can be seen in ordinary things such as basket weaving and netting, but for professional designers the sign of a good pattern can be one where the structure is hardly noticed at all; the design flows well and does not form odd shapes on the cloth.

From the ideas in your resource book select the material you think has the potential for a fabric

Different ways of using media and technique to create pattern.

Christie Arulappu
3rd year student, RMIT

Natalie Ryan
2nd year student, RMIT
Left and bottom

Verity Prideaux
3rd year student, RMIT

design, perhaps in relation to a particular brief. So far, you should have:

- decided on an illustration style for the motifs
- worked out a colour palette
- established any restrictions (like the number of colours).

Now you have to work out the design

Most professional textile designers will move directly to croquis stage, with the motifs to the correct scale, and with a repeat system in mind. It is much harder to do this without experience, so you will probably have to work through lots of croquis before you get to what you are happy with (or to what the client is happy with).

As one of the most commonly used repeat sizes is 64 cm, try working within a 32 cm x 32 cm format for your croquis. This should give you some idea of the area within which you should try to capture the feeling of the whole design and indicate where motifs will recur.

Croquis designs can be any size, in any medium, but to understand the restrictions of designing for printed textiles, it is a good idea to work within the most common constraints. You should also keep in mind that if a client did wish to buy the design, but wanted it put in repeat ready for production, or if you are going to print it yourself, you should make sure you are able to do so without destroying the nature of the design.

Start by drawing a 32 cm square on your paper and rule a grid on the page. This grid can have lines 4 cm apart — its purpose is so you can get used to aligning motifs as you go. It can be easily painted over or erased and certainly doesn't need to be visible when the croquis is finished. Prepare several pieces of paper like this. You will find, after working through Exercise 8 in this chapter, that all textile designs work over a grid that is often invisible. How accurately you adhere to the grid at the croquis stage is really up to you and is probably dependent to some extent on how far you intend to take the design process. If you only want to put down some ideas for fabric designs, regard the grid as a rough guideline. If you want to take it through to finished design, then adhere to it reasonably accurately, because although there will be more to do to your croquis, you will have saved yourself some work.

Croquis designs are a good way to explore your ideas — rather than producing one design, you should be producing a series, which might use the same motif with a change of scale or a different repeat system, for example. You might try the use of positive and negative motifs.

The main thing to keep in mind is that you have to pay attention to where the motifs will appear again, and you should indicate that

within the design so someone looking at it would get some idea of how the fabric will look. Photocopies are a good way of playing around with images and motifs in relation to each other, as they are a quick way of getting multiples, as well as changing the scale, without the labour of redrawing. But don't always work on motifs that are isolated — think about linking the images and background patterns. Think about ways in which you can make the flat design plane look more three dimensional. Use your resource material and patterns that occur naturally to help you devise ways of developing more interesting fabric designs.

Balance of the design is an important consideration. What is balance? It is an equal weighting of symbols, motifs and colour that best represents a sense of order in a design. A single

Mi Kyoung Kim

3rd year student, RMIT
Below left and right: *croquis designs are a good way to explore ideas — rather than producing one design, you should be producing a series that uses the same motif, with a change of scale or a different repeat system.*

Andrea McNamara

Designer and lecturer
*Resource material, croquis for
a series based on the Bayeux
Tapestry.*

placement print for a T-shirt can have a good
sense of balance within itself, but this doesn't
necessarily translate into a good fabric design if,
when laid out in a repeating format, odd lines
appear and unbalanced shapes detract from the
viewing of the images. Alterations might have
to be made to the image so that, for example,
awkward shapes made by the negative space
between motifs disappear. The same thing applies
when designing a motif that you imagine will
recur over a fabric length. Chances are you will
have to alter it from your original drawing, while
retaining the feel of that drawing, in order to
make it into a pattern and work as more than a
single image.

Keep an eye on the awkward spaces or the
gaps and lines that are inadvertently created when
you repeat motifs. This makes the job of putting

the design into repeat much easier later on. There
is more detail on how to avoid these things hap-
pening on pages 112 and 140 of this chapter.

The process of translating great ideas into actu-
al textile designs can be extremely frustrating.
Good textile designers need to have an interest in
the pattern and order of motifs, not just in the
creative generation of images. You can acquire the
necessary skills to put a design in repeat, but how
successfully you do it is another matter.

Overview of the process from pattern to production

The following overview of the process a design is
taken through, to get it to a stage where it can be
put into production, applies to most textile print-
ing in industry, although, of course, each factory
will have its own way of doing things. In printing
fabric by hand, the principle remains the same but
the processes differ.

- The croquis design with an indication of
 repeat, or implied repeat, is approved.
- The design is put into repeat either by hand,
 using a grid and tracing images, or electroni-
 cally on a computer.
- The design is laid out and the repeat checked.
- The artwork is produced. If the design is more
 than one colour, the colours are separated
 either by hand, camera or electronically.
- The artwork is transferred (manually or elec-
 tronically) to screen (rotary or flat) via the
 photographic process. At this stage the design
 cannot be altered or fixed. If there is a mistake
 in the design, then the artwork would have to
 be altered and the screen remade, at great
 additional expense.

- A strike off or test print is done to test the colourways on fabric.

- Once the strike off has been approved, or any adjustments made to the colour, the fabric is printed.

- If the design has been commissioned by a garment manufacturer, a sample run might be printed prior to production, so that sample garments can be made up and the range sold before the production meterage is produced. That way, only the required meterage is printed.

The language of pattern

The following terms are particular to textile design and the creation of patterns suitable for fabrics. These terms are defined because they apply to important parts of the design process of creating patterns ready for production of printed textiles. The words used will differ according to the country: **tram tracks** are alleyways in the UK. However, the processes remain the same in principle, wherever you are, and remain little changed in hundreds of years.

Andrea McNamara
Designer and Lecturer
Printed fabric for an ironing board cover: the patterns were derived from the material shown on page 108.

croquis

A croquis (sketch) design is used to describe a textile design that looks like it could be in repeat but technically isn't. However, it should imply repeat, so the croquis gives the general impression of what the fabric would look like. What distinguishes a croquis from paintings and drawings is that motifs or images should be seen more than once — some idea should be given of where they will reappear when the design is formalised and put into repeat. Designing in croquis form is convenient: it removes the apparent restrictions of working accurately in repeat and allows changes to be made before the time-consuming process of putting the design into repeat. Depending on the situation, you might hand over a croquis to someone who does technical artwork for the factory printing the fabric. If this is the case, you have to be aware that you are then dependent on the ability of the person working on the design to correctly interpret it. Croquis designs often have to have the number of colours reduced, the mark making refined or the layout slightly altered to fit a required format.

repeat

Putting a design into repeat is the process of determining exactly where the images/motifs/shapes/colours recur when the fabric is printed. Using a grid, either manually or electronically, designers check that all sides of the design will link up with no visible join. For production, the design has to be put into sections, which are printed over and over to create lengths. It is a process that can be quite difficult to come to terms with, as in the beginning it can seem to be undoing all the creative exploratory work that went into creating the design. Inexperienced textile designers are often disappointed by the way a great idea (or croquis) looks as printed fabric and often this is because of a clumsy repeat or an awkward layout. Repeat is something textile designers cannot avoid. As the skill of the designer improves, with the development of a better understanding of patterns and how the whole process of printing fabric works, there shouldn't be any need to feel that the design has lost its spontaneity or its looseness. Those qualities can be achieved in repeat but it might take a bit longer. If a design is going to be printed as lengths of fabric, whether it will be cut up and used for garments or used as curtains, it must be put into repeat. Sometimes, it is easier to work in repeat from the early stages of a design, particularly if the repeat size is known and the layout is simple.

repeat system

Repeat systems such as half drop and full drop are tried and proven formulas that are used as structures for building designs. An explanation and description of some of the most common ones follow this section. Remember there is no need for the system used to be obvious — a repeat system is really the hidden scaffolding for the design.

repeat size

The **repeat size** is measured from one part of the design (for example, the tip of a flower petal) to the exact point where that part occurs again, measured along a straight line. Some production methods, or factories, work to specific repeat sizes: 64 cm is quite common. The 64 cm could be made up of two 32 cm sections, which are the same, or four 16 cm sections, or eight 8 cm sections and so on.

repeat unit

The **repeat unit** is the section of the fabric that occurs over and over again. In the unit of repeat, all four edges will connect, in whatever repeat system is used. Crosses indicate where the next unit occurs. A layout might have 2 x 5 units (32 cm x 30 cm); the two units across will be the repeat size (2 x 32 cm = 64 cm) while the five units are the width of the fabric (5 x 30 cm = 150 cm).

layout or mastercopy

The layout is the arrangement of motifs, usually used when the motifs are in repeat. Layout is often used to refer to units of repeat laid out to the width of the fabric and the repeat size, that is, to the actual size of what will be put on the screen. Only line work is necessary — the layout is needed for the whole design, not one for each colour, but the details are not necessary.

cut-through line

This is the line that cuts through the layout, from selvedge to selvedge, so the images join up again when the design is printed. The edges of what is put onto the screen are the cut-through line. Before the positives or colour separations are painted up, you have to look at the layout of the design and determine the best path through which to cut the design. The main thing is to choose natural breaks, which occur in the design, and not to cut through the centre of images. This cut-through line is important, because, in conjunction with the way you have put the design into repeat, it disguises where the units of repeat begin and end on the printed fabric. See

Exercise 9 for a simple example of a cut-through line. Each colour in a design will require a separate cut-through line, although they will all roughly follow the same path. If you are not doing the colour separations then you don't have to worry about the cut through — you might have to put the design into repeat, but then hand it over to the client or to the factory that will handle everything from that stage on. Sometimes these later stages are done by a technical artwork team, which never produces original design work, but whose job is to make the designs ready for production.

Andrea McNamara

Designer and lecturer
Note where the cut-through line is in this all-over design for apron fabric. See also p. 224.

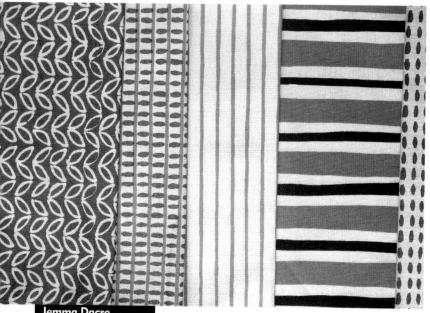

Jemma Dacre

Designer, Textiles for Nomads

Coordinating prints on cotton napery: simple spots and stripes can be coordinates for more complex image-based designs.

tram tracks

Tram tracks (or train lines or alleyways) in a design are unintentional lines or gaps that appear once the design is assembled. These are not apparent (especially to the inexperienced) until several units of repeat are put together and the designer stands back to observe the pattern. The important thing at this stage is not the images, but what they look like in relation to each other. If lines are inadvertently created, they distract from the detail of the carefully drawn imagery or the wildly expressive marks used: the first noticeable thing will be the gap. Of course, some designs will incorporate intentional gaps — **toile** de jouy is a style that does this, as do some geometric patterns.

proving the design

This is the same as checking the design, making sure that it repeats and that no gaps, overlaps, tram tracks or other distracting things happen when the design is laid out. It is done over a grid, by accurately tracing one side of the design and placing that tracing at the repeating edge of the other side of the design, at the correct repeat

size. Do the sides join perfectly? Are there any obvious (or subtle) holes? Could the layout be improved? Now is the time to fix it, because once you have started to paint up the design or it is on a screen, rectifying mistakes becomes time consuming and therefore costly.

coordinates

Coordinates are patterns that are meant to be used together. To coordinate a textile design usually means matching the colour palette, the illustration style and an overall effect. The coordinates don't have to be motif based; textures and the use of interesting colours are just as appropriate and require just as much design skill. Simple spots and stripes can be coordinates for more complex image-based designs, or the scale or layout of the main design can be changed. It is easier to get a clear picture of what coordinates are in a furnishing, interiors or homeware context, than in fashion, where an anti-coordinating approach can be a valid style: look at the use of clashing patterns together, for example, in street fashion, club wear and couturier collections. One of the biggest markets for coordinated design is in bed linen, where the quilt cover might have the main pattern on one side and a matching plain colour on the other. The pillowcases might have a coordinating print, which is smaller in scale than that on the quilt; or they could be plain, with a border print that takes elements from the main design; or they could have a large placement print. A colourway might double as a coordinate in a furnishing context. The important thing with any coordinates is that the end result retains the integrity of the original design concept and the whole story works together. Simple and

effective coordinating prints can be found in the Country Road Homeware range of bedding and more complex examples can be found in Sheridan bedding. Coordinates and the problems they pose could be a good starting point for a design project. Think about bed and bath linen, or table napery; isolate the products (napkins and tablecloth) and look at the potential for prints or plain coordinates (borders, all-over patterns).

style

A style is the category into which a design fits: floral, geometric, ethnic, conversational or novelty prints. More detailed descriptions of commonly used styles are on pages 114–17. These are useful to know when communicating with clients or looking for reference material in the library.

directional

When **directional** is used to describe a print, it means that the motifs or images indicate that the fabric has a strong vertical, horizontal or diagonal direction. Sometimes it means that the

fabric only goes one way, so directional prints are often less economical for cutting garments. This is because the pattern pieces can only be laid out facing one way. Directional prints are more often used in furnishing fabrics, as curtains and furniture are only ever seen from one viewpoint and larger pieces are needed.

non-directional

This is used to describe a design that will look virtually the same from all directions. The motifs will be facing in several different directions or equally face up and down.

Anna Kosnovsky
3rd year student, RMIT
Left: *a swatchbook of fabric 'pages' from 'East meets West' project, showing the creative effects of different print techniques.*

Bruce Slorach
Below: *contemporary print style developed by using a traditional ogee repeat format.*

Design styles

Throughout the history of textile design, styles have emerged into which designs can be categorised. Although this sort of categorisation is arguably unnecessary, it is useful to know what is meant by a few different style names, to facilitate research or to be able to interpret the instructions of a client.

floral

Floral designs are virtually synonymous with textile designs. Technically, floral, as a style, excludes the use of fruit, vegetables and trees, but does include foliage. If we look at all markets, florals are still the most popular style of textile design and the variety is infinite. Florals have become a dominant design source because of the variety of forms, the potential for flowing designs using the natural rounded shapes and the fact that they are very easy to live with.

geometrics

Unlike florals, geometrics are not derived from natural forms, and are usually designs where the grid is not overly disguised or at least where there is a strong linear feel to the layout. Geometric pattern has developed over centuries of invention. Stripes, patterns using non-representational motifs, designs based on triangles, spots, diamonds, divisions of circles and so on fall into the general geometric feel. Many geometric patterns are derived from weave structures, where the geometry and repetitive nature of the pattern are

Anna Kosnovsky
3rd year student, RMIT
Dutch delftware tile theme used as a resource and developed into repeat pattern. The surface effect was created with an overlay of PVA.

Jason Kenah
2nd year student, RMIT

Bruce Slorach
Two different uses of circular patterns in geometric structures.

Bruce Slorach

Pigment print on cotton used for streetwear range.

Andrea McNamara

Designer and lecturer
Right: *conversational or novelty print.*

determined by the process. Like florals, geometrics will always be a standard textile design style.

conversational or novelty prints

This category is rarely called by name in Australia (conversational tends to be a US term) but the category itself does exist. This style uses recognisable motifs and tends to be more related to what is currently fashionable. Popular imagery will change with fashion but the style of design remains. Often, a small image will be taken and used in an all over layout or put into a strange context or mixed with other motifs. Good examples of conversational or novelty prints can be seen on boxer shorts, a market with a fairly high turnover of prints. When it is St Valentine's Day, heart motifs will dominate the market. The actual motifs don't have to have show-stopper potential, although often they will in this category. Sometimes the images are recognisable upon close inspection of the fabric design, but what we notice most of all is the pattern formed by the motifs. The motifs could be in a geometric layout but, because of the identifiable nature of the images, the design would fall into the conversa-

tional or novelty print style. This style of print is probably most common in streetwear, surfwear and fashion, rather than furnishings. In a historical context, many of these prints are easily categorised by their period too, because the images will tell us what was popular at that time.

toile

The name of this style comes from fabric described as toile de jouy, meaning cloth from Jouy, a place in France, which was famous for its pictorial and pastoral scenes in the 18th century. Often, the fabric would have a narrative — historical, political, romantic — but the look of these designs is not that of fabric with a message. The designers were obviously primarily concerned with the look of the fabric, but chose things that were happening around them as their

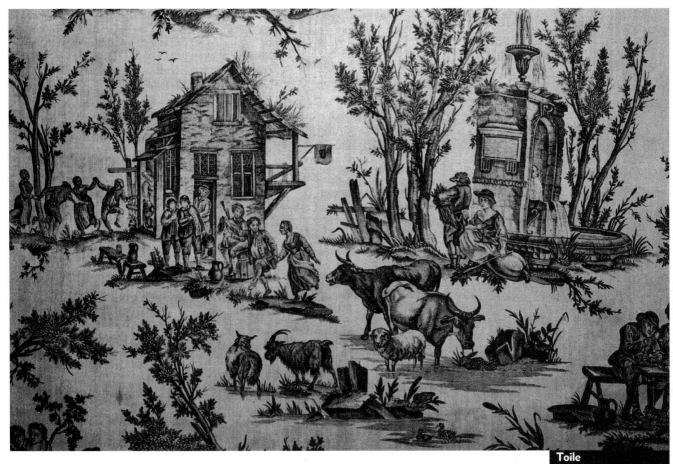

reference. Toiles are printed in one colour on a neutral background and look as if they have been engraved on the fabric because of the fine line work used to draw the images. The style is still very popular in furnishings as its elegance has stood the test of time. Usually, quite a lot of the fabric colour is left to show through and a simple repeat system, such as a half drop, is used. Take note of the tricks used in toiles to join the individual pictures into a flowing design for fabric. In Australia, Robertson Mead Handprints, a Sydney-based company, has kept up the tradition of toile designs, producing some of its own with a particularly Australian flavour.

Different periods have put their own mark on these broad styles, many of which are worth examining further. A few are listed here.

1800s	Early chinoiserie (the imitation of Chinese motifs) documented the trade between Europe and Asia
1900s	Effects of artistic movements on textile design: see the work of Dufy, Gauguin, Picasso, Matisse
1920s	Art deco and the investigation of ethnic culture for design purposes
1930s	Soviet Russia and the revolution of society depicted in farm tractors, weapons, or war
1950s	Space exploration and the age of the atom bomb
1960s	Pop art and the celebration of the synthetic: fibre, colour, optical
1990s	Environmentalism: natural colour and the use of technology to create multi-media design applications

Toile

A toile (pastoral or interior scene) design from 18th century Europe. The toile is a traditional copper plate print style.

Repeat systems

In the following diagrams, the repeating unit is indicated by solid lines.

full drop

The unit of repeat is placed in a vertical and horizontal layout, with each unit next to, and below, each other. Also known as square repeat (although the unit can be rectangular) or tile format.

half drop

A square or rectangular unit of repeat is placed in a vertical column layout, which drops by half the unit measurement in each successive column.

brick

A rectangular unit of repeat, which moves along half the unit measurement in each successive row, is placed in a horizontal layout. This obviously takes its name from the familiar brick format from which its structure is probably derived. Brick and half drop are often referred to as the same thing.

stripe

A stripe repeat has a layout with a predominantly strong vertical, horizontal or diagonal format. The stripe can have motifs within it, but is identified by its format.

spot repeat

In a spot repeat, the same motif is arranged in a 3 spot, 4, 5, 6, 7, or 8 spot format according to sateen weave structures. This is a simple formula to follow that can lead to the design having a strong direction or an all-over look. Details on how to use spot repeats are given on page 134. This system is very useful for producing coordinate prints for a main design.

diamond

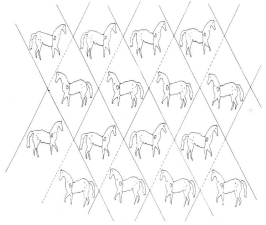

This is a unit of repeat that connects on all four sides, occurring at regular intervals in the layout.

all-over

All-over designs are those where the motifs appear at irregular intervals, within the unit of repeat, for a balanced effect. They can be packed, so very little background shows, or spaced, so the background shows through. All-over designs are those where the motifs are connected in some way so the pattern in a spaced layout will 'meander' across the fabric. These designs are usually made up of different but related motifs, such as several different floral motifs. Liberty or Laura Ashley prints frequently use this layout, but that doesn't mean the style is only suitable for florals.

tossed

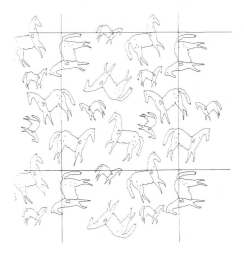

A tossed layout is similar to an all-over, in that the motifs appear at irregular intervals within the unit of repeat, but here the motifs are not connected to each other. They can be in a packed or spaced layout.

ogee

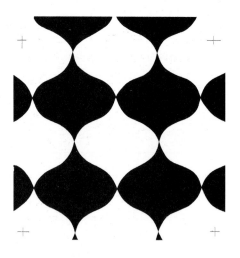

This is a traditional format, where an 'onion'-shaped unit repeats as for a half drop. The 'ogee' shape can be elongated or squashed to alter the design.

scale

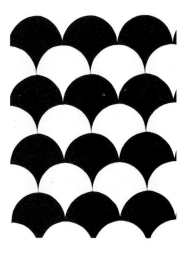

Like fish scales, the unit of repeat is based on a circle or oval shape that half drops.

mirror

This format is used extensively in textile designing, particularly with florals. It works best with an unbalanced or asymmetrical motif, which creates an interesting pattern when the mirror image is used. Most often the mirror image will be used in a half drop relationship to the original motif.

turn–over

When designing for products such as scarves, tablecloths, bandanas or other things that have a square format, it might be viable to use a turn-over system to work out the design. One corner is turned over (or mirrored), then turned again and again to complete the large square. When presenting this design, you will only need to show one corner.

Exercise 8
Working out the repeat system

A good way to familiarise yourself with repeat systems is to go through the process of analysing fabrics that have been industrially printed. You can use fabric scraps you already have or look for scraps of interesting fabrics in remnant bins.

Choose three fabrics samples to work on:

1 an all-over floral
2 a geometric print that incorporates a stripe
3 a print that has isolated motifs, which do not touch, scattered over the fabric.

At this stage do not choose designs that are too complex and try for light rather than dark coloured designs as these will not photocopy. Keep to designs that are not too large scale, as you will want to fit them on an A4 or A3 sheet for photocopying. You need a piece of fabric that is large enough for you to see where the motifs recur.

The aim of this exercise is to isolate the unit of repeat and establish the repeat system used. You will be singling out the part that recurs to make up the length. You need two different-coloured pens or pencils, or highlight markers.

Start with the floral.

1 Photocopy the piece of fabric, reducing the scale if you have to, to fit in more of the pattern. It is much easier to work straight onto the photocopy but, if the designs are too big, you can do this exercise by tracing the images onto tracing paper. (Position the fabric on a flat surface so that it is reasonably square — you might have to use masking tape to stick it to a table.)

2 Choose one easily identifiable motif or mark, and find exactly where it next occurs, both horizontally and vertically. These may not be on the same straight line, they could be lower or higher than the first one, or across. You must, however, look for exactly the same colour and size motif, which is facing in the same direction. Colour the first one in one colour (for example, red) and the recurring ones in another colour (for example, blue). You don't need to trace any detail, just colour the shapes, as you are only interested in the relationship between the shapes.

3 Choose another motif that is close to the first one, colouring it red. Find where it recurs, horizontally and vertically. Colour these blue. You will be working on several sections: the repeating unit (in red) and the adjacent repeating units (in blue), above and below, and to each side of the red area.

4 Keep colouring until you have one of everything in red and everything in blue surrounding it. If your floral has very little or no space between the flowers or has lines that connect the flowers, separate the unit of repeat (in red) by going around the edge of the motifs or looking for small gaps in the design. Don't cut flowers in half.

5 Now, try to determine which repeat system has been used: full drop, half drop, brick. Look at one of the motifs from the red section. Horizontally, where is the next one? Is it straight across, on the same line, or up a bit? Vertically, where is the next one? The relationship between the sections will show the repeat system used.

6 To check the repeat system used, choose that motif; draw a straight horizontal line through to the next identical motif. Do the same vertically. Keep joining that particular motif with lines, working over the red and blue sections, so you are drawing a grid over the design. Looking at the format of the grid, you should now be able to tell what the repeat system is. Use the diagrams on pages 118–20 to help you.)

7 With a marker, draw around the outline of the red area. Now you have the unit of repeat, the unit that is placed at regular intervals, according to a formal structure, so it can be printed continuously all over the fabric. This unit is placed over the grid, to give you the structure of the design. Note that this grid will not be perfectly square, because the fabric may have been distorted on the copier; however, this will give you

enough of an idea. You have reduced the flowing design to a few small motifs and a grid.

8 Check you have the right unit by either photocopying or tracing another two or three, and joining them to the first one, roughly following the straight lines you have drawn. If anything has been left out or overlaps, either add the missing bit or eliminate the extra part from the unit of repeat.

9 The repeat size is measured from a particular point on one motif to where that exact point recurs. This applies to the whole exercise. Do this for each of the fabric samples.

By working through this exercise, you can see that there are hidden structures, or regularity, in all fabric designs. The structure or grid does not have to be obvious and, in fact, shouldn't be obvious at all, until you dissect the design.

Fabric (a), photocopy (b), repeating unit (c) and the result (d) from Exercise 8.

Exercise 9
Putting motifs into a simple repeat format

Although this technique of putting a design into repeat is not used in industry, it is useful for developing an understanding of how repeats work — how one side of the design must line up with the other. Using this method, you do not design a unit of repeat that recurs over the fabric, but use the whole width of the fabric as the design plane. The disadvantages are the high likelihood of tram tracks appearing in the design and an unbalanced layout. The advantages are that the process seems quicker and you can work with large motifs.

1 From your resource material, from any brief, select a number of different motifs, say, seven or eight. Give some consideration to what motifs you think might work together well — ones that have a thematic link, perhaps. Have a variety of sizes and multiples of each motif. Cut out the motifs.

2 Get a large sheet of graph paper (on a roll, by the metre, it is called continuous sectional) or join several together to make a sheet that is 120 cm long and at least 70 cm wide. The width of most fabric is 115 cm; 70 cm will be the maximum width of the design area — the repeat size will be between 50 cm and 60 cm. If you need to stick sheets together, be careful to retain the squareness of the grid. Stick the graph paper sheet onto a table. This sheet of graph paper can serve as a grid for laying out all your textile designs, as it is only used to square up the design and is not actually drawn on directly. Having an accurate grid is essential.

3 Lay out some tracing paper, or detail paper, preferably the same size as the graph paper. Tracing or detail paper is much cheaper in rolls, or if you buy it by the metre, than if it is bought in sheets. Stick this sheet over the grid — at the four corners will be sufficient.

4 Following the lines on the graph paper, draw a straight line in pencil along each of the two shorter edges, 115 cm apart. This is the fabric width. Choose what is approximately the centre of these lines and draw a line down the middle of the paper, following the graph lines.

5 Now you have to take into account a production consideration, which is to determine the direction of the design in relation to how the fabric would be printed. The easiest thing to do is to make sure that you are working with the long side of the paper in front of you, which means you are facing the images the way they will appear on printed fabric.

Collection of motifs for Exercise 9. Note that the dogs all point in different directions and are different shapes.

6 Place the motifs you have cut out, around the central area, on top of and either side of the central line you drew. Fill up the width of the fabric (115 cm) but only go to about 20 cm either side of the centre line. Take care to balance your distribution of large and small motifs and not to have too many motifs facing the same direction, if you want an all-over random look. You may have to alter the size of

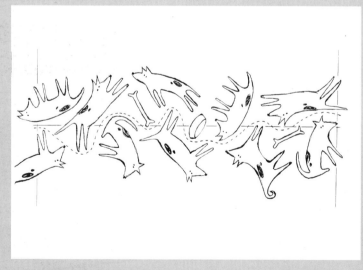

some motifs or photocopy (or draw) more of particular motifs. Use a small amount of glue (use a gluestick) to hold them in place, as they will probably have to be moved around several times.

7 Note that at the moment, this design *does not repeat*. What you are about to do is make the two long edges join up, which is called putting it into repeat. With a pencil, start at the centre of one of the selvedge edges and find a path through the design, which follows the centre line as closely as possible, but doesn't go through any of the images. It should go *around* the images. This line will weave in and out, but must end up at the centre mark of the other selvedge. It is known as the cut-through line.

8 Cut along this line, separating the detail paper with the stuck-on motifs into halves. The graph paper must remain stuck down and in one piece. Mark one half Side A and the other, Side B.

9 Keeping the drawn straight lines along the straight lines of the graph paper, reposition Side A where Side B was, and vice versa. Slide the halves apart so there is a blank space in the middle. How far you slide them apart determines the repeat size. Leave about 20 cm blank in the middle. Stick a strip of tracing paper in this gap so you will not be sticking motifs straight onto the graph. Note that, except for the 115 cm for the width of the fabric, the other measurements are arbitrary and relate to what size repeat you want to work to, which might be affected by available screen size and also the size of your images.

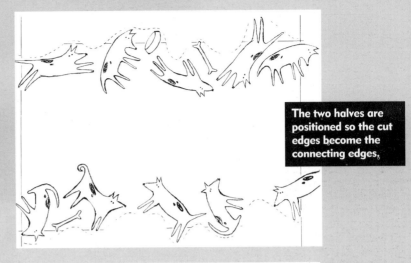

The two halves are positioned so the cut edges become the connecting edges.

10 Because they have been cut apart, the two outer edges will repeat, that is, they will join back together when the design is printed, as long as you have kept everything straight when you reassembled the design. Now all you have to do is fill in the middle blank part, keeping the feel of what you have already done.

11 Measure between the two edges, which have been cut (selvedge edge), and this will give you the repeat size of your design. Mark crosses on each end at these points.

12 You will need to check what the design will look like, to see whether the placement of images is balanced. To do this, trace the *whole* design on another piece of tracing or detail paper — no detail on the motifs is necessary, just the shapes. Include the straight line at the selvedge edge and the crosses. Place this tracing next to the original layout, matching the crosses. This duplicates what happens when the design is printed. It is now that you look for gaps, unexpected lines, or tram tracks caused by the direction of the images. Alter things at this stage, because when you print it no miracles occur that will remove these faults. Sometimes all you need to do is slightly move a motif or turn it around. Alter the original layout *and* the tracing. Usually, using this method, you will have to make some adjustment to your layout to get a balanced design.

This method is simple and it does work, but you have to be very careful about balancing the placement of motifs. Try the exercise a few times before you decide to take a design through to printed fabric — with

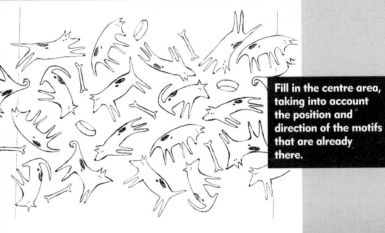

Fill in the centre area, taking into account the position and direction of the motifs that are already there.

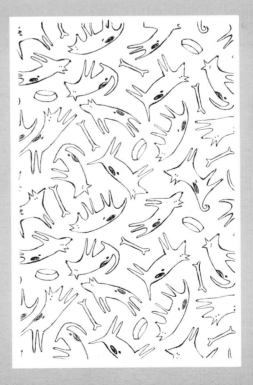

Piece two sections together and evaluate the result.

practice, you will be able to anticipate some of the gaps, tram tracks and other problems that occur, and avoid them by the way you lay out the motifs.

If you use this method to produce a design that you would like to take through to printed fabric, follow the process outlined in Chapters 9 and 10.

The dogs that have been highlighted black point in the same direction, which will create tram tracks in the design.

The position of the dogs in the bottom diagram on page 125 has been altered so the design flows better.

Production considerations

In addition to all the other thing you have to think about, you also need to consider what restrictions the production method or the product itself might have on how you go about putting the design into repeat. If you are working freelance, you would probably work in croquis form and put the design into repeat if a client requested it. It is good to work on croquis designs with repeat in mind so you can do it without changing the nature of the design. A safe repeat to work to, or at least keep in mind, is 64 cm, or divisions thereof, as that is the one most commonly used in industry.

If you are working on **furnishing fabric** designs, you need to ensure that your design repeats not only along the repeating edges, but from selvedge to selvedge. If the fabric is hung as curtains and two or more widths of fabric are required across the window, then the fabric should appear as a continuous pattern. It is more common for fabrics that have a strong directional layout or fabrics that can only be used one way to be furnishing fabrics. The usual direction for furnishings is vertical and the scale is often larger than for apparel fabrics. Fabric used for garments usually has to be multi-directional, so the pattern pieces can be placed on the fabric in the most economical way, which usually involves having them face both ways.

If you are working for a particular company, you will be told things like the maximum coverage the print should have. Fabric will be printed with either dye or pigment: a short explanation of the difference between the two is that pigment is printed in a base that sits on top of the fabric,

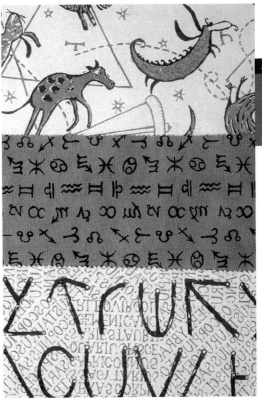

Andrea McNamara
Designer and lecturer
Coordinating prints from the 'Hocus pocus' series. Pigment print on cotton.

while dye is printed so that it becomes part of the fabric. See page 274 for a more detailed explanation of the differences between dye and pigment. Pigment-printed fabric is much cheaper to produce. Depending on the quality of the print base used, fabric printed in pigment can end up very stiff. This is most noticeable where the printed area covers a lot of the cloth. So you might be told to produce a design that has no more than 50 per cent coverage, which means that 50 per cent of the design area will be the fabric colour. Restrictions such as these mean that background colours are usually out of the question, because it would mean the design has 100 per cent coverage. This is fine if the fabric is printed in dye, or the quality of the pigment and base used is such that the handle is very good. A printed background colour is called a **blotch**. Some fabrics, such as a polyester taffeta, are not suitable for blotches, as

Matthew Flinn

Designer and lecturer
Right: *'Fleur de leaf'
print. Pigment print on
linen/cotton fabric.*

the print will look uneven if fairly solid shapes (like blotches) are printed on them. Printing on a coloured fabric poses other problems. The main problem is that the most economical bases with which to print are transparent, so the fabric colour will affect the print paste colour. An **opaque base** would be needed so that, for example, white can be printed on black, but this usually has very stiff handle and reduced rub fastness. Opaque bases are very popular in placement prints on T-shirts, where it doesn't matter if a relatively small area of the front of the shirt is a bit hard or rubbery. You need to have a basic understanding of this sort of information so you know *why* you are being asked to do certain things and you can find other ways of getting particular effects. If you can only work on white or natural coloured backgrounds, make the background colour an integral part of the design: utilise the negative space.

There are other restrictions such as the fact that solid vertical stripes (those that run parallel to the selvedges) cannot be printed using flat bed screens. Designs have to be cut at some stage so the pattern can be put on a screen and printed. If

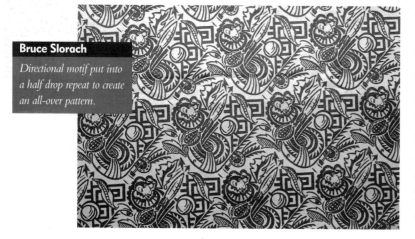

Bruce Slorach

*Directional motif put into
a half drop repeat to create
an all-over pattern.*

solid shapes are cut through, then the likelihood of the join showing is increased because the fabric can easily move or shrink while being printed. Solid vertical stripes can only be printed with rotary screens.

If you are designing for bed linen, sometimes it might be possible to use the entire width of the fabric for a doona cover design. This would mean that while you adhered to the 64 cm repeat used, you could use 1.8 m or 2 m as the design plane.

Other restrictions or things to consider might be given to you, particularly if you are working to a detailed brief where a product is the end result. As long as you understand why you are being asked to do or avoid certain things — and most restrictions boil down to money or the limitations of a production process — then you should be able to work within the boundaries given. Restrictions should be a challenge, not a hindrance.

Putting a design into repeat

There are several different methods of putting designs into repeat and these will vary from studio to studio. To some extent the method used will depend on the accuracy of the croquis or whether the designer is working straight into a repeat format. Method A is useful when you are developing layouts for designs, working in repeat from the beginning. Method B is appropriate when you have the croquis and need to put it into accurate repeat.

Full drop (Method A)

A full drop or tile or square repeat is probably the most readily understood repeat system. After a while working to a full drop format can seem a bit restrictive, because motifs recur immediately on the same horizontal and vertical lines. This means you have to be very particular about the direction you place them in, as well as their size and shape in relation to each other.

Method B will show you how to work up a design into repeat from a croquis. For the purpose of this exercise, Method A shows you how to put a design straight into repeat format, choosing several motifs from your resource material.

The underlying structure or the grid on which a full drop works is shown on page 131 (bottom diagram). Each of the squares shown here represents a 32 cm square, which will be a unit of repeat. Note that the unit does not have to be square. Using this system, each unit occurs immediately next to the other, in the same horizontal and vertical line. The 32 cm square is a common size to work to, but any size may be substituted.

1 Work on getting the unit of repeat correct. You will need graph paper, a sharp, hard pencil (2B), an eraser and several sheets of tracing paper. Stick the graph paper on a flat surface. Eventually you will need graph paper to lay out the whole design (see Exercise 9), so you could use that large sheet for this exercise as well. Rule up a 32 cm square sheet of tracing paper.

2 The process of putting a design into repeat is one of tracing the connecting edges of the design. This is done to duplicate what happens in printing, where the units occur over and over again in a predetermined order on the fabric. Tracing the connecting edges tells you whether motifs will crash into each other or whether gaps occur.

Mark the Top. Fill in the left side and most of the top edge of the design, using images from your resource material. Don't use 'half

Top

Draw crosses at the size of the repeat unit, and start to lay out the motifs along the top and left hand edges.

Trace or photocopy the motifs twice, and lay them out below and to the right of the first unit.

Fill in the remaining area in the first square, taking into account the position of the motifs that surround it.

Right: trace what you have done onto all copies, and put them back in place; far right: look for any lines or gaps in the layout. Sometimes these are caused by motifs that are close together following the same direction. The dogs that have been highlighted black will cause a line that runs through the design.

shapes' in the repeat unit, even if they extend over the square you have drawn. Make all motifs complete. As with Exercises 8 and 9 in this chapter, you don't need detail, just enough information to assess the placement of motifs in relation to each other. Make sure you work over the lines and the crosses, not around them, otherwise you will get gaps in a square format. The lines become your hidden structure.

3 Make two tracings of what you have just done. Include the crosses, the images, and Top on each. Line up the crosses with the original, placing one to the right side, and one directly below. Stick the tracings with small pieces of tape, as you will have to remove the tracings several times. Check that everything is aligned on the graph paper.

Now you can see where the motifs you have included in the design so far will repeat.

4 Fill in the remaining area in the first square, keeping the motifs consistent with what you

have already done. This is made easier because you know what the connecting edges are.

5 Trace what you have just added onto the other two tracings and stick them back in place. Now you need to check what the placement of all the images looks like in relation to each other, as a whole. Any changes can be made — remember to alter things on *all* copies. This is the stage when you have to check for lines and gaps, and all the things that occur inadvertently, which can be distracting from your actual design. (See Troubleshooting: proving the design prior to production, page 140.)

6 Once you are satisfied with the design, you can paint it up (see Chapter 7). If you are taking the design through to print, you will have to do one more step before painting up the artwork to go on a screen — produce a layout. When you are inexperienced, doing a layout is also a good way of looking for tram tracks and gaps in the design (**proving the design**). You get to see exactly what you will get when the design is printed. On a large sheet of tracing paper (around 115 cm x 70 cm), which is placed over graph paper, mark a series of crosses in full drop format, to the size of your repeat unit (in this case 32 cm x 32 cm). You could photocopy your unit of repeat, complete with crosses, several times, and use these copies to lay out the whole design, or you could lay one unit of repeat under each set of crosses and trace it in each square. Tracing may seem tedious at first, but is more accurate for this sort of work. Photocopies become distorted, and lose a few millimetres each time, so your whole layout, depending on how tightly everything in your design fits together, could become slight-

ly out. Photocopies are a great quick way of seeing what your design is going to look like — you could do the layout with photocopies when it is necessary to include any detail in your motifs.

If you are working on a 32 cm square, you will find that this doesn't divide evenly into the fabric width of 115 cm. Approximately three-and-a-half units fit across the width of the fabric. Depending on the nature of the design, there are two choices: lay out three units and at one end have a half-unit; or centre the three units and have a quarter-unit at each end. This cannot be done for furnishing fabrics, as the **selvedges** have to repeat as well. (See Production considerations, page 127.)

Make sure you have the design facing the right way, particularly if motifs have a certain direction.

Above: **the shape and position of one of the dogs has been altered to try to get rid of the line shown in the previous diagram, page 130**; below: **the first step in laying out the design in repeat is to trace a series of crosses, at the size of the repeat unit, to the width of the fabric.**

The long edges (115 cm) are the width of the fabric and the short edges are the repeat (e.g. 64 cm). The short edges are also the selvedges of the fabric. Visualise your design as hanging curtains and view it standing in front of the long edge.

Full drop (Method B)

If the repeat of your croquis is reasonably accurate (in other words, you have thought about a grid to work on and have given reasonable consideration to the repeat size) then this method is a bit quicker than Method A. But then, putting a design into repeat is always faster, and more straightforward if you have worked with repeat in mind while producing the croquis. Depending on the accuracy of your croquis, you could photocopy multiple copies, and stick them together, lining up images on a grid. This would give you a layout, to check placement of images etc.

The following steps are for when you don't have access to a copier, need to be accurate, or the design is too big for photocopies.

1 You will probably know what repeat size you worked to with the croquis, but if you don't,

measure it from a point on one motif to where that point would reappear on the same horizontal line and vertical line (e.g. 32 cm).

2 Draw the crosses to the repeat size on three pieces of tracing paper, and place one over the croquis, lining it up to be as square as you can with the design. Mark the Top. Trace the whole croquis, but make sure you do not include motifs that recur. You might have used the same image over again, within the unit of repeat — include these, but leave out the motifs you have added to the croquis to indicate repeat. Trace two more copies onto the other two sheets.

3 Join up the three copies, matching the crosses, and keeping everything aligned on graph paper. You will be able to see where motifs crash into each other or where gaps have been left. Make adjustments, remembering to alter *all* copies.

Follow Step 6 of Method A for the layout, or, if you are not taking the design any further, paint it up in the correct colours, and present it.

Half drop

As with the full drop method, there are several ways of going about the process of putting a design into a half drop system or, in fact, any system. The process of putting a design into repeat is one of placing motifs on a grid, tracing them and rejoining the design at the crosses that indicate the repeat, whichever method you use.

Think about the underlying structure of the half drop layout:

Again, in this example, each section represents a 32 cm square, but the unit can be any size, and it can be rectangular.

1 Work over a large sheet of graph paper, as for the full drop exercise. Draw up four sets of tracing paper with crosses at the repeat size and with Top marked. Mark also the midway point between the top and bottom — this is where the design will be half dropped to.

2 Start tracing those images that you want to work straight into a repeat design on the left side and most of the top, as you did for the full drop. Do this on each sheet (four copies in total).

3 Assemble these four tracings in the correct position, lining up two with the crosses at the half drop marks, to the right of the original, and the other directly below the original. Make sure you are aligning everything on graph paper. Alternatively, if you have a croquis that has a good indication of a half drop repeat, trace the whole thing onto the four sheets of paper. As with full drop, don't trace 'half shapes'; draw them as whole motifs.

The process is exactly the same as for developing a full drop: you know where motifs will recur, which enables you to fill in the central part of the repeat unit. Trace what you add to the central part onto all copies and carefully check the design.

Follow Step 6 of Method A (full drop) for layout procedure, following the half drop layout.

Half drop layouts tend to give you a little more scope for developing a flowing design, as there is more space between motifs recurring on the same line.

Spot repeats

Spot repeats are really formulas that you can follow to give a reasonably predictable result, if you are using the same motif, at the same scale. Spot repeats, which are derived from sateen weave

4 spot

3 spot

6 spot

5 spot

PATTERN *135*

7 spot

Right: **draw up a diamond within the repeating unit. Fill it with motifs; make sure you work over the line.**

structures, are based on grids divided into squares according to the 'spot size': a 5 spot repeat is worked out on a grid that has five squares down and five squares across. Motifs are placed on this grid, inside squares, ensuring that in any one row across and down, there can be only one motif. Some formats produce strong diagonals, while others appear to scatter the motifs. One unit of repeat is completed and then a full drop is used to lay out the design to check whether the distribution of motifs is right.

The formats for spot repeats are shown on page 135. In these examples, the motif (the dog) has direction. When working with a motif that has direction, note that within a square unit, there are eight different directions in which a motif can point. These can be used to make a multi-directional print.

Spot repeats are great for the development of coordinates, and it is quick and easy to produce a number of alternatives so you get what you want.

Swiss repeat

This repeat system is very handy when working from a croquis with a strong central drawing that you wish to use as the basis for a textile design, without being sure of what format to use for repeat. It works on a similar principle to that shown in Exercise 8: a line is cut through the centre of the design area, which is then opened out so the cut edges form the connecting edges of the repeat unit. A **swiss repeat** is a system that ensures all four edges of the unit will repeat when the design is opened out and the units are then laid out in a full drop.

Work through the following steps to understand how a swiss repeat works. Here, the system

is shown using isolated motifs, but remember this is a great way to cut through a drawing or croquis to put it into repeat.

1 Working over graph paper, draw a square, marking the centre of each side. Make sure the marks are accurate. Join the centre marks to form a diamond within the square. Use 32 cm x 32 cm for this example, but if you are working from a croquis, measure the square on the design, so it includes as much as possible of the images.

2 Fill in the central diamond with images, making sure you work just over the lines, rather than avoiding them. Mark the corners A, B, C and D as shown in the above diagram.

3 Starting at the centre mark on one side, find a path through the design to the centre of the opposite side and mark a line. Make sure you go *around* images, rather than chopping them in half. Do the same from top to bottom. The lines can be quite wavy, but must end up at the points of the diamond. Cut along these lines.

4 Rearrange the sections, following the diagram. Do this over graph paper, so the design doesn't go out of alignment. The

rearrangement means that the outside edges on what is about to be the unit of repeat will automatically join up with the opposite edges, when laid out in a full drop. Trace two copies of what you have done, or use photocopies. Bear in mind the inaccuracies of photocopies. They will, however, give you a good idea of how the design is developing, and photocopying is quicker than tracing.

5 All that is left to do now is fill in the centre section of the repeat unit, taking care that the spacing and images are kept consistent with the rest of the design. Trace these motifs onto all copies or use photocopies.

6 Using a full drop system, lay out the design, checking as always for lines that will cause unintentional tram tracks or gaps. You will probably have to move some motifs around: remember to change them on all copies.

Try using a swiss repeat system over a drawing or a painterly croquis design. The motifs don't have to be isolated. If the design is not too dark, or too large, photocopy it so you will be able to cut it up and reassemble it. If you can't, you will

have to trace the images from the croquis onto tracing paper.

- Place a square drawn on tracing paper over the design or photocopy and mark the centres of each side, as in Step 1. Label the sections A, B, C and D.

- Draw a line from the centre of one side to the centre of the opposite side, making sure you find a path that does not cut motifs in half. If the motifs touch each other, use the edges of the shapes as the path to cut through (see Step 3).

- Cut along the lines, and reassemble the design as in Step 4. The central area, because you are working from a croquis, will have images in it, but these may need adjustment in the context of the repeat (see Step 6). This is a good way of retaining the feel of your croquis while making sure the design repeats. You must ensure that you work to a grid when drawing up the square, and cutting and rearranging the design, otherwise the whole thing will be out of alignment.

Andrea McNamara

Designer and lecturer
'The bark and the bite':
manipulating the motif by
bending and distorting can
create a flowing pattern.

Exercise 10
Using motifs in different formats

This exercise is designed to get you to explore the possibilities of using motifs in a variety of formats. A good way of generating a series of croquis, whether you are doing your own work, or working for a client, is to try a motif, or several motifs, in different repeat systems.

In this exercise, using one motif, which must remain recognisably the same throughout the series, you should show the use of:

- four different repeat systems
- positive and negative space
- a change of scale.

1 Choose one motif from your resource material. It should be fairly simple, with a direction. Do not choose something that is essentially circular, or square, or rectangular, as you will not have enough flexibility in the formats you can work within. You can adapt your motif to fit into a particular format, as long as it remains recognisable — you can bend, elongate or shrink it.

2 Look at the diagrams for layouts in this chapter (see Repeat systems, page 118) and think about which ones you could use with your motif to generate a series of one colour designs. Choose four that you will try, for example, full drop, half drop, scale and spot repeats.

3 Follow the method described under full drop and half drop, for drawing up the design in repeat. Work in a 32 cm x 32 cm format over graph paper, so you keep everything square, and trace the connecting edges.

Don't force your motif into a repeat system that it doesn't suit — either adapt it so it does work, or choose something else that is more appropriate. Successful textile designs are produced by getting the right combination of motif and repeat system.

4 As well as looking at the four different formats, one of these designs should show the use of positive and negative shapes for generating pattern, and another should show the use of a change of scale. All the designs should look substantially different from each other, so it doesn't look as if you have just done the same thing over and over again.

Draw all four designs, and colour them in one colour — all the same colour.

Present them as a series — do they work together as coordinates? If they do, present them as such, perhaps mounting one main design, and two smaller sections of coordinates on the same board. Follow the guidelines in Chapter 7.

Sandra Spiteri
3rd year student, RMIT
Series of croquis based on same motif used in different repeat formats.

Troubleshooting: proving the design before production

Once the design is technically in repeat, in that all the sides join up, the design still has to be proved, to ensure there are no tram tracks or gaps. Spotting where these are likely to occur is one of the most difficult tasks when you don't have experience to tell you what will happen. The most important thing to remember is that if the design is being taken through to production, by you, or in industry, then it is now that you can fix the design faults, not when you see them printed over and over again down the length of the fabric. It is not the job of the client to spot where these faults might occur: it is the responsibility of designers who are putting the design into repeat.

The quickest way to check what you have done is to photocopy the repeating unit several times, trimming away the edges around the motifs, so the units butt up against each other. When you stick them together, make sure you keep the layout square. If you want to be 100 per cent accurate and your design is composed of units that fit quite tightly together, you will have to use tracings, because photocopies have an inherent inaccuracy of a few per cent from the original. The photocopies will, though, help you visualise what the design will look like. You need enough copies to be able to see across the width of the fabric (at least 115 cm) and at least as wide as the repeat (for example, 64 cm). Often, it is a good idea to make it even wider.

When you have it all laid out, look at it critically and objectively. Half close your eyes and look for awkward gaps or lines. Don't be distracted by any detail in the design — you are concerned with the relationship of shapes to each other and the negative space between them. Tram tracks are a common occurrence. Look for things like too many motifs pointing in the same direction — if the angle on some of them is changed, or the direction altered, the balance could be much better.

Look at your layout from all angles, even if the design goes one particular way. Looking at it upside down can often remove you from the familiarity of the motifs, to enable you to see them more objectively.

A **repeat mirror** is a useful thing you can make easily and cheaply and while it is not an accurate representation of how the design will be when printed, it can certainly highlight major flaws that you haven't noticed. Two pieces of mirrored glass are stuck together at a 90° angle, to make a corner. The pieces of mirror should be at least 30 cm square. The design is placed in the corner and the reflection lets you see what it will seem like when extended. Of course, you are looking at the reflection of the design, but it still gives an indication of a bigger design area, with the advantage of not having to paint up anything. The repeat mirror is a good device for visualising turn over repeats too.

There are specialist repeating glasses for textile design, but they are expensive and very hard to obtain. The glass consists of several sections inserted into a frame: the sections are arranged in full or half drop configurations. The design is pinned on the wall and the repeat glass held in front of it — while the design is reduced, it is also multiplied into the repeat format. It is not accurate, but gives a general idea of what the layout will look like.

Whichever way you do the layout or visualise the design before production, don't hesitate to move and alter things that you are not happy with, even though it is a tedious process of making often minor adjustments. After this stage, the positives must be painted up, which can be very time consuming, so you want to be happy with the results when the fabric is printed.

Some repeat designs that use a tile format (where the motif is within a square, in a full drop repeat) do not need to be proved so thoroughly, as the geometry of the layout ensures a repetitive pattern. For these designs to work, you do need to make sure everything is square and accurate.

Remember that, when printed, any **small flaw** is **magnified** many times over, **because** of the **repetition.**

Colouring the design

Most of this chapter is about putting things into repeat, using outlines of the motifs, and concentrating on the arrangements of the shapes. This is not neglecting the importance of colour: it is merely the easiest way to go about the process. However, if it is a multi-coloured design, once the relationship of the shapes is right, and the design is balanced in layout, you have to check the distribution of the colours. Too much colour in a particular area can make a design, which has a balanced layout, look quite out of balance. Colour distribution can also cause lines, gaps and tram tracks. Check how the colour is distributed before you finalise everything: assign colours to the motifs, over more than one repeat unit and use photocopies to quickly visualise the overall layout. This doesn't have to be carefully painted — use coloured pencils or markers. Just as the design was reduced to outlines of shapes, the colours are reduced to spots and blocks. This highlights where problems might occur.

Summary

The process of creating patterns and putting designs into repeat is an integral part of the textile design process, and it is the point where textile design departs from other design disciplines, demanding its own particular skills. These aspects of textile design can easily be seen as tedious and boring — it is very much a case of having to do things accurately and carefully to get results. You need to have a fascination for the whole process of producing printed fabric, and an appreciation of the order required, to get pleasure out of the organisation of images into a repeat system. This is where the rewards can be great: if you are going to print your fabric designs, or if you are handing over the finished design to someone else to print, then you have the satisfaction of seeing your design as printed fabric. The fabric will be made up of your repeating design unit. The principles of the system, regardless of the technology used, are hundreds of years old.

Finishing
and
presenting
designs

7

Mi Kyoung Kim
3rd year student, RMIT

143

Professional textile designers often have to present designs in a folio, whether working freelance or for a company where a design story has to be shown to clients or buyers. Knowing how to present designs well is crucial: designers need to know how to select and present work, so the design story is told clearly and simply, and the client/buyer knows what they are looking at. Presentation of design work can result in an immediate sale, further commissions, or no work at all.

Your interest will be in selling the fabulous design work, rather than the neat mount board and colour chips, so that many details of folio presentation will seem fussy. You have to remember that your work is representing *you*. You might be presenting your folio at a job interview: the client needs to know that you are reliable and capable, as well as creative. Most industrial processes thrive on a combination of organisation and creativity. Unfortunately, too, sloppy presentation, complete with dirty finger marks, glue stains or crooked mounts can mean that no one sees the designs: they will be too distracted by the messiness. Crisp, neat presentation, on the other hand, is almost invisible in that it doesn't detract from the quality of the design work. Once you are working as a designer, irrespective of the situation you are working in, the following need to be considered:

- whether the design has to be in repeat
- how the repeat is indicated
- the appropriate media
- whether colour chips are required
- whether the work should be mounted and, if so, in what format

- any special requirement of the client/studio/agent.

This chapter describes general guidelines for the finishing and presentation of design work; however, the practices of a studio or client for whom you are working should always take precedence.

How much do you have to paint up?

Keeping the format of designs consistent is a good idea; as stated, 32 cm x 32 cm is a widely accepted format, although a client might request a specific repeat size, which dictates the size of the painted up area. Formats for bedding and furnishings are often larger, because large motifs have been used. Obviously you will have to paint up a bigger area to show what the repeat is. Many designs for fashion fabrics will be small all-over patterns, where it may be necessary to only paint up, for example, 16 cm x 16 cm.

If the design has to be in repeat, make sure it is accurate, ready to be taken through to production. You need to include enough information to show how it repeats, so if you are working to a large repeat size, you have to paint up an area that is big enough to show everything. The simplest way to indicate repeat is to include half the motif on one side, and half on the other. That way, the client or buyer can see how the section you have painted will join up to other sections. Check that you have shown the repeat by looking at your design, and making sure that within the area you have painted up, you can find where a motif recurs, even if it is only a corner or edge

of the motif. The motif should recur accurately, indicating the repeat system you have used.

You don't paint up the actual repeat unit for presentation — you have to paint up an area that looks like a swatch of the fabric, which seemingly continues off the page, and can therefore have chopped-off motifs. The unit of repeat you draw up is for proofing of the design and the preparation of artwork for printing. Another way of indicating repeat, and ensuring that it is clear, is to continue the design outside the 32 cm square, which is painted up, with pencil outlines of the shapes. A quick (but expensive) alternative is to use colour photocopies to paste together a finished presentation. As the technology for colour matching on colour photocopies improves, this is more and more viable. You have to piece together the design, cutting around shapes on the copies (in a sort of cut-through line) so the copies and the original can be spliced together. Rather than a blunt cut, the cut-through means that the joining of the two is less obvious. An immediate advantage of this method (apart from time saving) is that of being able to present a larger design area for the client to see what the design will look like. This is particularly useful for designs that use large motifs, or have a big repeat, or when the client is paying by the hour and time becomes particularly important. See page 9 (left, middle) for a good example of using colour photocopies.

If you have been asked to do colourways, you don't have to paint up a 32 cm square for each colourway. Choose a part of the design that is indicative of the whole design and includes all colours. Usually, a 10 cm square will be sufficient. Make sure you accurately replace all the colours.

Painting up the design

Generally, a **finished design**, which is painted up in repeat, will serve as everybody's reference. It should have all the necessary alterations made, the correct colours, and be easily read by printers, or those doing the technical artwork who have to translate it. There should be no confusion about what the fabric will look like.

See Chapter 4 for further details about paper and media.

Selecting paper

Cartridge paper is acceptable for croquis designs and sketching, but the lighter weights tend to buckle with the use of ink and paint. Check any paper you plan to use for finished designs for its acceptance of wet media. Papers such as Arches, Fabriano, Michaelangelo, and Canson are more expensive than cartridge, but have superior qualities such as sizing, textures, and uniform absorbency, which make painting up easier. University is a flatter paper that is a bit cheaper and available in large format. This is useful when doing big repeats (sometimes this is a problem with other papers).

Often, finished designs are painted on a paper that has a slightly textured surface. The reason for this is two-fold: the texture duplicates the feel of fabric, and serves to disguise minor irregularities in the paint up. You can paint up the design on a coloured paper, but you have to be able to paint a flat background colour for those designs where the right colour is not available, or where white is included in the design.

Work on a piece of paper that is bigger than

the area you plan to paint up. When paper is painted right to the edges, it tends to curl. Some designers stick the paper to a flat board to hold it in place while they work on it. The advantage of this is that the board can be turned to make it easier to work on some areas that require directional brush marks, or are awkward to reach.

Transferring the design onto paper

Studios or designers have their own preferred method of transferring the pencil outlines of the design onto the paper used for the final paint up. Whichever method you use, before you start, put crosses at the repeat size, so you will be able to accurately transfer the repeat unit. If you have a lightbox, the design lines can be traced from the layout tracing when you put the design into repeat. If the paper you have chosen for the final paint up is too opaque to pick up detail, you can use the 'rub down' method. Use the tracing from the layout that has Top marked on it. Turn it over and, using a sharp, soft pencil, retrace the design on the back. Turn the tracing to the front again (Top will be facing the correct way). Place the tracing over the paper and, using the back of a spoon, with your thumb in the bowl to give even pressure, rub down the tracing, transferring the line drawn on the back onto the paper. A burnishing tool can be used instead of a spoon. You can rub down the line more than once. This is useful if you have to paint up more than one repeat or need to fill in edges of the design to show how it repeats. Line up the tracing accurately. If you have to transfer the line onto a dark coloured paper, back the tracing with white or light coloured conté pencil.

Choosing appropriate media

Design studios have their own preferences for media: some exclusively use inks, while others only use gouache. What they use will depend on the design process, after the design is handed over to the printer. If the fabric is printed in Australia, it is safe to say that gouache is the more common medium for presentation of designs, because that is what printers are used to. In Europe and Japan, however, inks are widely used because of the more intense colours and special effects with washes and blending that gouache does not allow. It is also important for designers to use a medium they feel comfortable with.

If you have have to put a croquis into repeat and paint it up as a finished design, you should, wherever possible, use the media and techniques you used to do the croquis. This will help to keep the feel of the croquis. You might have to control the use of media a bit more for the finished design.

Traditionally gouache has been the best alternative for duplicating pigment-printed fabric, while ink, because of its transparency, is used to simulate fabric printed with dye. Ink is useful where colours will overlap to produce other colours, and colours painted with ink do look richer than the matt finish of gouache. In the end, designers tend to choose media that suit their style and serve the needs of the company or clients they work for.

Colour that is screen printed onto the fabric is applied *flat*; there may be textured marks within the design area, and the design may not look flat, but printing is not handpainting, where irregularity in the application gives variation and tone

to the surface. Therefore, the colours on a finished design should be painted up flat, so the design duplicates what the fabric will look like and printers don't interpret messy paint ups as tonal effects. It is very difficult to get ink colours flat, so it is best to avoid using them on broad areas of colour, or where there is a strict requirement for flat colour.

Mixing and matching colours

Matching colours is largely a matter of experience, whether you are using ink or gouache. If you have been given the colours by the client, then the matching is vital. Test the colour you have mixed on the paper you are going to use, before you start painting up the design, and check the test in good light when it is dry. A cheap hair dryer is handy to speed up colour testing. It is safest to mix all the colours first, and paint up a quick sample section of the design, to check the colours look right with each other. Make sure you mix up enough colour to finish the design, and any possible coordinates, and to touch up areas if necessary. Mix up more than you think you will need — it is more economical to mix more and to save what you don't use, than it is to have to waste paint or ink trying to match the colour. Keep the colours in airtight containers, which prevent evaporation and spillage. Small clear containers with screw-top lids from fishing tackle shops are ideal. Label them with the design name, so they are easy to find if you have to use them again. Eventually you will have too many to keep, but keeping colours can save you a lot of time, particularly if you work on a series of designs, or for a client where you use a constant colour palette.

Brushes

Don't use your best brush for mixing: have a special brush that is soft, large and with a rounded end so it can be worked into the bottom and edges of the container. Look after your good brushes, using cheaper brushes for bleach or masking fluid. (See Chapter 4 for detail about brush types, page 57.)

There are two schools of thought on brushes for finished design work. One is to invest in good sable brushes and look after them. The other is to use acrylic fibre brushes and replace them regularly. Brushes made from synthetic fibres have more 'spring' in them; you decide whether this is a good thing for your way of painting.

Select a brush size and style consistent with the nature of the marks in your design. For fine line work, you might be using a 00; on other broader areas of the design, you might use a flat edge No. 6. Use commonsense: a large area will need a bigger brush you can load with colour, so you do not have to stop and start, which increases the likelihood of unevenness.

Before you start painting, test the brush as well as the colour on a strip of paper, which is the same as you are using for the design. Load the brush three-quarters of the way up, and gently press it against the edge of the container to wipe off the excess. Roll the tip of the brush onto the test paper and paint a line. It's a good idea when you are inexperienced to make your first mark on a scrap of paper each time you load the brush, in case it makes a blob.

Clean the brush every now and then while you are painting; this prevents the build up of

ink or paint in the head of the brush, which can affect the quality of the paint up. Get excess water out of the brush after you have rinsed it by blotting it with toilet paper.

Using gouache

Gouache is an expensive commodity, and the quality of the product improves with the price. Use it logically and economically. As a general rule, it is probably better to stick to one brand, as the colours will intermix better, although sometimes it is necessary to buy one particular brand for a special colour. White is added with gouache to make it lighter; adding water will only dilute the opacity. Black is used for shades and grey is used for tones.

The potential of gouache colours to dry flat varies, and some colours have more oil on the top, which should be removed before use. A small amount of white will often improve the consistency of colours straight from the tube, but this isn't always possible depending on the purity of colour required. Gouache straight from the tube should be mixed with just enough water to make it creamy and smooth so that it dries flat. Get rid of any lumps before you start painting. The consistency is the biggest single factor in determining whether or not the paint dries flat. If you are using colours that have been stored, stir the paint thoroughly, making sure it is completely fluid, before you use it, because heavier pigments will sink to the bottom. You need to work confidently and evenly with gouache — it is not a very forgiving medium for slow workers. Try not to overpaint areas too much, as it is more likely to dry streaky. Using gouache well is very much a matter of practice. You will have to be patient while you master it and be prepared to do things over again. Practice with small sections of the design, before you move onto the real thing; apart from ensuring that you have the colour right, and that you are using the right brush, it will build your confidence.

Gouache that has dried up can be reconstituted with clean water. Cover the dried up paint with water and leave it to soak, working a brush into it as it softens. This applies to paint that has dried up in the tube. If you are really desperate, cut open the tube, remove the paint, and soak it, before trying to mix it into a colour.

Poster paint can be used instead of gouache; it is cheaper but much coarser. If you have to use poster paint, use it throughout the whole design, because next to gouache it will *look* cheaper.

Painting backgrounds and blotches

Backgrounds and blotches are best painted with gouache, as it is even harder to get flat colour with ink. If you have to paint a solid ground colour, over which the design will be painted, use a ground brush, which is wide and flat. It will use a lot of colour, but requires fewer brush strokes and therefore is more likely to dry flat. Tape the paper in place, and start by painting broad vertical stripes down the page. Work broad horizontal stripes across the page, ensuring no paper shows through. Alternatively, you can wet the paper and, while it is slightly damp, paint the colour on, working quickly in stripes down and across. Be careful not to make puddles, which will happen if the paper is too wet.

Painting backgrounds is not advisable if the colour of the background is red based and lighter colours are to be painted over it. The red colours

tend to mix with the overpainted colours, and this seems to be unavoidable. Painting white over a coloured background is not satisfactory, as the white tends to get dirty from the intermixing.

Painting background or blotch colours that go around shapes is probably the most difficult thing to paint up. The blotch colour is best left till last, for several reasons: most designs will have white areas left, if you are working on white paper; left until last, you can ensure the colour of the background is correct in the context of the whole design and there is less likelihood of leaving greasy finger or hand marks. All of a blotch area should be painted at the one time and quickly. Paint in the boundaries of complex areas and then fill in the central area. Masks, stencils and Frisk film are useful when painting blotches (see pages 150–1).

Using inks

Inks tend to give a generally lighter colour feel to designs, because of their **translucence**. Colours are usually diluted with water to give lighter shades. Mix up a diluted black to make grey, which you can then use to make darker shades.

Inks are trickier to paint with than gouache as they are transparent and more likely to show streaks and unevenness. They also have a tendency to crawl, because they are more fluid than paint. The best way to avoid this is to choose the paper carefully, and to make sure that you don't have your brush too wet. Paper quality is vital with inks: absorbent papers like Canson and Arches are recommended, and any paper should be tested to make sure the inks don't crawl. The same rules for testing colours, selecting brushes, working smoothly and evenly apply, as for gouache. As inks are transparent, they are not suitable to paint over coloured backgrounds or on coloured papers. Take care with inks that the pencil lines don't show through the lighter shades — keep the pencil line as light and accurate as possible.

Fixing mistakes

If you make a mistake when painting on paper, it is possible to correct it, depending of course on how major the mistake is and if it is corrected as soon as possible. There are two ways of fixing mistakes.

1 Using toilet paper, absorb as much of the painted area as possible. With a clean brush and clean water, paint over the area, making it very wet. Soak up this again with toilet paper. Repeat until most of the paint is removed. A faint stain might be left — let it dry completely before repainting. This doesn't work on cartridge paper — only a good quality paper will withstand the constant wetting.

2 Use this method if the design area is impossible to fix using the first method. Cut out the damaged area from the design, and place a piece of the same paper underneath the cut-out area. If it is a blotch area, paint the replacement paper before placing underneath. With a fine hard pencil, trace the shape of the cut-out area onto the replacement paper, which will tell you what you have to paint. When you've painted it, tape the replacement paper to the reverse of the design. This will be less obvious if you cut a line that goes around the edge of a shape, where there is a natural break in the design.

When using ink, mistakes can be blotted off and repainted, if you get them quickly enough. Bleach can be used to remove spots of ink, but make sure the bleach has evaporated before repainting the area. Apply the bleach carefully with a cotton bud.

General handy tips

Keep a container of clean water handy to rinse your brushes in, and make sure it is stable so it won't be knocked over too easily. Contaminated water can quickly affect the colour you are painting, particularly if it is a light tint. A small bottle (with a nozzle) of clean water is good to have for adding drops of water to your gouache in the container or palette, if it starts to dry out. Don't add too much at a time or the colour will begin to dilute. Have the container of water and the colour as close as possible to the area you are painting. If you are always carrying your full brush across the design, it's bound to drip or splash.

Work from top left to bottom right as you are painting up the design, doing it colour by colour. This means that you never have your hand smudging wet paint. Rest your hand on a clean piece of paper while working so you don't leave a dirty mark or smudge the pencil outline.

Start with the lighter colours, in gouache or ink, and work through to the darker ones. If you do need to use an opaque white to cover a colour, use non-bleed or process white instead of white gouache. They give much better coverage. If the design has a blotch (background) colour, do this last.

If you are stopping and starting in painting up a design, make sure you stop within boundaries of a motif, rather than in the middle of a large area, where stopping will leave a line. Stand back every so often while you are painting to check the consistency of what you are doing. Make sure you haven't become sloppy with detail. Brush strokes, pressure, type of brush used, how you load the brush, what direction you are painting in — all these things affect the end result. If you are leaving the design unfinished, cover it, or put it away flat once it is dry.

Colour chips

You should also have colour chips of all the colours in the design. These should be neatly cut to about 3 cm square — cut them on top of a grid, with a sharp knife, not by eye. Colour chips should be kept for your own reference as well, and label them to show the design they were for, if you have sold the design, or if it was for a client. You might be asked to use those colours again for more design work and, rather than rely on memory, you should be able to look up your reference to check what they were. Colour chips should be presented in a straight line from left to right, with the predominant colour first and the colour with the least coverage on the right. If there are colourways, the replacements for each colour should be directly below. These can be on the back of the mount if they are too distracting on the front, or if there is no room for them. They are useful for telling the client and printers exactly how many printed colours are in a design. Include every printed colour, and do not include the fabric colour (usually white or cream).

Using masks and resists

Wax can be used as a resist in finished design work; it can be controlled quite well with care.

Masking fluid and Frisk film are very useful masks for producing finished design work. (See pages 73, 75.) Frisk film is ideal when you have to paint a blotch, and you want to protect the detailed design area you have painted. Masking fluid is good for textured effects and, with practice, is quite controllable.

Cut paper designs

Collage work is acceptable as finished design if the shapes have been '**intercut**'. If the design is based on flat areas of colour, and is not too detailed, this could be a good alternative to painting up. To intercut a design, cut shapes are inserted into exact cut-out areas of the design, so the collaged areas sit flush with the rest of the paper. If you aren't confident painting up flat backgrounds or blotches, this might be a good alternative in some designs.

Colour photocopies and computer printouts

Some companies are reluctant to accept colour photocopies and computer printouts as finished design, because of copyright problems. The implication for both is that multiple copies can be made. There are also restrictions on size with most accessible printers. However, as CATD becomes more commonly used, printouts will gain acceptance. Colour photocopies are used, as stated, to extend the design area presented in a finished design.

Mounting designs

Although mounting work can be seen as a waste of time and resources, simple flat mounting can give continuity to a folio, and ease of handling for looking through design work. Trim the designs so they are square. Use graph paper or cut on a gridded mat to do this; don't do it by eye. Use a sharp blade and a metal ruler to trim the designs to the correct size, so you don't spoil the work with jagged edges. Mount designs on white, off-white or fairly neutral boards or papers — avoid coloured or black board, as these can distort the colour sense of the design. Croquis can be trimmed and mounted on heavy cartridge, while finished designs are usually mounted on paste board, as they will receive more handling. Neatly flat mount the designs, but make sure the paper can easily be removed from the mount, in case the client wants to see it against another design or fabric. Use double-sided tape for the best results — a strip at the top and the bottom will hold it firmly, while allowing it to be removed. Boards might have to include coordinated designs or colourways and colour chips (which can be put on the reverse). In this case you would choose paste board or mount board, because of the extra weight. Colourways are mounted below the main design. Coordinates may or may not be presented on the same board as the main design, depending on how many there are.

Window mounting design work is rarely necessary, except for competitions and exhibitions.

Most clients will require information on the back of the design, such as the repeat size, the number of colours, and who you are, and where you can be contacted. The repeat size and number of colours are irrelevant if it is a croquis design.

Selling croquis designs

Some buyers prefer croquis, and many textile agents deal mostly in croquis designs, as they can be adapted to specified repeat sizes. Croquis are

quicker to produce and therefore cheaper to buy. They can use media more loosely and be sold on the basis of a concept or idea to be developed or refined later by a design studio. In Europe, the UK and the USA croquis on fabric are also sold; they might be handpainted ideas or printed images that have been trialled on fabric or samples that include stitch. This is less common in Australia, but might be of interest to designers who have a particular empathy with fabric or have access to print or dye facilities. Croquis on fabric are a great vehicle for selling textile design ideas; after all, the designs eventually get to fabric, so it is an obvious way of selling their potential.

Keeping a record of designs

You should document the work you do for clients, by either photocopying it, or by painting up a little more than necessary and trimming it off the main design. This record of the design should be filed; include details of the date and the client the work was sold to. You cannot sell the same design to two people, but as the incidence of copyright litigation increases, it is worth keeping a record to prove that you have produced the designs. Keep a record of the colour chips for each design, as you cannot rely on memory to produce coordinates for an old design, or to use the same colours again for a client. Write down what you used to mix each colour. This seems tedious, but will save you a lot of time.

When selling designs, it is worth getting the buyer to sign an agreement, which states they will use the design for a nominated purpose, such as for boxer shorts. This will not always be possible, as some companies buy designs at trade fairs with no exact purpose in mind. If they wish

to use your design as a letterhead or placement print, then they must notify you, and ask permission, in which case a fee may be negotiated.

What to put in a folio

Art and design courses at tertiary level usually request that prospective students present a folio of work at an interview when applying for a course. Job interviews for designers always include the presentation of a folio of work, which demonstrates to the employer what your capabilities are. If you are working freelance, at some stage you will probably have to take around a folio of designs to show potential clients. Eventually, companies that like the style of your work will contact you when they are putting together their ranges, but in the beginning you will have to promote your work so they get to know you.

From the very early stages of launching yourself as a designer, you will be involved in selling yourself via a folio of work. Select the work according to the situation; you should find out as much as possible about that situation before you present your work. If you are applying for a course, find out what the interviewers will be looking for and familiarise yourself with the sort of work produced by students in the course. See if the institution has an Open Day or holds exhibitions of student work.

If you are applying for a job, find out what the company produces, and where you can go to see the fabrics or products it manufactures. Before you take your folio to prospective clients, find out what each place specialises in. A folio for a manufacturer of upmarket bed linen might need to be quite different from that for a company that specialises in boxer shorts for the lower end of

Sivly Cao
3rd year student, RMIT
Colour chips are useful for showing the client and printer exactly how many printed colours there are in the design.

the market. Obviously, some skills will always need to be demonstrated: paint up technique and the ability to put designs into repeat, for example.

If you end up working with a client, you will get to know what they are interested in, and will therefore know what to take. Selecting work for a folio is mostly relevant when you are seeing a client for the first time. In this situation, your selection should highlight your strengths, and show the breadth of your skill. Think about what will sell you best in the context in which your folio will be viewed. A series of designs or croquis can often have more impact than single designs from ten different series: as a group, the designs will have more impact, and they show that you can work around a theme. Even the order in which you put the work in the folio is important. Don't just throw in everything and hope for the best. The sequence should be organised by theme, colour, or size and, between design series, include a few show-stoppers to arrest the attention of

the client/buyer/interviewer. The addition of a concept or story board to explain a design theme is another good way to break up groups of designs, or introduce a new theme. What have you got that the other candidates don't have? You need to include a mixture of croquis and finished designs, which show that you can explore ideas as well as finish them ready for production.

You need to have something to put your design work in, to keep it flat and enable the person looking at it to do so easily. Portfolios are available in 'A' sizes, and the more expensive ones have a hard exterior, with a clip system for inserting plastic sleeves and a zip, which extends over three sides. This ensures that the work doesn't fall out. Some designers prefer folios with a softer waterproof fabric exterior, without the clips for insertion of sleeves. They are lighter to carry around, for a start, and once the work has been looked at in sequence, the client can easily pull out particular designs they like. Size A1 is probably the most useful folio, as it will take large

Sivly Cao

3rd year student, RMIT
*Using gouache requires skill
and patience. It is very much
a matter of 'practice makes
perfect'.*

format work, but if you are working on fashion fabrics, an A2 size will probably be sufficient. It is a good idea to have your designs in plastic sleeves, as this protects the paper from continued handling. The client can always remove the designs from the sleeves to check colours or to hold against fabrics.

Generally, all design work should be presented flat. Work that has been rolled up is hard to view, as is work that is creased from folding.

Summary

Presentation of work can be instrumental in getting you the job or selling your design. Neat presentation is far more invisible than messy mounts or dog-eared paper. If you are working in a studio, you will probably not have to worry about the presentation or selling of designs; the studio designers will have their own way of

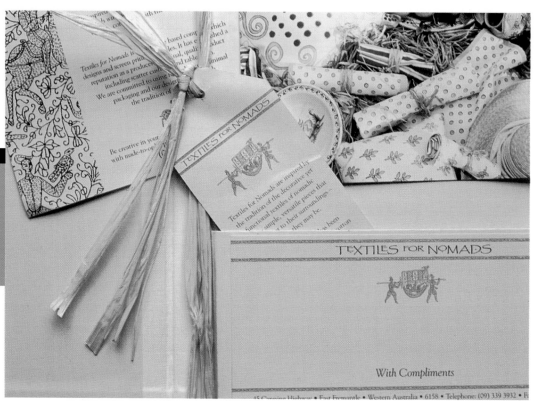

Jemma Dacre

Designer, Textiles for
Nomads
*A presentation folder, which
contains information and
photographs of the range, in
a style that is in keeping with
the product.*

communicating with clients or with the printers. Finishing the design, or painting it up in repeat, in the correct colours, to a specific size, could very well be the last you see of it. However, if you are involved in a studio, which is attached to a factory where the fabric will be printed, your role in the process might not be over.

Once the design is finished, it has to go through the process of being colour separated and translated into silk screen positives, ready to go onto rotary or **flat bed screens** so it can be printed. These processes can all be done by hand, or they can all be done electronically. The principle remains much the same with either method.

The fabric design is settled by now; the repeat, the colours, and the nature of the marks are finalised. This is the finished design presented to the people who handle the technical artwork — there is no looking back.

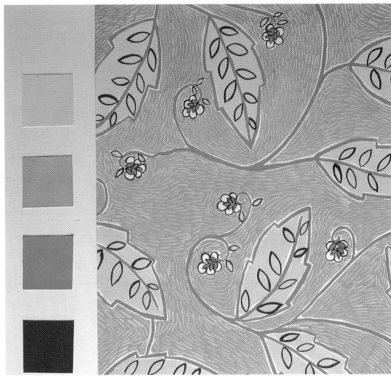

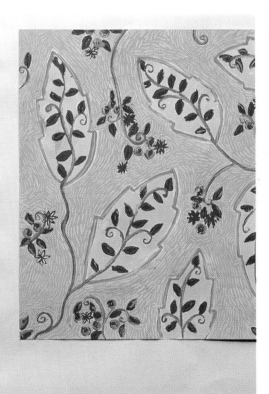

Natalie Ryan

2nd year student, RMIT
Above and left: *croquis and finished design for college project brief, 'Florals for bedding'.*

Fabrics

8

Matthew Flinn

Designer and lecturer
*'Roses': silk printed with
reactive dyes.*

157

An appreciation and understanding of fabrics is an asset to a textile designer — a good choice of fabric can enhance a design and, in turn, make the printed fabric and the product for which it is used, more attractive. In some companies, designers will not have any say in the fabric used for printing their design, but in other situations it will be part of textile designers' jobs to put together concept and story boards, where fabric selection plays an important role in the promotion of a range. To do this well, designers need to be aware of the sort of fabrics, what the different types are appropriate for, whether certain fabrics are suitable for particular products, or for printing. For those who are designer-makers, fabric selection is vital. The printed fabric, which is sold to a customer, should conform to certain expectations the customer will have, such as that it can be washed (unless stated otherwise) without the print coming off, or the colour running, and that it will last a reasonable length of time if looked after well. These things have to be tested with each new combination of fabric, print paste and end-use. The three are inextricably linked once a design goes into production; a favourable reaction to the design is dependent to a large extent on the success or failure of the combination.

This chapter is not intended to be an exhaustive study of fibres and fabrics, but rather a practical guide to the selection of appropriate fabrics and what to print them with. The science of textiles is a specialist area of

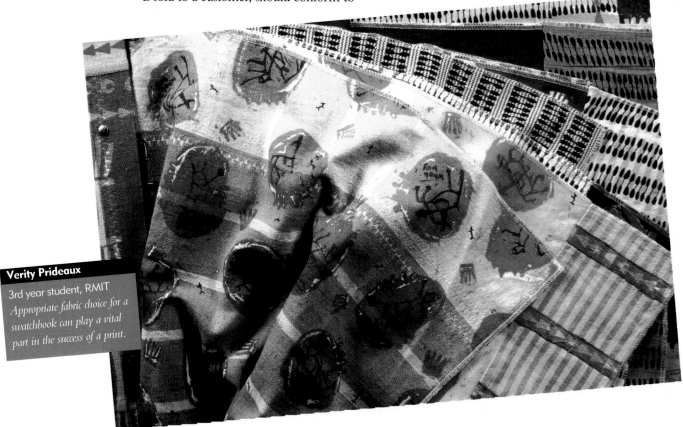

Verity Prideaux

3rd year student, RMIT

Appropriate fabric choice for a swatchbook can play a vital part in the success of a print.

study; the textile industry relies as much on its technicians as its designers to produce a good quality product. If the structure or composition of fabrics, or the chemistry of dyes and how they work becomes your primary interest, rather than the decoration of fabrics, then there are courses available that lead to employment in a technical area of the textile industry (see Chapter 13, page 298).

History of fabrics

The history of textiles, and specifically the development and production of cloth and dyes, mirrors the social, political and technological history of manufacturing countries throughout the world. Some of the earliest and most important trading commodities between countries were textiles. The earliest known fragments of fabrics, mostly cotton and linen, have been found in India and Egypt and date as far back as 3000 to 4000 years ago. The manufacturing processes for textiles were jealously guarded by older civilisations knowing that textiles in the old world meant wealth and patronage. Naturally 18th century colonisation of countries also meant the appropriation of their techniques and skills to be adapted for industrial mechanisation. As world population grew in the 19th century so did the need for textiles. The industrial age meant that workers had to come to cities to work in the mills and factories — the nature of society was changing. The textile industry of the 19th century created the industrial revolution required for manufacturing the textile goods; the finished cloth could then be exported to those countries supplying the raw materials for cotton, silk and linen produc-

tion. Most of what we know today about textile production has come from 19th and 20th century chemical, technical and design discoveries.

Where to buy fabric

Every city in the world will have odd places that sell interesting fabrics — shops that have been there forever, just like the fabrics they have hidden out the back. When you are looking for fabrics, think about whether it is important to have a regular supply of a certain fabric, or whether you are content with small quantities, which you may never get again. This is determined by the end-use: if you are producing silk scarves, which are sold through retail outlets, you need to have a regular supply of silk, so you probably need to find a wholesaler that will be able to supply you regularly.

Some wholesalers specialise in fabrics that are PFD or 'prepared for dyeing' and, by implication, printing. If you can get this sort of information from the supplier, it cuts out some testing, and ensures there are no finishes on the fabric that will make the print bleed or wash off after heat setting. Some wholesalers specialise in the supply of particular fabrics, such as silk or wool; these places are usually good sources of information about those fabrics and their special properties. One disadvantage of going to a wholesaler is that usually you can't buy a couple of metres — there will be a minimum purchase of a roll or half roll. The advantage, of course, is the price is lower. (See the list of suppliers on page 308.)

Fabric, of course, can be bought through retail outlets, where it is possible the fabric content will be on a label. Always keep looking for fabrics

that might be useful — it's a good idea to keep a book that has samples in it, with fabric content, price, and where it was purchased from.

If continuity of supply is not an issue, be resourceful: get samples of any fabrics from shops, and test their suitability for printing. Look at second-hand shops and markets for fabrics; look for things that you might be able to over-print or dye.

Selecting fabric

There are a few things to take into consideration before you even begin to think about whether or not a fabric can be printed. There are thousands of different fabrics to choose from, and most of them are unsuitable for printing. (More details on characteristics of specific fabrics are given in this chapter.) When selecting fabric you need to consider the following.

- The aesthetic appeal of a fabric, particularly when designing for the fashion market. Trends in fashion will dictate the seasonal use of particular fabrics. Prints will often be accompanied by plain coordinates, so it is worth finding out what the season's popular fabrics will be.
- Market trends with fabric developments and styling — specialist textile magazines are important to look at, especially if you are working in industry.

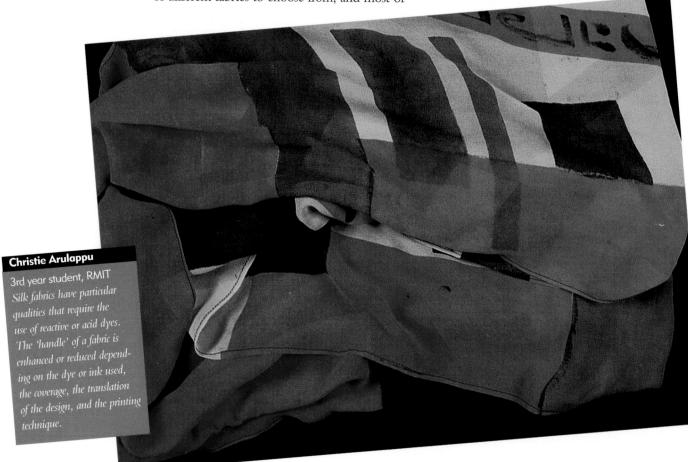

Christie Arulappu
3rd year student, RMIT
Silk fabrics have particular qualities that require the use of reactive or acid dyes. The 'handle' of a fabric is enhanced or reduced depending on the dye or ink used, the coverage, the translation of the design, and the printing technique.

Printed samples to assess suitability for printing.

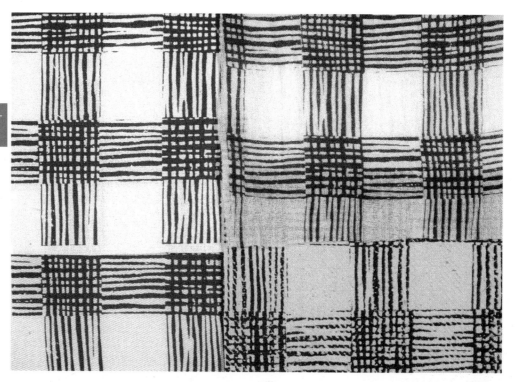

Printed pigment ink on natural fabrics.

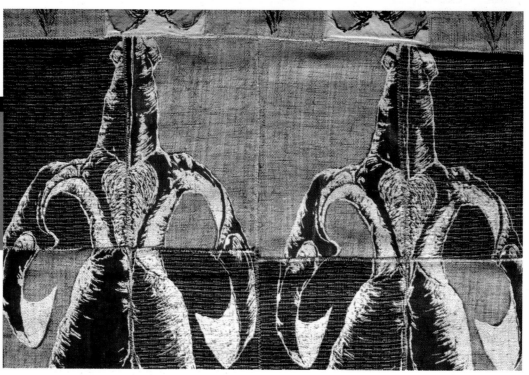

Fiona McLean

1st year student, RMIT
End product is essential to know when selecting fabrics, as some will suit the purpose of your design effect better than others. In this example the fabric is bleached to achieve a washed out look.

- End product is essential to know when selecting fabrics, as some will suit the purpose better than others. If the fabric is for clothing, it will need to have different qualities from fabric for upholstery. Even if you are working for yourself, producing limited runs of printed fabric, customers are going to ask your advice on suitability of fabrics.

- The nature of your print: if it has a lot of fine line work, it is unlikely that a coarsely woven fabric would do the print justice. If the print is very busy, it may not be wise to choose a heavily textured fabric to print on, but a textured fabric might be ideal for adding interest to a print with large flat areas of colour. Does your print need the rich colours and lustrous finish of a silk, or the warm softness of wool? What would show off the print to best advantage?

- As usual, cost will be a dictating factor in choice of fabric. Don't be distracted by a cheap fabric, as it could be false economy. If you are printing and selling fabric, customers will not be happy about buying fabric where the print outlasts the actual fibres. Fabric printed by hand is quite labour intensive when produced in small quantities — make sure the fabric you choose is up to scratch, and that it

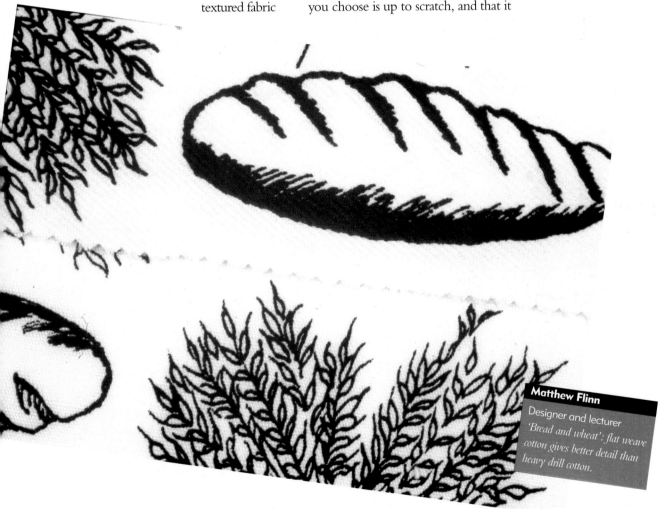

Matthew Flinn
Designer and lecturer
'Bread and wheat': flat weave cotton gives better detail than heavy drill cotton.

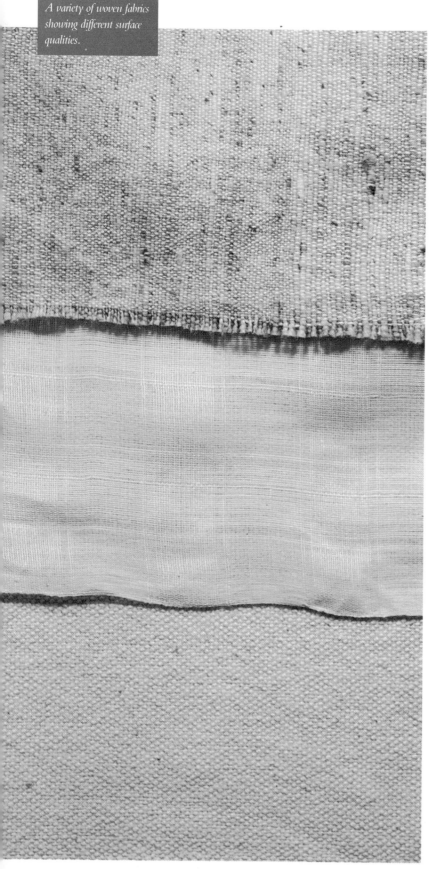

A variety of woven fabrics showing different surface qualities.

enhances rather than cheapens your design or product.

After you have established what qualities you need in a fabric, you have to determine whether it is suitable for printing:

- Generally, natural fibres are better for printing, particularly for small productions or at schools, where the fabric will be handprinted. However, you still need to check for finishes on the fabric that will affect the print.

- Lots of fabrics are **blends**, many of which combine the better features of both types of fabric. For example, polyester will be added to cotton, to improve the crease resistance and to make it dry faster. Check the percentage of synthetic fibre in the fabric and, if you have to use a blend, try to make sure the balance is in favour of the natural fibre, for example 70 per cent cotton, 30 per cent polyester. Even so, mixtures have to be tested, as a small amount of synthetic fibre can mean the fabric is unsuitable for a particular technique or dyestuff.

- Make sure you know the composition of the fabric. The burn test described on page 181 of this chapter is a good quick way of ascertaining this. There is also a fibre identification dye called Ultrastain; white fabric is boiled with dye, and then identified according to what colour it becomes. Generally, if the composition is on a label on a roll of fabric, you can trust that it is correct, although often this label will not tell you whether or not the fabric has a finish on it. Some finishes affect the stability of the print or cause the print to **bleed**. Don't rely on salespeople's information on fabric composition; they are unlikely to be aware of the implications of misinforming you.

- Some print techniques will only work on particular fabrics. Make sure you match the technique or dye to be used with an appropriate fabric. This book deals with processes and dyestuffs that are appropriate for use on natural fibres. Other techniques and dyes work on particular fabrics too. Discharge printing requires the fabric to be coloured with particular dyes; **transfer printing** or **sublistatic printing** will only work on synthetic fibres, and ***devoré*** (or burn out) will only work on the right combination of natural and synthetic fibres.

- One way of minimising risk, when using expensive fabrics, is to test everything before you buy several metres. You can't tell how the fabric will print from looking at it.

- Most fabrics to be printed should be white, off-white, natural or light coloured. This is because of what they are printed with: dyes are transparent, and therefore absorb the fabric colour into the print colour, and the most practical and economical bases for pigment printing are also transparent. There are products available for printing light on dark, but they pose other problems of production and fastness.

- Don't make things too hard for yourself in the selection of fabric. While you are learning about printing, choose fabrics that will not be too complex to print, such as a fairly flat cotton. Wools and synthetic fabrics are much harder to print, as there are more variables, and a more complex method of printing, and therefore more things can go wrong.

- Be wary of using fabrics that are very heavily textured or have a deep **twill**. The problem for inexperienced printers is making sure the print has even penetration into the fabric.

Fabrics
characteristics
and uses

Fabrics described in this section are those most commonly used to print on, but the list is not intended to be exhaustive. The details given relate to the fibre type, the identifying characteristics, and the use to which the fabric might be put. The emphasis is on the special properties of the fabrics that relate to printing. Other texts, which give more technical information and cover a wide range of fabrics, are listed in the Bibliography on page 307.

Fabrics are natural or synthetic, or a mixture of the two. Natural fabrics are either **cellulosic** (from plants) or **protein based** (from animals), or made from **regenerated cellulose fibre** (wood pulp). Synthetic fabrics are made from mineral sources (petroleum by-products). Fabrics can be broadly classified as vegetable,

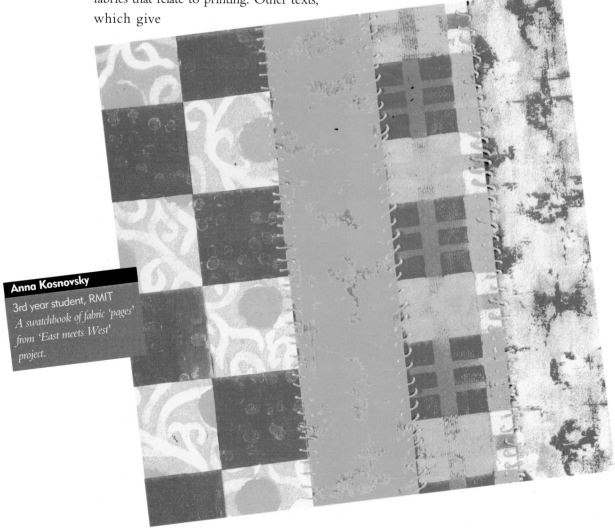

Anna Kosnovsky
3rd year student, RMIT
A swatchbook of fabric 'pages' from 'East meets West' project.

.nimal or mineral based. It is useful to know which category fabrics belong to because this determines the class of dye appropriate for printing.

Cotton *cellulosic*

Cotton is a natural vegetable fibre produced from the cotton plant. Its main features are that it is absorbent and cool, which makes it comfortable to wear, and it is durable. The quality of the fabric depends on the length of the fibres used — the longer the fibres, the stronger and more attractive the fabric is, for example, Egyptian cotton. Cotton is manufactured in a number of formats for different end-uses: the finer cotton yarns are lighter and made into woven fabrics such as poplins, voiles and fine cotton jersey for shirting and dress fabrics. The coarser yarns are used for denim and drill fabrics, which are heavier and harder wearing, for example, jeans and work-clothes. Cotton yarn is blended with other fibres such as polyester or viscose to create fabrics that have specific handling characteristics such as reduced creasing, softer handle and drip dry qualities, or, with silk, to give the fabric a sheen. Be careful of very cheap cotton, as it could contain other fibres that will affect printing. Cotton is one of the best fabrics to print on with pigment, because of its absorbency and the fact that cotton cloth is often a fairly flat weave. The molecular structure of raw or unfinished cotton is such that it does not accept dye as readily as, for example, silk. Mercerisation is a process that helps increase cotton's acceptance of dye. Additives may have to be used in the print pastes for cotton blends, or very thick or fine fabrics. Another feature of cotton is that it will retain its whiteness and has good scorch resistance. The Australian Cotton Foundation is a useful organisation to contact for further information.

A popular development has been that of cotton lycra; consumer demand for natural fibres has led to this fabric, which, with the addition of elasticity to all the characteristics of cotton, is ideal for casual clothing and sportswear. Most cotton lycra is 95 per cent cotton/5 per cent lycra, so reactive dyes work well on this fabric as well as pigments.

Uses

Cotton is widely used for garments, because it is hard wearing, and available in light and heavy weights, from crisp poplins to heavy drills and denims. Its capacity to absorb perspiration makes it cool to wear. The disadvantages are that it takes a long time to dry and requires more ironing, although that can be improved by the application of some finishes or by blending it with synthetics. As cotton washes well, withstands repeated washing, retains its whiteness, and absorbs perspiration, it is widely used in bedding, particularly when blended with polyester to improve drying and lessen the ironing required. As an upholstery fabric, cotton in heavier weights (for example cotton moleskin) is used, more because it prints very well than for other properties. Although it is strong, slowness to dry means that it may not clean well; treatments are available that can make the fabric more resistant to staining, but these can make the fabric unsuitable for printing. Cottons with a definite twill do not make good upholstery fabrics, particularly when printed, as they show abrasion marks very quickly. Cotton is appropriate in lighter weight curtaining, where care must be taken to ensure that print has good light-fastness properties.

Linen *cellulosic*

Another natural vegetable fibre derived from the flax plant, linen is gaining a more popular appeal especially for garments. Linen is often identified because it is easily crushed, and some fashion designers deliberately promote this characteristic as a sign of pure linen. However, it is often blended with cotton, silk or viscose to create a softer handle and reduce its creasing qualities. Linen has good absorbency, launders well, is a strong fibre that strengthens when wet, and is lint free. When printing linen, it is advisable to iron the fabric to remove any creases. Pigment and reactive dyestuffs work well on this fabric.

Andrea McNamara
Designer and lecturer
'Indiprint': linen union cloth.

Uses

Linen and linen blends are popular **fashion fabrics,** because of the characteristics outlined. In heavier weights, it is good for upholstery because of its strength, and is often blended with cotton for a good base fabric for print. Linen is widely used in tea towels; although it is not as absorbent as cotton, it does not leave lint on glasses and plates. Its other popular use is for bed and table linen; historically the word 'linen' has been used to describe all bedding and napery, including the linen press where it is stored.

Wool *protein*

All animal hair fibres are based on the protein keratin. Wool is one of the oldest fabrics in the world — domestic sheep are known to date back to 3000BC when the first sheep was taken to Europe for the improving of local wild stock, which were more like deer and produced very little wool. Sheep were imported into Australia at the beginning of white settlement and we now produce some of the finest merino wool in the world. Wool may be spun into two types of yarn, woollen and worsted. Woollen yarns are used for blankets and tweeds, while worsted yarns are finer and used for fashion apparel. Australia, like other wool growing countries, has a Wool Corporation to control and monitor the industry: wool is strictly marketed as Pure New Wool, or blended. The particular qualities of wool are that it is a good insulator, and has good absorbency — in blended fabrics, wool is used for warmth. It also does not ignite or burn easily. Wool can be difficult to print, as ideally it should be 'chlorinated' in order for the fibres to accept the dye, and it is quite difficult when buying wool to find out if it has been through this process. It is best to buy wool from specialists in fabrics prepared for

Patrick Snelling
Designer and lecturer
Australian wool printed with reactive dyes.

printing. It is expensive to print, in industry as well as for small studios, especially the finer qualities such as Cool Wool and **challis**. Reactive and acid dyes are recommended; pigment can be used but only for line work or metallic printing, and should be avoided where the particular qualities of the fabric will be destroyed.

Uses

Wool is, of course, widely used as a garment fabric, because of its warmth. Strong worsted yarns are good for suit fabrics, while other woollen yarns are soft, like knitting wools. Wool is a poor conductor of heat; its insulating value comes from the amount of air trapped between the fibres. It is absorbent, which means it feels good to wear. The fibres have a certain amount of elasticity, which minimises creasing. Care has to be taken with washing woollen fabrics, as sudden changes of temperature means likely felting or shrinking. Wool is traditionally used in carpets and rugs, because it is resilient and has high stain resistance, and is often blended with synthetics like nylon, which keeps the price down. Wool is used in woven and knitted upholstery fabrics, where again it is often blended with hard wearing synthetics to keep it economical to produce. Because of the prohibitive cost of printing wool, it is usually seen plain or in woven or knitted patterns, particularly in furnishings.

Silk *protein*

Silk is produced from the cocoons of silkworms, and is a strong, lustrous fabric, still manufactured using traditional techniques invented by the Chinese about 2640BC. It is more economical to produce in countries such as China, India and Thailand, because of the intensive labour involved in the production of silk (sericulture). The fabric is absorbent and therefore takes dye very well; the lustre and feel of the fabric and the intensity of printed colours tend to enhance designs. Silk is surprisingly durable and resilient, although some fabrics made from silk thread are very light, and therefore delicate. The variety of silks is enormous, ranging from heavily slubbed natural coloured silk for furnishing use to ultra fine chiffons and organzas for apparel. Silk yarn is blended with other fibres such as wool, cotton and viscose to improve handle and look. Reactive and acid dyestuffs are recommended for the printing of silk. Pigment can be used for minimal line work or where a metallic colouring is required but, because of its matt finish, it can spoil the appearance of the fabric and the resulting stiffness can affect the handle.

Uses

The appearance of silk fabrics dictates its use in fashion, where its handle, lustre and strong colours when dyed mean that it can have great dramatic effect. It tends to be marketed as a luxury fabric, and silk garments are usually expensive because of the cost of producing the fabric. The fabrics are beautiful, ranging from sheer chiffons, to silk jerseys for lingerie, and heavier weight woven silks. They require careful handling when washing and do not iron easily, hence dry cleaning is often recommended. (An old trick for ironing silk is to put the fabric in the fridge for an hour before ironing — it will press much better when it is cold.) Sunlight and perspiration can discolour silk. Its appearance makes it popular for cushions, but its other characteristics make it unsuitable for upholstery.

Viscose or cuprammonium rayon/acetate rayon *regenerated cellulosic*

These are artificial fibres, as they are not grown from a particular plant, or produced from an animal; they are derived from wood pulp. Acetate rayon is a cellulose acetate, and belongs more with synthetic fabrics, because it includes petroleum by-products (acetic acid, acetic anhydride and acetone) in its composition. Viscose and cuprammonium rayons belong with cellulosic fibres because they are made from wood pulp. The distinction is important when determining what to print with. They are inexpensive fabrics that are often blended with other fabrics, and are found in all aspects of textile production ranging from fashion to carpets, tyre manufacture to furnishing. The viscose or rayon content in a mixed fabric will contribute lustre, durability and easy acceptance of dye. Viscose rayon is the most commonly used fabric blend for textile printing. Pigment and reactive dyestuffs are recommended for the printing of viscose rayon. Synthetic fixers are required in the print paste mixtures.

Uses

Because of the versatility of viscose, it is found in an enormous range of fabrics and products, ranging from lingerie to carpets, lining fabrics to heavy velvets. As mentioned, viscose rayon is the fabric most likely to be printed and used for fashion. It has been called the 'universal fibre' because of the breadth of its application. Modified viscose fibres are common in carpets, and viscose blends are used for upholstery fabrics; in both cases, they are a hard wearing fibre, which keeps the cost down. Acetates are used in fashion, in satins, brocades, taffetas or organzas, where appearance is important.

Synthetic fabrics are made from synthesised polymers, rather than from naturally occurring plant or animal fibres. The most useful synthetic fabrics for a textile printer are nylon and polyester.

Nylon *polyamide*

Produced commercially by Du Pont in 1943, nylon was the first totally synthetic fibre made from phenol then later petroleum by-products. It has fallen from favour with fashion companies, because it is easily discoloured by perspiration and deodorants. It is printed with acid, disperse dyes (transfer printing) and pigment, although the pigment can give a stiff handle if the print has too much coverage. One of the most popular uses of nylon is lycra (*elastomeric nylon*). Derived from two words, elastic and polymer, this fabric was developed for lingerie, sportswear, underwear, ski and swimwear. It is resistant to perspiration and suntan oils. Care has to be taken when printing the fabric due to its elasticity. Because of its stretch capabilities and end usage, acid or disperse dyes are recommended for printing. In handprinting, some dyeback (colouring of unprinted fabric) may occur with certain dye colours when washing out the fabric after steaming. Pigments can be used if it is necessary to have an opaque or metallic print, although the result is not as permanent as dye. Sometimes it is necessary to add a stretch auxiliary to the print paste, as well as synthetic fixer.

Uses

Nylon is used in numerous capacities, the most successful is stockings and tights because it has inherent elasticity and will not shrink. It has very low absorbency, so dries quickly and doesn't need ironing, making it ideal for swimwear, when used with lycra. It is less popular for clothing, with the general trend towards the comfort of natural fibres rather than synthetic. It has more applications in the area of specialist fabrics for industrial uses because of its chemical inertness. It is widely used in carpets because it is hard wearing and cheaper, although it is more successful when blended, as it tends to generate static when used alone. Nylon is used in knitted upholstery fabrics, which will be exposed to hard wear and tear.

Matthew Flinn
Designer and lecturer
Printed tights; metallic and pigment ink on nylon lycra.

Polyester *polyester*

Polyester is most commonly found in blends, where it is used to reduce creasing, soften handle and add drip dry qualities. Cotton/polyester blends are very popular for bed linen, where the combination of fibre means the sheets will wash and dry quickly, and not require ironing. Fabrics with a high percentage of polyester tend to discolour easily — white will develop a greyish look after washing several times. Pigment tends to bleed on polyester fabrics, and the print paste requires additives to prevent that, as well as fixers to help the fastness of the print.

Uses

Polyester can be found in fabrics used for garments of all types, particularly in blends, because it has low absorbency and therefore dries quickly, requiring minimum ironing. It is less popular now on its own, again because of the increased popularity of natural fibres.

There are many more synthetic fabrics and new fabrics being manufactured all the time, but those fabrics of most use for printing are the natural ones, or those mixed with a small percentage of synthetics. The natural fabrics, apart from their general popularity and inherent characteristics, have better absorbency than synthetic fabrics, and will more readily accept pigment or dye.

Fabric finishes and treatments

Once you have established the fabric you want to use, you have to see whether it is suitable for printing. There are many stages through which fabric goes, before it gets anywhere near a shop or wholesaler, and it's useful to know about these processes and how they affect the cloth.

When the fabric comes off the loom or knitting machine it is not necessarily in a suitable state for printing or dyeing. There are natural impurities such as waxes in cotton, fats and salts in wool, size and starches in silk, and machinery oil and dirt in viscose and synthetics. These have to be removed for the even printing and dyeing of cloth. The following sequence refers to the preparation of white or natural fabrics only.

Singeing

The fabric passes through hot plates to remove hair and projecting fibres. This process is for cotton only.

Desizing

Size, which can be starch, gum, gelatine or synthetic, is added to certain yarns prior to weaving or knitting. It increases the strength of the fibre during the weaving/knitting process. It is removed by water or special enzymes. Calico is one fabric commonly purchased with the size still in it. This can be removed in a hot wash and should be done prior to printing.

Scouring

Scouring is used to remove impurities. This involves the heating of the fabric in alkaline solutions and, in the case of wool and silk fabrics, has to be done carefully. In industry, chemical scouring treatments using solvents are used to extract impurities.

Bleaching

Bleaching is used to obtain whiteness in fabric to make it satisfactory for dyeing. Using the correct bleaching process is important for intended dyeing and printing applications. Different bleaching treatments are used for cotton, synthetics, wool and silk. There is no permanent bleaching process for wool — it will always revert back to a natural creamy colour due to atmospheric oxygen, moisture and pollutants. Synthetic fibres can be bleached, although they are often white enough for the dyeing process.

Chlorination

Chlorination is used to improve the stability of the fabric, by reducing its felting properties so it is less likely to shrink. The chlorination process makes the wool have better uptake of dye, but also makes the fabric feel harsher. There are specialist print pastes that print unchlorinated wool but these are not widely available.

Mercerising

Mercerising is used extensively with cotton processing and involves treating the cotton under

tension with alkali solutions such as sodium hydroxide. This causes the fabric to develop a lustre and an increased affinity for dyestuffs, which helps with uniform dyeing. It actually changes the molecular structure of the fibres, so it accepts dye more readily.

The next stage is for the fabric to be dyed in high pressure vats. If it is to remain white or unbleached, it would move on to some form of finishing. After it has been dyed, most fabric will also go through further finishing processes.

Stentering

The fabric is pinned and stretched and heat set to correct its width and length and to align the warp threads. When you buy fabric you will see a row of pinholes down both sides of the fabric from the stentering process; these can help you determine the correct face side of the fabric to print on.

Calendering

The fabric is passed through a series of heated rollers under pressure, which causes a glazed effect on the fabric surface. The thickness of the fabric can be altered at this stage: calendering will reduce it or the use of card wires or teasles will raise or increase it.

Milling

This process is used in wool production where the felting of wool causes the fabric to matt together. Milling uses moisture, heat and pressure to improve the handle of the fabric.

Softening

This finish is used for apparel fabrics but is not usually permanent.

Embossing

Under pressure and heat, engraved rollers imprint a design or woven effect onto the cloth. This is more effective with thermoplastic fabrics, which can be moulded by heat and then harden during cooling, thereby retaining the design better.

Laminating

The fabric is coated with a plastic film, which is heat sealed to the surface. This is useful for sports bags or tablecloths.

Bonding

Two fabrics with different properties are heat bonded together with adhesive or foam. Some curtain fabrics have this finishing for insulation purposes, or fabrics for tablecloths might have a non-slip backing bonded to them.

Flame proofing

A chemical substance is applied to the fabric surface to reduce the capacity of the fabric to burn. This is a useful finish for children's nightwear and safety garments, although the effectiveness can be reduced by washing.

Waterproofing

Fabrics can be made waterproof or water repellent. Drizabone coats have oil impregnated in the fabric so they repel moisture. Scotchguard is another form of repellent used on upholstery; the fabric can be treated prior to being used or the piece of furniture can be treated after it has been upholstered.

Moth proofing

An insect repellent called Permethrin is applied to the fabric. This is especially useful for wool and silk fabrics kept in storage, or where a fabric must be archivally sound.

Anti-mildew and rot

This is not common as a finish on apparel fabrics and is mostly used for industrial textile applications and products such as awnings and blinds.

Resin finishes

Resin finishes are applied to many fabrics to improve the look of them. They add a sheen or polished look to the fabric; most resin treated fabrics are not suitable for printing.

Optical brightening agents (OBAs)

Some fabrics are further processed using OBAs. These are colourless dyes but are not bleaches. They are fluorescent and react to ultra violet light, making white fabrics look even whiter.

Most domestic detergents have these brighteners for normal washing. The main problem with fabrics and particularly T-shirts, which have been finished with OBAs, is that there is a greater likelihood of the fabric scorching while a print is being heat set.

Often, there is no way of telling what finish, if any, a fabric has on it. Your main concern should be whether or not the fabric can be printed and the best and safest way to try it is by testing.

Dye or pigment?

Fabric can be printed using either pigment concentrates in a base, or with dyes in a thickener. Pigment or dye is the colour component, and the base or thickener is what the colour is put in to print it on the fabric. Whether you choose to print with pigment or dye depends on the fabric, the print, the end-use to which the fabric will be put, the cost and equipment available.

The essential difference between the two is that pigment has no chemical affinity with the cloth, and therefore the print remains on the surface of the fibres. Dye, on the other hand, must have an affinity with the fabric on which it is printed, in order to work at all. Certain dyes are suitable for certain fabrics, whereas, in theory at least, pigment can be printed on any fabric.

Pigment printing is easier as the pigments are put into a base, mixed until the colour is right, and printed onto the fabric. The colour is tested by printing a small sample on the fabric to be used, drying it and checking it. It is altered by adding more pigment or more base. The fabric is printed and when the print is dry it has to be heat cured by dry heat so it is wash fast. Because the print sits on the surface of the fabric, it can stiffen the fabric and spoil its handle, depending on the quality of the base used and the amount of coverage of the print. The print will also be prone to poor rub fastness. The advantage of printing with pigment is that it is a process that is very much 'what you see is what you get'.

Dyes, however, are dissolved, mixed into the appropriate thickener, and printed. The process of getting the right colour usually involves extensive sampling, as the colour is affected by the fabric and the method of fixing. Once the print is dry, it has to be steamed to fix the dye onto the fabric, and then washed to remove the thickener. What will be left is the printed colour, and the handle of the fabric will be the same as it was before printing. The dye has become part of the fabric. Printing with dye gives a much better result — the quality of the fabric (the lustre and handle) is retained. The drawbacks of working with dyes are that it is more labour intensive than printing with pigment, and there are more stages in the process where things can go wrong. Working with dyes requires more patience in testing and sampling, but the rewards are greater.

Some fabrics really shouldn't be printed in pigment. The identifying characteristics of fabrics such as silk, which usually has a lustrous finish, or wool, which has a soft handle, will be lost if a pigment print with significant coverage is put on the fabric. The area printed in pigment will have a matt finish, which may not look as good as it should, if the fabric has a sheen or a soft texture. If the fabric is to be used for a scarf, for example, the print should penetrate to the back of the fabric, which will not happen with pigment because it sits on the surface. Sometimes using pigment will be unavoidable; if the use of metallics is required, there is no such thing as metallic dye, so it would have to be printed in pigment. Also, if the pigment is only used for line detail, or in an area of print with minor coverage, the handle or look of the fabric will not be affected. Combinations of dye and pigment can be quite effective within a design — large areas of colour

Class of Dyestuff	Pigment	Reactive	Acid	Disperse	Direct	Natural	Azoic	VAT
Manufacturers' name	Helizarin Permaset Harlequin Tintex	Procion Levafix Drimaren Cibacron Lanasol[1]	Milling Nylosan Polar Lissamine Coomassie	Dispersol Duranol	Durazol Solophenyl Chlorazol	Indigo Madder root Logwood Cochineal	Naphtol	Caledon Soledon
Fabric								
cellulosic								
Cotton	P	P,D	–	–	D	D	P,D	P,D
Linen	P	P,D	–	–	D	D	P,D	P,D
Viscose[2]	P	P,D	–		–	–	P,D	P,D
Protein								
Wool	P[3]	P,D	P,D	–	D	D	–	P,D
Silk	P[3]	P,D	P,D	–	D	D	–	P,D
Polyamide								
Nylon	P[4]	–	P,D	P,D[5]	–	–	–	–
Polyester	P[4]	–	–	P,D	–	–	–	–
Elastomeric								
Lycra nylon	P[7]	–	P,D	P,D[5]	–	–	–	–
Lycra cotton	P	P,D	–	–	D	D[6]	P,D[6]	P,D[6]

P–can be printed D–can be dyed

1 Lanasol is a dyestuff formulated for wool fibres; 2 Viscose is a regenerated cellulosic fibre and there are three types of viscose: rayon, cuprammonium, acetate. This chart refers to rayon, the most commonly used for printing; 3 Although wool and silk can be printed with pigment inks, the handle of the fabric will be affected; 4 Synthetic fixer added to print paste. Must not be rubbed when washing; 5 Can be used as a transfer dye. Painted onto litho paper and ironed onto the fabric; 6 Can be used but is not recommended. Can distort the nylon fibre; 7 Pigment printing requires the addition of a stretch auxiliary and synthetic fixer.

Mixed fibre blends:
Ascertain the proportion (%) of fibre types in the cloth. Check if one class of dye is suitable for both fibres. If none are, choose the appropriate dye for the higher percentage fibre, and note that there will be reduced colour strength. If this is not satisfactory, it may be necessary to print with pigment.

might be printed with dye, while an outline is in pigment.

Economic considerations often dictate that pigment is used in industry. Bases for printing pigment are improving all the time, with the addition of softeners and fixers, which give better handle and fastness. Fabric printed with pigment is much faster to produce, less can go wrong, and therefore it is cheaper.

Although, theoretically, pigment can be printed on any fabric surface, it will have limited wash and rub fastness on synthetic fabrics, without the addition of fixers to the base. Even then, the fastness will not be as good as on natural fabrics. Sometimes, this doesn't matter; for example, if you are working on a piece that is to be hung on the wall, wash fastness is not an issue, but aesthetic appeal will be. Pigment will bleed on fabrics containing polyester; the print crawls along the polyester fibres and creates a 'halo' around the printed area. This sometimes takes a minute to happen, so you need to check the test print when it is dry. This bleeding can be stopped by thickening the paste; no chemical reaction occurs, but by thickening the paste before you print, the print dries before it has a chance to crawl.

Some fabrics cannot be printed at all, because the finish on them prevents the dye or pigment from getting to the fabric. Many finishes do not wash off — they are crease-proofing treatments or resin coatings that improve the look of the fabric and are made to stay there. The pigment will be printed on the finish, with which it has no affinity, rather than on the fabric. Of course, if you are printing something that is just for show, which will never be used, then you might be able to find a base for pigment (for example, an opaque base)

that enables you to print an image on a fabric with a finish. Use the chart on page 179 to identify the appropriate dye for the fabric you have chosen. Once you have decided on fabric, and the dye or pigment to print with, and the technique you are using, then you must test the combination for compatibility to make sure it will give you the result you are after. More details on the virtues and drawbacks of dyes and pigments are given in Chapter 12, page 274.

The burn test

You can use a chemical called Ultrastain to find out what a fabric is, but the fabric needs to be white or natural coloured. This is not usually a problem when buying fabrics for printing, as they will mostly be white or light coloured. The burn test doesn't need anything other than the fabric and a match; it is a quick way of gaining information about the fabric's composition. Different fabrics behave differently when a flame is held to them. Fabrics can be broadly categorised according to how each behaves.

Use a small piece of fabric for these tests, and be careful where you do it — hold the fabric over a sink with some tongs. Some fabrics burst into flame very quickly, so you tend to drop them if you are holding them.

Cotton

Cotton burns with a yellow flame, smells like burning paper, and leaves a grey ash. Burning will continue after the flame is removed.

Linen

Linen burns with a yellow to orange flame, smells like burning grass, and leaves grey ash. Although it seems similar to cotton, it does not burn as readily once the flame is removed.

Wool and silk

These will ignite, splutter, and then self-extinguish. They smell like burning hair, or feathers, and the ash is easily crushed.

Regenerated cellulose — viscose, rayon

These burn readily, smell like paper, and leave a light grey, yellowish ash.

Acetate rayon

This burns less readily than cellulose fibres, and forms beads that shrink away from the flame. The beads crush easily. The smell is pungent, with a trace of acetic acid.

Polyester

These fabrics are difficult to ignite, and have a yellow flame that leaves hard round beads, giving off an aromatic smell.

Nylon

Nylon melts in the flame, and forms hard round beads, giving off a smell like celery.

Burn testing fabric doesn't give conclusive evidence of the fabric composition, or tell you what fabrics have been treated with. What it does provide, however, is a quick indication of what the fabric is most likely to be. It tells you if synthetic fibres are present (you can smell them, and see the fabric melting), which is important for printing. You can quickly verify salespeoples' assurances that a fabric is 100 per cent cotton.

Testing
fabrics and dyes

The testing and sampling of all fabrics, dyestuffs and print pastes is essential. Recipes and details about the process of sampling with dyes and pigment, and how to keep accurate records of your tests are given in Chapter 12. Here, the concern is whether or not the fabric can be printed. This is where you might discover it has a finish on it that prevents the uptake of dye, and that the finish does not wash off. It is better to discover that before you buy the fabric rather than after you have bought 5 metres of it. Buy a small piece of the fabric, or ask for a sample — even a strip 5 centimetres wide is enough. Use the burn test to establish the composition of the fabric. This will immediately tell you that some print processes will be appropriate, while others will be unsuitable. Use a small screen that you have handy and print any image on the fabric, using pigment or dye, depending on what you are going to print the fabric with in your length. There is little point in testing a piece of fabric with pigment, when you are going to use reactive dyes in the length.

Testing is about **duplicating** in miniature what **you will** do on a **larger** scale.

Take heed of what you find out in the test. If the print bleeds, double check that it wasn't your heavy-handed approach with the squeegee; or thicken the paste, and do another print to see if you have fixed the problem. Problems don't tend

to miraculously disappear, but they sometimes can be solved if you work out why the problem is occurring. A test that produces a dreadful result is much better than an awful printed length. Be careful in your testing — if you produce the tests sloppily, they won't give you reliable information.

If you are testing fabrics with dye, you will have to work through the entire process of printing, steaming and washing to establish whether or not the dye will work. Again, this will seem tedious, but it is the only way to circumvent things that can go wrong. Even with experience, when using a fabric for the first time, or with a different dye or paste, it is essential to test it.

One of the best things to do is to keep a record of all the tests you have done with fabrics and dyes; you can refer to it to see what fixed the problem before, or whether the dye worked on that fabric last time. This way, you build up your own reference of fabrics, dyes and processes, and how they link together.

Care
of fabrics

There are very strict standards of care instructions that accompany clothing and products for sale. Apart from legal requirements, if you are selling fabrics, or products made from your fabrics, it is your responsibility to tell the buyer how to look after them; it is easier in the long run to do this rather than have things returned to you by dissatisfied customers. Care instructions should give details on the fabric composition, and the best way to care for the fabric. Further information specifically on the care of printed fabrics is given in Chapter 12. The requirements for care labelling of products and fabrics are available from the Standards Association of Australia. Look also for care instructions on fabric that you buy, and ask when you buy it how it should be washed: by hand, machine or drycleaned. Be aware, too, of drycleaning processes, in particular those ones appropriate for your fabric.

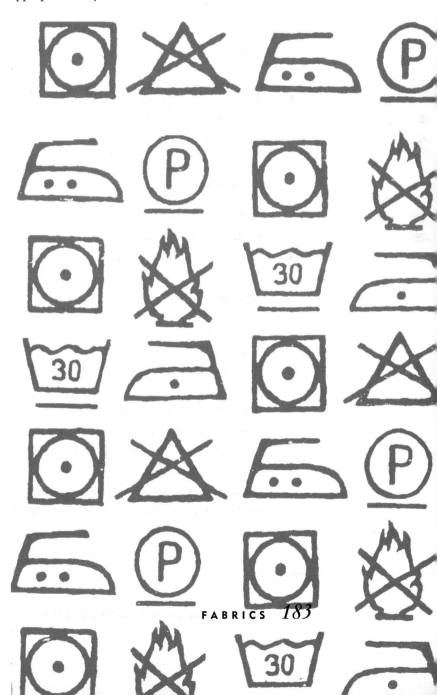

Exercise 11
Finding appropriate fabrics for printing

This exercise encourages the exploration of fabric as a surface to print on. If you are interested in printing your own fabrics, then you need to think about appropriate surfaces for your print. Each fabric type comes in so many different formats: flat weaves, twill, chambray, organza, chiffon, slubbed. You should familiarise yourself with what these terms mean by looking in fabric shops and checking what the fabrics are called. Organza, for example, is a very lightweight, stiff fabric, that can be silk, or synthetic. Twill is a word used to describe the weave of a fabric, which leaves diagonal lines: there are cotton twills in a variety of weights, as well as silk twills. Crêpe describes the wrinkled surface of the fabric, which could be wool or silk or synthetic, or a mixture. There are many more words to describe the finish or the weave of fabrics; they tend to tell you what the fabric *looks* like, but are not to be confused with fabric types. These terms will affect the way a fabric might be printed, but not what it will be printed with. Organza, for example, whether silk or synthetic, should be printed with dye (reactive, acid or disperse depending on the composition of the fabric) in a thick paste so the dye doesn't pass straight through the very light fabric, leaving hardly any print.

Collect ten samples of different fabrics. The samples need to be strips about 10 centimetres wide. The fabrics must:
- be white, off-white or unbleached
- include at least five different fabric compositions (linen, polyester, silk, wool and so on)
- have some natural and some synthetic fibres

- have surfaces with a definite weave or texture, which could be used to enhance a print (in at least five of the samples).

1 On a small square of fabric, use the burn test to establish the composition of each fabric, even if the composition is on a label. Although the burn test is not accurate with mixed fabrics, it will tell you whether a synthetic fibre is present in the fabric.

2 Use the chart on page 179 to determine, in theory, what the fabric could be printed with.

For example: if it is cotton/polyester, list pigment (with fixer) and disperse dyes; if it is wool, list reactive or acid dyes; pigment is not recommended because of handle of fabric.

3 Take a small square of each fabric to test whether it can be printed. Use any screen with any image, and print with pigment or dye, as you have specified in Step 2. If using dyes, carry the test through the appropriate finishing (steaming and washing). If you don't have access to dyes, test print it with pigment.

4 From your tests, establish whether or not the fabric could be actually printed, and what with. Assess the look of the print as well.

5 Nominate a use for each fabric, listing the particular features that make it suitable for that purpose. For example: lightweight 70 per cent cotton/30 per cent polyester blend: use for garments as because of the polyester it will wash, dry and iron easily and because of the cotton it is cool to wear and won't discolour easily.

6 For each fabric, find out what the care label should be, making sure it is appropriate for the use you have nominated, for example, it is not appropriate to hand wash a piece of furniture!

7 Present your findings in a book in which you keep technical information you can easily refer to. Work out the best system to document your findings so you will be able to decipher the information in twelve months' time.

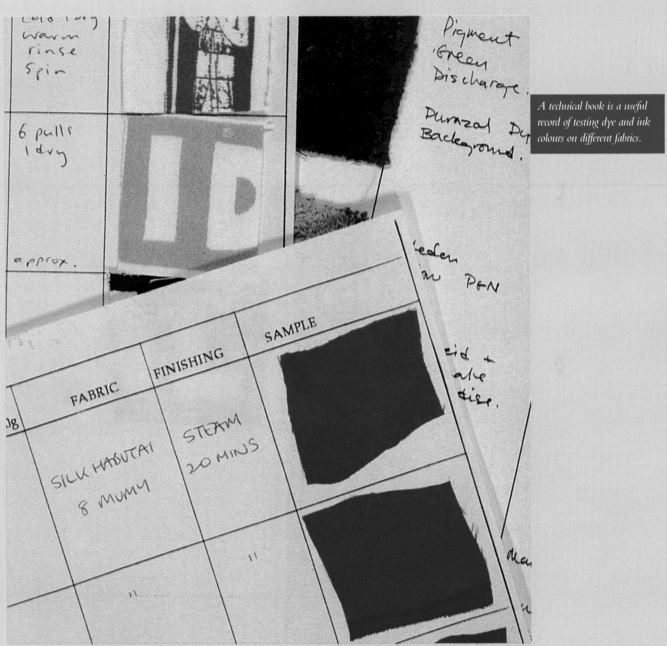

A technical book is a useful record of testing dye and ink colours on different fabrics.

Summary

Often, in industry or as freelancers, designers have no say in what fabrics their print design will appear on. In fact, they may never see their design on fabric. Or, if working for a bedding manufacturer, the fabric is constant (for example, 70 per cent cotton/30 per cent polyester, or a cotton **percale**), but the designs change with each season. In other situations, textile designers will be putting together concept or story boards to sell a range; they may have to show fabric types their print range will work with, in order to sell it to potential buyers. To do this well, designers need an empathy with fabric, and an understanding of what fabrics are suitable for, and a knowledge of what is available.

If you are in the position of designing and producing your own fabrics, then you can capitalise on having control over all aspects of the end product. This is where you should think carefully about the surface you will print on, in relation to the print you designed, and what the fabric will be used for. The same print could serve several end-uses, depending on the choice of fabric and colours. You have so many options, all of which can substantially change the look of the print — making it look either ordinary, interesting or stunning.

Consider how these things will affect your design: a closely woven flat cotton; a closely woven flat silk with a sheen; silk twill; silk crêpe; sheer silk organza; Indian cotton with a rough irregular weave; a cotton/silk mixture with a woven herringbone pattern; wool challis; a poly cotton mixture where the composition will be used to advantage in the printing: the polyester fibres will not accept reactive dye, so only the cotton fibres would print.

These are only a handful of options and, in the end, perhaps your choice will be dominated by economic considerations. Sometimes, though, the cheapest option is false economy: cotton homespun printed in pigment might make your design look cheap and nasty, whereas the same design printed with reactive dyes on a low grade silk might look a million dollars. As you will see, you have to go through a lot of painstaking processes to get the print on the fabric: don't sell yourself short by the fabric you print on. An inexpensive fabric like homespun is great for testprinting your design, to see whether the print joins up, or whether you have the repeat right. It's much better to make printing mistakes on homespun than silk. Once you have the physical aspects of printing the design under control, choose a fabric that will do your effort justice.

There is a direct relationship between the design, the fabric, the print paste and the end-use of the fabric. If you get the right combination, you will get enormous satisfaction from the process, as each part of the process is dependent on the steps preceding it. Choosing a beautiful fabric won't disguise a design that has a faulty repeat. And upholstering a chair in homespun will mean it has a very short life.

Christie Arulappu

3rd year student, RMIT
Opposite: *silk fabrics have particular qualities that require the use of reactive or acid dyes. The 'handle' of a fabric is enhanced or reduced depending on the dye or ink used, the coverage, the translation of the design, and the printing technique.*

Setting up

9

a print
workshop

Mi Kyoung Kim
3rd year student, RMIT

Although the majority of textile designers are not involved in the actual printing of fabric, a working knowledge of the processes is an asset when you are designing for an industry that has quite specific requirements and restrictions. As Chapter 6 points out, the ways in which designs are put into repeat have really not changed very much, and although technology has changed many of the methods of production, the principles remain relatively unchanged.

The designer should have a knowledge of the business in every stage of its progress.

(British Manufacturers Companion and Callico Printers Assistant, Charles O'Brien, 1791, London)

Overview of textile printing

The development of decorated cloth parallels that of constructed cloth. Early forms of decoration utilised the natural minerals and plants available to the first weavers and spinners of fibres. It became quite natural for plain cloth to be coloured or decorated in some way, to distinguish it from someone else's cloth. People from different villages had their own symbols and motifs to denote where they were from when travelling, or for ornate ceremonial purposes.

Colour was also a sign of importance and status. Certain colours were derived from rare plants or shellfish, requiring time and skill to work into dyes; these cost more and so only the wealthy could afford them.

Some of the earliest known examples of coloured cloth (dyed and printed) have come from India, Egypt and China. These countries had very sophisticated cultures and societies, and were quite advanced in the production of cloth. While northern Europeans were clothed in animal skins, and Oceanic people clothed in bark, the cultured people of Asia and the Middle East were wearing silk, linen and cotton cloth of fine quality and colour.

Because of the poor archival qualities of fabric, very few examples have been found for study. The earliest examples of coloured cloth fragments, found in Coptic tombs, date from around 3000 BC. There is also a great deal of information about Egyptian costume and fabrics from the tomb paintings of the Pharaoh kings, which describe the procedures for dyeing and decorating linen and cotton fibres. Even today the name Egyptian cotton is used to describe the finest quality cotton available.

In industry today, there are several different systems employed to produce printed fabric, many of which are steeped in tradition.

Resist printing

Very early forms of decoration included wood stamps dipped in resist pastes such as natural starch, clay, rice paste and gum, which were printed onto the fabric then dipped into indigo baths. The resist left the fabric area undyed,

creating a negative pattern. This technique circulated among countries trading with each other, and as the techniques became more sophisticated the patterns became more complex and the dyes and pastes had to be more reliable. African printers today still use the wood block resist technique. The Javanese developed the most recognisable form of resist printing called batik, which uses wax as the resist medium.

Stencils

The Japanese and Chinese were developing other forms of decoration by the use of stencils, and the technique is still used today for the traditional colouring of kimonos and ceremonial costume. The process involved the cutting out of intricate designs in rice or mulberry paper with any floating shapes being glued in position using fine hairs. Varnish helped to strengthen the stencil. The stencil is put over the cloth and a coloured paste or resist is applied with a stiff brush.

The use of stencils as a system of design production was developed by numerous countries over a long period of history. The Greek and Roman civilisations used stencils extensively for decorating villa walls and floors, mediaeval Europeans used them for church decoration and the American Shakers and pioneers developed them as a cheap alternative for floor and furniture decoration.

Wood block

One of the most important techniques developed for the printing of cloth was the wood block method. Used in China and Asia as early as 2000 BC and successfully developed by Hindus in India, the early textile industries in Asia and later Europe used the wood block method extensively for hundreds of years. There are wood block printing mills still in operation in India today, supplying select Australian stores with dress fabrics, and there are a few specialist printing companies in the UK producing William Morris designs using the traditional wood block method. In the late 17th century and early 18th century European traders brought fine quality damask cottons and silks back to France and England where mills tried to copy the designs and techniques of printing. The slow development of dyes and mordants restricted the early printers to using paper inks on fabrics, which proved unsatisfactory. The Europeans were desperate to start their own textile printing mills, at first using traditional dyes and then replacing them with the synthetic substitutes available from the 1840s onwards. They were also developing their own language of design. To this day the textile industry produces paisley cottons based on the Indian pine cone design, chintzes (multi-coloured floral designs) and calicos (very small flower designs) derived from the traditional fabrics of Indian regions. Wood block printing took off as the industry grew and demand for the fabrics increased. The drawback was the time-consuming and labour-intensive method: blocks were heavy and could not be made larger to cover bigger areas of the fabric. The French produced a mechanical wood block printing machine that looked promising but still had limitations, especially with the number of colours that could be printed. The textile printing industry tried different methods of production: some attempts at a rotary system were tried in the 1830s but the quality was

poor, and sharp lines were difficult to achieve. The next stage was to use metal instead of wood as the carrier of the ink.

Copperplate

This process was derived principally from the wallpaper and book printing industries. Its most productive phase was around the early 1700s with printing factories in France, England and Ireland producing very detailed patterns on cotton, linen and silk. The printing process was called intaglio and is still used today by artists. The technique involved etching an engraved line into a copper plate, inking it up and passing it under a press to transfer the ink to the cloth under pressure. Several drawbacks were the restriction in printing size, approximately 1 metre square, and registration of other colours. Fantastic detail could be achieved with this method and a characteristic style of this printing technique was the single colour used (blue, crimson, purple) with large all-over pastoral scenes or floral bouquets. Centres such as Spitalfields in London and Jouy in Reims, France gave their names to the cloth. Toile de Jouy is known today as a style of printed textile design. Many maps and commemorative cloths were printed using this technique.

Engraved roller

Increase in production was still a driving force in the development of a machine that could accurately print more than one colour and print hundreds of metres rather than 10 metres. The result was the transformation of the flat copper plate into a roll attached to a cylinder that could print continuously. The same etching technique was used, and machines were developed to etch the design onto the copper roller in a repeat sequence. There was now a need to generate more designs to cater for the variety of clients and markets, and so textile designers became an important part of the production process. Because of the accuracy of this method, several cylinders could be added to the machine and several colours could be printed at once in perfect registration. By the 1890s there were machines capable of printing up to twenty colours, and this, coupled with the development of synthetic dyes to replace the traditional indigo, madder and cochineal, meant that production of printed cloth soared. This system of textile printing was so successful and economical, many factories were using cylinder printing up to the 1950s when new technology was introduced to speed up production, and new printing styles were developed using synthetic inks instead of dyes.

Flat bed screen printing

Since early 17th century trading with Japanese and Chinese textile producers, there have been examples of screen printing using a silk mesh stretched over a wooden frame. A paste was pressed through the mesh, and the pattern was made by a stencil or varnish resisting the paste, preventing it from colouring the fabric. Use of the silk screen was tried in Switzerland, France and England in the 1800s but the European flat bed process of screen printing really took off in the 1920s. The new art styles of the period coupled with unusual sizes of cloth and applications for consumer goods required a form of printing that was flexible and cost effective. As with copper

printing, the silk screen process was first utilised by the paper and poster printing industries, then developed and adapted for textile uses. Developments in synthetic fibres led to replacing the traditional silk mesh with stronger nylon and polyester meshes. The production of photographic emulsions meant that any image could be processed onto a flat screen. Flat bed screen printing quickly established itself in industry as well as in education, as it enabled smaller production runs at lower cost, and the reusing of expensive screens. There are automated flat screen printing machines where the screens remain positioned in colour sequence along a table, and the fabric is continuously moved along under each screen, which is lifted then dropped onto the fabric. Ink or dye is pressed through the screen using a squeegee blade or magnetic steel roller, the screen is lifted and the fabric passes along to the next screen colour.

Rotary

This method of printed textile production is now accepted as the most cost efficient in the industry. It uses a combination of rotary screens, similar in concept to the earlier engraved roller technique, but now using a fine metal mesh. The design is either exposed onto the mesh photographically, or laser engraved via a computer. The production quality is very accurate and the time required to set up a design for printing has been reduced to a couple of days, enabling smaller print runs to be economically viable. Contemporary developments using computers have revolutionised the printing industry, from computer dye mixing machines and colour spectrometers to measure

colour, to design work being put into repeat on a screen and transferred onto a disk and then to a laser engraving machine.

Transfer or sublistatic

This process was developed as a method of printing synthetic fabrics. The process involves the printing of Disperse dyes onto a special non-absorbent transfer paper. The paper is usually engraved, roller printed and then stored for later use. The transfer printing process uses heat to vapourise the dye on the paper, which is then passed through a heated roller at 220°F contacting with the fabric, and transferring the pattern to the fabric. The colour of the print on the paper often appears dull, and bears no resemblance to the final colour of the print, which can be intensely bright. Only synthetic fibres work with this process, and the printed paper can only be used once, as the dye is then exhausted. Transfer printing is used to create special surface effects like fake leopard skin and imitation woven effects because very fine and accurate photographic designs can be used on flat smooth fabrics. Printed nylon tights are a good example of design flexibility. Because of the trend towards natural fibres, transfer printing has been relegated to the lower end of the textile market, used for placement printing and some knitwear applications. Some cheaper synthetic carpets are patterned using transfer printing; these designs do not have the depth or lasting qualities of those with a woven pattern. And in these times of recycling and reusing, it is interesting to note that the expended paper, which has a pale version of the colours left behind, is used by florists for wrapping flowers.

Inkjet

This is a relatively new form of dye application developed to meet the needs of computer-aided design and manufacturing. Dye is injected under pressure via hundreds of nozzles onto the fabric surface. It is used commercially for carpet production where definition of an image is not so critical because there is surface distortion. The process has drawbacks, but with increasing technology new ways are being found to exploit its potential. Currently a type of inkjet is used to transfer images from a computer, such as a scanned photograph or drawing. The image is digitally converted, a fabric is stretched on the machine and inkjet nozzles direct colour, line by line, across the fabric. The process is used for large one-off interior wall decor for hotels or banks or for large advertising banners.

What happens to the design?

Designs are handed over to a factory, or 'converter' as they are sometimes known, so they can be printed. Sometimes, the factory will be a part of a larger facility where the designer works and where the design team might also be in charge of producing the artwork that is to go on screen. In other cases, the factory will have an artwork department that takes a croquis, which might have been bought from a freelance designer, puts it into repeat, and produces artwork ready for screen. While the details might vary, in principle the sequence remains the same.

This is the final stage through which the artwork goes: it has to be reproduced in a form that makes it suitable for transferring onto a screen, whether it is rotary or flat bed, photographic or laser. In any process, this involves **colour separation**, where each colour is put onto a separate piece of film, or separated electronically. This is necessary because each colour is printed separately, and must therefore have its own screen. It also explains why multi-coloured prints are so much more expensive to produce than single colour prints. They are more costly at every stage of the design and production process.

'Camera ready artwork' and 'silk screen positives' are terms used for this stage of production. Unless the screen preparation is done electronically (in which case there is no hard copy at all) the design on paper has to be converted to opaque marks on film. This is done by:

- using a process or reprographic camera, which separates and transfers each colour onto film
- painting up each colour separately, full scale, with opaque media, onto drafting film
- colour separating one unit of repeat and using a reprographic camera to reproduce multiples to complete a full layout

or

- if the exposure system is that of step and repeat, then the colour separations from one unit are exposed in stages, in repeat, onto the screen.

Needless to say, if you are producing your own printed lengths of fabric, the most likely option open to you is the most time-consuming one: that of separating the colours and painting them up by hand. Using silk screen positives from a reprographic camera can get very expensive, but they are often the only way to convert something from paper onto film. They are certainly the most accurate and efficient way. Once

the design has been separated, and you have the positives, screens are made, one for each colour. This is usually done in industry via the photographic process, or by laser for rotary screens. The photographic process is where screens are coated with a light sensitive emulsion and, when they are dry, the design, which is now opaque media on film, is exposed onto these screens. This process is outlined in detail in Chapter 10. Once the screens are ready, printing can commence. Printing is a very quick process, if all the preparatory work has been done accurately.

Handprinting imitating industry

The industrial process of flat bed printing can be duplicated very closely by hand, and is a useful thing to do to understand the principles of repeat. In industry this style of printing has been mechanised to a large extent, but the principles remain the same, whether the fabric is printed by hand or mechanically. There can be noticeable differences between machine and handprinted fabrics, and it should be understood that there are some designs not suitable for handprinting. However, with adaptations of designs and concessions to the limitations of equipment, extremely good results can be achieved by hand. You can produce handprinted fabric on a very small scale, or you can go to the opposite extreme of setting up a small production facility. The distinction between handpainted and handprinted fabrics needs to be made. If you are painting fabrics, you need very little equipment — the dyes to paint with, the brushes to apply the colour with, and somewhere to do it. You may need access to

a steamer and somewhere to wash the fabric out, depending on the dye you are using. If you are printing fabric, the list of equipment is much longer. The biggest advantage of printing fabric is that of speed, once the initial preparation is completed. The image is on the screen and can be repeated over and over again. With handpainting, each time you need the image on the fabric, you have to paint it. The advantage of painting is the flexibility — there is no restriction (economic) on the number of colours used, and the imagery or pattern used can vary at whim. Painting is labour intensive but low in the cost of equipment, while printing is high in set-up costs, but is more economically viable to produce. Methods and recipes are given for one-off techniques in Chapter 11. The emphasis here is on printing: the equipment needed to set up a basic facility, and how to go about producing printed lengths of fabric, on a small scale. The same principles apply to setting up a production facility, but the nature of equipment you purchase will differ according to what you are aiming to produce. The greatest benefit of handprinting is that things can be quickly trialled, sampled and produced, without being locked into a complex or lengthy manufacturing process.

The hardware

This section deals with all the equipment you need. The emphasis is on printing designs in repeat, using photographic screens — emulating what takes place in industry. What is recommended is based on general requirements; some things may be outside your budget but the

function of each piece of equipment is detailed, so you can substitute other things that might do the same job for your purpose.

Building a print table: structure, surface, registration rail and stops

A print table needs to have the following features:

- a stable structure
- a firm, flat surface with some 'give' in it
- a surface into which staples can be put, and easily removed
- a top layer that can be easily removed and washed when dirty
- be a length that fits easily into the available space, allowing access from all sides

- be at least 3 metres long if you want to print lengths in repeat
- a straight rail along one side of the table if you are going to print repeat lengths.

Tables can have these features in a variety of formats, according to the available budget, and the projected use of the facility. Many tables have been built from unorthodox materials, and have worked perfectly well in the situation they have been designed for. Here, we will outline the most common materials used, and why they are appropriate, but remember that you can always improvise.

The most common table frames are wooden or slotted angle (metal); the latter is more easily dismantled if its location is not too permanent. Depending on what the floor is like, stability can be improved by bolting the structure to the floor.

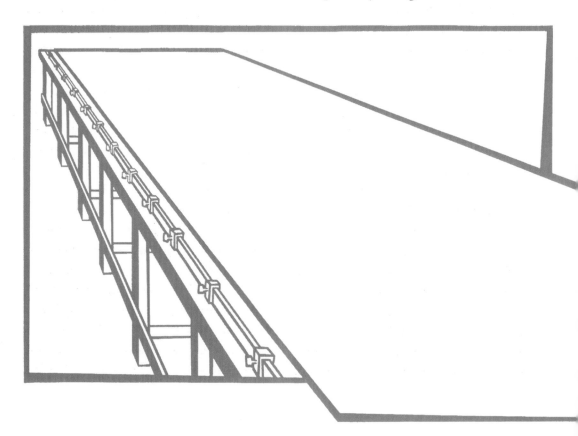

The width of the table should be that of the fabric you intend to print (usually 115 cm) plus about 30 cm for the rail and for the frame to rest on. Most small print tables are not wide enough to print fabric that is 150 cm wide: the cost of screens large enough to print this width and the cost of exposing the designs onto them make it prohibitive when you are starting out.

The top of the table is usually chipboard (18 mm thick), which is attached to the frame. Sometimes the top is kept separate, because of space restrictions, and is stored upright, and placed on top of an existing table when it is needed. This is obviously less stable than attaching it to the frame.

On top of the chipboard, there should be something with 'give' in it: this is because fabric is absorbent and needs to have the print pushed through. This surface should be firm, not spongy — the ideal surface is 6 mm saddle felt, which is available by the metre, is wide and evenly flat, and is dense but resilient. In most situations, however, the cost of this is prohibitive. A good cheap substitute is carpet underlay, particularly the foam one. If you are using a felt underlay, make sure it is not too lumpy, as the lumps will affect the print. The surface, whatever it is, should be continuous if possible, as joins can show up in the print. If you do have to join pieces, splice them, or butt them together, rather than overlapping them. The felt, or substitute, should be stretched as tightly as possible across the chipboard and over the edges, and stapled in place, underneath the surface. This needs to be permanent, so put the staples close together so they don't pop out. If you have stretching clamps, use them to help pull it tight. This surface is the future of your print table: it has to be looked after if it is going to last and not develop dips and holes. It needs to be protected from spillages, which will ruin it, by a water resistant covering that is not slippery or plastic. 10oz canvas is ideal for this, as it can be painted with cheap white water-based house-paint to make it water resistant enough to be wiped down if necessary. Staple the canvas over the felt, or substitute, again on the underside of the table rather than the top, which is your print surface. The paint will also shrink the canvas a bit so it fits tightly. Once the canvas is attached to the table, paint it with water-based white household paint — a couple of thin layers should make it sufficiently resistant to moisture.

The felt and the canvas remain permanently on the table. The top layer, which you actually print on, should be less permanent, and able to be easily removed when it needs to be washed. This is known as the **backing cloth**, and should be *dehsouti*, which is a 4oz or 6oz canvas, a bit like calico. *Dehsouti* is a fabric that washes well, which is important if the print table will be used by several different people, some of whom might be more careless than others. It's wise to have a couple of spare cloths, so that if something is spilt and the cloth has to be washed you have another one to put down immediately.

To print a design that is in repeat, you need to be able to line up the end of the screen against a straight line, which is your **registration rail**. This rail must be straight; the most common system for handprinting has the rail sitting above the table surface so the screen can rest against it. Angle iron, which is about 4 mm thick and 40 mm x 40 mm, is probably the best and most economical solution. It can be bolted to the table,

or clamped to the table when required using G-clamps — this is appropriate if the table is to be multi-purpose, and will be used for printing lengths, as well as other techniques for patterning fabric that do not require a registration rail.

Along this rail, the **registration stops** will be placed at regular intervals, according to the repeat size. There is no such thing as a standard registration stop that you can buy. Usually, you have to have them made by a small engineering firm or someone who has the facility to make tools. Stops are slid along the rail, then screwed in

place at regular intervals (the size of the design repeat), and tightened by a wing-nut. They must be able to be moved along the rail, fixed in place, and all be the same thickness.

In addition to the repeat being worked out at the design stage, whether or not the design joins up at the printing stage is dependent on several other factors:

- The design on the screen must be positioned, at the time of exposure, so it is square to the rail. This is called **registering your screen**.
- The registration rail must be straight.
- The stops are accurately measured at the repeat size.

Imagine that your fabric is a continuous line that has been divided into sections, each of which is the part of your design that has been put on the screen. The printing process is a system devised so that each colour of the design on each screen will match up with the other, and everything will match up so there are no visible joins in the design when the fabric is printed.

Depending on the complexity of your design, it is possible to use a very simple and unsophisticated method like sticking pieces of masking tape along the rail, at the measured repeat size, to line up the screen.

Screen frames

It is better for small productions or schools to have wooden frames rather than metal. Metal are used in industry because they are more heavy duty and won't warp in larger sizes. Wooden frames are easier to handle, can be more easily registered using screw-on **brackets**, and can be stretched by hand if necessary.

Cross-section of Print Table

Rail
Registration Stop
Table Top
Frame

Registration Stop

Screw to tighten stop on rail

Backing Cloth (Removable)

Canvas (Waterproofed)

6mm Felt or Blankets

Chipboard

Cross-section of Table Top

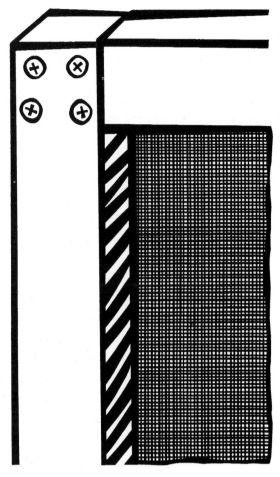

don't come apart with constant wetting. The frame must sit flat — old frames eventually tend to warp, but they should start flat.

Frame sizes are dependent on the sort of work you will be doing, the size of the images, and what size surface you will be printing on. The main things to consider are:

- A smaller frame for printing T-shirts or placement images can be made of thinner timber than a larger frame. Small frames for T-shirts are usually made from timber that is 40 mm (wide) x 32 mm (deep) and an average size frame is 410 mm x 550 mm (inside measurement). This allows enough room for a large placement print and a well each end where the print paste can sit. If you are using a T-shirt printing carousel, the frame size must sit comfortably on the printing board.

- Larger frames for printing fabric in repeat should be made from timber that is around 55 mm (wide) x 40 mm (deep). The inside measurement of the frame should be that of the width of the fabric (115 cm) plus enough room for a well (add about 15 cm, which gives you 7.5 cm at each end) so that gives a total of around 130 cm. You can, of course, get away with a bit less, but this gives you an ideal well, which makes printing easier. The width of the frame will correspond to the repeat size and scale of imagery that you commonly work to. If you don't know what that is going to be, then an inside measurement of 75 cm to 85 cm gives you maximum flexibility. If you always work to a fairly small repeat (such as 32 cm) and use small scale images, then you could get away with much less.

The main criteria used in the selection of timber for frames are that it must be:

- reasonably water resistant
- resistant to warping easily
- light, especially if the frames are large
- soft enough so screws can be easily inserted for registration brackets.

The timber that best fulfils these criteria is Western Red Cedar, which is not a cheap timber but is a good long-term investment. Many cheaper alternatives will warp or are too heavy.

The joins at the corners should be lap joints; they need to be screwed as well as glued so they

Mesh

Once you have decided what size frames to get, you have to choose the appropriate mesh and mesh size. There are two main sorts of mesh: multifilament and monofilament. Multifilament mesh is made up of multiple strands twisted together, while monofilament mesh has single strand yarns. Multifilament mesh is cheaper and will serve some needs adequately. Monofilament mesh tends to be a much better long-term investment.

Multifilament mesh

This mesh comes in sizes of 8TXX, 10TXX, 12TXX and so on. 8TXX is known as 'flywire' to screen printers, who consider it to be so coarse that you might as well print through flywire; 10TXX is probably an average grade for textile printing, with 12TXX being slightly better quality. Sometimes multifilament mesh is what you need: if you are working with paper stencils, rather than photographic images, then this cheaper alternative is appropriate. If you only need a screen for occasional images, you could get away with the cheaper one. If you are using the Hydrograph system (see page 256) to get images onto the screen, you need to use a multifilament mesh to get a good result from drawing onto the screen with crayon. The crayon tends to give a better definition of line on multifilament mesh, where it becomes embedded in the wound fibres. Often, choosing what is immediately cheaper can be false economy. Think about what you will be doing with the screen, and choose the mesh accordingly. If you are working with photographic images, and reclaiming your screens (stripping off designs in order to expose new ones) then you would opt for monofilament mesh. When using multifilament mesh, pigment and photographic emulsion tend to build up around the edges of the design area, making it much harder to strip.

Monofilament mesh

Mesh sizes are graded according to the threads per inch: 43T mesh has 43 threads per inch, 77T mesh is finer, with 77 threads per inch, while 100T is finer still. The more threads per inch, the smaller the gaps through which the print paste can pass, and the better the definition of a photographic image. The choice of mesh size will depend on the design you are printing, what you are printing with and what you are printing on.

Most textile printing, particularly with pigment, is done with 43T mesh, which is a good multi-purpose size. If you are printing with dye you could use a finer mesh, like 55T or 77T, because dye, being soluble, will give a smoother, finer paste. Some techniques, like **polychromatic printing** (see Chapter 11), need 77T mesh for best results; a design that has fine lines and is very detailed, or uses halftones, will require at least 55T mesh. It is rarely necessary to use a coarser mesh than 43T but, occasionally, metallic and opaque pastes, because of the coarse nature of the pigments, might need a very open mesh like 38T, particularly if the areas to be printed are broad, flat colour. The wrong mesh size can result in the paste drying out on the screen (mesh is too fine), or not enough detail picked up in the exposure (mesh could be too coarse). These two things can be due to a number of other factors that should be checked as well (see Appendix A).

Monofilament mesh is necessary if you are stripping the image off when you have finished using it (this can be weeks, months, years after you put it there). This is called reclaiming screens; the alternative to reclaiming is to put new mesh on the frame each time you want to change the image. This is really a waste of resources, as well as time, although setting up a system where the screens are reclaimed can seem expensive (see page 229–30).

Mesh is available in nylon and polyester, at roughly the same price. Polyester is probably going to be the best bet, because it has a lower absorbency rate than nylon and retains its tautness for longer. This is important if you are going to be reclaiming screens, as you will be subjecting the mesh to water from a high pressure gun. Nylon mesh is more likely to be used in industry: it is more absorbent than polyester, and will therefore absorb the photographic emulsion permanently. If thousands of metres of fabric are to be printed, then the permanence of the stencil is significant. In small production, or school use, polyester is a better choice, because the stencil will easily last the distance of several hundred metres if it had to, and will strip off better when reclaiming the screen.

Squeegees

Squeegees have two parts: a handle and a blade. The handle can be metal or wood. The most common harm done to a squeegee is to leave it in the wash trough and, if the handle is wooden, this can lead to warping, so the blade becomes loose and often falls out. Leaving squeegees in water can also lead to the rubber blade warping. Metal handles are generally heavier. What you choose is really a matter of personal preference, or what you can afford. There are several different types of squeegee blades; the most common are black neoprene and yellowish polyurethane (which is harder). Again, different people will recommend different things, but it comes down to what you are printing, and what surface you are printing on. A more flexible surface (saddle felt) means you could use a more rigid blade. A rigid print surface means you should probably choose a more flexible blade. The quality of the print will be affected by the squeegee, the angle at which you use it, the pressure with which you print it, and the surface you print it on. It would be fairly pointless to invest in a top quality squeegee, when you are printing on your kitchen table.

Generally, textile printing uses a blade that is flat. The printer will hold the squeegee on an angle as it is passed across the screen, and this is what controls the amount of print paste that goes

onto the fabric. Some textile printers have a preference for squeegees that have a bevelled edge (sharpened to a 'V'), and which are used in a more upright position. These squeegees are more appropriate where the rest of the equipment is of a reasonably high standard, as they tend to be less forgiving in their result, and require better control by the printer.

If you are buying new squeegees, make sure they correspond in size to the internal width of your screens. The frame should be several centimetres bigger either side of the squeegee, to allow it to pass smoothly across the mesh. You might as well have the largest squeegee that will comfortably fit inside the frame, as this gives you maximum flexibility with the size of images you can print. Squeegees are generally sold at a price per centimetre, so you can have whatever size you want.

Wash trough

You will need a trough for washing screens after they have been printed, washing out screens that have just been exposed, stripping screens, and washing squeegees, coating troughs and incidental things like containers and spatulas. Everything in textile printing can be washed out in water, and should be washed out soon after use, to avoid blocked screens or damaged equipment. The trough should be deep enough so the largest screen you are using will fit comfortably, and not too high, so you don't have to strain to reach the edges when you are washing out big screens. It should also have reasonable water pressure, particularly if you are going to attach a high pressure gun. Ideally, it will be far enough away from

your print table, so water doesn't splash on printed fabric. Plastic strips, or a shower curtain, can help to close off an improvised sink if space is a problem. Washing out screens, and particularly stripping screens, can cause a lot of noise, which is something to consider if you are setting up print facilities.

You should also think about a non-slip surface on the floor around the wash area, especially if the trough is used by a large number of people. You need to be aware of what is going down the drain and where it ends up. Most local councils insist that you install a mixing tank, which filters what goes down the drain, catching the solids that build up in a 'trap', which has to be regularly cleaned out. Make sure all excess pastes are cleaned out of screens before they are taken to the wash trough; this is the most effective way of preventing solids going into the drainage system.

Pressure guns

If you are using the photographic process to put designs onto screens, then you need to investigate ways of reclaiming screens. Instead of removing the mesh each time a design is finished, the photographic emulsion, and therefore the design, is stripped from the mesh, leaving a screen ready to be coated, and the new design exposed onto it. The best way to strip the mesh is to have the stripper that works with the photographic emulsion you use (all suppliers of photographic emulsion should be able to provide a corresponding stripper) and a high pressure gun. The gun has a compressor (which provides the pressure) and a trigger-operated nozzle, which is attached to the water source. In small productions or schools,

where the usage is not great, a domestic version of a high pressure gun will suffice. These are sold as high pressure cleaning equipment, to be used for cleaning cars or house exteriors but they clean screens just as well. When the gun will be used continually, it would be better to invest in an industrial pressure gun. Remember the gun will generate a lot of spray, as well as noise from the compressor, so where you use it is important.

Dark room or drying cupboard

Screens that have been coated with photographic emulsion need to be left to dry in a clean, dry place, which is dark and light tight. Ideally, screens should be dried horizontally; if you have to dry them vertically because of your darkroom size, then you need to ensure they are coated well, so all the emulsion doesn't run down the screen. Ideally, a good drying cupboard or dark room will have horizontal slats on which the coated screens can sit to dry, will be ventilated so a heater can be put in the cupboard to speed up the drying process, and will be sealed well with a spring-loaded door, which cannot be left open. Ventilation with a heat source is important, because if the area becomes too hot, the emulsion will be baked onto the screen. This drying area could have a red safety light. Naturally, budget restrictions often dictate less than ideal situations; the important thing is to have somewhere dark to keep your screens, where they will not be knocked or bumped while wet. If the screens have to be left to dry vertically because of space restrictions, make sure they are coated well. The photographic emulsion should be kept in a sealed container, away from light and heat.

Coating troughs

Photographic emulsion is applied to mesh of the screen with a coating trough. The metal edge needs to be kept clean and smooth, as nicks and old emulsion give an uneven coat on the screen. It will probably come with a protective rubber strip on the coating edge, which should be replaced when the trough is not in use. If you can only afford to buy one trough, choose one that fits a smaller screen and can also be used to coat larger ones, if coated in two or three sections. Although these troughs can be expensive, they are essential if a good even coat of emulsion is to be achieved on the screen. It is a futile exercise to use the photographic process to put designs onto screens, and to coat screens with a squeegee. Squeegees tend to give a very thick, uncontrolled layer of emulsion, which can cause an uneven exposure. The photographic process is the most accurate and cost-effective method of screen making available to handprinters, as long as the screens are coated, dried, exposed and washed out properly.

side view of coating trough

Sharp Edge for Coating

Handle

Stand

Exposure units

The major expense of setting up facilities to expose screens photographically can be the exposure unit. Ultra violet (UV) light is required to expose the screen. The UV light can be in tubes or globes. The artwork must be tightly in contact with the screen mesh. Ideally, this is done by sticking the artwork onto the back of the screen, and placing the screen in a vacuum frame, which has a glass surface through which the light will pass, exposing the design onto the screen. The light source may be underneath the frame or the frame may be vertical, facing the light. The exposure units (vacuum and light), which are built for use with large screens, are expensive so the output of the production facility needs to be able to justify the investment. They are necessary if a large number of screens are being exposed on a daily basis.

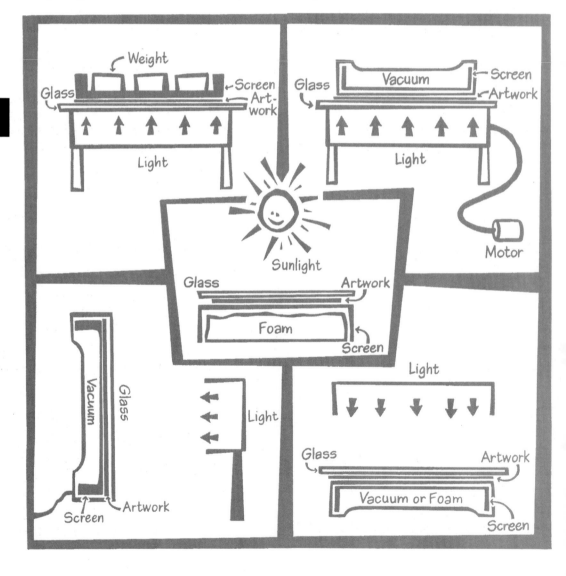

different methods of exposing the screen

It is possible to improvise an exposure unit, and various solutions to the problem exist in schools, community groups and small production studios. The solution outlined here is economical to build, and easily adapted to suit other sizes. The dimensions given are for exposing small T-shirt screens.

The light source

UV lights in tube form are available through some lighting distributors. They come in different strengths, according to their length. The tubes are mounted in a box that is painted white inside, which allows for maximum reflection of light, and has a glass top. An automatic timer could be fitted to the on/off switch. The main thing to ensure is that there are sufficient tubes in the box to give enough diffusion of the UV light

to expose the maximum size screen that will fit on the glass. The tubes really need to be mounted right to the ends of the box, and to be about 20 centimetres apart. The box shouldn't be too deep (about 30 cm), as this will also reduce the strength of the light by the time it reaches the screen.

The vacuum

A vacuum frame can be improvised with a vacuum cleaner motor and a black rubber bag, which encloses the light source. A simpler method is to place the artwork on the glass of the lightbox, place the screen on top of the artwork (or stick the artwork to the back of the screen) and then put a board (such as chipboard), which can be weighted with sandbags or a few telephone directories, inside the frame. This primitive, low

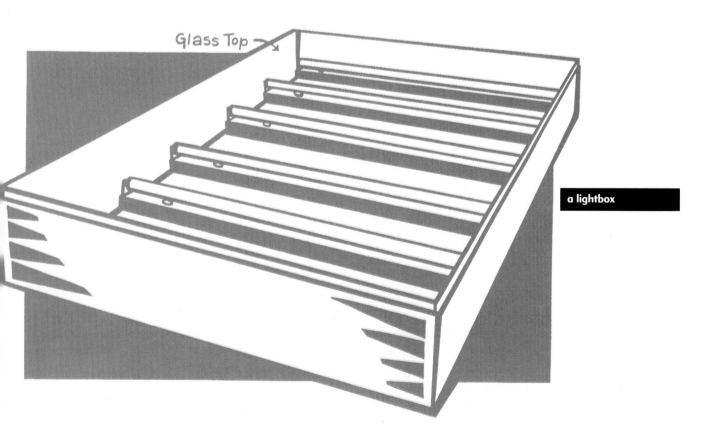

Glass Top

a lightbox

budget method works well, as long as the board covers the artwork area, and the weights are heavy enough, and evenly distributed, to make good contact between the artwork and the screen.

Any exposure unit must be screened off from other areas when in use, because of the potential damage it can cause to eyesight. This can be done with a blackout curtain or a wall. In the case of the improvised 'box of lights' described, a black cloth over the whole unit while it is exposing would suffice.

Exposure times will vary with each exposure unit, in combination with the photographic emulsion you are using. Some quite sophisticated units might take 240 seconds for a perfect exposure, while some of the more primitive may take up to 20 minutes to do the same thing.

Further variations are caused by the quality of the artwork you are exposing, or how opaque it is. Page 235 tells you how to test what is the best time for your particular equipment, and to vary the times according to the artwork.

Registration table

While it is not absolutely necessary, a registration table is inexpensive to make and very convenient to use. You need chipboard, which is slightly bigger than the biggest frame being used, with a piece of angle iron attached to one end to simulate the registration rail on your print table. A sheet of sectional (or graph) paper should be stuck to the board, square to the rail. Draw a line on the paper that shows where the design

should start, leaving enough of a well for the print paste. This line indicates where you should position the design, so you can transfer the crosses from the artwork to the screen. If space is a problem, this registration table can be stored upright and placed on top of another surface, otherwise it could have its own permanent position, close to where screens are coated.

Hair dryers, fans and compressed air

It is a good idea to have a way of speeding up the drying of the fabric, as leaving it to dry naturally will usually take too long. Fans on stands that sit on the floor are a good idea — if they sit on the table, it is quite likely they will be left there and cause a depression in the surface. These fans are also very useful for drying wet screens; while compressed air is the quickest way of doing so, it is also a more expensive option, and only really necessary in a high volume production. Hair dryers are very useful, particularly for drying samples and colour tests, but the cheaper domestic ones tend to burn out fairly quickly, as they are not designed to be left on continuously. Industrial hair dryers are expensive, but have much stronger motors that withstand heavy usage.

Staple guns

Look for a staple gun or tacker that can be held comfortably and is not too heavy. Staples used to attach the fabric to the table surface are usually no bigger than 6 millimetres, otherwise they are too difficult to remove. Most staple guns tend to jam after a while, and need to be replaced, so look for a supplier that offers a repair or replacement service, and make sure staples are in regular supply.

Scales

Weighing scales are handy to have in the print room, especially if you are contemplating working with dyes. Kitchen scales that measure in 10 gram or 20 gram intervals up to 5 kilograms are useful, as well as scales that measure smaller amounts such as 1 gram or less. Electronic scales are the most accurate but, of course, are expensive so a good alternative is a set of scales with weights. These are reasonably accurate to 0.2 grams, which is more than adequate when you are starting out.

Auxiliaries

Apart from all the equipment listed here, there are a number of other items that every print room needs such as: airtight containers for storing print paste, buckets or bowls for mixing colours, spatulas for stirring colours and cleaning out screens, brushes and sponges for cleaning out screens, rags for cleaning up mess. Packaging tape is another consumable required in the print room to tape the edges of the screen where the emulsion meets the wood, and to quickly block out any pinholes that might occur while printing. Packaging tape is a cheaper alternative than masking tape: it is waterproof, and can be easily removed for stripping the screen. If it is applied to the screen carefully, it will withstand many washes. The other alternative is gummed paper tape but, because it is not waterproof, it requires lacquering — methods that do not involve the use of any solvents are preferable.

Printing fabrics *10* preparation and techniques

Patrick Snelling

Designer and lecturer
*North American Indian
motifs and reference to woven
blankets are used as resource
for the design.*

209

*T*his chapter tells you step-by-step how to get your artwork ready for photographic screens, how to prepare your screens (degreasing, stripping, registering, coating, exposing) and, finally, how to print your design in repeat. Chapter 11 concentrates on other methods of applying surface decoration to the fabric, using other than printing in repeat with photographic images. The purpose of this chapter is to show how hand-printing can imitate industry.

Artwork **preparation**

This section concentrates on getting your design ready for exposure onto a screen photographically. There are other methods of screen preparation, or techniques that use screens in ways other than photographically. These are discussed in Chapter 11. Photographic screens are the most accurate way of transferring marks onto fabric. The designs are converted to opaque marks on film, which are exposed via a light source onto a screen coated with light sensitive emulsion. The light source will harden the photographic emulsion, where it has direct contact. The emulsion will not harden where it has been blocked by the opaque media on film; it will therefore wash out, leaving open mesh. Silk screen positive is the generic term for film produced by hand or camera, ready for exposure onto a screen. Preparation of artwork also involves colour separating the design; each colour in a design must be on a separate screen, and must therefore be on a separate piece of film.

The preparation of artwork and screens using the photographic process can be summarised as follows:

1 The design is produced on paper (either placement print or repeat design). Make sure that all design problems are resolved before proceeding any further.

2 The design is laid out on graph paper and squared up. Registration crosses are placed in each of the four corners.

3 The design is colour separated onto film, either by hand or using a reprographic camera. Each piece of film should have identical registration crosses.

4 Register the screen.

5 Coat the screen.

6 Expose the screen.

7 Wash out the screen (see pages 231–8 for details on Steps 4–7).

Each studio or factory has its own particular way of doing each of these steps, involving different pieces of equipment. It is important to note that the principle remains the same.

Using a reprographic camera

In industry, most silk screen positives are produced by a reprographic camera. The design is transferred by the camera onto film, which is ready to expose onto a screen. This ensures that the marks on the film are opaque, and identical to those in the design. It is fast and efficient, and therefore expensive, which is why many smaller operations do the same thing by hand. Type, and some textured or tonal effects, should be repro-

duced by camera for the best results. In making the positive, the camera can be used to change the size of the image. Depending on the camera size, you can have multiples of your unit of repeat reproduced, or you can lay out the whole design in photocopies, and have a positive made; or some reprographic services have the facility to take your image and put it into repeat for you, providing you with a full size positive ready to go on screen. Reprographic cameras are also great for creating tonal effects using halftones. This is where tone is converted to a series of dots: where the dots are close together, there is a dark area of tone, with lighter shades created by the dots being further apart. Using halftones in a design means you can use one screen, but give the illusion of printing more than one colour. The more sophisticated reprographic cameras will electronically colour separate multi-coloured designs, and can also separate full colour designs into the four process colours so they are reproducible. Process printing (see page 46) is used within the paper printing industry to print many familiar things, such as posters, magazines, books. It is becoming increasingly popular for textile printing, because it enables almost anything to be printed, using only four screens. However, the colour separations for process printing are very expensive, and the results are not always completely controllable for textiles, given factors peculiar to fabric such as absorbency and movement. If the dots are not properly aligned, the image can develop an out-of-focus look, so if a design is being produced for process printing on fabric, it should have built in error to cope with the inevitable inaccuracy. The process colours themselves are bought premixed, so they will combine to make all colours.

Handprinters do not often use this method because of the accuracy required and the expense of the colour separations.

Film

If the positive is done by hand, the design needs to be transferred onto a surface through which the light will pass. Drafting film is ideal for this, as it readily accepts wet media, it is a good flat surface to work on, and it remains stable. It is available in rolls, which is usually more economical, or sheets, in a variety of widths and thicknesses. The width should correspond to the repeat sizes you commonly use. The thinner the film the better, for photographic purposes, as it will have better transparency. Most drafting film will have a cloudy appearance, but is transparent when put in front of light. It is available from art supply or graphic/technical drawing supply shops. Acetate can be used, but its shiny surface makes it difficult to achieve flat opaque marks; it is wise to avoid using it unless you want to achieve specific effects. Drafting film is expensive, but can be reclaimed if the opaque medium you are using is not permanent; brown opaque or pencil can be washed off, using a scourer or abrasive cleanser if necessary to remove stubborn stains.

Opaque media

Products are available specifically for the production of silk screen positives, and are often known as 'brown opaque', which is a water soluble, reddish-brown paint. It is much better to get a good quality opaque paint, that gives good even coverage, is fluid to use and will not scratch or peel

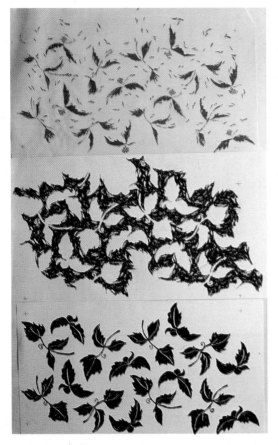

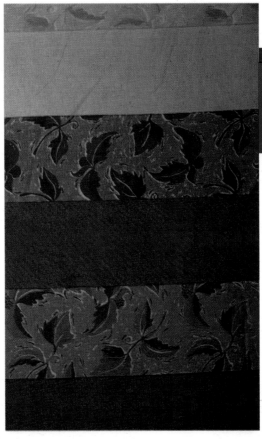

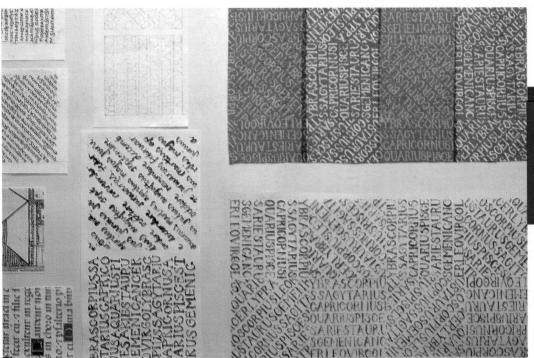

off the film too easily in everyday handling. Opaque paints need stirring before use, should be kept with the lid on firmly, and be used in a separate dish, rather than straight from the container. The excess can be left in the dish to dry out, and then, if it is a good quality paint, be reconstituted with a small amount of water for further use. Enough water should be added to make the consistency fluid, without diluting the opacity of the paint. Check the opacity frequently during painting, either by working on a lightbox, or holding the artwork up to the light. If you can see through it, it is not opaque! Some streakiness in the painted areas is OK, but remember the aim of producing the silk screen positive is to prevent the light from hitting the emulsion and hardening it in the areas of the design. It is much better to be safe than sorry. The better the positive, the better the exposure is likely to be. The other wet medium that is opaque, by its nature, is technical drawing ink, used in a pen or brush. Work slowly and carefully with drawing ink, as it can become less opaque if you move too quickly across the film.

Other media suitable for silk screen positives are black chinagraph pencils, 6B or EE pencils, and litho crayons, which have a reduced degree of opacity and therefore require more careful use. All of these have to be used quite firmly on the film, in order to be dense enough to block the light, and the exposure should be shorter than that for 100 per cent opaque positives (such as those produced using a reprographic camera). When you are using pencil, the positive will look much darker than it actually is, until you look at its opacity when held up to the light or put on a lightbox. Pencils such as HB or 2B are meant

for fine detailed marks, and their opacity is too unreliable for use in silk screen positives. The golden rule is to always test the medium you are using on a scrap of film, and hold it up to the light, to see if it is opaque. If it is, use it!

Rubylith film

Rubylith film is a product designed to make stencils for silk screen positives. It is a red film on an acetate backing; the red film is cut using a sharp blade, and the parts that are *not wanted* in the design are peeled away, leaving the clear acetate. Rubylith film is transparent, enabling it to be placed over the design, and cut out accurately, but the red colour of the film reads as opaque in the exposure. Yellow and red films are available — the particular colour of the film refracts the light, therefore preventing it from hitting the emulsion. This film is used for designs that can have a cut edge, and is particularly useful for broad areas of colour, which are quickly cut but would be tedious to paint up flat. Cut as accurately as possible, particularly where two edges meet, as this makes the peeling back much easier. Using the blade, carefully lift a corner or edge of each piece being removed, and slowly peel it back, lifting it off. As with most techniques that require cutting, make sure your blade is sharp. Rubylith film is not cheap, but will often save time or achieve a cut edge effect, which is important in the design.

Con-Tact

Black Con-Tact paper is useful in the preparation of silk screen positives by hand, as it is affordable, and enables you to have cut shapes that can

be stuck onto drafting film. It can be bought easily from most hardware shops or supermarkets. The difference between using Con-Tact and using rubylith is that you have to trace the shapes onto the Con-Tact, cut them out, peel off the back, and place them in the right position on thefilm; with rubylith, you can see through the film, so you can accurately work over the design, removing everything that you don't want.

Photocopy acetate

Acetate sheets from photocopiers have a size limitation for designs that are in repeat and are not usually opaque. **Photocopy acetate** is useful for making positives for placement prints, and can be made opaque by rubbing drawing ink into the toner on the top side of the copy. This is done by dabbing ink onto the design area using a cotton bud or cloth, letting it soak in for a few minutes so it begins to dry, and then wiping it off. Where there is toner, the ink will have been absorbed, so it becomes denser and more opaque. The other option is to use two copies stuck together, but there is the possibility of a double image on the screen, plus additional expense.

Techniques for preparing silk screen positives by hand

All these media listed can be used in combination on the one silk screen positive, and can also be applied to the film in a variety of ways. Wet media can be painted, sponged, splattered, dabbed, sprayed. Where possible, you should try to use the technique used to produce the marks, when you are trying to reproduce them on film.

This is not always possible, particularly when you are also isolating the colour onto its own silk screen positive. However, many techniques are appropriate.

Frottage (see page 77) Rub straight onto the film, from textured surfaces like wire mesh, or from shapes you have cut in lino. Use chinagraph pencil, or litho crayon, or 6B or EE pencil.

Test a section on scrap film, and remember that thinner film will give a more sensitive result for textures. A shorter exposure may be necessary for rubbings.

Block printing You can ink up a linocut you used in the design on paper, with water-based block printing ink, or paint it with brown opaque, printing it straight onto the film. You need to play around with the amount of ink or paint on the block because the film is not absorbent, so there is a tendency for the image to 'blot'. The problem with linocuts printed straight onto the film with block printing ink is that they dry extremely slowly. This can be fixed by carefully sprinkling talcum powder onto the printed areas to absorb the moisture from the wet ink; it can be virtually dry in minutes. It is a good idea to dry the prints as you go, so the whole thing doesn't get messy or smudged. If the design is in repeat, mark on the film where the images are to be printed, or work carefully with the layout underneath.

Resists Candle wax or a very light coloured crayon can be used as a resist on film for wet media. Draw with the candle or crayon, and paint over it — you may have to thin down the brown opaque paint to get a better resist, or use ink. Sometimes too you will get a better result if you

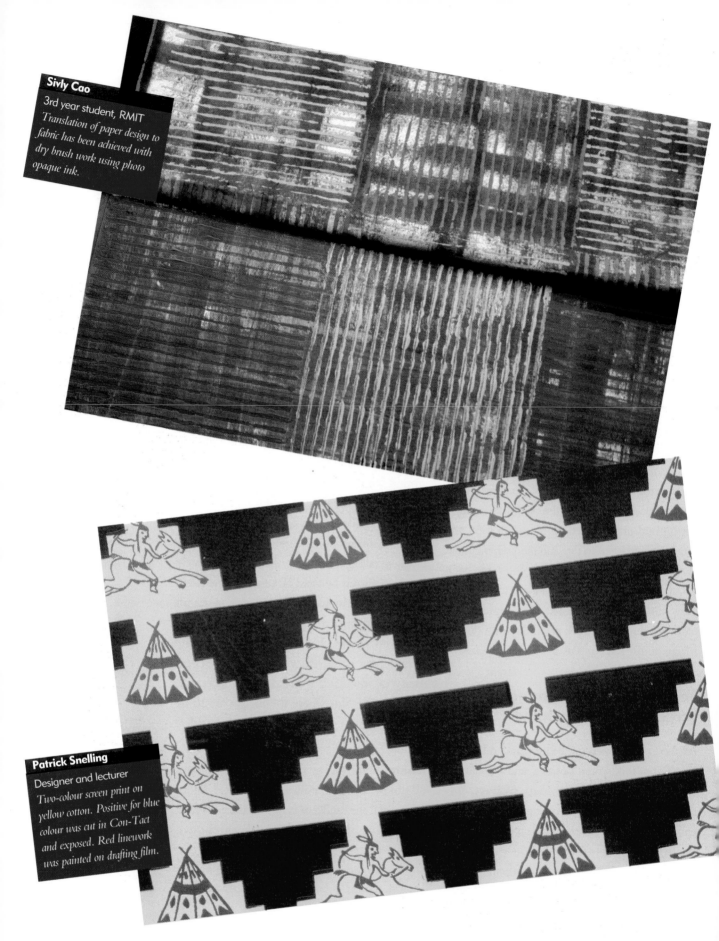

Sivly Cao

3rd year student, RMIT
Translation of paper design to
fabric has been achieved with
dry brush work using photo
opaque ink.

Patrick Snelling

Designer and lecturer
Two-colour screen print on
yellow cotton. Positive for blue
colour was cut in Con-Tact
and exposed. Red linework
was painted on drafting film.

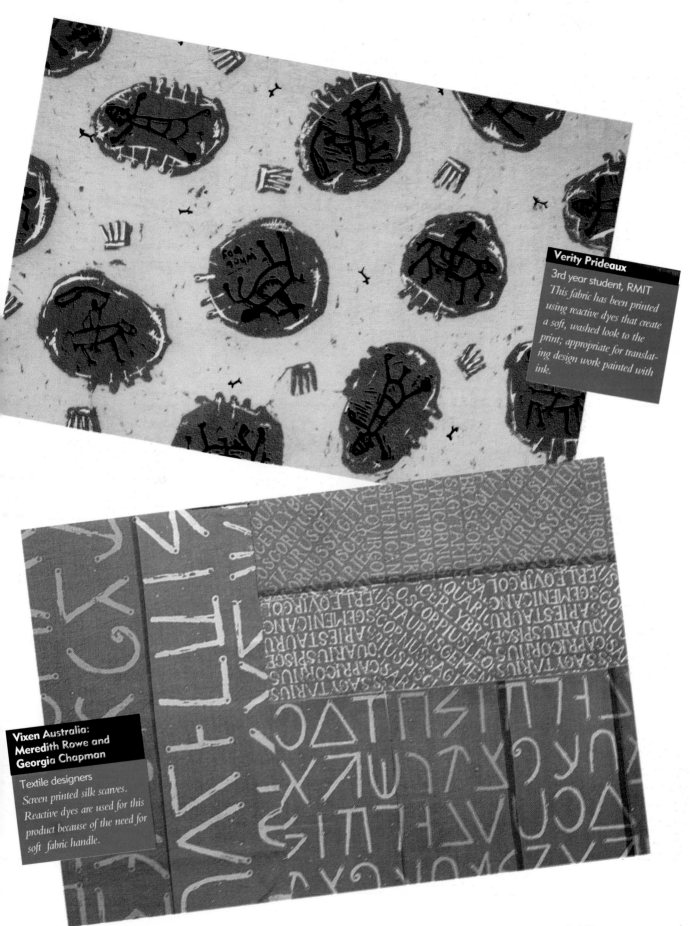

Verity Prideaux

3rd year student, RMIT
This fabric has been printed using reactive dyes that create a soft, washed look to the print; appropriate for translating design work painted with ink.

**Vixen Australia:
Meredith Rowe and
Georgia Chapman**

Textile designers
Screen printed silk scarves. Reactive dyes are used for this product because of the need for soft fabric handle.

use a hair dryer to melt the wax a little, before painting over it. Wax can be used to rub over a textured surface, or linocut, to make a resist to be painted over. There is no need to remove the wax from the film before exposure — the light should pass through it.

Masking fluid This can be used on film, just as you would use it on paper. You probably need to play around a little with the consistency of the brown opaque, as you don't want it to be so thick that it seals the masking fluid and will not rub off. Try using technical drawing ink as the opaque medium. It is a very useful technique for achieving textural effects.

Frisk film Frisk film or other masks can be used on film in the same way they are used on paper. Use them to isolate areas where you will splatter or sponge the brown opaque paint for textural effects, for example.

Stencils These can be cut from black cover paper and exposed straight onto a screen. Flat found objects, which are reasonably opaque, can be exposed straight onto the screen — you can also try things like open wire mesh, or lace fabric, as long as they are not too thick, as this would mean there was not good contact with the screen, which will give a blurred result.

Scratching/scraping The brown opaque can be scratched off the film to give interesting results.

Natalie Ryan
2nd year student, RMIT
Opposite: *a lino block was used in the original paper design and the effect on fabric was duplicated by inking up the block and printing onto the film to create a positive.*

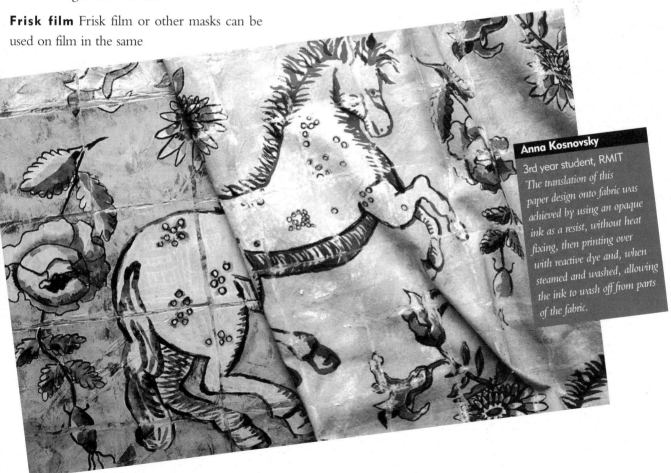

Anna Kosnovsky
3rd year student, RMIT
The translation of this paper design onto fabric was achieved by using an opaque ink as a resist, without heat fixing, then printing over with reactive dye and, when steamed and washed, allowing the ink to wash off from parts of the fabric.

Converting your design into marks on film

Unless you can afford to use camera silk screen positives, you often have to be quite inventive with the ways you convert the marks you made on paper into opaque marks on film. Sometimes, it is necessary to analyse the essence of those marks, rather than reproduce them exactly, by asking yourself — what function does that effect serve within the design, and is there another way of doing it?

This is often the case with background textures within a design, for example. The texture in your paper design may have been the result of dry brush on rough paper; film is flat, so you need to find another way of doing it. It might be rubbing with a chinagraph pencil over a rough surface, for example, to get a similar effect.

In the process of painting up the positives, or colour separations, it should not be the case that the life and spontaneity of line or form disappears. Try to capture the spirit of what you did on paper. In industry, it is often the job of someone other than the designer to paint up the separations; it is very important to carefully and accurately convert the design to film. The client will often have no idea of the process of getting the design onto fabric, and will expect a result that looks exactly like what they approved on paper.

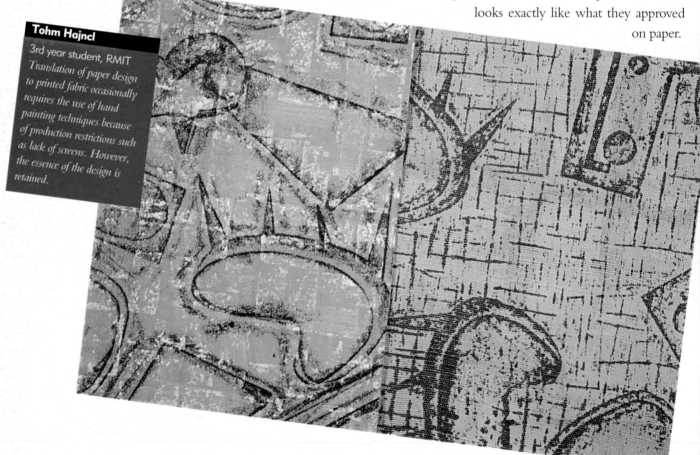

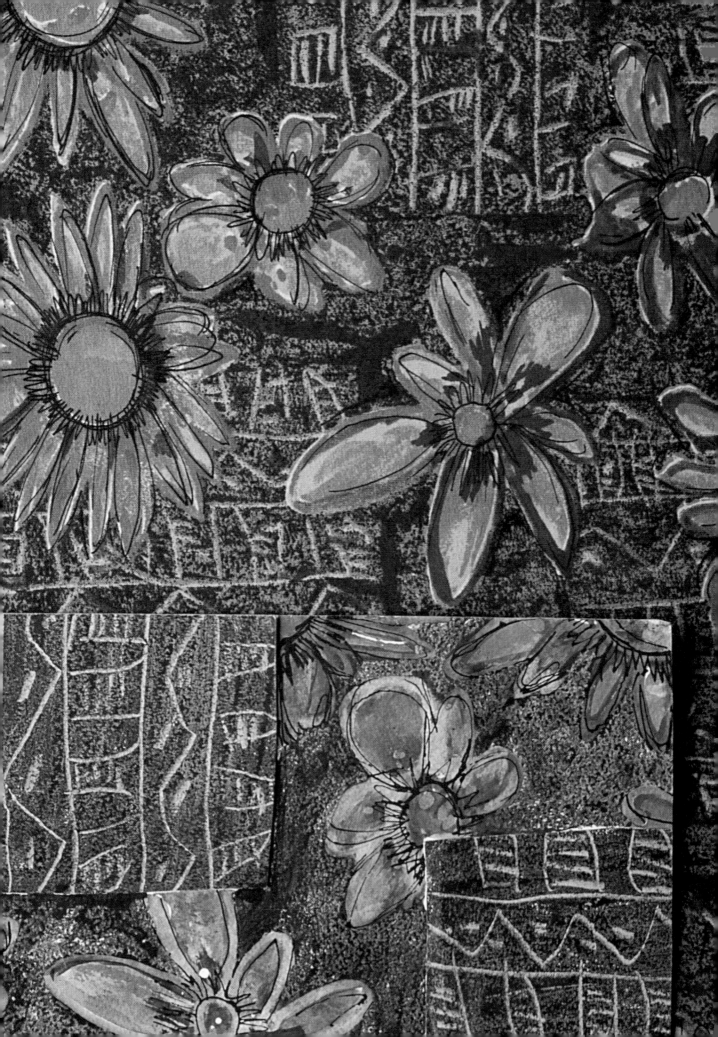

Colour separation for placement prints

Placement prints produced by hand will usually have up to four colours, but may go up to six or eight colours. The process of colour separation is the same, whether the design has two or eight colours, regardless of how it is printed.

On paper, the design should be resolved, with the number of colours specified by colour chips. Have ready one piece of film per colour, cut to slightly larger than the design area. Rule registration crosses on the first piece of film, outside the boundaries of the design. Stick the artwork down on the table or lightbox where you will be working, and place one piece of film over it, also sticking it in place. Choose one colour and, using the appropriate medium, paint or draw only that colour onto the film. Often, the first one will have the most detail, for example, an outline. When that is dry, place another piece of film on top, trace the crosses, and paint up the next colour. Depending on the design, these two colours may have no space between them; if this is the case, have a very slight overlap of the two colours — no more than a millimetre. Continue to place the films on top of each other, until you have the entire design on separate pieces of film. Once you have more than three or four layers, you probably need to be working on a lightbox, or remove the colours that are not relevant to the colour you are currently doing. The registration crosses on each film enable you to double check whether it will all join up — the crosses should therefore be accurate.

Remember that within a colour separation for one design you might have to use three or four different media. On the one piece of film, you might use, for example, black contact and chinagraph pencil. When you come to expose that design onto a screen, you need to consider the media used, as they will affect the time for which you expose that screen. As a general rule, the time chosen will be dictated by the least opaque medium.

Colour separation for repeat designs

The principle of colour separation is identical for placement or repeat designs; the difference is that with repeat designs, you also have to deal with the repeating edge and keep the design square so that everything will join up when printed.

Cut-through line

From Chapter 6, you will remember that this is the line that cuts through the layout, from selvedge to selvedge, so the images join up again when the design is printed. The edges of the design, which is put onto the screen, are the cut-through line. Before the positives, or colour separations, are painted up, you have to look at the layout of the design, and determine the best path for cutting through the design. The main thing is to choose natural breaks that occur in the design and not to cut through the centre of images. This cut-through line is important because, in conjunction with the way you have put the design into repeat, it disguises where the units of repeat begin and end on the printed fabric. It can make or break a fabulous design, which is being handprinted. Each colour in a design will

require a separate cut-through line, although they will all roughly follow the same path.

To work out where the cut-through line should be, put two units of repeat together, lining up the crosses. You should not really be able to tell where one starts and the other finishes, unless the design is geometric, and the 'tile' layout is being used, so that edges of the unit form part of the pattern. Look along the edge where the two meet, and, in pencil, draw a path that separates one from the other but *does not cut any shape or continuous line in half*. Use the space between shapes or images in the design, or the spot where one shape touches another, to make this artificial break a continuous design.

In determining the cut-through line, the overall look of the design will not be altered. The layout will also remain unchanged, although it might be reorganised to put it on a screen and print it without the join being obvious.

Once you have determined where the cut through line will be on the full colour design, adjustments might have to be made for each colour, but roughly the same path will be followed for each design. The design can now be laid out, ready to paint up.

Laying out the design in repeat

If you are selling textile designs, and are asked to put them in repeat, you do not have to present the client with a full scale layout. You need to paint up a section of the design that shows the repeating unit, and where it recurs; it will be handed to a technical artwork team further down the production line, who will lay it out and colour separate it, either manually or by using a computer. When you are handprinting, it is more than likely that you will do this process yourself, although some graphic reproduction services will have the facility to provide you with a full size positive of your design, from one unit of repeat that you give them. This is an expensive (but convenient) alternative.

The following information is particularly relevant to handprinting, but the principle is that which is also used in industry. Before you can do the silk screen positive, or colour separation for a design in repeat, you need to lay out the design so you know where to paint on the film and to prove the repeat. (Refer to Chapter 6 for how to get your design in repeat.)

Painting up the positive

To work out how much of the design you have to paint up on the film, you need to take into account several factors:

- How big is the screen you will use?
- How wide is the fabric you will print?
- What is the repeat size?
- How wide is your squeegee?
- How much fabric will you produce?
- How complex is the design — how long will it take to paint up?

Most fabrics are 115 cm wide. Fabrics for upholstery and bedding are often much wider, and many silk fabrics are only 90 cm wide. It is more difficult to handprint fabrics that are 150 cm wide, as it involves the use of very large screens and a wide table, both of which are prohibitive cost-wise when you are establishing yourself. Anything wider than 150 cm is virtually impossible to handprint, in repeat, although you can

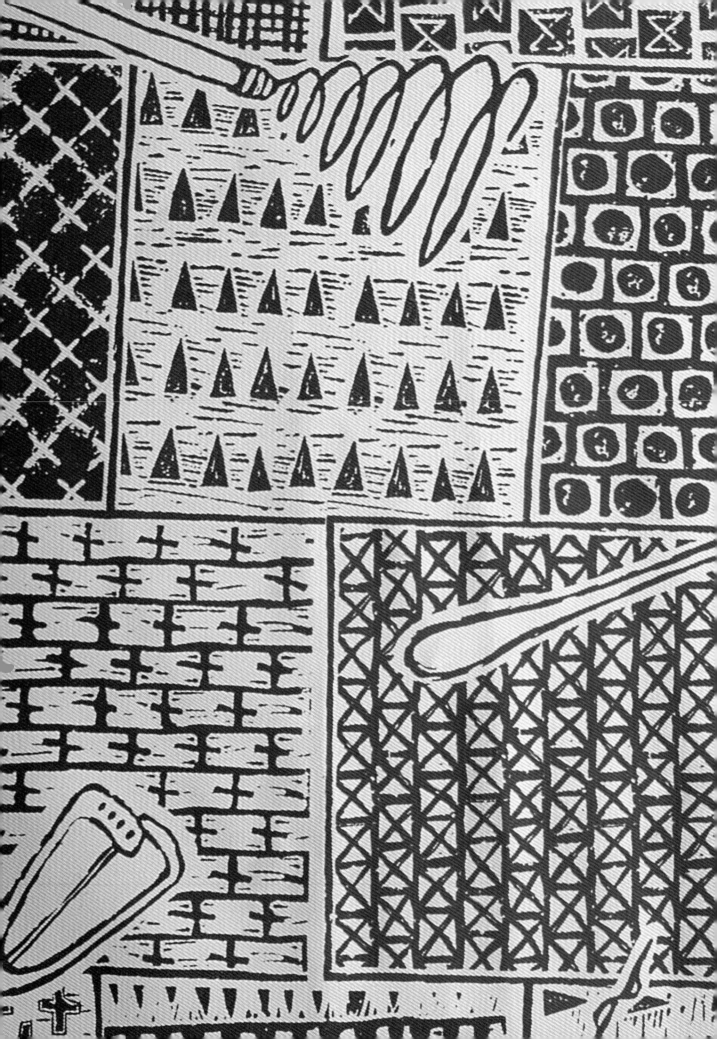

devise all sorts of methods using placement printing to do so. It is sensible to work to 115 cm, as you can still print fabrics that are narrower.

Refer to pages 198-9 of Chapter 9 for recommended sizes and important considerations if you are buying frames. Make sure you measure the inside area of your frame, leaving enough room for a well for the print paste at either end, and at least 5 cm at each side for the squeegee to

pass evenly across, before you decide how wide to paint up your design.

If your design is made up of repeating units in a full drop, which are 16 cm x 16 cm, you could put the design on the screen with a repeat size of 16 cm or 32 cm or 48 cm or 64 cm and so on. The smaller the repeat, the more you have to print, which is why you need to consider how much fabric you are likely to print. As a general

Andrea McNamara

Designer and lecturer
Opposite: *the two colours indicate where the cut-through line is in this all-over design for apron fabric. When printed in one colour, the fabric will appear continuous.*

Printintin Design Studio

Top: *the design on paper;* **middle:** *colour separation, yellow and black;* **bottom:** *screen print for T-shirt.*

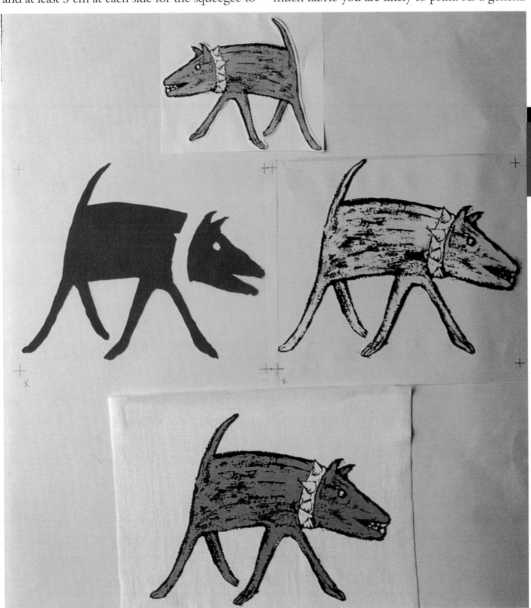

rule, anything less than 30 cm becomes extremely tedious to print, no matter how small a quantity you are doing. Look at how complex the design is, and how long it is going to take you to paint up one, two, or three repeats. The simpler the design, the bigger the repeat can be, providing it will fit on the screen you have, and you have a squeegee wide enough to print it.

The following instructions assume you have your design in repeat according to the process outlined in Chapter 6.

1 Stick down a large piece of graph paper (or continuous sectional paper), preferably on a flat surface where you won't have to move it until it is finished. Take your unit of repeat, and either photocopy it or trace several copies of it onto detail paper — you need the outlines of shapes, and any other lines that are important to the structure of the design. Make sure you have the registration crosses on each copy.

2 On top of the sectional paper, lay out these copies of the unit, so they are all square, lining up the crosses with each other and the grid. It doesn't matter that your design might not fit perfectly across the width of the fabric in complete units — you may end up with half a unit on one end. The main thing is that it is continuous. Stick the copies in place. If you are still nervous about whether the design repeats correctly, trace one side of the design, including the crosses, and line it up with the crosses on the other side, making sure everything joins up. If it doesn't, it should be corrected at this stage, as it is too late once it is on the screen.

When you are laying out the design, make sure you have the motifs facing the right way, in relation to where the selvedges of the fabric will be. (See Chapter 6, page 131.)

3 Lay a piece of drafting film on top of this layout, and trace the crosses at either end. Using the appropriate medium, paint or draw up the first positive. If you need more detail than the layout provides, place the original painted up unit underneath the film, and work on each unit one at a time. Take care to put the original in the correct position. Depending on the nature of your design, each motif or shape within the design can probably have some variation — this often gives character to handprinted designs. Reprographic cameras give you the exact unit of repeat over and over again.

4 Once the first colour is finished and dry, lay the second piece of film over the first, place the four crosses at each corner on the film, and proceed with the second colour. Depending on the design, you might have to allow a small overlap if the colours butt up against each other; do this if a white gap will detract from the design. Too big an overlap will create a dark line of a different colour that may also detract from the design.

Which colour is painted up first?

It will depend on the design as to the order colours are painted up. As a general rule, choose the colour that has the least coverage, or is the palest, to work with first. Sometimes, however, the colour with the least coverage will be a highlight colour, which is printed over the top of the other colours; in this case, it would be painted up last. If one colour has line detail to be printed over everything else, paint it up first, as it will show you where to put the other colours.

The main things to remember are that the

crosses should be transferred to each piece of film, and that, if possible, the colour separations should stay in the one place (or at least flat) until finished, so that rolling them up and transporting them doesn't make the design go out of square.

For registration, choose one corner, usually the lower right-hand one, and make a mark such as 'R' or 'RAIL', which only reads correctly one way.

Finally, make sure that your silk screen positive is opaque. If it isn't, touch it up before exposing onto a screen.

Handy hints

When you are working by hand on silk screen positives, you risk one end being neat and tidy, and the other end of the same colour separation having a much looser style and possibly being less opaque. To avoid this, don't work on each colour from one end to the other: work all over the film at the same time, painting up some from one end, and some from the middle. Apart from anything else, this reduces the boredom of the exercise!

Smudges and fingerprints should be cleaned off the film, using a cotton bud dipped in water or methylated spirits to remove ink. What exposes is dependent on your exposure unit and how long you are exposing screens for. As a general rule, faint stains will not expose.

Make sure you don't sit in a cramped position for hours on end painting up the separations. It is advisable to get up and stretch every twenty minutes or so, particularly if you don't have a drafting board and ergonomic chair.

Far left: *one section of repeat;* **left:** *all-over design; pigment printed cotton.*

Screen
preparation

Screen care

Proper care of your screens means that screen preparation is kept simple and straightforward. After you have printed with your screen, make sure you remove all the excess print paste before washing, so it doesn't get left in the edges and won't go down the drain. All excess print paste with pigment in it can be recycled into black, or other colours, rather than wasted. Wash both sides of the screen, and use detergent applied with a sponge as a final wash — this reduces the likelihood of staining and blocking. If you are using dye, make sure you rinse the screen, and wipe it with detergent, until no more colour comes out; if you don't do this thoroughly, then the colour is likely to stain your next print. Be aware of where you are leaning your screen, so it can't fall over and tear, and make sure your storage system allows easy access, so the brackets on one screen will not rip another screen. Ripped mesh is the most likely thing to lead to the screen needing new mesh; if the screen is looked after, the emulsion can be stripped and a new design exposed, many times over many years.

Stretching screens

If you intend to reclaim screens using a pressure gun to blast out the images then you should have the frames meshed professionally. They will be stretched on an industrial screen stretcher, using a two part adhesive, so the mesh will be taut, straight and more permanently attached to the

wood. It is often more economical to buy new frames meshed, than it is to buy the frames and mesh separately and do it yourself. Screen stretchers are very expensive pieces of equipment, and require the use of lacquer or very strong adhesives, so you need to have a good ventilation system and wear a respiratory mask. Always be aware of the effect on other people in the work area. It is probably better long term to have your screens stretched professionally.

You can stretch a screen by hand, using clamps It is good to know how to do this if you don't have access to professional services, or you need to redo a screen in an emergency. Screen stretching clamps are handy to have in this situation, as they assist you in getting the mesh taut and straight. You also need a staple gun. The mesh should be cut to about 5 cm larger than the outside of the frame. Start in the centre of one of the longer edges of the frame, and staple the mesh in place, putting the staples on the side edge (rather than the face, or table side) of the frame. Put the staples close together, and on an angle, as they are less likely to tear the mesh. On the opposite side, and starting in the middle, pull the mesh across, keeping the grain straight, and pulling out as much movement as possible. With finer meshes take care that you don't rip the mesh by pulling too hard. Staple in place, and complete that side, clamping and stapling each section. Repeat the process with the remaining two sides. Fold the corners neatly, and staple down, trimming away excess on all sides. You can use lacquer in addition to the staples to adhere the mesh to the frame; if you don't, the print paste can be easily pushed between the mesh and the wood, generally seeping onto a surface where you don't want it.

Degreasing screens

New mesh requires **degreasing**, which is a two-fold process usually done with one product: cleaning the mesh to remove grease and impurities, which prevent the photographic emulsion from adhering; and roughening of the fibres to enable the mesh to accept the photographic emulsion more readily. Most companies dealing with screen printing auxiliaries will have a degreaser in their range of products. They are a type of detergent available in abrasive pastes as well as liquid form. For new mesh, an abrasive paste is a good idea, but for general screen maintenance, use the liquid form. Generally, degreasers are scrubbed on both sides of wet mesh, left for 5 minutes, and then washed off thoroughly, using a pressure gun if you have one. Often, you can get away without degreasing screens before you use them, but because of the few times when you can't (and it is impossible to determine whether you should or not just by looking at the screen) it should be done routinely. Screens should be degreased after they have been stripped several times, to keep the mesh in the best possible condition, as part of their general care and maintenance for a longer life.

Stripping screens

Photographic emulsions usually have a stripper that accompanies them as a screen preparation package. There are several different strengths of stripper; one is a powder that dissolves in water to make a solution. This should be applied to the mesh prior to using any of the stronger pastes. Before you strip any screens, make sure all the tape has been removed from the back, and then follow the manufacturer's instructions for application, making sure you wear gloves and protective clothing. Generally, these liquid solutions are applied to a wet screen, on both sides of the mesh, left for 5 minutes or so, and then blasted off with a high pressure gun. The liquid stripper can be applied at 5 minute intervals a couple of times before blasting, if the image is particularly

brush liquid stripper thoroughly over both sides of screen

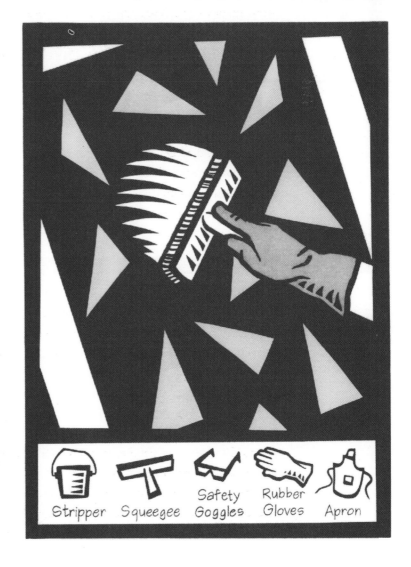

Stripper Squeegee Safety Goggles Rubber Gloves Apron

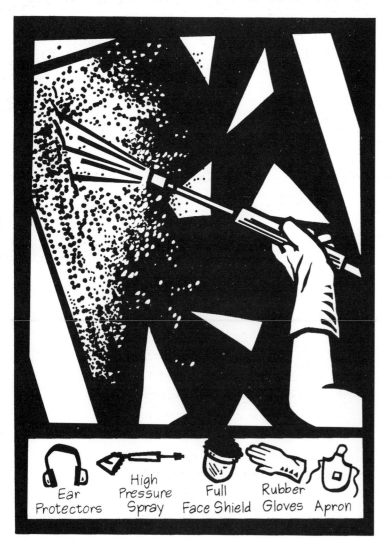

Ear Protectors High Pressure Spray Full Face Shield Rubber Gloves Apron

**blasting emulsion off
the screen**

bottom, and from one side to the other. Waving the gun aimlessly at the mesh generally has poor results. The gun should also be held fairly close to the mesh, so it causes less spray everywhere else and has maximum effect.

If the emulsion is hard to remove, you might have to use a caustic paste, which is stronger than the liquid stripper. These pastes should only be used on a screen that has been stripped first using the liquid solution. Again, follow the manufacturer's instructions for best results, but generally, the pastes can be applied to wet or dry mesh, left for 5 to 8 minutes, and then blasted off. If the paste is left too long on the mesh, it weakens the fibres and can cause the mesh to disintegrate. When using caustic pastes, great care must be taken — wear protective clothing to cover bare skin and you need eye protection, as the blasting of the screen can cause bits of paste to splatter everywhere. Try to avoid working in close proximity to other people when you are using the paste and liquid stripper, and make sure the strippers are not going to make contact with any other screens.

Preparing your screens well is the best way to ensure that the exposure of the design will be successful. Make sure the screen is stripped properly: before you are satisfied that it is clean, hold it up to the light to check whether there are any areas where the emulsion is still blocking the mesh. If you are not sure whether it is ready, dry it off with a hair dryer, and check it again. Stains from old designs are not a problem. Always strip the emulsion back to the edges of the frame, even though you may only want to use the centre section of the mesh. This ensures the mesh will be easy to strip next time.

hard to move, or if your pressure gun is not very powerful. The most important thing to remember is that if the stripper dries on the mesh, it hardens the emulsion, which becomes almost impossible to blast off. As much emulsion should be removed with the liquid stripper as possible, as of all the reclaiming products it is the safest to use and can be very effective if correctly used, and if the screens are washed out thoroughly after printing.

When blasting the emulsion off the screen, work systematically over the screen, from top to

Registering screens

Before the screen is coated, you need to work out where the design will be placed on the screen. You have worked out the repeat, and kept everything square while doing the colour separation; all this was done because the design will be repeated over and over again, along a straight line, which is the registration rail.

Follow these steps as a checklist each time you register the screen.

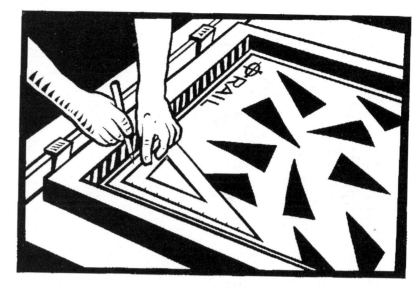

1 Square the crosses on your artwork to the rail. Do this by placing your artwork on the grid on the registration table you have set up, or by placing the artwork on the print table, and measuring the same distance from the rail for the two crosses at the rail end. Remember to allow enough space inside the screen for a well for print paste; 5 or 6 centimetres is the minimum you should have.

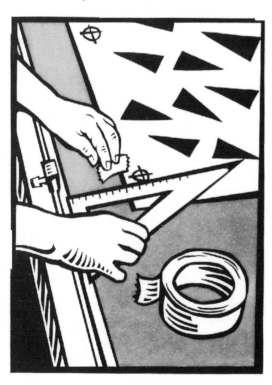

2 Place the clean, dry screen over the artwork, centreing the design within the frame. The design doesn't have to be centred; if there are holes or blockages in the screen, position the design to avoid them. Ensure that the design is not running off the mesh, and that the frame is right up against the rail or the bar on the registration table.

3 Transfer the crosses onto the screen, in pencil, using a ruler for accuracy. A hard pencil is best, as it will give good clear crosses; if you are reclaiming screens, it is unwise to draw your crosses in pen, which is harder to remove. Make a mark near the lower right-hand cross, such as R or RAIL; this should correspond to whatever mark you put on your artwork. As mentioned on page 227, you should choose a word, or a letter that only reads correctly one way. This mark is to indicate which way up your artwork will go on the screen, as well as which way round.

4 For a multi-colour design, register all screens to the same artwork; *do not move the artwork in-between registering the screens.* The crosses on all the colour separations should be identical; the point of transferring the crosses from artwork

to mesh is to ensure that each colour is in the same position, in relation to the rail. It doesn't matter if the frames are different sizes, or if one colour is slightly to the right of the frame, while another is in the centre. The important thing is to make sure the artwork will go on the screen square to the rail.

Once all the screens are registered (they have crosses on them and indicate which end is the rail end) you are ready to coat the screen with photographic emulsion.

Coating screens

Photographic emulsion comes in two parts: an emulsion and a sensitiser. Once these two parts are combined, the mixture is light sensitive, and should be kept in a cool, dark place with the lid firmly on. If you are not putting designs on screen very often, it is probably a good idea to buy photographic emulsion in smaller quantities of, say, 1 litre. This will be more expensive, but the emulsion has a shelf life once mixed. Depending on the brand you are using, this could be six to eight weeks. Follow the manufacturer's instructions for mixing but, generally, the procedure will be to fill the sensitiser container with warm water, shake to dissolve, and then add this solution to the emulsion, making sure it is thoroughly mixed. The emulsion should then be left for several hours before coating a screen, to allow the air bubbles to subside; the bubbles can cause **pinholes.** Wear rubber gloves when doing this.

There are many photographic emulsions on the market. Choose one that fits your needs: tell the manufacturer what you will be using it for, including whether you are going to be reclaiming

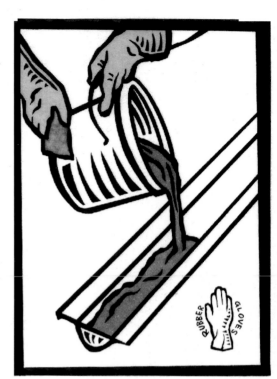

fill the coating trough with photographic emulsion

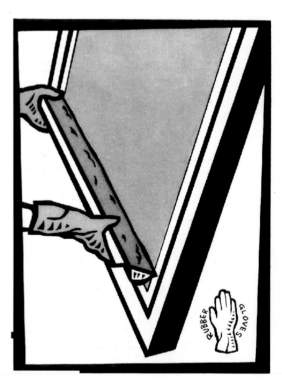

tip the trough so the emulsion meets the mesh; start at the bottom, on the outside of the screen

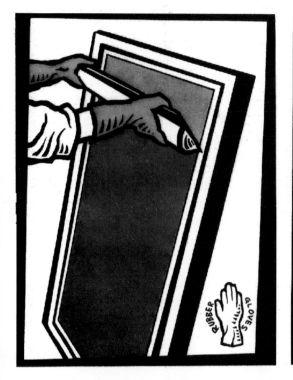

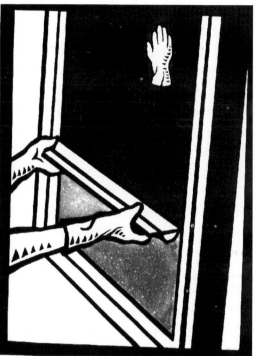

Far left: **take the trough firmly to the top of the screen;** left: **turn the screen around and do the same on the inside of the mesh.**

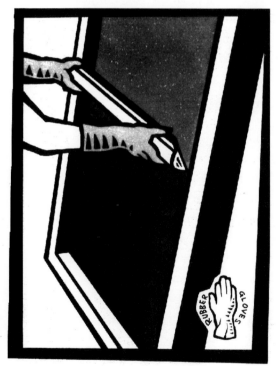

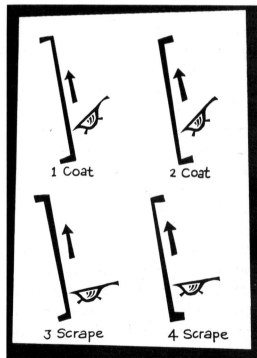

1 Coat

2 Coat

3 Scrape

4 Scrape

Far left: **turn the screen and scrape off the excess emulsion by bringing the trough slowly and firmly up the mesh, but do not tip the trough. Repeat on the inside of the frame;** left: **coating the screen, an overview.**

screens, what the quality of the artwork will be like, and what sort of exposure unit you have. If you are reclaiming screens, you will need an emulsion that strips readily, rather than one that is very hard and durable, lasting tens of thousands of metres. Find out what the shelf life is when mixed, and ask for a safety data sheet with the product, so you will be aware of the chemicals you will come in contact with.

Try to coat the screen in an area that is not very light; a dark room is not necessary, but you should try to work efficiently, and keep the screen and the emulsion out of brightly lit areas.

1 Fill the trough with emulsion. If the screen is large, get someone to hold it for you while you coat it. Start at the bottom, on the outside of the frame, and hold the edge of the trough against the mesh, tipping the trough until the emulsion meets the mesh.

2 Slowly move the trough firmly up the mesh, putting a layer of emulsion on the screen. Keep the trough on an angle, so the emulsion keeps coming out. Make sure the trough is not against the wood of the frame.

3 Repeat this on the other side of the mesh, keeping the trough angled.

4 Now that both sides are coated, remove the excess, by going back to the first side, and using the edge of the trough to remove emulsion. Start at the bottom, and move the trough up, but this time do not tilt it. You should be able to see the excess coming off the screen.

5 Repeat this on the other side.

6 Before you put the screen away to dry in a dark room or cupboard, make sure it is evenly coated and there are no thick areas, which will cause blobs when drying. Also, make sure there are no areas that are too thin, which are likely to form pinholes. It might be necessary to remove more emulsion or to coat one side again. Scrape off any emulsion, which is on the inside or outside of the wooden frame, using a spatula. Try to avoid excessive coating or scraping, as this will increase the likelihood of pinholes.

A heater in the drying cupboard can speed up the drying process. Make sure it is not too close to the mesh as it can harden the emulsion so the design will not wash out. Have a heater on in the drying cupboard for half an hour before you put the coated screen in there. Even a cold air fan speeds up the drying process. Depending on how you are drying screens, and the size of the screens, this could take 30 to 90 minutes.

When you are coating screens, make sure you get as close to all the edges as possible. This reduces the need for excessive amounts of tape around the edges, and lessens the chances of print paste leaking through where it is not wanted.

Exposing screens

This advice is general, because each combination of exposure unit, photographic emulsion, and artwork will lead to a different exposure time. You will have to do a test when using the equipment for the first time, or when you change any of the variables in your system. Work out the ideal exposure time for artwork that is perfectly opaque (painted with brown opaque paint, or cut out of rubylith film) without too many fine lines. This will give you a good measure against which to judge how long other artwork should be exposed for.

Doing a test strip

The exposure time will depend on the strength of the light source, and the photographic emulsion you are using. Some emulsions are 'faster' than others, but these are often harder to strip.

Work out roughly what you think the range of exposures will be; for example, the more primitive the unit, the longer the exposure is likely to be, say between 10 and 20 minutes. More sophisticated units may vary between 3 and 6 minutes. Work out what exposures you should test, in order to get a good range, increasing at regular intervals. For example, you could try 150, 180, 210, 240, 270, 300 seconds. With the more makeshift unit, you would try 10, 12, 14, 16, 18, 20 minutes, where the light source might be a 1000 watt globe.

Coat and dry a small screen. Use a piece of artwork you already have, or produce a strip especially for the test. Divide the strip into about six even sections; these should be a minimum of 5 centimetres long. Each section will correspond to a time. Have ready a piece of black paper, which is big enough to cover the artwork; cover paper is ideal. Stick the artwork to the screen, and cover all but one section with the black paper. Place the screen in the vacuum frame, or on the glass, with weights, depending on your system. Expose for the first interval. Remove the screen, and move the black paper along so two sections of the artwork are revealed, then expose. The first section has now had, for example, 180 seconds, while the second has had only 150 seconds. The other four sections have been protected by the black paper, and have therefore not been exposed at all. Repeat this process of exposing the screen,

and moving the paper to reveal one more section, until the last section has been exposed. The last section will have had the shortest exposure, and the first one the longest. Wash out the screen. Look at the results: with the shortest exposure, the emulsion may have started to come off, not having had enough light to harden it properly, while the longest exposure may be difficult to wash out. Somewhere in the middle lies the ideal time. Do a test print when the screen is dry, and look critically at the result. Find which section has the clearest image, with the least pinholes. Once you have established the perfect exposure for very opaque artwork, you can vary the time for less opaque artwork, or for artwork that has finer lines or textures, or detail. The rules for exposure times are:

- the less opaque the artwork, the shorter the exposure time
- the finer the lines, or the more detail in the artwork, the shorter the exposure time
- the broader and more opaque the artwork, the longer the exposure time.

There is a limit to how short a time you can expose a screen for; your test strip might indicate this otherwise the emulsion will wash off, leaving no design whatsoever on the screen. If the exposure is too short, there is a likelihood of dust specks or smudges exposing, and of pinholes forming as the emulsion is too unstable. If the exposure is too long, the screen will be hard, or impossible, to wash out, and some detail might be lost. More detail is given in Appendix A.

Once you have worked out your times, keep a record of them for a little while, so you can see if the same things are going wrong all the time, and as a quick reference for future exposure times.

How to expose a screen

1 Make sure the screen is completely dry — if it feels a bit damp, chances are it is only superficially dry. This can cause the emulsion to wash off, even after the screen has been exposed.

2 When you are ready to expose the screen, take it out of the dark, and stick the artwork to the back, or flat side, of the screen. Match the crosses on the artwork with those on the screen, and check that R or RAIL reads the same way on the artwork and screen. This ensures you have everything facing the right way. Work quickly, because the screen is light sensitive.

3 Place the screen, back or flat side facing the glass, whether in a vacuum frame, or on a lightbox. Turn on the vacuum, or place weights on the artwork, to give good contact between the screen and artwork. If you are using a vacuum, remember the vacuum must stay on during the exposure, so the contact remains tight.

4 Draw the blackout curtain, or substitute. Set the timer and turn on the light. If the light

stick artwork to the back of the screen, ready for exposure

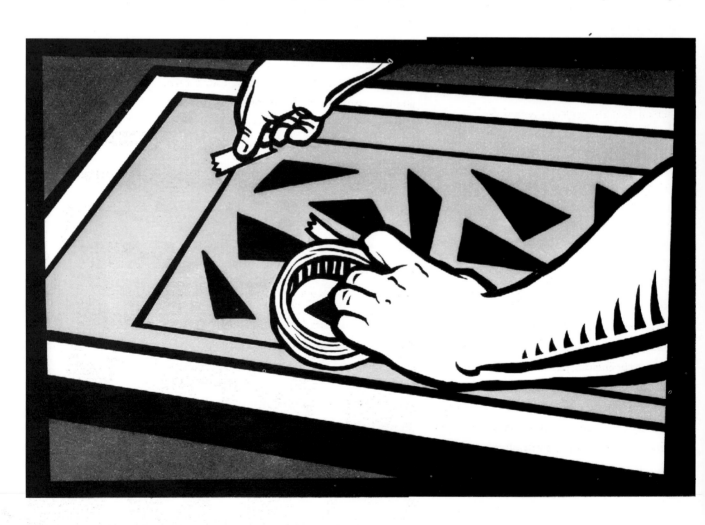

doesn't have an automatic timer, invest in a small battery operated one, which has a persistent beep.

5 When the exposure is complete, turn off the light or the vacuum, remove the artwork from the screen, and wash out the design.

Washing out the screen: developing the image

Warm water is ideal for washing out your exposed screen, but cold will suffice, and is better than having the water too hot.

1 Gently wet both sides of the screen, working over the whole surface evenly. At this stage the image should be seen on the back of the screen, becoming clearer as you wash.

2 Increase the pressure slightly and, working evenly across the screen, front and back, wash out the design. Again, depending on your combination of photographic emulsion and exposure unit, this may take anywhere from 30 seconds to 3 minutes. You should be able to see the image go 'white', which is really the emulsion washing out of the areas you painted opaque, so that you are seeing the mesh.

3 After the design has 'dropped out', keep washing the screen for at least a minute, until the yellowish film disappears, and the emulsion doesn't look so slimy. This is residue chemicals being washed out. If these are not washed out, they can cause a temporary scum, which blocks the print and is a major inconvenience.

4 Rinse the screen with a mild detergent and leave to dry, or dry with a fan.

Touching up the screen

Before you print the design, check to see whether there are any pinholes, registration crosses or other incidental marks that require patching up. Hold the screen up to the light, or check it on a lightbox. The most immediate way of doing this is with tape on the back of the screen, but this is temporary, and tends to need redoing after the screen is washed. Use the photographic emulsion to touch up the holes. Apply it in small amounts to the back of the screen, where required, blocking the holes. This emulsion needs to be left to dry, and then hardened in front of the light. It does not have to be washed out before use; the exposure is only to harden the emulsion you patched up with. The screen is then ready for use, and the repairs should be reasonably permanent. Some people still use lacquer to touch up screens, because it is immediate and permanent. However,

touching up pinholes

tape the edges of the screen on the back, using packaging tape

Printing

In this section, all the information given relates primarily to printing with pigment, although the process generally applies to printing with dye. For more specific information about using dye, refer to Chapter 12.

Test prints

The next step is to put a bracket on your screen and do a test print. This will ensure that you correctly patched up everything, that you remembered to tape the edges, that your screens all line up with each other, and that the repeat is correctly measured. At this stage there is not a lot you can do if the repeat is incorrect within the design; you can correct, however, a miscalculation in the repeat size, or incorrectly or inaccurately measured stops. A test print is essential, no matter what stage of development you are at. It helps you to get to know the idiosyncrasies of that particular design: what sort of squeegee you should use, and at what angle, and how much pressure you need to apply, how you should lift the screen, how tightly the fabric needs to be laid out and so on.

The first test print can be done on paper or a cheap cotton fabric. If you are very inexperienced, perhaps try it first on paper. Newsprint, which is cheap and available on a roll, is a good choice for testing screens. Secure the paper to the table by stapling or with tape. If you are using fabric, staple the piece in the right position. (See page 241.) For this initial test print, you only need to print two or three repeats, which means setting three or four stops.

this is not advisable. The use of lacquer can be totally avoided in a textile print studio; this allows a better working environment when you are not subject to the inhalation of fumes. Also lacquer is much harder to remove from the mesh if you are reclaiming screens, whereas photographic emulsion comes out very easily with stripper.

The final thing to do to your screen prior to printing is to tape around the edges. The tape is to seal off the mesh between the coated area and the wood. You will notice now the benefits of coating your screen right up to the edges of the frame, as there will be less area to tape out.

Later, when you are sure the repeat size is right, you might do another small test print to make sure the colours are right, and that the fabric you have chosen is suitable for printing.

Setting the stops

Measure the repeat. Remember, the repeat size is the distance from one point in the design to where that point recurs. You might be able to measure it from your crosses on the artwork (if you positioned them at the repeat size).

Now set the stops. You need a metal ruler, which has clear divisions into centimetres and millimetres. Place a piece of tape on the repeat size, for example, 32 cm. The stops are set by measuring the repeat size from the left hand side

of one stop, to the left hand side of the next stop. Or, from the right hand side of one, to the right hand side of the next. The diagram below shows the right way, and the two most common incorrect ways to set stops.

Imagine the **rail** as a **continuous** line **divided** into **regular intervals** that **correspond** to the **repeat size** and **format** on which your **design** is **based.**

Use the ruler, with its mark at the repeat size, to move the stops along the rail into the right spot. With the mark on the ruler, you lessen the chance of inaccurately or incorrectly measuring.

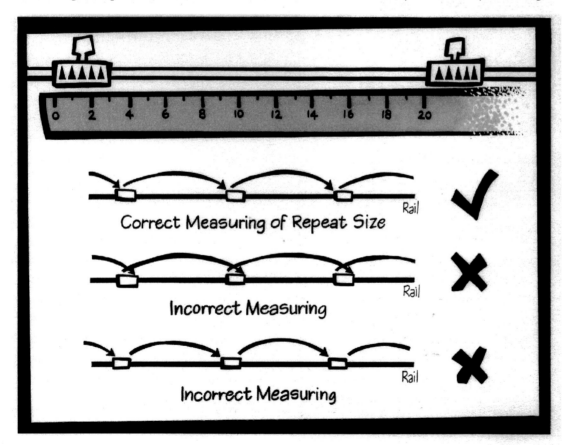

When all the stops are in place, tighten them. If they have a wing-nut as the tightening mechanism, you can use the slot in another stop to tighten the ones that are set. This prevents them from moving as you print, and from someone else fiddling with them and therefore moving them.

Attaching the bracket

You now have to attach something to the rail end of your frame that will tell you where to put the screen down in relation to the stops, carefully measured at the repeat size. Brackets take a variety of forms, but are usually a piece of metal with two screws attached to the rail end of the frame. The metal should protrude enough over the frame so that it will sit against the stop but not so far that it will push the screen away from the rail. The convention is that the bracket goes on the screen on the right-hand side, to sit to the left of the stop. The main thing to remember is that you should be consistent in what you decide to do.

Place the screen against two stops, roughly centreing the frame between them. This means there is less likely to be movement, or 'swing', in the positioning of the frame as you print. Place the bracket to the left of the stop that is nearest the right-hand edge of the frame. Depending on how precisely your design fits together, you might be able to use something as simple as a piece of masking tape on the frame to indicate where to put the screen in relation to the stops. If there is room for error, which usually means the motifs will have space around them, or everything overlaps each other anyway in a very busy print, you will probably get away with using masking tape; make sure it stays on the frame when you wash the screen. The tighter the registration, the more necessity there is for a bracket to be firmly fixed to the screen, reducing the margin for error in the placement of the screen against the rail.

For multi-coloured designs, the brackets must be put on all screens, so they line up with the stops and with each other. The easiest way to do this is to put a bracket on the screen that has the most 'information' on it ; this is usually the screen that has the most coverage. Make sure you have the registration stops in place, and leave them there. Print this screen, dry the print, and then position the next screen against the stops, so

Frame Bracket

Rail Stop Stop

the design is in the right place. Put a bracket on the screen, where it will sit against the stop. Print it, dry the print, and line up any other screens in the same way. All the screens have now been lined up to each other, and to the rail.

Laying out the fabric

The fabric needs to be positioned parallel to the rail, and at the correct distance from the rail for where the design starts on the screen. Lay the screen on the table, against the stops, and measure where the design starts. There is usually a gap of at least 10 cm between the rail and the selvedge of the fabric. Use a small set square to lay out the fabric straight. Start at the centre of the length, on the rail side, and staple the fabric to the table, using about one staple every length of the staple gun. Some lighter or stretchy fabrics will require even more staples than this, while others will require less. The stapling minimises movement when printing, so the design will join up. Don't pull the fabric as you staple it: you should try to keep the grain straight. Staple the other long side next, smoothing it out flat, rather than pulling it extremely tightly. Next, do the two ends, pulling the fabric only where it is necessary to straighten the grain.

There are alternatives to stapling the fabric, which is obviously not done in industry as it is a labour-intensive process. The table surface can be rubber glued with a pressure-sensitive adhesive: the surface can be washed down after each print, which reactivates the glue. The rubber is very expensive, and a less forgiving surface for the beginner to work on. Canvas can be glued, but the glue needs constant reapplication, because

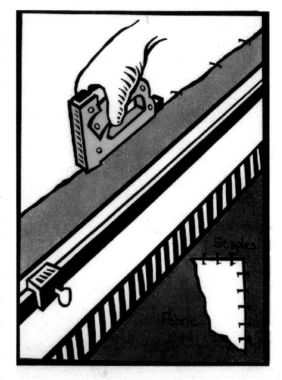

lay out the fabric parallel to the rail. Use a staple gun with 6 mm staples for easy removal.

staple the rail side of the fabric first

to staple the far side of the fabric, start at the centre and work out to either side. Make sure the fabric is not pulled so hard lengthwise that the grain is crooked.

finally, staple the ends, pulling the fabric to remove creases and trying to keep the edges straight

the surface is not water-resistant enough to wash down. One disadvantage of a glued surface for purposes other than production printing is that the adhesive attracts every tiny thread or staple that soon becomes embedded in the surface, and, when printing lighter fabrics, eventually shows up in the design. A removable backing cloth and the laborious method of stapling tend to be the best option in the beginning; certainly while the print facility is shared by a number of people for a variety of purposes.

Now you are ready to do a test print!

Setting up to print

This section deals with the order to print in, and how to make sure your design appears as a continuous length of fabric. (See pages 245-8 for more detail on how to get a good print.) It applies to printing in repeat, with screens that will print the width of the fabric. Unless the printer is very tall, this sort of printing will usually involve two people, one on each side of the table, who have to pass the squeegee to each other mid-screen.

Look at the stops you have set along the rail, and think of the space between each pair of stops as a print. Number these spaces (in your head) as No. 1, 2, 3, 4 and so on.

How do you know where to put the screen down? The bracket that you placed on the rail end of the frame should be placed next to the stops, which have been set along the rail. The bracket should be consistently placed to the left (or right) of each stop. The important thing is that it is always to the same side. By now as long as you have followed each step, everything has been determined so your design will fit together.

Checklist before you print

- design is in repeat
- artwork, or colour separation, has been done over a grid (graph paper)
- registration crosses are on the artwork
- each screen has been registered
- artwork has been lined up with the crosses when exposing
- registration rail on the table is straight
- a bracket (or substitute) is on each frame
- all screens have been lined up to each other and the rail, if it is a multi-colour design
- stops have been set at the correct repeat size for the design

You are going to print No. 1 and No. 3, before you print No. 2 and No. 4. When you print No. 1, the paste will be very wet. If you put the frame in position ready to print No. 2 straight away, the following things will happen, more often than not, because the frame will be sitting on top of the very wet print of No. 1:

- the first print could blur
- colour might be removed from the first print where the frame sat on top of it
- when the screen is picked up again and placed in the next position along the rail, it might put the colour it picked up from the wet print back onto the fabric.

If you print consecutive prints, you will make a mess.

every second print is printed and touch dried

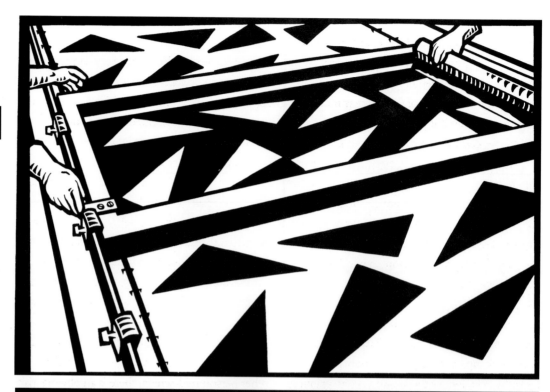

in-between print is completed

finished print

For your first test print, don't worry about drying the prints. Print No. 1 and No. 3, and then No. 2. Because it is a test print to see if the repeat is right and whether there are any parts that need taping, the quality of the actual print doesn't matter, especially if it is on paper.

The procedure is: print every second print, make sure they are touch dry, and then fill in the gaps. It is really up to you how you decide to organise this. When you are starting out, it is advisable to wash the screen after the first prints, dry the fabric, dry the screen, and then fill in the gaps. When you are more experienced, you will be able to juggle getting the fabric touch dry, with a fan or hair dryer, without letting the screen dry out. If the screen is left for too long, particularly if it is near the fan drying the fabric, it will block up, meaning the second prints will be faulty. The longer the length you are printing, the more chance you have of not washing the screen. You can flood the screen while you are waiting for the fabric to dry, by putting a coat of print paste across the screen, lightly applied with the squeegee, to keep the print area wet. This is not a good idea with a very fine detailed design, as there is a greater likelihood of blocking or blotting. You should always print out the flooded screen onto another piece of fabric, before resuming the real print. If you are printing with opaques and metallics, wash the screen after printing the first prints: the high solids content of these pastes means they dry quickly in the mesh. How quickly the fabric dries will be dependent on the weather, how you are drying it (fans), what fabric you are printing on (how absorbent it is), what you are printing with, and how firmly you have printed. There is no consistent answer to the question 'How long does the fabric take to dry?'.

Using the squeegee

In handprinting, the squeegee, the print paste and the printer/s are the main factors determining the quality of the print. There are so many variables with these three factors that it is no wonder the process was mechanised.

Usually, printing requires two passes with the squeegee: one across to the other person, and one back again. This will vary according to what you are printing on, and what you are printing with. As a rule, the denser the fabric, the more pulls may be required. However, other factors such as the consistency of the paste, the pressure used, and the angle of the squeegee can significantly reduce the physical effort of printing.

The first thing to work out is printing with a partner. Because the squeegee is passed to the other person mid-screen, there is an obvious risk of this showing up in the resulting print. One person might print heavier or lighter than the other; there might be a line where you paused before handing the squeegee over. To ensure more even distribution of pressure, choose a print partner with similar strength, or print with the same person whenever possible. When handing over the squeegee, make it a smooth action, rather than a 'snatch and grab'. The squeegee should be held from the top, with palms and thumbs pushing it forward and down at the same time. Generally, people position their hands closer to the outer edge of the squeegee, so the partner's hands can be placed more centrally when taking over; these positions are reversed on the second pass.

The next factor to consider is the angle at which the squeegee passes across the fabric. Start with trying to maintain a 45° angle. If you hold

using the squeegee

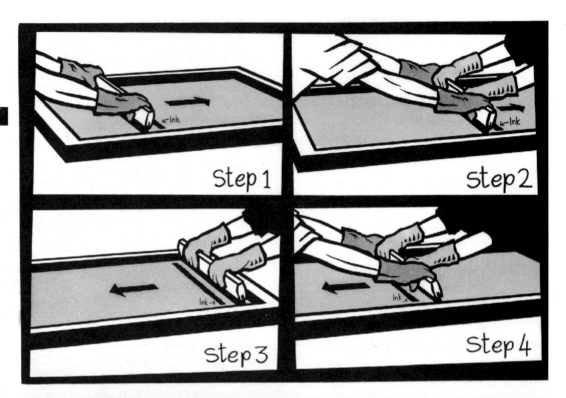

Step 1

Step 2

Step 3

Step 4

angle at which the squeegee is held when printing

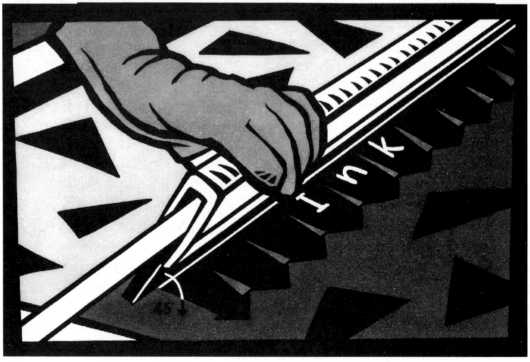

the squeegee too flat, all the print paste will be pushed up towards the handle, leaving very little to go onto the fabric. This is usually manifested by looking as if you are running out of print paste before getting to the other side, but you can stillsee paste on the squeegee. If you hold the squeegee too upright, not enough paste will be getting to the fabric; the result is usually a print with not very good coverage. The angle at which the squeegee is used is determined by the design (fine lines, detail, broad, flat areas of colour) and the consistency of the print paste. If the paste is runny, you probably need less angle.

To achieve the correct pressure, you need to be firm, rather than use every bit of strength in your body. If you press too hard, the print will look blotchy; if you don't press hard enough, then the coverage will not be very good. Sometimes you might get a better result by doing more pulls, while using less pressure; at other times more pressure and less pulls will give the desired result.

The best thing to do when you are inexperienced is to familiarise yourself with the variables, and what can be done to fix an unsatisfactory result. Look carefully at your test prints, and ask yourself whether the print looks the way you want it to. Most results that are not up to scratch can be caused by several different factors: check Appendix B for more information.

Another thing to consider is what the squeegee itself is like: is it flexible or hard? Does it sit flat on the table surface, or is it warped? A flexible squeegee will usually allow more print paste to pass through the mesh and onto the fabric, but it might give a less crisp print. A hard squeegee will usually require more control with angle and pressure to get a good result. Sometimes (in fact,

Andrea McNamara
Designer and lecturer
Print swatches used to test colours and fabrics for 'Hocus pocus' series.

Fiona McLean
1st year student, RMIT
Once the images are on screen they can be combined in different ways.

more often than not!) you won't have a huge choice in squeegees, and will have to make do with what is available. This is when you have to rely on the other factors you can alter, like angle, pressure, and consistency of the paste.

Print paste

The main thing to note is that the consistency of the print paste should be considered, and altered where necessary. Refer to Chapter 12 for details on how to alter the consistency of the different print pastes, and Chapter 8 for information on dye suitability of various fabrics.

A heavy weight cotton fabric or a fabric with a deep twill will probably require a more fluid paste to get reasonable coverage with the colour, whether it is printed with dye or pigment. The surface is denser, and will probably use quite a lot of paste. Logically, the paste should be runnier so it has more chance of sinking in.

A light weight cotton or silk will accept the colour more readily and, if the paste is too runny, it is likely to bleed. To retain definition in the print, while getting good coverage, it may be necessary to thicken the paste.

Which screen is printed first?

In a multi-coloured design, there are several factors to be considered before you decide which is the best screen to print first. All the screens should be registered to each other, have brackets (or substitutes) attached, and a test print should have been done, so that everything is ready to go.

The screen that has the least coverage or the screen that is the lightest colour should be printed first. Which of these you choose will depend on the nature of your design. Choose the screen with the least coverage if it is the one that will cause the least amount of movement in the fabric, and will dry the fastest, so the next colour can be printed. Choose the lightest colour because other colours might overlap it.

Where a screen has a colour on it that is a defining line, which outlines all the other colours, it will usually have to be printed last, even if it has the least coverage. This is particularly the case when printing with pigment; it is less of an issue with dye, which is transparent. Where a background colour is the lightest, but has the most coverage, it might be printed last, as long as it doesn't have other colours over the top of it.

Generally, all of one colour is printed, and then all of the next, although it might be more practical to print every second print, in all colours, and then to start the whole process again, filling in the gaps in all colours. This reduces the waiting time for screens to dry, and is probably most viable when printing small lengths.

When using a combination of pigment and dye, the pigment must be printed first. This is so that the pigment is printed onto the surface of the fabric, rather than onto a layer of Manutex. Heat cure the pigment with an iron before printing the dye colours over the top.

Summary

The information about printing is intended to give you a good idea of what the variables are and should help you diagnose what has gone wrong, so you can fix it. Printing is quick, if preparation has been done correctly at all stages:

- design
- artwork
- screens
- fabric selection
- print paste suitability
- sampling.

Printing is largely a matter of preparation and practice.

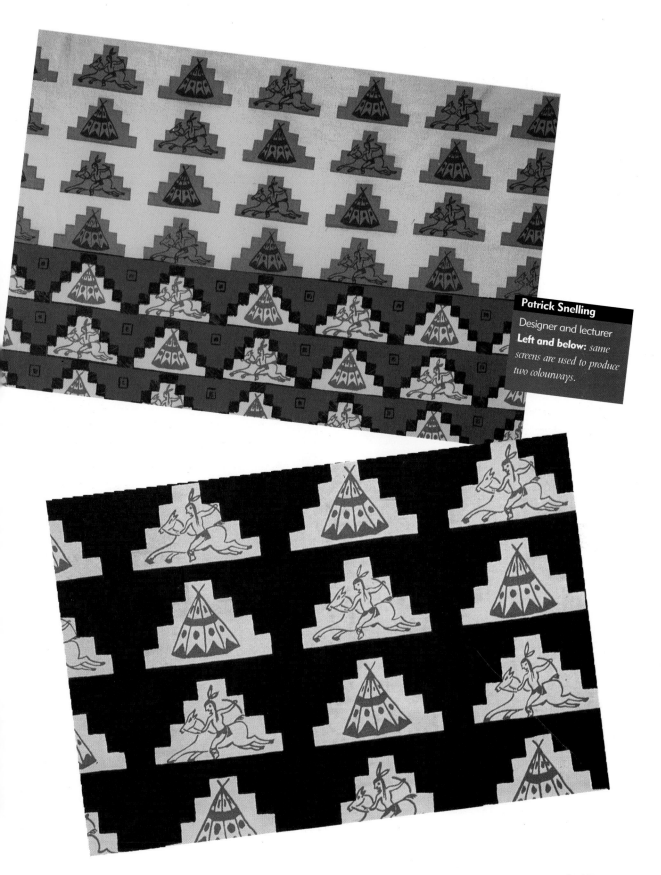

Patrick Snelling
Designer and lecturer
Left and below: *same screens are used to produce two colourways.*

Alternative methods for producing printed textiles

11

Andrea McNamara

Designer and lecturer

'*Flora*': *handpainted silk with reactive dyes.*

This book outlines the process of designing and printing fabric, duplicating the practices used in industry as closely as possible. However, the screen and the base fabric can also be used experimentally, creating new and interesting ways of using images, fabric and dyestuffs. The techniques described in this chapter are used when cost or time is not important, or when the product itself is for an exclusive market, which demands that no two products are the same. Or it may be simply that the designer-maker does not have the necessary equipment or resources to facilitate the normal or recommended production process.

The earliest forms of production textiles through to current styling trends in contemporary textile design have required designers to imitate and reproduce the intricate surface characteristics of block printing, tie dyeing, batik or stencil resists. It is too expensive to create these fabrics using original and time-consuming techniques so alternatives and translations have to be designed

Sandy Stokes

3rd year student, RMIT
'Batalaxe' fabric: combination of screen printed images, hand painting and stencilling to achieve a one-off effect.

for mass volume consumption. Industry has always used an historical or cultural style from another society or country as a starting point. Textile design in the 1990s is more than ever part of a global market that relies on a vast array of design resources from different countries and cultures. Whatever stage designers are at — whether in school, college, industry — they should always show an element of invention. The best textile design is where an original idea is developed using creative marks, great motifs and ideas that are then translated or converted using skill and ingenuity onto a textile fabric of superior quality. This is the ideal, but not all industry can afford the luxury of time and money spent on a lot of creative research. However, the research and inventing stages of the textile design process should not be ignored. Wherever good design is to be found, experimentation and invention have usually played a part in the design process.

Why should textile designers use one-off printed textile techniques? In some cases, depending on the role or job description designers have, it may not be appropriate to work directly on fabric. In other situations, it will be essential to trial designs on fabric. The studio textile designer who is printing fabric for a one-off garment or other application may have to improvise a printing style using materials and tools at hand. Designers experiment with paper-based materials and media, so why not do the same at the textile stage, if it is appropriate? In Europe and the USA some textile designers work directly on cloth croquis, handpainting, stitching, stencilling, bleaching, painting the

Vixen Australia: Meredith Rowe and Georgia Chapman

Foil placement print on scarf. An adhesive is screen printed onto the fabric, a foil sheet is placed over the printed adhesive, heat applied and the foil is peeled away from the non-glued areas.

fabric surface as if it were paper. While this way of selling designs is not currently accepted in Australia, it is probably indicative of a future trend.

Designers should use a combination of techniques and materials to be more resourceful and flexible. However

Anna Kosnovsky
3rd year student, RMIT
Swatch fabric that combines print and machine stitching.

Fig. 161.—FEMALE FIGURE, FROM BEHIND

Cervico-

Fat
of flank

Dimple over
post-superior
spine of ilium.

Gluteal furrow

not all textile design is technique driven, and textile designers, especially students, should be careful of falling into a trap where one technique is used exclusively, for everything. Not only does it become boring to look at, but in a folio it does not give an employer, client or assessor an overview of your design potential. If you do have a favourite technique, then apply some invention to it. Try other media, different fabrics, new colour combinations, alternative dyes or inks, use over-printing techniques in combination with stencil effects. Not only will you develop new skills and methods of application, you will be inventing a new style or design for potential sale.

This chapter is primarily aimed at those designers who want to see their ideas realised on fabric and require techniques that produce effects without costly equipment and resources.

The two main areas with alternatives to the techniques outlined in this book are screen preparation, and application. Neither of these methods should be thought of in isolation, nor are they independent of the photographic process of screen preparation, or the principle of printing in repeat.

You can play around with the recipe or method for one-off techniques, trying to get a particular effect, or to see what happens. As a rule, keep a record of these changes, because you might want to repeat the process again. In some instances the result might be due to an anomaly in the process or materials you are using, and therefore it is unlikely it can be produced again, but if you do document what you have done you are more likely to build up a reference you can refer to, and from which you can draw conclusions. The test book is the designer-maker's bible and will always prove invaluable for research purposes.

Screen preparation

Paper stencils

The stencil as a decorative technique has been used by Chinese and Japanese cultures for centuries, and has been adopted by Western artists and designers for a wide range of applications. In textile design, the use of the stencil has enabled repetitive motifs and symbols to be transferred to fabric thus saving time and cost.

Paper or acetate stencils can be used when screens are in limited supply: stencils can create solid or textured areas on the fabric with the use of a clean screen. The paper stencil is an accepted printing technique and if creatively used can provide designers with an increased use of a single screen. It is best used with a clear, unblocked mesh for creating areas of solid colour. A paper stencil can be used in conjunction with a photo stencil. Use the finished artwork (drafting film or acetate sheet) as a guide for cutting out the paper stencils by tracing the shapes onto newsprint or cartridge paper and then cutting them out to create negative shapes. This is taped to the back of the clear screen and ink printed through onto the fabric. It will create a positive image. If accurately cut, the photo stencil image will be perfectly positioned on top of the paper stencil printed area. The positive shape that was cut from the stencil can also be positioned onto the fabric surface with spray adhesive, and over-printed. This will form a resist, and a negative shape will be created on the fabric. Freeform stencils using paper can be developed, torn or cut pieces of paper in strips or as confetti can be distributed over the surface of the fabric and over-printed, or

Sarah Crowest

Textile artist
Opposite: *collection of images on small screen that allows flexibility of printing on dyed backgrounds. Handpainting with pigment inks is used to highlight areas of the design.*

similar shapes can be torn or cut out of a single sheet of paper and printed through. If you want to print a number of the paper stencil motifs, it is worth cutting the stencil from acetate or drafting film. Both of these are washable and more durable than paper, which tears when wet.

A stencil can also be developed by directly transferring found objects to the screen. This can be used as a negative stencil on fabric by stippling ink or dye around the shape, or it can be used as a positive stencil by exposing directly onto a photographic screen.

Sarah Crowest

Textile artist
Opposite

Wax crayon

A wax crayon can be drawn directly onto a clean meshed screen. A lino block or textured surface can be placed under the mesh and rubbed over with wax crayon, resisting the ink or dye printed through it onto the fabric. Using wax crayon straight on the screen will give a negative image; where the wax is on the screen, the paste will not print. The wax crayon has to be used firmly to actually block the mesh; hold the screen up to the light to see whether you have created a stencil by blocking the mesh. With this technique, it is important to thoroughly remove the wax from the mesh after printing with hot water and detergent, or a pressure gun if you have one. The cheaper grade wax crayons give the best stencils, which are readily removeable. Wax crayon screens will not last forever — the image may break down with continued use — but it can be used to create some very interesting textural effects.

Hydrograph

This method of screen preparation has been developed for use where photographic facilities are out of the question but the designer might want to use a graphic style of image on a screen. Hydrograph works by coating the screen with a yellow emulsion called the 'filler', which is left to dry. It can then be drawn on with a special ink. The ink is left to dry on the screen, which is horizontal, and then washed out. The ink breaks down the filler, leaving the mesh exposed so the image prints. There is also a special Hydrograph crayon that is used on the screen mesh before it is coated with the filler. The crayon resists the filler. Again, once the screen is dry, the crayon is washed out, leaving the mesh exposed. Letraset and tape can be used as resists on the screen mesh in the same way as the crayon. Hydrograph works better on cheaper multifilament mesh, and produces a stencil that is reasonably durable, inexpensive, and easily reclaimed, using its own stripper.

Application

There are no hard and fast rules about how many of the methods of screen preparation or techniques given here should be used. By their nature, they are methods that should be used in an exploratory way: to see what you can do with them, and to see how you can make them serve your purpose.

Resists

A resist is basically a substance that prevents the penetration of a dye or colouring matter through the base fabric, thereby causing a negative or lighter coloured pattern to be created. The use of resists has developed over centuries of textile manufacturing from a number of different cultures and countries. Early cultures used mud, leaves and sticks for blocking out or decorating; they used natural colouring substances such as plant dye and mineral pigments on bark cloth, animal skins and crude woven fabric.

The resist is usually removed from the fabric once the dye has been applied. Traditional forms of resists have been rice or cassava pastes, known as starch resists, which are still used by African cultures such as the Nigerian Yoruba people. This style, Adire, uses starch-based pastes applied to the fabric by a metal or plastic stencil. While wet the paste can be combed or speckled using basic tools. The characteristic of this technique is the indigo blue colour of the cloth, dipped numerous times in a vat to obtain very dark shades of blue-black. The paste resists the dye and creates a negative image on the base cloth. Different shades of blue can be obtained by over-stencilling after dyeing the cloth. The principle of this sort of resist printing can be adapted to include using chemical dyes, which means being able to use any colour. Flour paste can be used as the resist with a detergent bottle as an applicator,

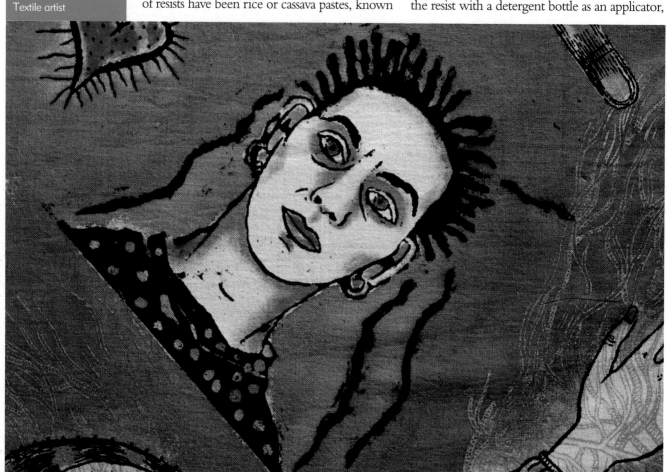

Sarah Crowest

Textile artist

squeezing the paste carefully onto the fabric surface to create pattern. A lino block or wood block could also be used to apply the paste to the fabric. The consistency of the paste is vital: not too runny, not too thick. The paste must be dry before colour is applied to the cloth. The paste can be peeled off, or removed by soaking the fabric in warm water. Any cold water dye is suitable for this technique; use the recipe in Chapter 12 for handpainting with reactive dyes, or dye the fabric in a dye bath. Better results will probably be achieved with hand-painting, as the saturation of the dye bath can break down the resist, depending on how far it has penetrated into the fabric. A flour paste is not a durable resist, so excess heat and agitation will impair results. Heavy cotton fabrics are best to use, silk is not recommended.

There are techniques for using printing inks as forms of resists. These emulsions, which are usually used for pigment print-ing, can be used to create softer effects that simulate discharge styles. All pigment-printing inks resist the effects of chemical dyes, although white and paler shades of inks can be stained a light colour. A pigment ink resist is useful when printing an opaque or metallic ink in conjunction with chemical dyes, especially when silk or fine cotton is being used. The pigment ink should be printed first, heat set on the table by ironing (if registered), or cured in a baker. The other screen colours are printed over the pigment printed areas, dried and fixed, then washed. The dye will wash off the pigment areas; fake discharge and indigo resist styles can be achieved this way with the added

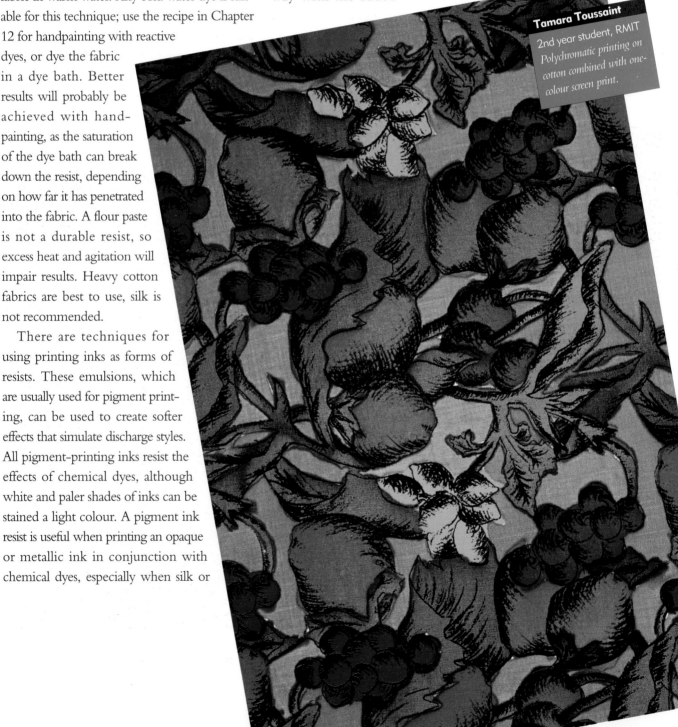

Tamara Toussaint
2nd year student, RMIT
Polychromatic printing on cotton combined with one-colour screen print.

advantage of repeat length volume. Care must be taken with washing off, as the fabric must not be rubbed or unduly agitated; it is best done by hand rather than in a machine. Talcum powder or chalk can be used to create resists; simply sprinkle the powder onto the surface of the fabric, then over-print. Depending on the density of the powder, a speckled, textured effect is achieved. It is also easily removed from the fabric surface but is best suited to small pieces of fabric.

Most of these techniques will require trial and error, playing around with the variables until you get the desired effect. Using resists is a great way of translating designs that have used wax crayon and ink, or masking fluid and ink, or bleach on dark backgrounds onto fabric paper.

Wax

One of the oldest forms of resist is wax, and it is used extensively today for batik decoration in Indonesia and surrounding island countries. The traditional colouring of batik is brown and blue, with a characteristic 'cracking' effect, but the use of commercial dyes has made it popular among contemporary designers. A mixture of paraffin and beeswax is used, the ratio is altered to create

Sarah Crowest

Textile artist

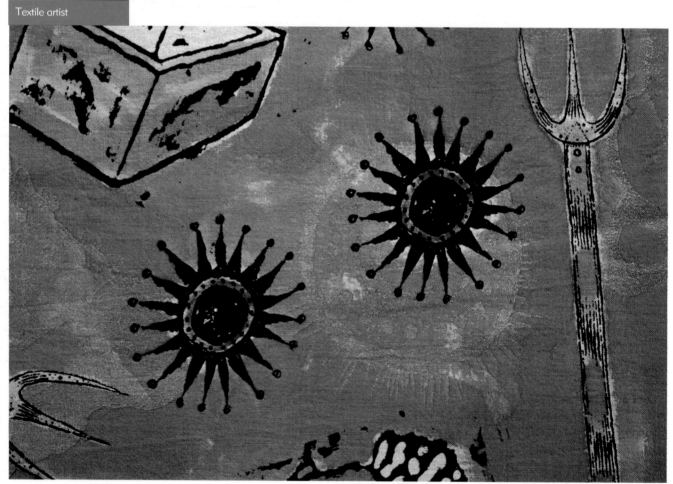

more or less 'cracking'. The molten wax is applied to the surface of the fabric with a brush or by a tool called a *Tjanting*, which can create lines for drawing boundaries. The fabric is dip dyed or painted using a cold water dye (see Chapter 12); the waxed areas will remain undyed. The fabric can be progressively waxed and dyed to build up pattern, working from light to dark colours: first the areas to remain white are waxed, the fabric is dyed, for example, yellow, and when dry the areas to remain yellow are waxed. The fabric could be dyed red, which will create orange, and when dry the orange areas are waxed, and so on. When finished the wax is removed by ironing the fabric between two sheets of

paper, which are changed as they absorb the wax. Finally, the fabric can be washed in hot water or drycleaned to remove all trace of the wax. To produce batik fabrics, you need to have a frame for stretching the fabric over, a way of keeping the wax hot (usually in a container sitting in water in an electric frying pan or a saucepan on a hot plate), and facilities for dyeing the fabric. A stencil cut from thick card, a found object or a design etched into a lino block can be used to create a resist; place it behind the fabric and then rub over it with wax crayon or a candle. A wood or metal block dipped

Georgia Chapman

Designer
Discharge printed and hand painted velvet. The technique is to take out the base cloth colour and replace it with hand painting using reactive dyes.

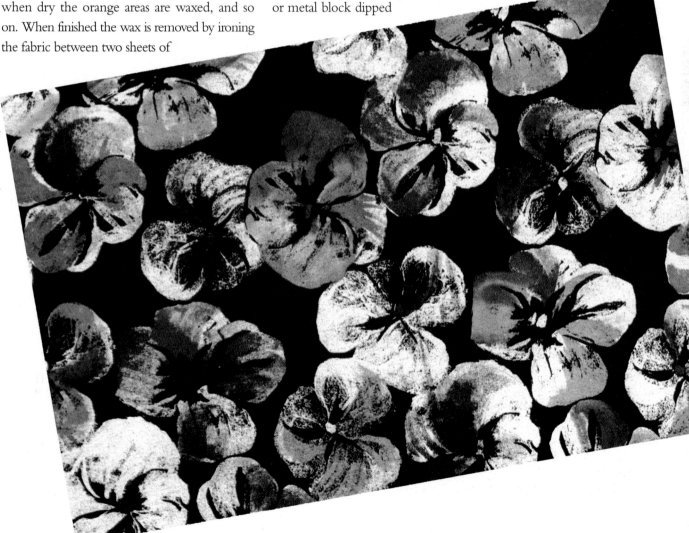

in wax can put the pattern on the fabric. Ink or dye applied over the fabric surface will be resisted by the wax, creating an image. The wax can be removed by heat. Wax is a cheap and flexible resist medium, and the technique can work on a variety of fabrics (wool and synthetics are not recommended). It is quite labour intensive to build up multi-coloured fabrics, and care should be taken when working with hot wax to ensure that it doesn't spill or catch fire.

Gutta

A more recent form of commercial resist is called Gutta, which is available from most craft suppliers. It is a latex-based product applied using an applicator to the surface of the fabric, which is usually stretched onto a frame. It is more expensive to use than wax, but has better handling characteristics, works very well on finer fabrics such as silk and can be removed from the fabric by drycleaning. Very fine drawn lines can be achieved with this technique and using cold water dyes — either reactive dyes, or packaged dyes (see Chapter 12) usually available where you would buy Gutta. Gutta can also be bought in several colours including gold, silver and black to create boundary lines around the design areas: these are formulated not to be removed from the fabric. Gutta in effect seals the design areas, so colours can be painted next to each other without bleeding into one another while wet. Problems that occur are clogging of the applicator, and seepage of colour into other areas, which is caused by Gutta not having penetrated far enough into the fabric to create a seal. Control of line work and consistency of drawing are important to achieve good results. Gutta usually has an easily identifiable style, because of the

Louise Leibhardt

3rd year student, RMIT

Right: *a series of images on screen, printed on gingham fabric and used in conjunction with an appliqué technique;* **right, below:** *screen printed images on painted background using reactive dyes.*

white line that usually occurs as a dominant feature in the design.

Polychromatic printing

This term simply means 'many colours'. Dye is painted directly onto the mesh of a screen, and transferred to the fabric by printing with Manutex paste, which contains the chemicals necessary for fixing the dye onto the fabric. The technique is easy to manage and with practice can result in some spectacular effects on the fabric surface. There is no limit to the number of colours that can be printed at the same time, using only one screen. It is a one-off technique employing hand-painting and drawing skills using reactive dyes on natural fibres (see page 286). Pigment inks or synthetic fabrics are not suitable for this technique.

For best results, use a screen with 77T mesh (see page 200). Coarser mesh will give a less detailed print. Prop up the screen so it is not sitting on a flat surface, then paint on the inside surface. If necessary a drawing can be placed underneath to give guidelines for the design. Reactive dyes are mixed with water to form a liquid solution and painted directly onto the screen mesh with a brush, similar to painting ink onto paper. There are no rules about the strength of colour: paint a small amount of dye onto paper before you put it on the screen. Colours can be built up by layering them, drying them with a hair dryer, or working wet on wet for softer effects. The same colour can be over-painted, dried then over-painted to create subtle tones of the same colour. Clean water can be brushed onto the painted area to weaken the strength of the colour just as in watercolour painting. Don't worry that

it looks as if it has disappeared when it dries on the mesh — when it is printed, the full strength (or subtlety) of the dye will be realised.

The size of the screen determines the area to be printed; if you want to print a 3 metre length, then you would have to paint up a 3 metre screen. The painted dye can remain on the mesh for extended periods, but be careful of splashes from any liquids. Painting up the colour or design onto the mesh is the first stage. To speed up production, designers can use a line screen to print the image onto the fabric first as a guideline, then apply colours using the polychromatic technique.

The next stage is to print the design onto the fabric. Care must be taken at the preparation stage, laying out the fabric so it is flat and stable. Very light silks could have a layer of Manutex printed first, to add stability. To transfer the dye from the screen to the fabric surface, a Manutex paste is used. This is the same paste as used for direct printing with reactives, but rather than the dye being in the print paste, it is on the screen. The paste contains the fixing and wetting agents and will enable the dye to be absorbed and fixed to the fabric surface.

To print the screen, the paste is poured onto the screen at one end, and printed using a squeegee that must be passed over the mesh firmly at least twice and often more depending on the density of the fabric. Make sure there is plenty of paste in the screen. If there is excess dye on the screen, some streaking, which you cannot do very much about at this stage, may occur. It is a sign of too much dye on the mesh and can be corrected next time.

Carefully remove the screen from the fabric. You will have to dispose of the paste left on the

screen because it has been contaminated with the coloured dyes. You will only get one print from this technique in the full strength colours; a second print may be made using fresh paste, but the strength of the colour will be considerably weaker (about 50 per cent strength of the first print). The fabric must be thoroughly dried prior to fixing by steaming, baking or batching (see pages 280-4). The fabric will feel like a piece of paper, and it must not get wet prior to fixing. After fixation the fabric must be washed to remove all excess dye and Manutex paste, and will become much softer. See Chapter 12 for details on fixing and finishing.

Handpainting and dyeing

Application of dye or ink can be by handpainting directly onto the fabric surface. The choice of brush, roller, hybrid tool or other mark-making device will obviously give you specific effects, especially combined with the choice of fabric surface: coarse, fine, slubbed, woven, knitted, non-woven. With handpainting a softer, more painterly effect will be evident — crisp, graphic lines are tricky, and are probably best printed. Try using masking tape on the fabric to help create stripes. Try handpainting lighter colours first and successively working on top with darker colours. Try using one colour only, apply it, dry it and then apply it again to build up a monochromatic colour background onto which you can over-print a photographic image. You could apply a resist to the fabric before handpainting. If screen printing a solid colour is not possible due to lack of screens, a good quick method to achieve the same result is to use a paint roller to apply dye.

When you need a large piece of fabric in one colour, consider first whether you have the equipment and space: is it easier or cheaper to buy a piece already dyed in the shade required? If not, consider dyeing the fabric yourself. Dip dyeing is one way of achieving a surface effect by colour and pattern on the textile surface, two or more buckets of different dye colours can be used. The wet (but not dripping) fabric is dipped into the dye buckets in chosen areas, the dyes are absorbed and blend into one another where they meet. The fabric can be tied as in the Shibori or tie-dye technique, where parts of the fabric are tied with cotton or rubber bands into patterns. The dye is resisted in the tied areas, which remain undyed, and patterns are formed. The cloth, after it has been dried and fixed, can be re-tied and dipped again in another colour to create over-dyeing techniques. This is also useful when printing an opaque ink or dye onto the fabric and then over-dyeing the whole fabric piece. The colour of the printed area is muted by the over-dyeing. The printed area must be fixed or cured before over-dyeing, although worn or distressed look fabrics can be created by incomplete fixation methods. Bleach can also be used to create effects on the dyed fabric, over-painting it onto printed fabrics in certain areas to emphasise or soften the printed or background colours. Wear rubber gloves and use in a well-ventilated area.

Recipes for painting and dyeing using reactive dyes are in Chapter 12, although depending on the colours you require using dyebath methods, it could be appropriate to use commercial dyes such as Dylon and Rit, which are available from the supermarket. These are called direct dyes: all

the chemicals are in the powder, to which you add salt and water. They are not as stable as reactives, and usually require heat for best results.

Monoprinting

As the name suggests, this technique is another from which you only get one print. The effects created by this technique are not as fine as those created by polychromatic printing, instead they have a more textural quality. Either pigment or dyes can be used. If using dyes, choose the appropriate dye for the fabric, and a suitable thickener, for example, use reactive dyes in Manutex paste (as for direct printing with reactive dyes). Mix the colours you want, using pigments in extender, or dyes in Manutex. Apply the colour with brushes or other tools to a sheet of perspex. It is better to work on a small area. The surface area can be painted with as many colours as you like — it can be drawn into with the wooden end of a brush to create negative areas and images, or rolled onto the perspex with a small foam roller to create blended areas. Work quickly — the paste must not be allowed to dry on the perspex. Try to aim for an even distribution of colour to prevent thick splodges occurring on the fabric during transfer. When the design area is complete, pick up the perspex sheet and place it face down on the fabric, which has been stapled or adhered firmly to a flat surface. Rub evenly over the whole surface of the back of the perspex. Lift off the perspex and the design will have been transferred to the fabric. If using pigments, fix by ironing or baking. If you used dyes, fix by steaming and finish by washing. A flat, non-textured fabric is ideal for this technique. When using pigment, the end result will be quite stiff, because there is usually quite heavy coverage. This will not happen with dye; once you have fixed the dye by steaming, and washed out the Manutex paste, the fabric will have the same handle as it did prior to printing. For more information on using dyes, look at the recipes and methods outlined in Chapter 12.

Lino and wood blocks

Lino blocks cut for use on paper, for design work, or for creating silk screen positives can also be used to print directly onto the fabric. The block is inked with print paste — pigment in binder, which has a thick consistency is probably the most suitable medium — and transferred to the fabric using even pressure on the back of the block. A more traditional form of this technique is the wood block, used in textile printing for centuries, and still used today in India and Pakistan. Fabrics that are block printed have a particular look (consider William Morris fabrics).

Direct stencils

For textile design, the use of the stencil has enabled repetitive motifs and symbols to be transferred to fabric in numerous different ways, either via a screen, as outlined on pages 255-6 of this chapter, or directly onto the fabric. For designer-makers, the stencil has applications in direct printing techniques such as for stippling dye or ink directly onto the fabric surface, either inside a stencil or around the outside of a cut shape. The stencil

can also be developed by using found objects such as leaf forms, wire mesh, cut paper or acetate shapes directly on the fabric surface. Torn paper used with an airbrush can create textured edges or tonal gradations. Use in a well-ventilated area and wear a mask. The stencil can be used to make overlapping and tonal effects and is especially useful when used in conjunction with an airbrush to create halftone effects on the fabric with ink or dye. Even the fabric itself can be used as a stencil by simple methods such as pleating or creasing the fabric, spraying or over-printing then stretching the fabric out: this can be used to achieve stripes, checks and *trompe-l'oeil* effects.

Airbrush and airbrush effects

The airbrush can create very subtle, tonal effects in conjunction with most of the one-off techniques mentioned in this chapter, but its use has lost favour in recent years due mainly to the health and safety aspects of the technique. You need excellent extraction and correct filter masks and should work in an isolated area where the spraying can be controlled. Most schools and workshops do not have this facility, so it is best avoided. Similar effects can be achieved using stencils, with hard brushes to splatter the colour onto the fabric to get tonal effects. The consistency of what you are splattering with can have enormous bearing on the end result — you might have to make the paste thinner or thicker for better results, whether you are using pigment or dye. Even using this small scale, seemingly harmless 'imitation airbrush' you should be wearing a mask and working in a controlled environment.

Heat transfer/sublistatic printing

Sublistatic printing was first developed for the textile industry as a new method of production because of the increased use of synthetic fabrics during the 1950s and 1960s. The technique is designed for synthetic fabrics only because of the transfer qualities of disperse dyes. The fabric to be printed must be synthetic or a mixed fibre with a high percentage of synthetic fibre. In industry, the disperse dye is printed onto a special paper that is coated to resist penetration of the dye. It is dried and can be kept in storage until required, when it is brought into contact with the fabric under pressure and with high temperature, usually through hot rollers. The dye on the paper turns into a vapour and condenses onto the fabric surface as a solid and is then fixed by the heat; in industry this takes only a few seconds. Once the printed paper and fabric have made contact through heat and pressure, the printed paper has expired, and cannot be used again. It is a fast process and is currently used for putting logos or placement prints on swimwear, tights and aerobic wear.

Outside industry, heat transfer printing has great application as a one-off technique, working on litho paper with disperse dyes, using a small press or an iron to transfer the dye to the fabric. The shiny side of litho paper is non-absorbent enough to paint the dye onto, and stable enough to take wet media. There is no limitation on the colour or technique you can use to apply the liquid dye to the paper surface. The transfer dye is mixed with water so it is in liquid form, and can be mixed up in a variety of strengths. It can be painted, sponged, sprayed, splattered onto the

paper, or used in conjunction with special fabric crayons to create resist effects and textured surfaces. The paper can be cut up or torn and repositioned to create woven or *trompe-l'oeil* effects. It is an exhaust technique, so the paper can only be used once. The design image will also be printed in reverse on the paper, so typography or symbols that cannot be reversed are rarely used. The exhausted paper is often used by florists to wrap flowers for customers.

One of the difficulties of working with disperse dyes is that their colour in liquid form, and when painted on the paper, bears little resemblance to the colour of the fabric after the print has been transferred. To get a predictable result, colours should be tested and trialled. It is a great technique for printing nylon tights, which can be pulled onto cardboard 'legs' and treated as a flat surface to which a print can be applied. Because it is a printing system that uses dye, there is no change to the handle of the fabric and no further fixing is required, other than the application of heat during the transfer process.

Fabric crayons/fabric pens

These can be useful for working on small areas, but can be time consuming and expensive on larger pieces of work. Fabric crayons can be used in conjunction with a lino block or stencil or photographic screen to create a repetitive form or texture, or put a surface effect on a flat colour ground. Fabric pens are useful for outlining areas with a line, but fabric suitability must be borne in mind — rough or textured fabrics will affect the drawing quality. In most cases, fabric pens are waterproof or permanent and can be used with surprising effect on fabrics.

Technology techniques

Increasingly textile designers are finding new ways to interpret visual ideas onto fabric surfaces using technology. One development that started out with small inkjet printing machines has now developed into a full size textile print production model. An inkjet printer linked to a computer will print out designs using four ink colours; cyan, yellow, magenta, black. Some printing companies have exchanged inks for disperse dyes and are printing them onto paper that can be transferred onto fabrics. Developmental work on inkjet printing directly onto the fabric is being done. Experiment with ways of successfully translating your design ideas using new methods or techniques. It is often with one-off techniques that ideas and techniques develop. For example, some photocopy centres offer the service of colour copying images onto fabric. There is a size restriction, and it is not a cheap process, but it is a great way of visualising paper designs on fabric, and producing images on fabric for one-off pieces.

Quality control

Some of the ideas presented here are starting points from which you may discover different or easier ways of producing your images on fabric. If the product is to be sold or displayed, it is essential to consider the finished qualities of the work, whatever technique or effect you choose to use. If it is a garment, is it washable? If it is for furniture, will the dyes or inks come off the fabric with wear? Is the production technique suitable for the designated end-use? Will the colours fade

in light? Will the fabric rot because of the caustic processes used? Consumers will complain if such things happen to the expensive one-off product they have bought from you or a retail outlet. Not only that, the reputation you may enjoy as a one-off designer-maker can disappear overnight if your product starts to attract unfavourable comment from the consumer, shopowner or client. Being a one-off designer-maker does not allow you to skimp on finishing processes or absolve you from taking care with the products and techniques you are employing, unless, of course, the product is designed to disintegrate!

Summary

The combination of printed images with hand-painted effects can be unique and diverse. The scope for textile designers with these individual techniques is as wide as for paper designing, with the advantage of working directly onto a fabric surface. Traditional craft as well as contemporary techniques are mentioned in this chapter and using combinations of styles, techniques, materials, media and fabrics will help to provide textile designers with an ever-increasing armoury of skills, techniques and ideas for their folios.

Andrea McNamara
Designer and lecturer
Opposite: *handpainted silk, 'Flora'.*

Recipes

Andrea McNamara
Designer and lecturer
'Tea towel': screen printed
pigment on linen.

This chapter contains information that should be read thoroughly to develop an understanding of what the various components of print pastes do. The recipes are in a quick reference format : you could copy them into your technical notebook, so they are on hand in the print room. This chapter is to be used in conjunction with the Troubleshooting tables in Appendixes A, B and C, which help you diagnose what happened, if things go wrong.

While it is possible to print with acid dyes and disperse dyes, this chapter concentrates on these two systems:

- *pigments* because they are accessible, economical, and easy to use

- *reactive dyes* because of the flexibility of their application.

Because reactive dyes are used cold, they can dye fabric in a dyebath, or be handpainted, or printed using several different techniques. Reactive dyes are a great way to start; once you have mastered using them, and with a bit of research, you will be able to print with other dyes—although the print paste ingredients change, the principles are similar. There are also print techniques such as discharge printing and *devoré* that are not included. These require a knowledge and understanding of print processes generally, and are not for beginners. This chapter provides concise practical advice to help you build up the confidence to pursue your own interests.

For more information about fabric characteristics and how they might affect what you print on, and with, see Chapter 8.

Pigment or dye: which one to use?

Pigments will print on most fabrics; there are additives that make this possible, although it is more appropriate for some fabrics than others. A pigment print remains a layer printed on top of the fabric surface; it does not become part of the fabric. However, because there is a natural linking with cotton fibres, there is a better print quality and fastness when used on cotton. As a general rule, the cheaper the print paste, the harsher the handle. Because the print remains a layer on the surface of the fabric, pigment does not usually have good rub fastness. Again, the cheaper the print paste, the poorer the fastness. Printing with pigment is much cheaper and less time consuming so it is appropriate to use when producing a high volume, low price product. If you have a limited budget, and very little in the way of equipment, pigment printing is the best choice.

Once dyes have been fixed by steaming and have been washed they become part of the actual fabric. Dye takes on the characteristics of the fibre it has been printed on: a print using reactive dyes will have the lustre and soft handle of silk, the sheerness of organza or the rich texture of wool. Different dyes have an affinity with particular fabrics; reactive dyes work with cellulosic and protein fibres—natural fabrics. Printing with dye is more difficult and more labour intensive, but the rewards are the quality of the printed fabric. Dyes cannot be opaque. By their very nature, dyes are transparent, and this quality should be utilised. Dye colours are rich and strong, and great depth can be achieved by using overlapping colours. If opacity or

metallic effects are required, pigment might be used in combination with dye within a printed design.

Printing
with pigments

The most straightforward substance to print with is that of resin-bonded pigments. The colour is added, in concentrate form, to an emulsion. This emulsion is also known as print paste (or extender or base). There are premixed colours available, or you can buy the concentrates and base separately and mix your own colours. This gives you greatest flexibility, and saves money in the long run. When you print with resin-bonded pigments 'what you see is what you get'. Once the colour is printed on the fabric and dried, it is heat cured to fix it, but it doesn't change in appearance. This is a major difference to printing with dye.

There are different bases for different purposes and effects:

- The most common (and economical) one is a transparent base, which is suitable for printing colours on light or pale fabrics. The printed colour should be darker than the fabric colour. The fabric colour will affect the printed colour.
- Opaque base is used to print lighter colours on darker fabrics. It can have very stiff handle, and some brands have poor wash and rub fastness. It also has a tendency to dry out on the screen, so care needs to be taken when printing to avoid this. It is great for use in placement prints.

- Metallic base is used with metallic pigments, and gives a sheen (gold, silver or copper) to the print surface. It can be printed on light or dark fabrics, and also has a tendency to dry out on the screen. Check the shelf life of the brand you buy as metallics can separate if they are left too long. For health and safety reasons it is advisable to buy metallics premixed in gold, silver or copper. This avoids having to deal with metallic pigments, which are very dry and easily inhaled.
- Pearl lustre has a mother of pearl finish, and can have pigment added to it to give a metallic-looking colour. The colours tend to have a whiteness when they are dry. It is opaque, so it can be printed on light or dark fabrics.
- Puff binder gives a raised effect when heated after printing. Follow the manufacturer's instructions for doing this as times and temperatures vary for different brands. Pigment is added to the base (which is opaque); these colours also have a 'white' look.

There are other products available for printing that give special effects, such as foil printing, and new products are being developed all the time. These will often relate to particular fashions, and are usually expensive.

Most of the bases can be diluted with transparent base for a reduced effect. (Check with your supplier whether or not the various bases you use are compatible.) Puff binder, for example, is very expensive, but if you use 50 per cent puff, and 50 per cent base, you might get the effect you require, at half the cost. Depending on what colour you are printing, you may not need 100 per cent opaque base; for example, bright blue on

green fabric might require a 60 per cent opaque and 40 per cent base.

Colours can be mixed and stored in an airtight container for months. If you have a shared print facility where there is often print paste left over at the end of the day, it might be worth starting a 'slops bucket' for dumping excess print paste. It should be periodically strained through mesh, to remove any lumps and dried bits. Add pigment to make print pastes for general usage; the easiest thing to make is black, as other colours tend to get very murky. Colours made from 'slops' are good to use for test prints. Avoid putting colours made using opaque or metallic bases into the bucket, as it will become too difficult to mix up useful colours.

There is a wide range of colours available in pigment and, with practice, good colour matching can be achieved. When you are checking a colour to see if it is right, always dry it before you decide; when dry the printed colour may vary slightly from what the print paste looks like when wet.

Pigment can dry out on the screen and do permanent screen damage. Take care while you are waiting for prints to dry that you don't leave the unwashed screen in front of a fan, or near a heater, or that you haven't forgotten it and left it sitting for half an hour against the table.

Auxiliaries

Sometimes, printing problems can be solved by the addition of something to the print paste (see Appendix C).

The basic auxiliaries you will need for working with pigments are:

- Fixer S helps fix the print on fabrics that have a synthetic content. Add 5 g (one teaspoon) per kg of base. Don't add more than the recommended amount: more is not better.
- Ammonium sulphate can be used to thin any of the bases, without diluting the colour. Make up a 20 per cent solution, by adding 100 g of ammonium sulphate to 400 mL of warm water. Use this solution at a rate of about 5 mL per kg of paste. Use more if diluting the paste so you can handpaint it. You might need to add some to opaque bases, for example, if they are too thick and therefore difficult to print. Different brands are mixed to different consistencies; assess whether the thickness is appropriate for your needs.
- Thickener is used at a rate of a maximum of 5g per kg; different bases have different thickeners. They are added when the paste is too runny, or to thicken a paste for a particular purpose. Check with your supplier for the most appropriate thickener for the extender or base you are using.

How much pigment do I put in ?

In industry recipes are kept for each colour, so that it can be easily repeated when the client re-orders. This is not necessary when you are operating on a small scale, although it is often useful to keep a record of what pigments were used to mix a colour, even if you don't weigh them precisely. Pigment concentrates can be intermixed. Colour matching can really be done by eye; add small amounts of colour to the base until it looks right and then test print a small section of the print, and assess the colour when it is dry. However, there is a limit to how much colour the

bases will take. If you exceed the limits, you are wasting pigment: the excess pigment will not change the colour, and will wash out of the fabric. The golden rule when mixing colours is less is more. If it is too light when you test print it, you can always add more, but it is very difficult to take it out.

The following table gives a general indication of the recommended maximum amounts of pigment. Different brands will have different recommended amounts.

Combining pigment and dye

Sometimes a design will demand that you use both pigment and dye within the one piece of fabric. For example, the design might have a gold metallic line that surrounds areas of flat colour, and you are printing on silk. Always print the pigment first. Dye is printed in a **Manutex** paste, which is later washed out, so if you print the pigment over the dye, you are printing on top of Manutex, instead of the fabric. Remember

Base	Pigment per kg	General information
Transparent	up to 30 g for most colours	Some colours are weaker and may require more, e.g. scarlet and lemon.
	up to 100 g for fluorescent colours	
	60 g for black	If you are mixing black from 'slops' of other colours, you will need less as there is already pigment in the other colours.
	200 g for white	This will not make an opaque white. Use 800 g base:200 g white pigment.
Opaque	up to 60 g for most colours, including black	Remember that the colours will have a white feel to them; this makes it impossible to get a good black. Black made from transparent base is recommended.
	200 g for white	Use 800 g base:200 g white pigment. You might find it is cheaper to buy ready-mixed white opaque.
Metallic base	up to 100 g metallic pigment	Metallic base cannot hold coloured pigments: use pearl lustre for metallic colours, or gold lustre for tinted metallic colours, e.g. greenish gold.
Pearl lustre	up to 100 g of most colours	The colours will have a white sheen.
Puff binder	up to 100 g of most colours	The colours will have a white look.

to heat cure the pigment before you steam and wash. Pigment can be used in combination with dye to create resist effects.

Fixing pigments

To be wash, rub and light fast, pigment printed fabrics need to be heat cured at 130°C–150°C for 3–5 minutes. In industry, this is done through an oven or baker, where the fabric or placement print passes through at a controlled temperature for a certain period of time. Most small studios or schools have no need for a baker; they are expensive to buy and run, and are really only required when production is regular. The alternatives are to iron the fabric, ensuring even heat all over the fabric; if you have access to a small press, this will make the job easier. An industrial dryer at a laundromat is another option, but it is really taking pot luck, as you have no way of knowing how hot the dryer is. The first time you use a dryer, wash test a piece you heat cured using this method, and see if the print comes off. You will have to leave the fabric in the dryer for about 30 minutes. If the fabric is light coloured, it might be a good idea to make a big light cotton bag to put it in, inside the dryer, to keep it clean. The biggest risk is that the agitation of the dryer will cause the print to rub off, before it has been fixed. The dryer method is not always satisfactory, but sometimes there is no alternative.

Washing instructions for pigment printed fabrics

Washing instructions for a printed garment or product should give details on the composition of the fabric and what it has been printed with. Always wash test a scrap of fabric you have print-

ed and heat cured before you sell it to anyone, to make sure the print stays on the fabric.

General washing instructions for handprinted fabrics are :

- Warm hand or gentle machine wash, depending on the printed item. It is not very likely that people will want to hand wash tea towels, for example.
- Do not rub the print when wet. This is when it is most likely to rub off.
- Do not bleach.
- Drycleaning is not recommended for opaque, metallic and puff bases.

Printing with reactive dyes

Reactive dyes are named as such because they undergo a chemical reaction with cellulosic fibres; they are also appropriate for silk and, to a lesser extent, wool. They are used cold, which makes them ideal for a wide range of applications. The powdered dye is dissolved in water, to which chemicals are added, so that the fabric can be immersed and dyed (dyebath), or the colour can be painted on (handpainting). The dissolved dye can be added to a paste made with Manutex (a thickener) so that it can be printed. The dissolved dye can also be painted directly onto a screen, and then transferred to the fabric by printing with Manutex (polychromatic printing). In this chapter, there are recipes and instructions for each of these applications.

There are several chemical types of reactive dyes: Procion is the most common, followed by Drimarene and Levafix. Which one you choose

will usually be because of availability, or because a particular colour range is needed. Quite a lot of information is given in the name of the dye. For example, Procion Red MX8B: Procion is the type, Red is the hue, MX means it is cold dyeing, and 8B means it is a very blue (B) red. It is 8 parts towards blue. It would be quite a different red from, say, Procion Red MXG, which is more yellow. The supplier should be able to help you decode the colour name, which will help you decide what colours you need to start with.

For best results, reactive dyes need to be either steamed or treated with sodium silicate solution (Reactafast) in order to fix them when they have been printed or painted. However, a major advantage of reactive dyes is that some result will be achieved if they are air cured, unlike most other dyes where steaming is the only alternative.

Health and safety

Short-term exposure to reactive dyes is considered to be non-harmful. Contact with skin and eye may result in irritation. Inhalation of dye powder may result in respiratory irritation. Most problems associated with reactive dyes are from exposure to the dye powder, rather than from handling the dyes in solution (after they have been dissolved). For best protection, wear a respiratory mask when you are mixing the dyes; at least wear a dust mask. Always wear gloves when handling the dyes, whether in powder form or in solution. The best practice is to have an area designated for the mixing of dye, and to enclose that area if possible. All dye should be stored there, and dyes should not leave that area except in liquid form. This protects other people from inhaling the dye powder, and controls where dye powder is kept.

Preparing to print with dye

The print table should have a clean backing cloth on it that will be removed and washed as soon as you have finished printing. This cloth will catch any dye that passes through the fabric, or is slopped onto the table when printing. It is wise to have a few backing cloths on hand; the cloth should be changed after each printed length. Make sure you have protective clothing and rubber gloves. Generally, you need to be as clean as possible when using dye at all stages: when you are measuring it out, while you are printing, and then when you are cleaning up.

Auxiliaries

Whether you are dyeing, painting or printing with reactives, there are several things required in the dyebath, paste or solution:

- Common or Glauber's salt (sodium sulphate) is needed in a dyebath to push the dye onto the fabric
- Soda ash is the alkali and dye fixing component in a dye bath, painting solution and print paste. Generally, silk and wool require half the soda ash used for cotton.
- Urea is a humectant, which means it attracts and retains moisture; it is used to aid the penetration of dye into the fabric during steaming. It also improves the solubility of dye, and therefore enhances the depth of shade. The amount of urea in the recipes will be dependent on factors such as the climate (dry or damp), the way you fix the fabric and the nature of the fabric itself.
- Resist salt L (nitrobenzene; sodium m sulphinate) is used when painting and printing to

improve the stability of the dye, and therefore to assist in the build up of colour.

- Manutex is an alginate; it comes in powder form, and with water makes a paste to which dye can be added for printing. Manutex is easily washed out of fabric after fixing, leaving only the dye, which becomes part of the fabric. Manutex RS is an economical alginate, usually used for printing cotton. Manutex F has a higher solids content, and is used for printing silk, wool and cotton. Both are the same price in powder form, but more Manutex F is required to make the paste, so it is more expensive to use. You can vary the thickness of the paste by adding more or less powder; as a general rule, lighter weight fabrics require a thicker paste, while heavier weight fabrics require a runnier consistency.

- Mesitol NBS is used in the washing process to pigmentise the excess dye, which prevents back staining of the fabric. Back staining is the term used for discolouration of the unprinted areas of the fabric. After most of the excess dye has been removed by rinsing, Mesitol is added at the rate of 2 g per litre of water, and the fabric is left to soak in it for 20 minutes.

Whatever way you apply the dye to fabric, you need the following:

- dye powder to colour fabric
- liquid or paste to get the dye onto the fabric
- chemicals to aid its penetration and fixing.

Without the other ingredients, a lot of the dye will wash out. Once the dyes and chemicals are combined, they should be used within 3 hours, as they start to lose strength.

You can keep stock solutions, but do not add dye until you are ready to use it.

Fixing dyed fabric

Dyebath

If the fabric has been dyed in a dyebath, it doesn't require any fixing, as that has taken place when the soda ash was added. It just needs to be washed out thoroughly.

Handpainted or printed fabric

The fabric requires steaming or sodium silicate solution for the chemical reaction to take place; this is when the dye becomes part of the fabric, and the intensity of colour is built up. Whether you choose one method over the other will depend on your circumstances, and the nature of what you are doing. If you have access to a steamer, that should be your first choice. If not, use sodium silicate solution (Reactafast) which is widely used throughout Indonesia. If you are producing small items in small quantities, Reactafast is ideal. If, however, you are regularly printing lengths with reactive dyes, applying Reactafast to the fabric is labour intensive. It requires thorough washing out, and is not as easily removed as Manutex.

Reactafast (sodium silicate solution) Apply the dye in the usual way. Allow the fabric to touch dry, and coat the area to be fixed with a thin layer of Reactafast. It can be applied with a brush. Leave to cure for 12–24 hours. Rinse out the excess dye, in warm water; it will then require several hot soapy washes to remove the Reactafast. This solution is strong alkali: wear gloves and avoid eye or skin contact.

Steaming Cotton that has been printed with reactive dyes should be steamed within several hours of printing. The strength of the colour will start to reduce the longer it is left. Wool should also be steamed within hours of printing, but silk can be printed and left and steamed days or weeks later with no discernible loss of colour. There are various sorts of steamers, the most common is the box steamer. The fabric is placed inside a stainless steel box, which has water inside it, and which sits on an external heat source (see page 282). The lid is put in place, and the fabric is steamed for 10–40 minutes, depending on the fabric and the heat source. You will always have to test any new steaming arrangement, gauging the success of the results on the retention and penetration of colour.

The printed fabric is rolled up, with another piece of lightweight fabric, around a steel rod which fits inside the steamer (see page 282). This other fabric, known as a steaming cloth, prevents dyed surfaces from touching each other and transferring to places where colour is not wanted. The steaming cloth should be light and open weave such as muslin or cheesecloth to allow the steam to pass through. Take care that no loose threads are hanging in the water when you insert the roll as this can cause moisture to spread inside the roll and ruin the print. Also, don't let too much steam escape when you insert the fabric. You don't need a huge amount of water in the bottom of the steamer—5 cm is ample.

Steaming a test print is a vital part of the process of sampling. A sample should be steamed

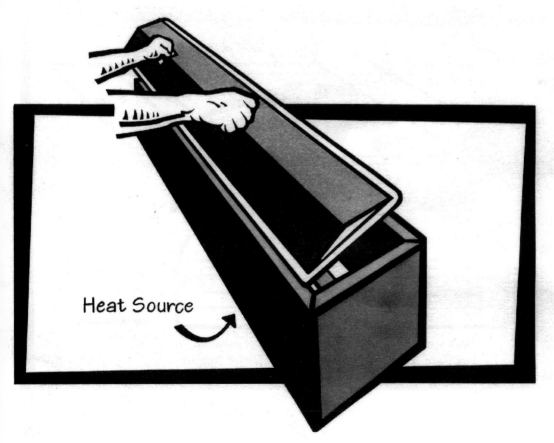

box steamer with lid

Heat Source

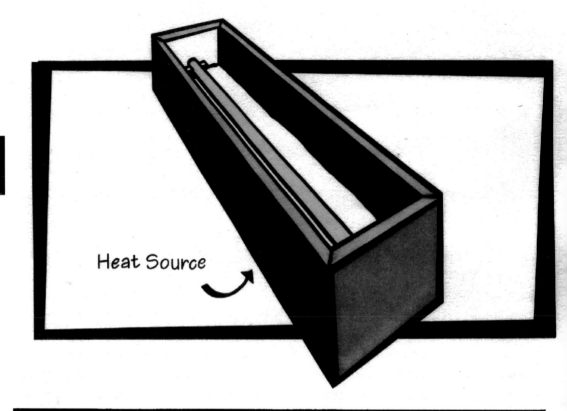

inside the box steamer: the rod sits on brackets at each end

Heat Source

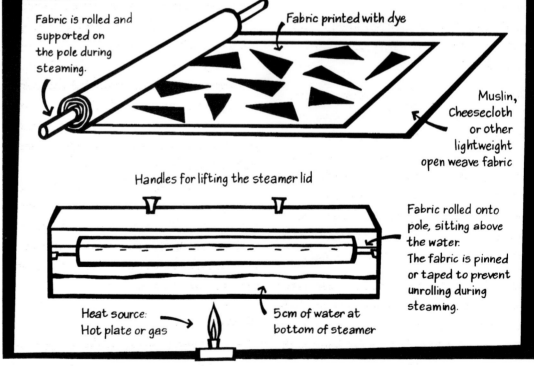

steaming fabric

Fabric is rolled and supported on the pole during steaming.

Fabric printed with dye

Muslin, Cheesecloth or other lightweight open weave fabric

Handles for lifting the steamer lid

Fabric rolled onto pole, sitting above the water.
The fabric is pinned or taped to prevent unrolling during steaming.

Heat source: Hot plate or gas

5cm of water at bottom of steamer

and washed or dried, before results are accepted or rejected.

If you don't have access to a box steamer, you could improvise a small steamer quite simply. You need a reasonably deep stainless steel or enamel container (like a billy) with a wire basket (chip fryer) that fits inside. Line the basket with thick felt, or several layers of a thinner felt: this will absorb the moisture caused by steaming. The lid of the container should also be lined with felt, or a layer of felt placed over the basket before putting the lid on. If you don't line the basket, the condensation will make the fabric too wet, so that the printed areas will bleed. Wrap the sample in another piece of a light open weave fabric, so that the printed surfaces don't touch each other. A small steamer like this will be suitable for small scarves, samples and tests, but is not appropriate for lengths. It is also generally better for lighter fabrics such as silks.

After steaming, the fabric should be rinsed thoroughly to remove the Manutex paste and excess dye.

Dry heat If you don't have access to steaming facilities, ironing thoroughly with a steam iron is one alternative, but the colour intensity will not be as good. Wash out the fabric. If you are not steaming, it might be necessary to slightly increase the urea in the print paste, as this will help create the moisture necessary for the fixation process to take place. More urea is not necessarily better; too much urea can cause other problems.

Air curing Roll up the printed fabric with a layer of light open weave fabric, and wrap it in plastic. Place the roll in a humid environment, like a bathroom, and leave for 48 hours, before washing out. Again, it might be necessary to increase the urea in the print paste. When you are air curing, the longer you leave the fabric the better the colour retention will be. It will not, however, be as good as if the fabric was steamed.

There is the option of not fixing the print at all, and merely washing out the fabric. If the colours are far too dark and you want to reduce their intensity, you could try washing the fabric without steaming.

Washing out the fabric

Generally, fabric that has been steamed will lose less colour. Ideally, have ready two containers or sinks full of water. There should be enough water so that the fabric can move freely. Rinse the fabric in cold water—excess dye will come out immediately. Put the fabric into the second container of water, and move it around while you are filling up the other one again. Rinse a few times, until a substantial amount of dye has come out, and then add 2 g Mesitol NBS per litre of water. Leave to soak for 5–10 minutes; this will help to pigmentise the excess dye so that it doesn't colour the unprinted areas of the fabric. Wash the fabric in warm water with a small amount of detergent. Some thicker cottons may require washing and soaking overnight.

Keep an eye on the fabric as it is drying— sometimes, particularly with cotton fabrics, colour will seep out of the printed areas if it hasn't been washed thoroughly. If this starts to happen, put it in water again immediately, leave it to soak, and rinse until *all* the excess dye is out.

Exercise

Here is a helpful exercise to enable you to see clearly what effect the different finishing processes

will have on the printed fabric. Cut a piece of fabric, which has been printed with reactive dyes into six pieces. One piece should remain as it is (unwashed), another should be washed out with no finishing at all, and each of the other four should be finished in the ways outlined on pages 281–3. One piece should be steamed, one painted with Reactafast, one ironed and one air cured.. Label them as they are finished and washed, so you can compare the results. The steamed sample should show the strongest colour, while the one to which nothing has been done should be a much paler colour.

Cleaning up

With all print processes, cleaning up is important, but when using dyes, it is a vital part of the whole process. The repercussions of not cleaning up properly can be far-reaching, and will often affect other people's work.

- The backing cloth you have printed on should be removed and washed straight after you have used it. Any dye on the cloth will transfer to the next print.
- All screens, squeegees, spatulas and bowls must be thoroughly washed, because any traces of dye left in them will end up where you don't want them.
- The steaming cloth should be washed.
- The bench where you mixed the dye, and the scales should be wiped down, ready for the next person. Dye particles are impossible to see until liquid is added. Everything might *look* clean, but wipe it down anyway.
- Make sure you haven't left blobs of dye along the rail of the table, or in the sink.
- Wash your rubber gloves.

The Recipes

Dyebath (recommended to use for Procion MX dyes)

Make sure you read about health and safety when using reactive dyes (page 279).

For best results, use a container that allows the fabric to be moved about during the dyeing process. Don't try to dye too much fabric at the one time; the hardest thing is to get even colour across the fabric, and the best way to achieve that is to have a large container, plenty of water, and to regularly stir the fabric.

You will need:

- fabric—you need to know how much this weighs dry
- a container (plastic bucket, trough etc.)
- common or Glauber's salt: this pushes the dye onto the fabric
- soda ash: this fixes the dye
- dye.

How much water ?

The amount of water is determined by how much is needed to cover the fabric, and allow it to move. It will be roughly 10–15 litres of water for every 500 g dry weight fabric.

How much salt and soda ash ?

The salt and soda ash are calculated in relation to the water.

- 50 g salt per litre of water
- 5–10 g soda ash per litre of water (5 g pale shades, 10 g strong shades)

How much dye?

The dye is calculated according to the dry weight of the fabric.

For **full shade colours** 4–5 g of dye for every 100 g of fabric

For **black** 8–10 g of dye for every 100 g of fabric

For **pale shades** 0.5 g of dye for every 100 g of fabric

Use this as a guide to work out how much dye you need. If the colour is not dark enough, you can always dye it again. However, if the shade is too dark, it is very difficult to remove colour.

Method

Weigh the dry fabric.

Cover the fabric with water.

Measure how much water you put in.

Calculate the amount of salt and soda ash you need.

Dissolve them separately in hot water. Dissolve the dye in warm water.

Lift the fabric out of the dyebath.

Add dye solution to the dyebath with one-third of the salt solution.

Stir well, to make sure the dye is evenly distributed, and put the fabric back in the bath.

Add the rest of the salt in two stages at 10–15 minute intervals. Keep stirring.

You can add all the salt at once. Adding it in thirds gives a more even result.

Check the depth of shade. When you are satisfied, the colour must be fixed.

Add the soda ash solution in two parts, at 15 minute intervals.

Stir regularly.

Leave 40–60 minutes for fixation to be complete.

You can add all the soda ash at once. Adding it in two parts gives a more even result.

Remove the fabric.

Rinse well in cold water, and then hot soapy water.

Wash in warm water until it runs clear.

The soda ash can be added at any time when the desired shade is reached.

Handpainting with reactive dyes

There are several techniques for painting the dye on the fabric; the one you choose will depend on the effect you want. Whatever method you choose, you must include the chemicals, whether they are in a solution, in a paste, or in a paste that has been applied to the fabric. If you add dye to the painting solution and paint directly onto the fabric, you will get marks that have a very painterly effect, with 'bleeding'. This might be what you are after. However, if you want crisp painted marks:

- You might use the dye in painting solution, with Gutta or wax to define the design lines. The chemicals will be in the solution.
- You might thicken the painting solution, by adding 950 mL of the solution to 50 g Manutex F, which has been pasted with methylated spirits. The paste can be thinned further with more solution. Add dye to the paste, and paint. The chemicals will be in the paste.

- You might paint the fabric with runny Manutex paste. Mix as above. Brush this onto the fabric before painting, and allow it to dry. The fabric then becomes stiff like a piece of paper, and the dye will not bleed. The chemicals are in the paste, so mix the dye with water, and paint onto the Manutex.

To mix 1 litre of handpainting solution

urea	50–100 g
soda ash	5–10 g (Procion)
	10–20 g (Drimarene, Levafix)
	(halve these amounts for silk)
resist salt L	15 g
water	to make up 1 kg
	(or 1000 parts)

Decide how much of the ingredients you need using the information on page 280 about their functions. If in doubt, choose a quantity in the middle of the range. You will make a solution that has 1000 parts.

Weigh	urea	75 g
	soda ash	10 g
	resist salt L	15 g
Add these up.		100 g
Subtract from 1000.		900
	(which is how much water you need)	
Measure warm water.		900 mL

Dissolve all the dry ingredients in this water.

Now you have 1 litre of painting solution, which without dye will keep indefinitely. Add the dye when you are ready to paint. For full shades use 5 g of dye per 100 mL of painting solution, and for black, use 8 g per 100 mL. Dissolve the dye in a little hot water and add to measured amount of painting solution.

Polychromatic printing with reactive dyes

This technique is used to print as many colours as you like onto the fabric, once. The benefit of this technique is the detail of mark making and the intensity of colour that can be printed. It is a one-off technique; the dyes are painted onto a fine monofilament mesh screen, dried, and then transferred to the fabric using a Manutex paste, which has the necessary chemicals in it. You only get one good print from the screen; if you print it a second time, the colour strength will be about 25 per cent of the original. The technique works best with a fine mesh (77T) screen.

Prop the screen off the table surface, and paint onto the inside of the mesh. Dye is dissolved in warm water, and can be painted, sponged, sprayed etc. onto the mesh. Colours can be overpainted to build up depth of shade. Use a hairdryer to dry the dye as you apply it. The painted screen can be left indefinitely, until you are ready to print it. To transfer the design to the fabric, use Manutex paste (see the recipe on page 287).

You may have to print across the screen several times, depending on the thickness of the fabric. As you print, watch for streaks appearing in the paste; these will eventually print onto the fabric if you keep going. They are streaks of dye, and will therefore stain. You will have to discard any excess paste in the screen, because it will have been contaminated with dye from the colour on the screen.

Once the fabric is printed, it needs to be steamed and fixed.

Direct printing with reactive dyes

This is the method where the dye is put straight into the Manutex paste, and then printed through a screen. The screen could be made using any of the alternatives outlined in Chapter 9. The paste is the same as that used for polychromatic printing.

Dissolve the dye in warm water, and add to the print paste.

For **full shade colours**	4–5 g dye per 100 g paste
For **black or navy**	8–10 g dye per 100 g paste
For **pale colours**	0.5 g dye per 100 g paste

You will have to mix the colours as you need to use them, because once the chemicals have been combined with the dye, the colour starts to lose strength.

Follow the guidelines for printing in Chapter 10. Once the fabric is printed and thoroughly dried, it needs to be fixed.

To mix up 1 kilogram of paste for direct or polychromatic printing

This method applies to making a paste for printing both cotton and silk.

cotton	Manutex RS	25–50 g
	urea	100–150 g
	soda ash	5–10 g (Procion)
		10–20 g (Drimarene, Levafix)
	resist salt L	15 g
	water	to make up 1000 parts

silk	Manutex F	50–100 g
	urea	100–150 g
	soda ash	5–10 g (may be omitted)
	resist salt L	15 g
	water	to make up 1000 parts

Decide how much of the ingredients you need, using the information on pages 279–80 about their functions. If in doubt, choose a quantity that is in the middle of the range. You are making a paste that has 1000 parts.

Weigh Manutex RS 40 g

Paste with some methylated spirits.

Weigh	urea	100 g
	soda ash	10 g
	resist salt L	15 g

Add these up. 165 g

Subtract from 1000. 835

(which is how much water you need)

Measure 835 mL warm water.

Dissolve the remaining dry ingredients in this water.

Stirring rapidly,

Pour the solution onto the Manutex paste; continue stirring and the mixture will start to thicken. Don't stop stirring once you start adding the water.

Leave to stand overnight to thicken once it is all stirred in. If the paste is lumpy the next day, use a blender, or electric mixer to beat it, or strain it through mesh.

This paste can be mixed and kept for several months in an airtight container, as long as the dye has not been added to it. Once dye is added, it should be used within 3 hours.

Printing wool with reactive dyes

Woollen fabrics are not easy to print. The surface of woollen fabrics is often not very absorbent, making it difficult to print. As outlined in Chapter 8, ideally wool should be chlorinated if it is to be dyed or printed, so the fibres will accept the dye. There are recipes available for chlorinating wool, but it is a time-consuming process, and not appropriate to deal with here. If the wool has not been chlorinated, the resulting print could look washed out or uneven. Unless you are buying the wool from a wholesaler or retailer specialising in fabrics that are prepared for printing, it is unlikely that you will be able to find out whether the fabric has been chlorinated or not.

Although the same can be said of all fabrics, it is essential to test woollen fabrics for their suitablity for printing before you buy or print a length. Woollen fabrics are expensive, and mistakes will therefore be costly. It might be a good idea to wash the wool first, using a detergent such as Lissipol, which will remove the grease often present in wool, and then rinse thoroughly to ensure that no trace of the detergent is left. Again, do a quick test on a small piece of the fabric to see if this is necessary.

The recipe for printing wool with reactive dyes is very similar to that used for printing cotton and silk, but the soda ash should be omitted. Manutex F is used because of its higher solids content, which will give better print definition. Check with the supplier about whether or not the reactive dyes you have chosen are suitable for printing wool. Add 10 g Wetter OT to each kg of print paste, to assist in getting the dye into the fibres.

The other options for printing wool are to use acid dyes in a paste made from Indalca or Guar gum, or to use either reactives or acid dyes in a special paste prepared for printing unchlorinated wool, which can be purchased from Kraft Kolour dye specialists. The choice of reactive or acid dyes will depend on the colours you want, and the fastness required. All the chemicals are in the wool paste and, with testing, the results can be very good. Wool should be steamed as soon as possible after printing. Steam and wash as for cotton and silk, but note that wool should not undergo any sudden changes in temperature from hot to cold.

Sampling and test printing with reactive dyes

Once you start working with reactives, you will need a technical workbook, in which you keep small swatches of all colours you have ever mixed, and recipe sheets to record those colours. You should also keep a record of things that you learn about incidentally, often this occurs because things have gone wrong.

The easiest way to sample a colour is to take 50 g or 100 g amounts of the paste, and add a corresponding amount of dye. For full shades, you would be using, say, 2 g in 50 g of paste, or 4 g in 100 g paste. If your test is successful (that is, it is the colour you wanted), then you need to decide how much paste to mix up, and multiply your test recipe by, say, 5 to make up 500 g of paste. Doing the samples in small quantities means you waste as little paste as possible.

Knowing how much paste to mix up is difficult; it depends on how absorbent the fabric is, how much coverage is on the screen, and the consistency of the print paste. Roughly, 1 kg of paste in a blank screen will print 3 metres. This means that 1 kg would print 6 metres if the screen had 50 per cent coverage. This calculation cannot be accurate; it is intended to be a starting point only. Keep your own records about how much paste particular prints use per metre.

Below is a table you could copy and use to document your recipes and other information.

Colour	Recipe	Notes	Fabric sample
e.g. burnt orange	100 g paste (Manutex RS) 2 g Pro scarlet MXR 1 g Pro Brown MX2R	steamed for 20 mins, left to soak for 20 mins	

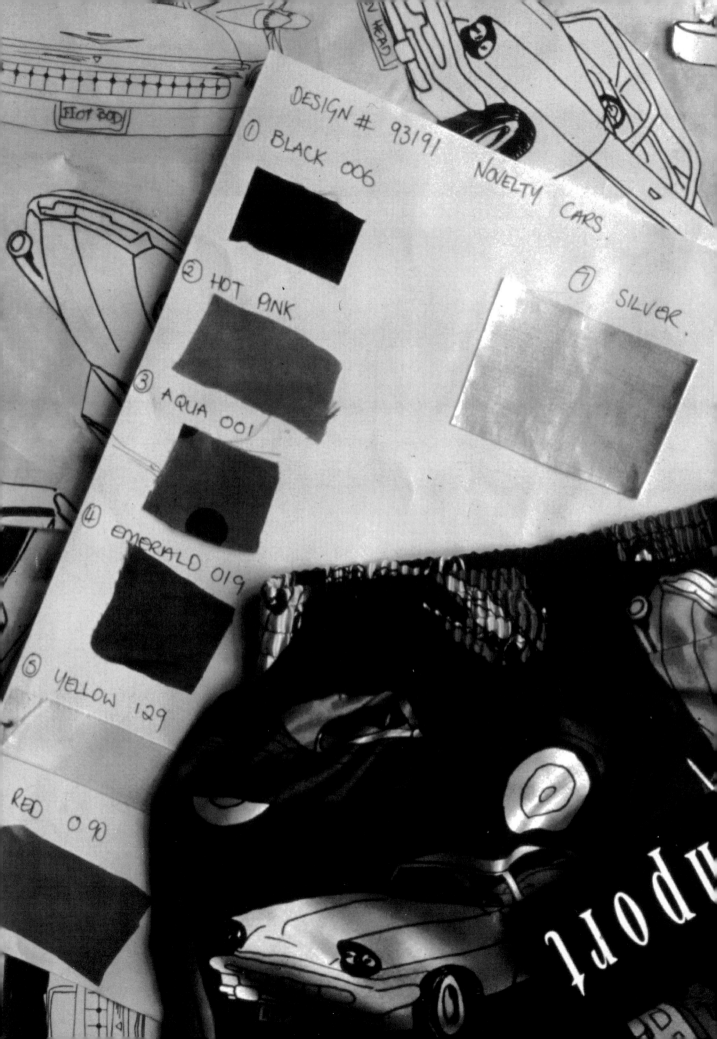

Careers in **textile design** and **related industries**

As with most industries in the 1990s, the textile industry requires designers who have creative as well as technical abilities. This is particularly relevant in Australia, where the textile industry is much smaller than that of the UK, USA or Europe. In Australia, the opportunities for specialisation are fewer, and designers must be prepared to not only design, but to paint up finished artwork, prepare designs for printers and provide technical colour specifications. In most situations, designers must have an understanding of the print processes used, in order to be able to provide designs that are ready for production. In a bigger industry, different people would handle each aspect of the design, from conception to production.

The textile designer
a changing role

In the 1990s, employment status, acquired skills and conditions of employment of textile designers are undergoing change. The way people work today, especially designers, can be determined by a number of factors. Traditionally designers have worked on site, or close to the factory where production takes place, but in the 1990s the computer, modem and fax have enabled textile designers to work independently, at home or in a studio catering for the needs of a range of clients. Many designers in Australia are producing work that is predominantly printed overseas, utilising communication technology to overcome difficulties created by distance. Another visible trend in the 1990s has been for textile wholesalers to close down their own design studios, and instead use

design studios that are servicing several companies, or employ designers on a freelance basis. This is obviously an economic necessity; however a company need not lose an identifiable style, once it establishes a good rapport with a design studio.

This chapter looks at the sorts of jobs that might be advertised as Textile Designer. It also looks at the specific skills of textile designers, and their scope for application to other jobs.

The job descriptions are general, because the details of each position will vary according to the size of the business, and the nature of the business. Employers of textile designers will vary: design studios, textile wholesalers who import fabrics, but produce an in-house range as well, bedding manufacturers, fashion companies, underwear or hosiery manufacturers, swimwear and surfwear companies, to name a few. In some cases, there will be one designer who acts as stylist, colourist and manager. In other cases, there will be a studio manager, several designers, and several assistants.

Studio assistant

This is the lowest rung of the employment ladder for a textile designer; it is where most designers begin. Someone who has just left school, or a recent graduate with no experience of working might be employed as a studio assistant to help the designers. What is learned in this sort of job is as much about meeting deadlines and being professional as being skilful in the interpretation of client needs. It is all about working as part of a team, being organised and seeing how design tasks are analysed in terms of the production restrictions. Daily tasks will include painting up colourways, putting designs into repeat, producing

finished artwork, putting together story boards, buying art materials, contacting clients, organising the despatch of designs. Much of this will be under direction from a studio designer, or the design manager, depending on the size of the company. Many things studio assistants do will not be design specific, but they do contribute to the successful running of a design studio.

The studio assistant classification varies from place to place. Obviously, a school leaver with no specialist knowledge of textile design will be given more general tasks (and less pay!) than a textile design graduate, who will have many skills, but little experience of the application of them in industry, or the particular ways and style of a specific company. How assistants perform as part of the team will determine how quickly they are given more responsibility; while working as a studio assistant, there are opportunities to see and learn many new ways of doing things, so it is important to take note of what is happening in the studio.

The studio assistant role is a form of apprenticeship; it is the starting point for other areas of employment in the textile industry. With this body of experience, it is easier to gain further employment opportunities or to pinpoint preferred specialist areas to work in.

Studio designer/manager

The studio designer's role usually involves deciding the direction to pursue for a client, contact with the client (although this could be a studio manager's responsibility), and generally more creative involvement in the design process. The level of creativity in the designer's role will be deter-mined by the company for whom the designer works, or by the client for whom the work is being produced. The designer will be responsible for the assistants, ensuring that details such as the correct layout and colours are established before the design is painted up, or prepared for the printers. Some designers might have areas of specialisation within a company, or design studio: one designer might be expert in producing florals for bedding, while another might specialise in large scale abstract furnishing designs. These areas of expertise are usually determined after several years of working across a number of different areas; specialisation too early will limit career opportunities in such a small industry.

Increasingly, studio designers are expected to have a knowledge of computer-aided textile design, a growth employment area within the textile design industry. This is a potential area of specialisation for recent graduates who have good computer skills.

The studio manager will often do very little hands-on design work, and might have a role more closely aligned to that of the stylist. The manager's role will depend on the size of the studio. The manager might have to liaise regularly with clients, as well as sales staff, buyers, production teams. The studio manager will invariably be the one who coordinates and oversees all the separate pieces: the client's requirements, the work done by the designers and assistants, the strike offs from the factory, making sure they all fit together to fill the brief. Needless to say, the studio manager's position requires several years of industrial experience, to build up the knowledge required to coordinate all aspects of the design production process.

Stylist

The stylist is a key figure in the running of a textile design studio. This term is used in other design industries, especially fashion and interior magazine work where textiles and products are 'styled' — bringing together ideas about products, colours and themes for consumers. Two important styling magazines for textile designers are *View* and *International Textiles*. The textile stylist is responsible for the overall 'look' of the design range, consulting company management and the studio manager on the selection of designs for forthcoming seasons. The studio manager may, in fact, be the stylist. The stylist performs many functions: designating work to the studio assistants, supervising the studio functions, checking strike offs with the printers. Again, this job requires all-round experience and expertise acquired over a number of years in the industry. A stylist should have a good 'eye' for design, but need not necessarily have great design skills. Stylists will often travel to trade fairs to pick up international trends or colour predictions for forthcoming seasons, and will then use that information to establish directions for their own company's design range, or that of their clients.

Some companies who do not employ a designer as such, will often employ a stylist. Stylists might look at the work of freelance designers on a regular basis to see what will fit in with the stories the company is creating for a particular season, or work with one or two freelance designers with whom they build up a good rapport.

Colourist

This job description is perhaps more relevant overseas, as the Australian textile designer tends to have to be more skilled at a variety of tasks. A converter or textile company may employ a specialist freelance colourist to work on a range of colourways for a client who gives the converter the finished design and requires alternative colourways of that design. The job can be done by hand or by textile computer software.

Companies who deal with furnishing fabrics are likely to employ a colourist; this person might not produce any design work at all, a colourist's job is to put colours together, establishing what the colourways for each design will be, coordinating fabrics and so on. In order to be able to do this, the colourist will need access to colour trends and predictions, sales figures relating to particular fabrics and colours, as well as having what can best be described as an 'intuitive colour sense'. It is a skilled job that requires experience and good research skills to help with colour prediction and with theory, and practical working knowledge of colour media. So often, it is the colour of a particular fabric that creates so much of the fabric's appeal to the consumer.

Colourists need not confine their skills to a textile outcome. Often they work with interior designers and architects on colour schemes for interiors (domestic or public) or with industrial designers on colouring products.

Freelance textile designer

Freelance employment is very common in the design industry; it is not peculiar to textile design. In textile design, the work can be very seasonal, because of fashion ranges coming out at particular and predictable times, for example, bedding ranges are released at certain times of the year. Freelance designers need to be aware of these

'seasons' and make themselves available for work at these times. The traditional way to make yourself known as a freelance designer is to take a folio around to companies, selecting work that is appropriate for each potential client. The other way designers who are starting out obtain work is by word of mouth; if you are skilled and known to be reliable, then word spreads and the work starts coming in. Often, if designers prove to be competent and reliable, a company will continue to give them work on a regular basis. Sometimes a company will employ designers on a freelance basis to do work in-house. This will mean working on the company premises, usually as part of a team, and usually so a particular deadline can be met. The other freelance model is that of several designers sharing a studio (phone, fax, photocopier); they may pool the clients as well, allocating a client to a designer depending on the expertise of individuals, or they might work for their own particular clients. Being a freelance designer can be a very isolated occupation, so sharing a studio with other people is a good solution. It also expands the options available to a client, and the facilities affordable to the designers.

The consultant/predictor

This role requires a lot of experience and a broad knowledge of the textile industry. Consultants are very common in other design or business industries, and cover the professional, strategy-based areas of the textile industries. Freelance consultants usually travel to textile trade fairs around the world, have very good access to marketing intelligence, and gather large amounts of resource data for clients who cannot afford the time or the money to get it themselves.

Consultants can charge a much higher fee than freelance designers because the client is getting focused knowledge and ideas from a variety of sources. The job is potentially tenuous, but a good consultant is a valuable asset for a company that needs reliable, up-to-date information. Consultants supply the client with written and visual materials specific to the client's needs; presentation of this package is important. The package could consist of concept boards with fabric samples and yarns from overseas or interstate wholesalers, colour predictions, overseas trends, and styling considerations. This type of position requires sound marketing knowledge and very good contacts over a broad range of textile-related businesses.

Textile artist: designer-maker

This category of employment is one of the hardest for the textile designer straight out of college to enter. Some options are to produce limited edition or one-off fabrics, or produce a range of textile products, or exhibit work in galleries. A broad range of skills is required to do any of these successfully.

Market research is needed to establish whether there will be a demand for a product, or a gallery that will exhibit textile work. Sound business knowledge, especially the means of securing payment for work done, is well advised. State craft councils and small business centres can offer very good advice and literature on the financial and business aspects of setting up on your own. The hardest aspect of this choice of employment is that facilities to produce printed fabrics are needed. If access facilities through community groups or government-funded projects exist, then this is a

great way to establish whether or not it is what you want to do, and whether you can actually survive. Studios with facilities for printing fabric are expensive to establish, unlike studios for design work, where you need only light, a table, and paper and paint.

What skills are specific to textile designers?

Apart from those occupations outlined, there are many more opportunities in allied areas, which may be advertised as 'designer' or 'buyer' or 'colour consultant'. Textile designers need to look at their skills laterally, and examine what other areas they could turn their hand to, such as:

- surface pattern designer (gift wrap, tiles, carpets, rugs, decals)
- colour consultant
- textile agent
- textile buyer
- teacher
- textile conservation
- textile science or technology.

Surface pattern designer

This area of design is becoming very popular with textile designers who, by nature, are decorators of surfaces. Under the category of surface pattern design can be included floor coverings such as sheet flooring and vinyl tiles, wallpaper, paper-based products such as gift wrap, greeting

card design, swing tags, promotional products, T-shirt design, ceramic tile and decal design. Most of these are usually commissioned by agents or by word of mouth; the jobs are suited to freelance designers who welcome a variety of styles and end product outcome. Some of these areas use skills specific to textile design, such as recurring motifs (tiles, wallpaper, decals) or coordinating patterns.

Colour consultant

Because colour plays such an important role in design for fabrics, good textile designers have a practical understanding of colour principles and how to apply them. These skills can be used in consultancy work for interior designers, architects, or clients who want a colour scheme for their home. Textile designers are very used to putting colours with other colours, working with clients, and extracting from clients what it is that they actually want. There are colour consultants who specialise in wardrobe, makeup, car colours.

Textile agent

Whether or not designers use an agent to sell their work is usually dependent on how good they are at selling work, or how much they enjoy selling, or whether they can afford to pay the commission. This job specification is centred on the use of marketing skills. Textile agents do not have to start off with a textile design background, but it certainly helps to have a knowledge of processes and techniques when selling work direct to a client. The role played by the agent is quite

important for freelance designers; the agent provides a service of networking and contacts that the textile designer would have to spend years developing. Some agents concentrate on overseas selling, taking folios of work to trade fairs or visiting the major textile companies in Europe and the USA to sell direct. The agent usually takes a commission fee for every design sold. The agent will also sell designers' work to local or interstate clients, and give designers styling advice about designs that sell well and design trends for future work. It is, after all, in their interest to sell designs to make a living. Sometimes, a studio manager who is going on a selling trip overseas will add the work of freelance designers to expand the range of work offered in the folio and, of course, to make the trip more economically viable. An agent's fee would be taken from work sold.

A career as a textile design agent involves all aspects of the textile industry, not just printed textiles, and is an area where communication with clients and designers is a major part of doing the job successfully. Experience of the design, manufacturing and buying of textiles in the industry can only be acquired over time.

Textile buyer

This is an important position within the fashion and furnishing industries, both retail and wholesale. Retail buying is primarily working for major stores, or smaller chains or even small one-off interior furnishing shops. Wholesale buyers work mainly with clients in industry rather than buying for the general public. Industry clients would include hotel chains and interior designers. Buying is to do with marketing and business management rather than sitting down and designing fabric. Buyers will select fabric or product from textile industry sales personnel or agents or designer-makers. Buyers select what fabrics are stocked in the fabric department of a large store; they need to be able to visualise fabrics together — printed, plain, knitted, woven — so they look good on the sales floor, serve the customers' requirements, and offer a wide enough choice. Buyers have to have a good working knowledge of textile manufacture and be knowledgeable about design trends in Australian and overseas markets. They usually buy a season ahead so choices and predictions have to be good if the product is going to sell to customers (retail) or clients (wholesale). Buyers work closely with media and public relations departments of organisations and may have the responsibility of styling magazine publicity for the store, merchandising displays, and could also be the company representative at trade fairs, fashion parades and product launches. Buyers with textile design training and some retail or wholesale experience are ideally placed to promote the role of textile design companies and their designers.

Textile conservation

This is a very small area of specialisation, and a career in textile conservation would probably involve further study. Museums and art galleries have textile collections, which are housed usually for their cultural significance. To become involved in this sort of work, you would have to be interested in the history of textiles, its documentation, and the history of manufacturing processes. An interest in and understanding of

textile design would serve as a useful background to the museums' specific concerns.

Teacher

With an additional teaching qualification, a textile design trained person could become an art teacher, who could teach drawing, graphics, CATD, print-making. The most common way to get teaching qualifications in the art area is to do a degree course and then a Diploma of Education.

Textile chemist or technician

If your main interest becomes the structure or composition of fabrics, or the chemistry of dyes and how they work, then you may be suited to a career in textile science or technology. There are specialist courses available for these careers. Industry relies on its technicians as much as its designers for a good quality product.

Technical artwork

If your interest is in technical skills, rather than generating original design work, you may find employment in colour separations. To do this well, you need an understanding of the design process, and an ability to translate designs within production restrictions. Training is usually on the job.

Textile design education

If you are interested in 'textiles', try to establish whether it is the design side that appeals to you, or whether you are primarily a hands-on person who would rather see everything taken through to your own conclusion. Most of textile design for industry is produced on paper, and designers may never see the realisation of it onto fabric, or they may see it many months later. While there are several courses in Australia that offer 'textiles' or textile subjects, there are not many that offer courses that specialise in textile design for industry. Entrance to a textile design course requires good drawing skills above all, and the ability to use colour, or an interest in pattern and surface decoration.

Make sure you are well informed about the course for which you apply. Visit the campus, look at what the students are doing, and ask questions.

Summary

This chapter is intended to expand the possibilities for employment of textile designers. While much of what textile designers do is very specific to a fabric outcome (repeat, presentation, method of printing), those skills can be far more widely applied.

Appendix A Troubleshooting
coating and exposing screens using the photographic process

symptom	possible cause	action
The design washes off the screen.	■ Under exposure — the emulsion has not hardened. If this is the cause, it will tend to be all over the screen. ■ Degreaser or stripper or paste not washed off the screen properly, so that it resists the emulsion — this tends to happen in patches rather than all over.	■ *Strip the screen properly, dry, and recoat. When exposing again, lengthen the exposure time.* ■ *Strip the screen thoroughly, blasting out the stripper, and dry, coat, and expose again.*
The design will not wash out of the screen.	■ Over exposure — the light has passed through the artwork, and hardened the emulsion. ■ Over exposure because the artwork not opaque — the light has passed straight through and hardened the emulsion. Most likely with artwork using chinagraph pencil, or rubbings etc. This is quite likely to be the cause if it happens in patches.	■ *Strip the screen, dry, coat and expose again, and shorten the exposure time. Check artwork -see next entry.* ■ *Strip, dry, and coat screen. Check artwork over light-box, and touch up what is not opaque. If the whole thing is not opaque, shorten the exposure time, but check that this is not less than recommended times. See* Exposing screens, *pp. 234–5.*
The design doesn't wash out of the screen properly especially along the edges — the design seems fuzzy.	■ There is not good contact between the artwork and the screen.	■ *With a vacuum frame, perhaps the air was not sucked out before the exposure started. With any other method of exposing, check the factors that ensure that the contact is good, e.g. weights are evenly distributed. Check that the screen is not warped.*
Parts of the design have almost washed out clearly, but not quite.	■ Parts of the artwork may not have been quite opaque.	■ *It is sometimes possible to use a small amount of very diluted stripper rubbed onto the back of the screen where the blocked bits are, and washed off immediately. The risk of course, is that the emulsion will be stripped from parts where you don't want it to.*
Poor quality image — loss of detail.	■ Wrong mesh size or type of mesh. If your design is detailed, and you are using multifilament mesh, or mesh coarser than 43T, you are bound to lose detail when the screen is exposed. In both cases, the fibres are not close enough together to hold the detail of your design.	■ *If you can, change to a screen that has between 55T and 77T monofilament mesh. If not, make the artwork more definite. Don't use any lines finer than a 0.4 technical drawing pen if you are handprinting and are inexperienced.*
The screen looks completely blank when removed from the exposure unit — no faint images can be seen.	■ The screen has not been exposed — the timer was probably set, but the light not turned on. If there is a cover over the light, it was not removed during exposure. The vacuum frame was not turned to face the light source.	■ *You can re-expose the screen straight away, perhaps exposing it for a slightly shorter time, because it has been out of the dark. There is no guarantee that this will work, but you don't have anything to lose by trying as otherwise you have to strip the screen and redo it.*

symptom	possible cause	action
The screen is riddled with small holes (pinholes).	■ Poor coating can lead to pinholes — scraping off too much emulsion, or scraping off the excess too many times. A blunt coating trough can give a very rough coat. Old mesh can lead to pinholes.	■ *If the holes are isolated, patch them up using photographic emulsion. If they are all over the screen, you may have to strip it and start again. Depending on the detail in your design, you might be able to coat the screen again (without stripping it) and re-expose it, making sure that the artwork lines up perfectly. If only one section is bad, you could recoat just that section, using a small trough, and line up the artwork perfectly when re-exposing.*
The screen is riddled with small holes (pinholes).	■ An exposure that is very short can lead to pinholes, as the emulsion becomes very sensitive and picks up dust specks etc. from the glass of the exposure unit.	■ *See preceding entry about recoating screens. It might be necessary to strip the screen and start again if the design is very detailed or textured, as it will be hard to line up the artwork in the same place.*
The screen was coated without registering it first.	■ Absentmindedness, bad organisation, or rushing.	■ *Position the artwork on the registration table, or the print table, and get the coated screen out of the cupboard — work quickly, as the screen is light sensitive. Put the crosses on the mesh, and then line up the artwork straight away, and expose it. If the screen you forgot to register is from a multi-colour design, make sure you put the artwork the same distance from the rail as you did for the other screens.*
The screen seems to develop pinholes after a few washes.	■ This means the emulsion is breaking down, and was probably not exposed for long enough in the beginning. ■ Stripper may have been splashed on the emulsion while someone else was stripping a screen — this will often appear as dribbles rather than holes.	■ *Touch up the holes and re-expose the screen to harden it again. If it gets worse, you may have to strip it and start again.* ■ *If it is possible, patch up the damage. Otherwise, you could recoat just the damaged section, depending on the design (see note above). If all else fails, you will have to start again.*
The screen looks OK, but when printed for the first time seems to be blocked in parts.	■ 'Scum' is left on the mesh from the washing out process — residue chemicals are left on the mesh as a result of the screen not being washed out for long enough.	■ *Scum is not permanent, and will usually come out in the first wash. It can be avoided by washing the screen down for a minute or so on both sides after you think you have finished, or by looking for a silvery residue in the mesh when the screen is dry. This can be wiped out with a sponge prior to printing. A soapy sponge at the end of the wash after exposure will reduce the likelihood of scum.*

Appendix B Troubleshooting
common printing faults

symptom	possible cause	action
The print looks as if it is bleeding.	■ The fabric has a finish on it — the bleeding might appear a couple of minutes after it is printed.	■ *Thicken the paste with a fabric ink thickener so that it can't run. Doing this will not give good wash fastness, but is fine if you only need a print to look good. Try washing the fabric before printing if your test print bleeds.*
	■ The fabric has a synthetic content — this tends to bleed along the synthetic fibres almost instantly.	■ *Thicken the paste, if using pigment, so that it can't run. Again, this may have poor fastness; add synthetic fixer.*
	■ Your printing is too heavy handed — this will look blotted, with loss of detail.	■ *Try a test print with less pressure.*
	■ The paste is too thin — this will usually apply to finer fabrics.	■ *See Chapter 12 Recipes for details on how to thicken pastes.*
The print is patchy — not good coverage.	■ Not enough print paste in the dye well.	■ *Try putting more paste in the dye well than you thought you would need to keep the screen wet.*
	■ Not enough pulls.	■ *See Using the squeegee, pp. 245–7.*
	■ Not enough pressure.	■ *See Using the squeegee, pp. 245–7.*
	■ Squeegee held too flat, or too upright.	■ *See Using the squeegee, pp. 245–7.*
	■ Print paste too thick.	■ *See Chapter 12 Recipes for how to dilute pastes.*
	■ The screen has become blocked.	■ *If the screen has been left for too long, unwashed, the pigment will start to dry out. This is particularly relevant if it is hot, or the screen is near a fan. Wash the screen immediately. Permanent screen damage can occur this way.*
Small spots appear on the fabric.	■ These are probably pinholes in the screen, see Appendix A. If the spots are consistently in the same place, they are pinholes.	■ *The immediate (temporary) solution is to put tape over the holes so that you can keep printing. Patch the screen with emulsion when it is dry for a more permanent solution.*
	■ The other possible cause is that they are 'splatter' marks caused when you lift the screen — they tend to be more random than pinholes.	■ *Check that the spots are not in the actual screen and then change the way you lift the screen — try from side to side, or lift slower.*
Design does not repeat — gaps where it doesn't join up in some places , but in other places it is OK.	■ Inaccurate artwork — this is likely to be the cause if you look at each repeat, and the way the design joins, and there is an identical fault on each join.	■ *Check the artwork again, concentrating on the part the print shows to be faulty. You might have left out a section in the colour separation. You will have to make the screen again if this is the case.*

symptom	possible cause	action
Design does not repeat — gaps where it doesn't join up in some places, but in other places it is OK.	■ Stops are measured inaccurately — this will be the case if one or two repeats are out, but the rest is OK. ■ The screen could have been put down in place carelessly, and was not positioned against the stop, or against the rail. ■ The fabric might not have been stapled tightly enough, and moved after the first print.	■ *Check the stops are measured accurately — even a few millimetres might make a gap obvious.* ■ *When you do another test print, make sure you are careful with the positioning of the screen.* ■ *Do another test print, making sure there is no movement in the fabric.*
There is a consistent gap or overlap at regular intervals.	■ The stops are measured at the wrong repeat. ■ The stops have been measured from the wrong points — if the gap or overlap is the same as the width of a stop, then this is the cause.	■ *Measure the gap or overlap, and reset the stops, adjusting the repeat size; overlap — increase the repeat size; gap — reduce repeat size.* ■ *Check that the stops have been measured from the left hand side of one to the left hand-side of the next — see diagram on p. 239.*
The design joins up at the rail end, but has a gap that gets wider at the other end.	■ The design has been registered or exposed on the screen crookedly — if the fault is recurring this will probably be the case. ■ The screen has not been put down against the rail — if the fault is here and there, this will probably be the cause. ■ There could be something like a pencil against the rail, preventing the screen from sitting flat.	■ *It might be possible to prop the screen on one side to make it straight to the rail. A screw at the base of the frame, which makes it sit out from the rail, might do the trick if the fault is minor. This works best with a one-colour design.* ■ *Test print again, and make sure the screen is flat against the rail.* ■ *Remove it!*
Double image or blurred print.	■ The screen moved as it was being printed — this is most likely to happen when the print has low coverage. ■ The screen is warped.	■ *If you are printing with two people, make sure one pushes the screen into the rail as the other prints. Use weights on the frame if printing by yourself.* ■ *Use weights on the frame, and hold it flat.*
'Shadow' marks have appeared on the fabric.	■ This is probably 'pick-up' from putting the screen down on a wet print. ■ The marks could be caused by movement in the fabric, which causes the wet paste to 'flick' as you lift the screen after printing.	■ *Make sure that the adjoining prints are touch dry before printing those in-between.* ■ *Make sure that you lift the screen carefully — try lifting from side to side — or make sure the fabric is taut.*

Appendix C Troubleshooting
using reactive dyes

Many of the problems with using reactive dyes will be the same as those outlined in Appendix B: problems with the fixing and finishing of fabric printed or painted with dye, or print problems that are peculiar to working with dye. It is important to test print when working with dye: assess your results when the test print has been steamed, washed and dried. Make sure the recipe is appropriate for the fabric you are using.

symptom	possible cause	action
The test print looks as if it is bleeding, or has poor definition, before it has been steamed.	■ The consistency of the print paste is too runny.	■ *Mix a thicker paste — add more Manutex powder.* ■ *If you need to print immediately, thicken the paste by adding fabric ink thickener, and keep going.*
	■ The fabric is very light, or slippery.	■ *Make up a runny paste with Manutex and water, and apply it to the fabric by painting, or printing through a blank screen. Let it dry, and print the design over the top. The fabric becomes stiff, so the print will have good definition. The Manutex will wash out after steaming.*
	■ The fabric has a finish on it.	■ *Try washing the fabric prior to printing; if it doesn't wash off, the fabric will probably not be able to be printed, as the colour will not be able to penetrate past the finish. Always test fabric suitability.*
	■ You have printed too heavily, printed too many pulls, or used the wrong squeegee or angle.	■ *See Appendix B.*
The print looks as if it has been bleeding after steaming, but before it has been washed.	■ The fabric has been steamed for too long or the steaming conditions are unsatisfactory. ■ The fabric was not totally dry before steaming — this will be more likely if the fabric is heavy weight. ■ The print paste has too much urea in it.	■ *Reduce the steaming time, so the fabric does not get as wet.* ■ *In the steaming process, the damp print will bleed. Thoroughly dry fabric with fans or hair dryers.* ■ *Urea is the humectant in the paste; cut down the amount of urea so the fabric does not get as wet.*

symptom	possible cause	action
The fabric looks as if it is bleeding after it has been washed out.	■ The most common cause of this is that the fabric has not been washed out thoroughly. ■ You could have excess dye in the print paste.	■ *Soak the fabric longer, particularly if it is cotton, or a heavy weight fabric. Excess dye trapped in the fibres will seep out as the fabric dries, even though the rinsing water looked clear. If you see this happening, quickly wash the fabric again. Some heavy fabrics might need to soak overnight in cold water.* ■ *Check that you have not exceeded the recommended maximum: 4 % for colours and 8 % for black.*
The print washes off the fabric, after it has been steamed and washed.	■ The fabric is synthetic, and therefore has no affinity with reactive dyes. ■ There were no chemicals added to the print paste. ■ The dyes you used were not reactive dyes, and therefore have no affinity with the fabric.	■ *Do a fibre identification test : use either Ultrastain or the burn test (see p. 181). This should be done prior to any printing.* ■ *Without the urea, resist salt, and soda ash, the dye will not fix during the steaming process. Check each time that you have everything.* ■ *Check the dye you used; in a school or shared facility, there are often several different classes of dye available.*
Too much colour has washed out of the fabric, after it has been steamed and washed.	■ The fabric has some synthetic content. ■ The dye has not been fixed properly: if the fabric is cotton, there was not enough soda ash in the paste (or it was omitted). ■ The steaming conditions were not satisfactory: either it was not hot enough, or the fabric was not steamed for long enough, or too much fabric was steamed at once, or the steaming cloth was too thick (in a box steamer). ■ The print paste was too old, and had therefore expired before printing. ■ Too much time elapsed between printing and steaming. ■ When the fabric was washed, the first bath was too hot.	■ *Do a fibre identification test (see p. 181).* ■ *Test again, making sure you add soda ash to the paste.* ■ *The less hot the steamer is, the longer you will have to steam for. Look at ways of increasing the heat in the steamer for better results. If the steamer is satisfactory, increase the time. Steam fabric in smaller quantities. The steaming cloth should be light, and open weave, to allow steam to pass through. Look at using Reactafast as a fixing method.* ■ *Once the soda ash is added to the print paste, the reaction begins, and the colour starts to slowly expire. Colours should be mixed as required. The longer they are left, the greater the reduction in strength.* ■ *Cotton fabric should be steamed as soon as possible after printing for best results. You will progressively lose colour the longer you leave it.* ■ *The first bath should be warm, not hot; too much dye will wash out straight away if the first bath is too hot.*
The print looks as if it has poor coverage after steaming and washing but seemed fine before finishing.	■ Print paste too thick : if it is too thick it will only print the surface of the fabric, and even lengthy steaming will not make the dye penetrate into the fibre.	■ *Thin down the print paste : it can be quite thick, but should not be sticky and difficult to print.*
The print looks patchy after it has been steamed and washed.	■ The dye was not dissolved properly, or the paste is lumpy.	■ *Let the paste stand overnight, if possible, to fully dissolve the Manutex. If the paste is still lumpy, strain it through mesh before printing with it. Lumpy paste will cause white 'spots' in the print. Make sure all the dye particles are dissolved in warm water, before adding to the print paste.*

symptom	possible cause	action
The print looks patchy after it has been steamed and washed.	■ The fabric may have a finish, or treatment applied to it that is uneven. A good example is wool that was chlorinated unevenly. The fabric may have been washed unevenly so that not all of the size has been removed.	■ *Wash fabric in hot soapy water.*
The unprinted areas of the fabric are discoloured.	■ This is probably due to something that happened in the washing out procedure Check also that you did not exceed the maximum amount of dye : 4 % for colours, 8 % for black.	■ *If the first bath was too hot, too much excess dye has come out suddenly, and fixed itself to the 'white' or unprinted areas of the fabric. You could try washing the fabric for longer. Check that you did not have excess dye in the print paste.*
The colour in your length is different from your sample.	■ The fabric you sampled was different to the length you are printing. ■ The test print was not steamed properly, and not washed out properly.	■ *You should always test print on the same fabric that you are using for your length. Colours will look very different on different fabrics.* ■ *The test print should be produced exactly as the fabric will be.*
The print does not go through to the other side of the fabric as you want it to.	■ The consistency of the print paste should be runnier. ■ You haven't steamed the fabric. ■ You haven't steamed the fabric for long enough. ■ You need more urea in the print paste.	■ *Use less Manutex powder when making the paste.* ■ *Often the print will not go through to the other side until the fabric has been steamed and washed.* ■ *Increase the steaming time.* ■ *Increase the amount of urea in the print paste; remember that too much urea can cause the print to bleed during steaming.*
After steaming, colours that have been printed over each other have not really overlapped to give a third colour.	■ The steaming conditions are not satisfactory. ■ The print paste should be runnier because the dye has to go through a layer of Manutex before reaching the fabric. ■ The colours were mixed up too strong.	■ *Because there are several layers, it might require longer or hotter steaming.* ■ *Use less Manutex powder when mixing up the paste.* ■ *Try using dye strengths of less than 2 %. Overlapped colours will show much better in weaker strengths of dye, than full strength.*
You can't get good definition when handpainting.	■ Dye in a painting solution is used to achieve a wash effect, or for loose application of colour	■ *If you want good definition with handpainting, either put the dye in a very runny Manutex paste (with the chemicals) or put a layer of Manutex on the fabric first, and use the handpainting solution.*
All the colour washes out of the handpainted fabric.	■ The possible causes will be the same as for printed fabric; a common mistake when handpainting is to forget to add the chemicals to the dye.	■ *As for printing.*
The polychromatic print has streaks of colour through it.	■ When you printed, you have picked up excess dye from the areas painted on the mesh.	■ *As soon as you notice small streaks when you are printing, stop. The streaks will continue to appear, and will usually get stronger as more excess colour is picked up. Try less pulls. Also, try using less dye when you mix up the colours.*

symptom	possible cause	action
In a polychromatic print, there are white 'spots' where there should be printed colour.	■ Some of the dye was not dissolved properly before it was painted onto the mesh.	■ *Make sure all the dye is dissolved before you paint it; the paste transfers the colour to the fabric, but cannot dissolve the dye.*
The printed fabric has mysterious spots of colour on it.	■ Dye from someone else's print has been transferred from somewhere else (usually the backing cloth) when you printed.	■ *Make sure that the backing cloth is washed every time someone has printed with dye. Keep the print table and surrounding area clean. Dye particles are usually invisible until you print, and the wetness of the print paste dissolves them. It is usually too late to get rid of them once they are on your fabric.*
Streaks of other colours keep appearing on the print.	■ The screen or squeegee was not washed properly last time you used it, and old dye is now being transferred to the fabric.	■ *Make sure you wash screens thoroughly. You need to be more careful when using dye: use detergent and warm water, and a brush or sponge.*

Bibliography

Books

Atterbury, Paul. *Art Deco Patterns: A Design Source Book*. New York: Portland House,1990.

Audsley, G A. *Designs and Patterns from Historical Ornament*. USA: Dover Publications, 1980.

Audsley, G A and T W Cutter. *The Grammar of Japanese Ornament*. London, UK: Studio Editions, 1989.

Baseman, Andrew. *The Scarf*. New York: Stewart, Tabori & Chang, 1989.

Bosker, Gideon, Michele Mancini and John Gramstad. *Fabulous Fabrics of the 50s (and other terrific textiles of the 20s ,30s and 40s)*. USA: Chronicle Books, 1992.

Brandon-Jones, J. *Silver Studio Collection: A London Design Studio, 1880–1963*. UK: Lund Humphries in association with Middlesex Polytechnic, 1980.

Bredif, Josette. *Toiles De Jouy. Classic Printed Textiles from France 1760–1843*. UK: Thames & Hudson, 1989.

Clarke, W. *An Introduction to Textile Printing*. UK: Newnes Butterworth, 1980.

Colchester, Chloe. *The New Textiles.Trends and Traditions*. UK: Thames & Hudson, 1991.

Day, Lewis F. *Pattern and Design*. UK: B T Batsford Ltd, 1979.

Dyer, Rod and Ron Spark. *Fit To Be Tied: Vintage Ties of the Early Forties and Fifties*. New York, USA: Abberville Press.

Fisher, Richard and Dorothy Wolfthal.*Textile Print Design*. USA: Fairchild Pub., 1987.

Fritz, Anne and Jennifer Cant. *Consumer Textiles*. Australia: Oxford University Press, 1989.

Ginsberg, Madeleine. *Illustrated History of Textiles*. UK: Studio Editions, 1991.

Gohl, E P G and L D Vilensky. *Textiles for Modern Living*. Australia: Longman Cheshire, 1988.

Guild, Tricia. *New Soft Furnishings*. UK: Conran Octopus, 1990.

Hefford, Wendy. *The Victoria and Albert Museum's Textile Collection: Design for Printed Textiles in England from 1750 to 1850*. UK: Victoria and Albert Museum, 1992.

Jackson, Lesley. *The New Look: Design in the Fifties*. London: Thames & Hudson, 1991.

Jones, Owen. *The Grammar of Ornament*. UK: Omega Books, 1987.

Joyce, Carol. *Designing for Printed Textiles (a guide to studio and free-lancing)*. USA: Prentice Hall, 1982.

McDermott, C. *English Eccentrics. The Textile Designs of Helen Littman*. London: Phaidon Press Ltd, 1992.

Mauries, Patrick. *Fornasetti: Designer of Dreams*. UK: Thames & Hudson, 1991.

Mellor, Susan and Joost Elffers. *Textile Designs*. UK: Thames & Hudson, 1991.

Mendes, Valerie and Frances Hinchcliffe. *Ascher: Fabric, Art, Fashion*. UK: Victoria and Albert Museum, 1987.

Menz, Christopher. *Morris and Company. Pre-Raphaelites and the Arts and Crafts Movement in South Australia*. Australia: Art Gallery Board of South Australia, 1994.

Morgan, G and Robert Craig. *Lizards, Snakes and Cattle Dogs*. Australia: Reptilia Publishing, 1993.

O'Callaghan, Judith. *The Australian Dream: Design of the Fifties*. Sydney: Trustees of the Museum of Applied Arts and Sciences, Powerhouse Publishing, 1993.

Paine, Melanie. *The Textile Art in Interior Design*. London: Mitchell Beazley, 1990.

Parry, Linda. *Textiles of the Arts and Crafts Movements*. London: Thames & Hudson, 1988.

Perez-Tibi, Dora. *Dufy*. London: Thames & Hudson, 1989.

Philips, Peter and Gillian Bunce. *Repeat Patterns: A Manual for Designers, Artists and Architects*. UK: Thames & Hudson, 1993.

Phillips, B. *Fabrics and Wallpapers: Design Sources and Inspiration*. Ebury Press, 1991.

Proctor, Richard M. *The Principles of Pattern Design*. USA: Van Nostrand Reinhold, 1969.

Proctor, Richard M and Jennifer F Lew. *Surface Design for Fabric*. USA: University of Washington Press, 1984.

Racinet, A C. *The Encyclopedia of Ornament*. London, UK: Thames & Hudson, 1988.

Racinet, A C. *Handbook of Ornaments in Colour Nos 1, 2, 3, 4*. USA: Van Nostrand Reinhold, 1988.

Radice, Barbara. *Memphis*. New York: Rizzoli, 1984.

Rose, Cynthia. *Design After Dark. The Story of Dance Floor Style*. UK: Thames& Hudson, 1991.

Rothstein, Natalie. *Silk Designs of the Eighteenth Century. From the Collection of the Victoria and Albert Museum*. London: Thames & Hudson, 1990.

Schoeser, Mary and Kathleen Dejardin. *French Textiles: From 1760 to the Present*. Laurence King Publishing,1991.

Shobo, Kawade. *Designers' Guide to Colour Nos 3, 4, 5.* Australia: Angus & Robertson, 1992.

Simmons, Max. *Dyes and Dyeing.* Australia: Van Nostrand Reinhold, 1978.

Steele, T. *The Hawaiian Shirt. Its Art and History.* New York: Abberville Press, 1984.

Stevens, P. *Handbook of Regular Patterns.* USA: MIT Press, 1980.

Storey, Joyce. *Textile Printing.* London: Thames & Hudson, 1974.

Strizhenova, Tatiana. *Soviet Costume and Textiles 1917–1945.* France: Flammarion, 1991.

Sumner, Christina. *A Material World: Fibre, Colour and Pattern.* Sydney: Powerhouse Publishing, 1990.

Tasinskaia, I M. *Soviet Textile Design of the Revolutionary Period.* UK: Thames & Hudson, 1983.

Volker, Angela. *Textiles of the Weiner Werkstatte 1910–1932.* UK: Thames & Hudson, 1994.

Whitford, Frank. *The Bauhaus: Masters and Students By Themselves.* London: Amazon Publishing, 1992.

Wozencroft, Jon. *The Graphic Language of Neville Brody.* UK: Thames & Hudson, 1988.

Yates, Mary Paul. *Textiles. A Handbook for Designers.* USA: Prentice Hall, 1986.

Australian periodicals

Available from newsagents
Belle Design and Decoration, GPO Box 5252, Sydney NSW 2001

Designink, 11 School Road, Ferny Creek Vic. 3786
Fashion Quarterly
House and Garden
Monument Architecture Quarterly, PO Box 172, Double Bay NSW 2028
Vogue Living, *Vogue Australia*, 170 Pacific Highway, Greenwich NSW 2065

European and American periodicals

*Available from newsagents
Colors, Via di Ripetta, 142 00186 Roma, Italia
Elle Decoration (UK, USA, France), Victory House, Leicester Place, London WC2H 7BP, UK
ID Fashion magazine, 3rd floor, 134–136 Curtain Road, London EC2A 3AR, UK
International Colour Authority, 33 Bedford Place, London WC1B 5JX, UK
International Textiles, 33 Bedford Place, London WC1B 5JX, UK
Maison et Jardin, 4 place du Palais-Bourbon, Paris, France
Surface Design Journal, PO Box 20799, Oakland CA 94620, USA
The Artist's and Illustrator's Magazine, Tower House, Sovereign Park, Market Harborough, Leicestershire LE16 9EF, UK
The Face, The Old Laundry, Ossington Buildings, London W1, UK
The World of Interiors, 234 Kings Road, London SW3 5UA, UK
Textile View, *Colour View*, *Interior View* (European), Europress Distributors Pty Ltd, 352 Drummond Street, Carlton Vic. 3053.
Available from: Perimeter Books, 190 Bourke Street, Melbourne Vic. 3000

Suppliers of equipment, inks, dyes and printing auxiliaries

Victoria

Art Mat Pty Ltd
1 Queens Avenue, Hawthorn Vic. 3122
03 819 2133
Supplier of art and design materials and equipment.

Zart Art
4–41 Lexton Road, Box Hill Vic. 3128
03 890 1867
Supplier of art and design materials, screen printing equipment, inks, dyes and auxiliaries.

Art Stretchers Pty Ltd
28 Orr Street, Carlton Vic. 3053
03 663 8624
Supplier of art and design materials, papers, textile inks, squeegees and printing equipment.

Artistcare (Australia) Pty Ltd
101 York Street, South Melbourne Vic. 3025
03 699 6188
Supplier of art and design materials.

Calico House
521 Chapel Street, South Yarra Vic. 3141
03 826 9957
Supplier of natural cotton fabrics for printing.

Days Screen Printing Supplies
119 Camberwell Road, Hawthorn East Vic. 3123
03 813 1511
Supplier of screens, squeegees, mesh, printing equipment and inks, drafting film, opaque media and photographic screen emulsion.

Kraft Kolour Pty Ltd
Factory 11, 72 Chifley Drive, Preston Vic. 3072
03 484 4303
Supplier of a wide range of dyes, inks and printing auxiliaries, screens, squeegees, mesh, fabrics, film, opaque media and photographic emulsion. Australia-wide mail order service available.

Marcus Art Pty Ltd
218 Hoddle Street, Abbotsford Vic. 3067
03 419 8477 or 1800 816 652
Suppliers of printing inks, screens, squeegees,
paper, art and design materials.

N S Eckersley (Sales) Pty Ltd
116 Commercial Road, Prahran Vic. 3181
03 510 1418
Supplier of art and design materials and
equipment.

Marie France
223 High Street, Kew Vic. 3101
03 853 2668
Supplier of silk and dyes for handpainting on
fabric.

The Silk Workshop
244 High Street, Kew Vic. 3103
03 853 9986
Supplier of silk and dyes for handpainting on
fabric.

Toyo Screen
29 Gordon Street, Kilsyth Vic. 3137
03 728 6800
Supplier of photographic screen emulsion,
cleaning agents and screen strippers. Screen
stretching.

Océ-Australia Pty Ltd
89 Tulip Street, Cheltenham Vic. 3192
03 263 3333
Supplier of drafting film.

New South Wales

Batik Oetoro
203 Avoca Street, Randwick NSW 2031
02 398 6201
Supplier of dyes, inks and auxiliaries.

Elsegood Fabrics Pty Ltd
1st Floor, Silk House, 8 Little Queen Street
Chippendale NSW 2008
02 319 2266
Supplier of silk and other apparel fabrics.

Edman Wilson Co. Pty Ltd
18–20 Whiting Street, PO Box 290,
Artarmon NSW 2064
02 436 0371
Supplier of screens, mesh, all printing equipment
and textile inks.

Colormaker Industries Pty Ltd
44 Orchard Road, Brookvale NSW 2100
02 939 7977
Supplier of textile printing inks.

Harlequin Textile Inks
52-62 Arncliffe Street, Arncliffe NSW 2205
02 597 6366
Supplier of textile printing inks and screen
cleaning chemicals.

Hydrotech Pty Ltd
1519 Botany Road, Botany NSW 2019
02 316 7607
Supplier of photographic emulsion, strippers and
printing auxiliaries.

Norman Reynolds
PO Box 170, St Peters NSW 2044
02 550 2677
Supplier of photographic screen emulsion,
screen cleaning chemicals, mesh and frames.

Oxford Art Supplies Pty Ltd
221-223 Oxford Street, Darlinghurst NSW 2010
02 360 4066
Supplier of all art and design materials, screen
printing equipment, textile printing inks and
photographic emulsions.

South Australia

Marie France
92 Currie Street, Adelaide SA 5000
08 231 4138
Supplier of silk and dyes for handpainting on
fabric.

Commission Dyers Pty Ltd
7 Pinn Street, St Marys SA 5042
08 276 2844
Supplier of dyes and printing auxiliaries.

Toyo Screen
159 William Street, Beverley SA 5009
08 347 1035
Supplier of photographic screen emulsion,
cleaning agents and screen strippers.

Queensland

Harlequin Inks
45 Peel Street, South Brisbane Qld 4101
07 846 5211
Supplier of inks and printing auxiliaries. Screen
stretching.

Toyo Screen
28 Boyland Avenue, Coopers Plains Qld 4108
07 274 1300
Supplier of photographic screen emulsion,
cleaning agents and screen strippers.

Australian Capital Territory

Arttech Warehouse
30 Lonsdale Street, Braddon ACT 2601
06 257 1711
Supplier of artist materials, drafting film, textile
inks, screens and dyes.

I & J Trading
12 Pirie Street, Fyshwick ACT 2609
06 239 1948
Supplier of textile printing inks, screen stretching
and printing equipment.

Western Australia

Creative Hot Shop
96 Beaufort Street, Perth WA 6000
09 328 5437
Supplier of printing equipment, dyes, printing
inks, art and design materials.

The Paper Merchant
316 Rokeby Road, Subiaco WA 6008
09 381 6489
Supplier of textile printing inks, screen printing
equipment and wood blocks.

Educational Art Supplies
17 Hampden Street, Nedlands WA 6009
09 386 5477
Supplier of art and design materials.

Jacksons Drawing Supplies
103 Rokeby Road, Subiaco WA 6008
09 381 2488
Supplier of art and design materials.

Tasmania

Walch's Art and Graphic Supplies
130 Macquarie Street, Hobart Tas. 7000
002 233444
Supplier of art and design materials, textile inks
and screen printing equipment.

Index